THE PHOTOGRAPHER'S MARKET® GUIDE TO

BUILDING YOUR PHOTOGRAPHY BUSINESS

SECOND EDITION

THE PHOTOGRAPHER'S MARKET® GUIDE TO
BUILDING YOUR
PHOTOGRAPHY BUSINESS

SECOND EDITION

VIK ORENSTEIN

WRITER'S DIGEST BOOKS

www.writersdigest.com
Cincinnati, Ohio

The Photographer's Market Guide to Building Your Photography Business. © 2010 by Vik Orenstein. Manufactured in China. All rights reserved. No other part of this book may be reproduced in any form or by any electronic or mechanical means, including information storage and retrieval systems, without permission in writing from the publisher, except by a reviewer, who may quote brief passages in a review. Published by Writer's Digest Books, an imprint of F+W Media, Inc., 4700 East Galbraith Road, Cincinnati, Ohio 45236. (800) 289-0963. First edition.

For more resources for writers, visit www.writersdigest.com/books.

To receive a free weekly e-mail newsletter delivering tips and updates about writing and about Writer's Digest products, register directly at http://newsletters.fwmedia.com.

14 13 12 11 10 5 4 3 2 1

Distributed in Canada by Fraser Direct, 100 Armstrong Avenue, Georgetown, Ontario, Canada L7G 5S4, Tel: (905) 877-4411. Distributed in the U.K. and Europe by David & Charles, Brunel House, Newton Abbot, Devon, TQ12 4PU, England, Tel: (+44) 1626-323200, Fax: (+44) 1626-323319, E-mail: postmaster@davidandcharles.co.uk. Distributed in Australia by Capricorn Link, P.O. Box 704, Windsor, NSW 2756 Australia, Tel: (02) 4577-3555.

Library of Congress Cataloging-in-Publication Data

Orenstein, Vik, 1960–
 The photographer's market guide to building your photography business / Vik Orenstein. -- 2nd ed.
 p. cm.
 ISBN 978-1-58297-572-6 (pbk. : alk. paper)
 1. Photography--Business methods. 2. Photography--Marketing. I. Title.
 TR581.O74 2009
 770.68'8--dc22
 2009015126

Edited by Melissa Hill
Designed by Claudean Wheeler
Production coordinated by Mark Griffin

DEDICATION

To my family: Tim, Kate, and Albie

ACKNOWLEDGMENTS

I'd like to extend my heartfelt thanks to the following people who all contributed in one form or another to the completion of this book.

The photographers who contributed their words and/or pictures to this project: Peter Aaron, Stephanie Adams, Doug Beasley, Craig Blacklock, Roy Blakey, Hilary Bullock, Kathleen Carr, Connie Cooperman-Edwards, Bob Dale, Chris Darbonne, Laura Dizon, Kerry Drager, Colleen Farrell, Patrick Fox, Michelle Frick, Stormi Greener, Timothy Guay, Susana Heide-Theissen, Evy Johansen, Lewis Kemper, Judy Kennamer, Leo Kim, Rob Levine, Kathy Locke, Randy Lynch, Kelly McSwiggan, Karen Melvin, Jim Miotke, Sharon Morris, Maria Mosolova, Donna Pagakis, Iberionex Perello, Lauren Peterson, Keri Pickett, David Sherman, Lee Stanford, Beth Wald, Jennifer Wu, Avril Young, and Jim Zuckerman.

My family: Tim and Kate Dale and Albie Sher.

My portrait subjects: the Augustine family, the Barnett family, the Bergsrud family, the Brazsee family, the Burgess family, the Dagnault family, Kate Dale, Tim Dale, the Feriancek family, the Grandstrand family, the Hughes family, the Hodgson family, the Mattys family, the Nunnelly family, the Palumbo family, the Peterson family, the Rudelius family, the Rusing family, the Silva family, and Albie Sher.

My team: Kim Barnett, Pat Lelich, Marjie Theiman, my CPA Jim Orenstein, my lawyer, Janet Bouche-Krause, my literary agent, Diana Collier, and my editor, Melissa Hill.

And finally, team BetterPhoto.com: all the fantastic staff and instructors who make it so inspiring and so much fun to "be" there, and all my students, past and present.

CONTENTS

TO BE A PHOTOGRAPHER

A lot of people say they want to be a photographer, but what do they really mean when they express this desire? Who do people think a photographer is, and what do they think he does?

Basically, most people think a photographer is a visual artist. They imagine a photographer spends most of his time shooting pictures and editing images in a digital darkroom; he makes a lot of money; he gets to work with gorgeous models and glamorous advertising people and brilliant architects and other talented types; he gets to use cool equipment and travel to exotic locations; and he gets to see his work in magazines and advertisements. All this, *and* he gets to set his own schedule!

Well, this is all true … about 20 percent of the time. But the other 80 percent of being a photographer falls into other categories that may seem more mundane at first glance.

So if being a photographer isn't exactly what people think it is, what is it?

This is an assignment shot for the *Minneapolis StarTribune* by Stormi Greener. This image shows the stack of catalogs this woman received during a single holiday season between Thanksgiving and Christmas.

PROS AND CONS OF BEING A PHOTOGRAPHER

Is being a photographer all its cracked up to be, or is it a case of "be careful what you wish for, because you might just get it?" As in all professions, there is good and bad.

THE PROS

- **THE GEAR:** I admit it—photography equipment is amazing and exciting! A fast lens with (as we say in the business) "good glass," is truly a thing of beauty. A new camera bag, with its cunning storage compartments and Velcro and pockets can give me a rush. If you aren't a gear head when you start shooting, you will be one soon.

- **THE MONEY:** Sure, it fluctuates. If you don't work, you don't get paid. But when you pull down $17,000 for one stock image, make $1,600 for a day's work, have a $6,000 portrait sale, or get $4,500 for shooting a wedding, none of that seems to matter.

- **THE COMMUNITY:** Whether you belong to an Internet community, a professional association, or just go down to your local professional camera store and talk shop with the sales folks, hanging out with like-minded people is very satisfying.

- **THE INDEPENDENCE:** When you work for yourself in your own small business, you get to decide what you want to do, and when and how it do it. That doesn't mean you'll get to take it easy—it usually means you'll be working twice as hard as you would be if you were working for someone else. But it will be on your terms and on your schedule.

- **SEEING YOUR WORK IN PRINT:** This is possibly the best thing after the gear. Truly, it never gets old to see your work in print. I have tear sheets I will forever treasure, including a brochure for a medicine to eradicate canine intestinal parasites (with someone else's macro shots of worms floated on top of my adorable images of a little girl and her golden retriever puppy). If intestinal parasites don't even kill the buzz, you know it's good!

THE CONS

- **THE UNCERTAINTY:** Let's face it—we don't go to eight years of graduate school and get a degree that tells the world we are certified photographers. We don't get any fancy initials after our names like esq. or Ph.D. or DVM or DDS. So we have to settle for acting certified. Like the scarecrow in *The Wizard of Oz*, we have the brains but without a diploma we might not believe it.

- **THE WET BELLY:** My colleagues who shoot nature have a phrase for going out at dawn and lying down in the grass to get great images. They call it "wet belly photography." The fact is,

we often have to do things in order to get the shots we need that we most certainly didn't sign up for: stand in raw sewage; get charged by angry rhinos; stick Spam sandwiches to paper plates with toothpicks and superglue. It's a dirty job sometimes.

- **THE MONEY:** Yes, the money is listed under cool perks and awful drawbacks. That's because when you work, the pay can be pretty good. But when you don't, it can be nonexistent. I have a dear friend whose family has a running joke: "Dad, are we rich this month, or poor?"

- **THE LACK OF BENEFITS:** Here I'm talking about the financial kind. No paid vacations, no health insurance, no maternity leave, no sick pay. Not only that, but you have to pay self-employment tax, which is the extra percentage that, were you employed, your employer would pay for you.

A nature shot by Kerry Drager. Photos like this one are most likely to be sold through a stock agency.

- **THE CROWD:** This job is fun, and exciting, and creative, and sometimes even glamorous and highly paid. So there has to be a downside, right? Well, the downside is that when you're a photographer, everyone and his brother wants to do what you do. So there are times in the market (especially

since the proliferation of digital technology) when it's awfully crowded.

BEING A PHOTOGRAPHER MEANS BEING IN BUSINESS

"I became a photographer in part because I didn't want to be a businessman," says fine art and commercial photographer Doug Beasley. "But you can't be a photographer without being a businessperson. Not if you want to stay in business very long."

Unless, of course, you're independently wealthy. Then by all means, go ahead and have shoddy business practices. Don't worry about anyone ever buying your work. Charge too much, or charge too little, don't answer your phone, don't return calls and don't deliver anything on time. Knock yourself out. But for the rest of us, good business practices are as important to our success as our creative talent. You may be a photographer today, but no matter how brilliant your work is, if you still want to be a photographer tomorrow, you must concern yourself with every aspect of your business.

"That doesn't mean you have to be [naturally] good at [business]. You're still allowed to struggle," says fashion and commercial shooter Lee Stanford, owner of Stanford Photography in Minneapolis. He jokes to make an important point—you don't have to be Donald Trump or Bill Gates, or a graduate of Harvard Business School. Business may well be a challenge to you through your entire career. You may have to work twice as hard at your business as you do at your art. But can you name one worthwhile thing you get in life without a little sweat? Honing your business skills will benefit you, your customers and your photographs.

"I think we all come into this business thinking we're going to be shooting most of the time. In actuality, we spend very, very little time shooting and a whole lot of time taking care of business," explains Minneapolis commercial photographer Patrick Fox, owner of Fox Studio. "I like the business part; I think it's fun. You shouldn't go into photography if you can't be passionate about all of it, the business side included."

Personally, I never pictured myself (pardon the pun) as a businessperson. My attitude when I opened my first studio was, "Hey, let's put on a show! We can do it in my dad's barn!" I never thought that someday I'd be running four studios, eagerly awaiting monthly reports from my bookkeeper, intently examining profit/loss statements, reconciling Visa logs, calculating my average sales or studying fee structure as if it were a science. Sometimes when I'm doing these things I soothe myself with a little mantra: "I love the glamour, I love the glamour, I love the glamour."

Now I actually do love the business side of my, well, business, just as Patrick Fox says. It took me a while to embrace the whole business mogul thing. My first employee gently pointed out to me that there was this little thing called the alphabet and that maybe my files should be organized according to it. An early client tactfully suggested that I audit his business course at a nearby university. Amused and flattered by his concern, I declined. Now, thirteen years later, I wish I had followed through on his suggestion. Perhaps 90 percent of the photographers I interviewed have no business background, and many share this regret. While this lack of business background didn't stop any of us from building our businesses, we've come to realize it may have slowed the process.

"I learned by making every business mistake there is ... some of them several times," says fine art photographer Doug Beasley.

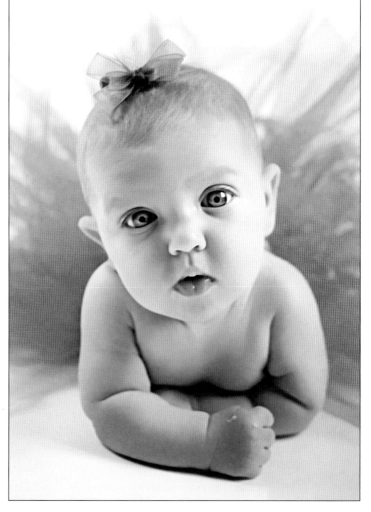

An example of a baby portrait by Michelle Frick. With the proliferation of digital capture, photographers are no longer at the mercy of labs to control the look of their direct color images. The result has been an explosion of exciting creative techniques like the high contrast, high color saturation we see here.

While he doesn't recommend his method of trial and error—and more error—he says, "If I could go back and do it over again I'd take business classes. But the lessons I learned the hard way, I'll never forget."

BEING A PHOTOGRAPHER MEANS HAVING AN OBLIGATION

All photographers have an obligation to tell their subjects' stories, whether they shoot sports or pets, nature or war. Photojournalists portray the horrors of the battlefield so that perhaps one day there will be peace. They risk their lives to this end. The rest of us, working under significantly less danger, have the same obligation to tell our subjects' stories. Whether it's a simple portrait, an architectural image or a fashion shot, we must strive to *see* our subjects and record their story in the context of their culture, their place in time and history.

BEING A PHOTOGRAPHER MEANS BEING YOUR OWN PRODUCT

We have a tendency to think that as photographers we're selling our images, that our pictures are our product. But we are mistaken.

"When someone hires you for a job, they're not buying your images, because after all, you haven't even shot them yet. No, they're buying you," says Doug Beasley. "One of my recent commercial clients told me he chose me over the other hopefuls because I talked to him about how I wanted to shoot the job, and the others had talked to him about their equipment, their technology."

Though your clients probably think they are buying your images and nothing but your images, in reality they are buying their experience with you: your conscious and unconscious messages to them about your level of expertise; your understanding of their project; how much you value them as clients and like them as people. As strange as it seems, the final take is almost incidental. The client's impression of the final photographs is built on every interaction you have with them—before, during and after the take.

What you are selling is the value they receive from working with you—your creative voice, your service, your vision and the way you relate to your clients and your subjects.

BEING A PHOTOGRAPHER MEANS HAVING INTIMATE RELATIONSHIPS

A portrait photographer often sees her clients when they're feeling very stressed out: They're agitated from getting the kids together and pulling Dad away from the golf course and getting the dog to and from the groomer and getting everyone and everything to the photo studio in one piece. They're worried about whether their kids, husbands, dogs and hair will cooperate. They deliver themselves into your studio frazzled and anxious. They need reassurance and encouragement, and not from just anybody—they need it from you, their family photographer. And if they don't get it, it doesn't matter if you're Annie Leibowitz, you will not get good results.

A stock travel shot by Jim Zuckerman.

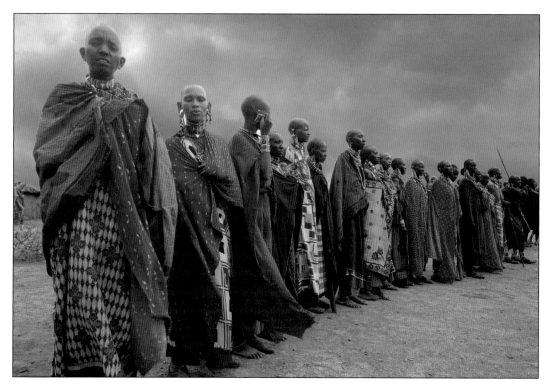

An architectural photographer's clients bring their work to him with all its vulnerabilities and compromises. The architect wanted granite columns, but her client chose soapstone. The architect wanted decorative exterior lights, but the cost didn't fit into her client's budget. The architect wanted to create a beautiful edifice, but her client needed a strip mall. The architectural photographer's job is to make the architect trust him with her project. He needs to make her understand that he sees the compromises she was forced to endure, and assure her that he will render her work in the best possible light.

You and your clients have been thrust into an immediately intimate situation and you will come out of it one of two ways—best buddies or sullen adversaries. There is seldom any middle ground here. You must meet their needs with compassion or the results can be disastrous. And you can't display compassion without being open and human yourself.

"Photography is an economic business built on relationships," says commercial shooter Bob Pearl, owner of Pearl Photography. "Aside from the enjoyment of capturing images, the clients are the greatest thing about this whole business to me. I have great clients. Most of them have become my friends. I love people. I think that's why my clients come back, for this as much as because they're happy with my work."

"It is about relationships. Name a business that isn't," says Patrick Fox. "We need to be professional and personable. We need to be 'people' people." Patrick also notes that this rule applies to others besides the clients: "Be nice to the ... person who runs the [art buyer's] office. Don't be a prima donna, because that person has pull. Building good relationships wherever you go, that's how you invest in your business."

"There's a lot of competition out there; the market is fierce," says sports and commercial photographer David Sherman. "If two photographers are showing equally good work, the client will hire the one who's easiest to get along with, the one they feel rapport with. I got my contract with the NBA partly because I'm easy to work with, because there were people in the organization who liked me and went to bat for me."

(Opposite) This stock image of a flower by Jim Miotke could easily be imagined on a greeting card or in a calendar.

A wildlife shot by Lewis Kemper.

Success can create a paradox, because once you become more established, you tend to become more removed from your clients. The better you are at interacting with clients, the more success you have in business, the less direct contact you have with clients—but when you stop working hard to keep the relationships alive and start taking them for granted, you can lose them. "It's like a marriage that way," says Lee Stanford. "Just when you think you can kick back and relax is when you have to get down to work."

BEING A PHOTOGRAPHER MEANS RIDING THE CREATIVE ROLLER COASTER

"The sad fact is that a lot of what we do is just not creative," says Bob Pearl, summing up the sentiments of almost every photographer I interviewed. "When you're shooting a boat catalog, for instance, they often want the same shots: shots so you can see the seating in the boat. There are only so many angles you can use and still show the seats.

"You can get in a rut, because people start coming to you because you do a certain look or technique, and it's new and it's great, and you're excited and the clients are excited. But then that's all anyone wants you to do, and it's not so exciting anymore. But it still pays the bills, so you can't stop."

Each photographic specialty has its own standard shots: for fashion there are outline and lay-down shots; portraiture has head shots, full length and three-quarter; models' comps require a full-length swimsuit shot, a head shot, and a business shot; architectural has basic exteriors, detail shots and wide-angle interiors, and the list goes on. Even if you don't understand the terminology for each shot, you can deduce that they aren't the artistic shots you dream of creating in your new career.

"For each take, you shoot ten shots for the client and two shots for yourself," says David Sherman. "You live for those two shots." But sometimes it's not the clients or the market that constrict a photographer creatively. "You start out in this business scared," he says. "You're scared you're not good enough, you're scared you'll do something wrong and blow a take, you're scared someone will come up to you and accuse you of impersonating a photographer. But all that fear makes you work more creatively. When you've been in business for a while and the fear goes away, maybe you don't work as creatively anymore because it was partly the fear that fueled your passion."

In short, don't fight your "stage fright." Those butterflies in your stomach mean you care enough to do your very best work.

"It's like anything," says Lee Stanford, "once you master it you can get bor[ing]. I try to remember that this might be old hat for me, but it's exciting and it's an investment for my clients. So I make sure their excitement rubs off on me."

Being a photographer means enjoying those creative highs as well as tolerating the creative lows.

BEING A PHOTOGRAPHER MEANS REINVENTING YOURSELF EVERY DAY

Photographers are at the mercy of the changing economy, the marketplace, styles and trends, and technological advancements just as farmers are at the mercy of the weather.

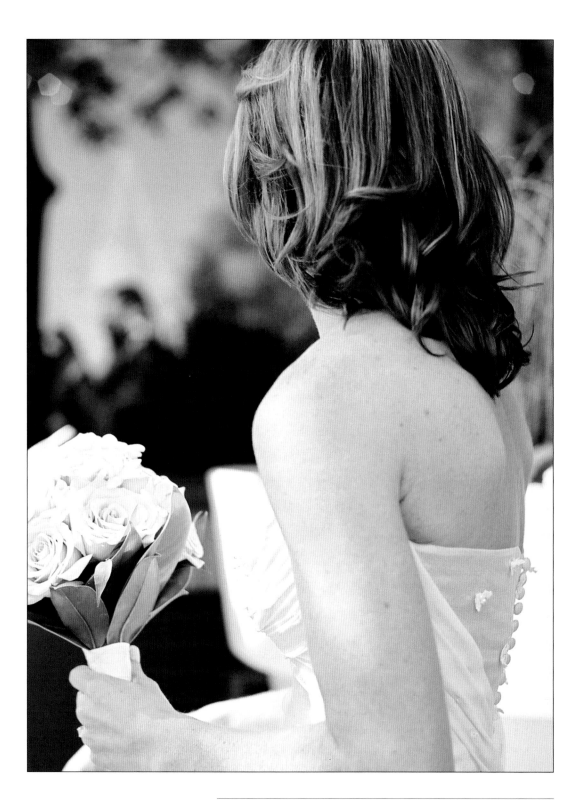

The photography business is a little like that child's game, "Button, button, who has the button?" The child puts a button in her hand, puts her hands behind her back, wildly passes the button from hand to hand, then brings her little fists forward and asks you to guess where the button is. Similarly, you need to know in which photography specialty the button (i.e., the income potential) is. But just as in the child's game, the button doesn't stay in one place forever. Events happen in the industry that suck the money right out of one area and pop it into another.

For instance, twenty years ago there was good money to be made in stock photography. But digital technology and the Internet have made the playing field bigger, and the images easier and cheaper to obtain. For a while, it looked as though stock photography was a dying specialty, and royalty-free stock was going to be the deathblow. But now, five years later, stock is an exciting market again. Many agencies are accepting work from photographers who have considerably smaller bodies of work, making it easier for newcomers to connect with agencies.

At the same time the life was getting sucked out of the stock photo business, baby boomers were becoming more prosperous and starting families. Their newly disposable income and artistic sophistication opened the door for high-end artistic portrait studios to flourish. But now, with digital SLR (digital single reflex) cameras becoming better and better and cheaper and cheaper, the cities are flooded with talented amateurs who take little bites out of the market.

Fine art and commercial photographer Doug Beasley is one photographer who recognizes this as an opportunity, not a slamming door. "I can't change the whole market, so I change myself," he explains.

Patrick Fox gives the example of an architectural photographer who found the Minneapolis market a little lean when the economy faltered and made a change to lifestyle shooting. Lifestyle as a category didn't even exist when this architectural shooter first started in the business, but now it's a big part of the market.

"You don't necessarily change your specialty," says Minneapolis architectural and commercial photographer Karen Melvin. "You change your emphasis, or you raise the bar. Maybe you keep

(Opposite) The trend in wedding photography is toward an edgier, more artistic, more editorial style, as we see in this example by Hilary Bullock.

shooting architecture, but you market to commercial clients as well as editorial clients. Or you hone your art and raise your day rate, instead of trying to compete with the masses who are caught up in the price wars."

This reinvention presents different challenges depending on your career stage.

On the one hand, when you are just beginning to make your way in the industry, you aren't as emotionally or economically invested in an area of specialty, so shifting gears can be simpler. It's an entirely different problem if you're an established, top of your field, high-end photographer with a couple of decades under your belt. But it's that old dog/new trick scenario: You have the ability, but you haven't learned a new trick in a long time, and why start now? On the other hand, once you open your mind to trying new business and creative practices and techniques, you realize you have years of experience fetching and shaking paws, you know your way around town and where all the neighborhood dogs hang out. These are assets that can make your reinvention easier and more enjoyable.

So no, being a photographer is not exactly what the uninitiated imagine it to be. But in my twenty-one years in the business I've met hundreds of photographers in all areas of specialty, and I know of only three who have left the calling. The great majority of us are lifers—and we like it that way.

You're still reading. That means you probably still have interest in becoming a photographer even after exploring some of the drawbacks of the profession. You've accepted the bad news up front and you're still not scared away. You're determined that the professional is right for you. Now you may be wondering if you are right for the profession.

TO BE OR NOT TO BE A PHOTOGRAPHER: THAT IS THE QUESTION

I am often asked one burning question, but it is inevitably framed in different ways:

- "Is my work good enough to compete at the professional level?"
- "Do I have what it takes?"
- "Am I good enough to start charging for my work?"

- "Am I good enough to start investing in equipment, classes, promotional materials or a studio?"
- "Do I have 'it'?"

An architectural exterior by Jennifer Wu.

I think what people are really asking when they ask me these questions is "Should I take the risk of investing myself emotionally and financially in becoming a photographer? Will I be able to make a living?"

When I get asked this question, there is always part of me that wants to answer it with another question: "I don't know. You tell me." It's not that I'm trying to be sarcastic—it's just that your tools for success are inside you—not outside you.

I believe aspiring photographers often try to rely too heavily on their instructors or other outside sources—even friends and family—to tell them if their work is good or not good.

BE YOUR OWN WORST CRITIC

You need to honestly, constantly and almost brutally critique your own work. Compare it to the work of established photographers whose work you admire. Is yours as good? If not, why not? Figure

In addition to her portrait business, Stephanie Adams has a passion for shooting live music.

out why. This is exactly how photographer/author/instructor Jim Zuckerman did it.

"In the seventies, I looked at a book of photographs by David Muench. I thought his work was brilliant! I looked at my photos, and they weren't as good—by my own assessment. So I had to figure out why."

By using Muench's work to set his own personal gold standard, Jim was able to teach himself how to improve his work. He even recommends making yourself a written checklist so that when you view a master's work, you remember to consider every important element. Things like light, exposure, focal length, background and foreground elements, and perspective. And additional elements come into play depending on your area of specialty; for instance, for landscape photographers, dominant foreground; for people photographers, expression and decisive moment. Even just making this checklist will help you learn to critique your own work with a more discerning eye. You need to have the attitude, "I have to do better. I will do better."

But if we are to be our own judge, jury, and executioner, then do we really need teachers, colleagues and feedback from others?

Yes, we certainly do! Feedback from more experienced practitioners and from colleagues is essential to our artistic development. It simply shouldn't override our own internal sensibilities. Only you can give yourself permission to pursue you photographic vision.

WHAT DO YOU MEAN, YOU DON'T HAVE HEALTH INSURANCE?

But surely all those brilliant, successful photographers who have come before us had lots of support from friends and family, right? Not necessarily.

"My family thought I was going to wind up a bag lady," says fine art photographer/teacher/author Kathleen Carr.

And successful nature photographer/author/teacher Brenda Tharp's father was himself a serious amateur photographer, but when she told him she wanted to go to Brooks Institute for college he flatly turned her down.

"He saw photography as a hobby but not a career, and he wanted me to have a 'real job' so I'd be safe," Brenda recalls.

I personally was advised to become an accountant because there would always be a need for accountants, and to take typing so that I could always fall back on being a secretary.

As much as all this unsolicited advice throws a wet blanket on our hopes and dreams, should we listen to it?

"Yes, of course, you have to pay attention to externals," says Kathleen Carr. "Don't jump blindly into a saturated market with no plan and no vision. But if your intuition tells you to do this—if you have a strong impulse from inside—then you should do it. We all have certain gifts to give and things to learn in our lives. Whenever I follow my inner sense of knowing I always find myself in the right place at the right time."

TIMING IS EVERYTHING

"Start now," says Jim Zuckerman. "If you wait until you can compete with the masters, you'll wait forever. I look back at my work

This image by Doug Beasley came not from previsualizing the shot as it is, but from eliminating the fence from the foreground and then moving in closer and closer. Thankfully the horse didn't run away.

from ten years ago, and I cringe. I think, 'What was I thinking?' Photography skill and artistry is a maturation process. There's no shortcut. It continues for the life of the photographer. It's like medicine—there are a million different medical situations and there are a million different photographic situations. Every patient is different, every sunset is different. I'd rather have a doctor operating on me who has done one thousand operations before, not three. It's the same with photography. The longer you're at it, the better you'll be. As long as you continue to realistically and honestly critique your own work."

But how can you start now if you don't have the technical skill? If you don't know everything there is to know?

"There's a difference between visual awareness and technical skill," says Jim Zuckerman. "Technical skill is learned. It comes with practice, repetition, fieldwork, course work. Visual awareness is inherent."

Visual awareness is the difference between seeing and just looking. Just as there is a difference between hearing and listening.

You can look at an image and see where the camera was in relation to the subject; where the light was; what type of light it was; what time of day the image was made at; the focal length; the distance between subject and field and subject and photographer; the aperture and shutter speed; whether blur is from camera shake or motion blur or and undesirable focus area; the orientation of the camera (north, south, east or west) the ISO [light sensitivity setting]; and what color shirt the photographer was wearing. Well, most of the time the shirt is a stretch. But you get the idea. If learning to see all this in images interests you, then you have visual awareness.

SEEING IS KNOWING

What if we don't have visual awareness—a natural ability to "see?" There are many in the field who believe it can't be taught–either you have it, or you don't. But Ibarionex Perello is one photographer/writer/teacher who believes that if a person is motivated, she can learn to see. "It's literally about seeing the light. When you've got a student in the field and she looks up and she 'sees' the sunrise or the sunset for the first time, really sees it—I can tell, I know what she's feeling. It's like waking up! It's a drug! And from that moment, the whole world is different for that person."

A macro image by Connie Cooper-Edwards.

ROOM FOR DISAGREEMENT

So if the established pros can disagree on whether visual awareness can be taught or not, are there other issues they can disagree on as well?

The answer is a resounding yes! I was recently at a conference at which one speaker,

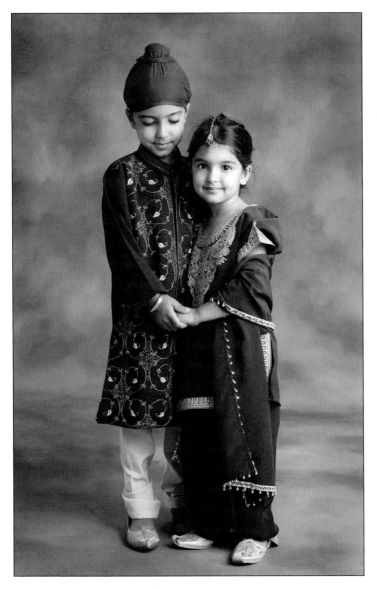

A traditional studio portrait by Vik Orenstein.

during the course of his presentation, commented that he loved auto white balance—it was the neatest thing since the napkin! An hour later, another speaker got up and talked about how he hated auto white balance—it never gave him the results he was looking for.

At an informal gathering of female portrait photographers, the subject of fill flash came up. One said she always used fill flash on overcast days to brighten up the skin tones and put a little sparkle into the eyes of her subjects. Another piped in that she hated the tiny pinprick catch lights that fill flash created, and that she'd rather have none. These were both highly esteemed photographers in the same specialty in the same market.

Once I had a student at BetterPhoto.com submit the same image to myself and to another instructor for feedback. He specifically asked which version of an image I liked better—a classic landscape format or a panorama. I told him that I much preferred the landscape version and went into detail about why. The next day he sent me a link to the feedback from the other instructor—who of course preferred the panoramic version of the image.

This room for disagreement is another great reason to have your own internal critic—if you don't, life could get very confusing!

WHO DOESN'T MAKE IT

• **THOSE WHO DON'T TRY IN THE FIRST PLACE.** This is a given. If you don't do, you don't get to have done. But there is a perk to not trying: You can always say, "If I would have gone into photography, I'd have been much better than that guy."

• **THOSE WHO DON'T HAVE VISUAL AWARENESS.** Have you ever looked at a sunrise or a child or a historic moment and felt deeply moved on a visceral level? Have you even looked at your own images and felt that they fell short of your expectations? Have you ever looked at the work of those who came before you and been amazed and humbled? Then you have artistic vision.

• **THOSE WHO MAKE EXCUSES.** You never want to say, "yes, but" about your images. If you do, it means that you know they're not top drawer. "Yes, but the only time I could shoot this was at noon." "Yes, but I forgot my tripod." "Yes, but my subjects wouldn't cooperate." And so forth. I once had an acquaintance explain to me that she'd had a number of friends tell her that she was good enough to go pro. She sat me down with some images she had made and asked me my opinion. One image was of a little boy holding a soda can in one hand and a dirty washrag in the other–the top of his head was cut off but there was plenty of space at the bottom of the frame under his feet, and the recyclable bin was in sharp relief behind him. The image was made with direct flash, the exposure was dark and the white balance was blue. I gave her a very gentle and honest critique, touching on the technical challenges and suggesting ways to improve. She looked at me politely and patiently and when I was through, said, "But don't you think his smile is adorable?" She clearly was not interested in making her photos better. She probably wound up working for her friends for free or very cheap, and probably was happy with that.

• **THOSE WHO DISLIKE HARD WORK.** "We have all seen students who are stunning smart but lazy," says Jennifer Wu. "They come to class late, miss classes, turn in one half of an assignment. They miss opportunities. They may start out with amazing visual acuity. But they don't push themselves to find new ways to see, to make

themselves better, so ultimately they don't succeed. I imagine they go on to the next thing, and they're good at that, and they fizzle out there, too."

• **THOSE WHO WAIT FOR THE OUTSIDE TO TELL THEM WHAT'S GOING ON INSIDE.** Yes, you should absolutely seek out teachers, mentors and peers, and get feedback on your work as much as you can. Get opinions. Get criticism. But at the same time you should be analyzing your own work, as well. You should take the feedback from others that rings true to you, based on your own observations, and apply it to make your work better. Don't let outside opinions be your sole basis for directing the course of your photographic journey.

• **THOSE WHO JUST WANT TO PAY FOR THEIR EQUIPMENT.** It might seem smart during economically challenging times to set your expectations low, thereby avoiding a huge disappointment should your dreams exceed your reality. I have had many aspiring pros tell me they really want to start charging for their work and run a very small, very modest business just to make back the expenses for their cameras, lenses and studio lighting. While this may seem sensible, or even admirably realistic, it usually means these folks will do exactly what they set out to do: earn a very modest amount of money that will come close to paying for their equipment but not their time or expertise. No one ever aims for a rock on the ground and hits the moon.

• **THOSE WHO LOVE THEIR DAY JOB.** If you love what you do for a living, that's wonderful! You are a very lucky person—luckier than most, in my experience. And that is a great thing for your overall health and well-being, both mentally and physically. But quite honestly, I believe overall satisfaction with your existing career or job is a stumbling block to becoming a professional photographer. Photography is a challenging field to break into; it always has been. One almost needs to be unhappy with their current employment to be motivated enough to take the risk and pay the dues that it requires to make this enormous leap. It's not just about what you're running toward, it's also about what you're running away from.

WHO DOES MAKE IT

Portrait of controversial author Salman Rushdie by Stormi Greener.

• **THOSE WHO ARE NATURALLY DRIVEN TO IMPROVE THEM-SELVES AND THEIR WORK.** Doug Beasley notes, "So many photographers strive for mediocrity. They should strive for excellence." Ibarionex Perello says he most admires his students who start out with moderate visual talent, who are persistent and who have good communication skills. "These students tend to show enormous improvement in a very short time. They don't just shoot the same images over and over. They listen to feedback, they stretch themselves, they take risks, their work grows," he says.

• **THOSE WHO APPRECIATE LOOKING AT GREAT PHOTOGRA-PHY AS MUCH AS THEY ENJOY SHOOTING.** Many, many successful photographers start with a great appreciation of other photographers—both those who came before them and their contemporaries. If you can see artistry in the work of others, you can find it in your own work, too.

• **THOSE WHO CAN HYPER FOCUS.** Have you ever been shooting and when you're finished, you realized hours have passed and you

A digitally manipulated photograph by Jim Zuckerman.

thought you'd only been about ten minutes? Or working in Photoshop or in the darkroom (if you're lucky enough to have access to a darkroom) and hours go by and you don't even notice you've missed dinner? That's hyper focus. Many of the professional photographers I know (including myself) have it. It's a plus because it makes hours of what could be toil seem like heaven.

• **THOSE WHO CAN FALL DOWN AND GET UP AGAIN.** If you can fail, and try again, and fail, and try again, you'll probably succeed at anything you want to do, photography included. If you talk to anyone who has succeeded at anything, you'll hear tales of more failures than successes. That's because they tried, they weren't afraid to take risks and they accepted that if you want to win you have to be willing to fail. It's a numbers game—if you try ten times and succeed on the tenth try, you've got nine failures to prove your tenacity!

• **THOSE WHO CAN SAY, "I CAN IMPROVE" AND NOT BE ASHAMED.** If you need to be perfect, you'll pretty much feel creatively paralyzed most of the time. You need to allow yourself to be imperfect. So accept your imperfection, but at the same time strive to improve.

• **THOSE WHO HAVE A DESIRE TO SHARE.** I bet very few, if any, really talented photographers create images and store them away without ever showing them in some form or at some venue. We make pictures out of a need to share what we see. We need to tell our visual stories.

Of course all of us see some of ourselves in the "who does make it" and in the "who doesn't make it" lists. In chapter two, photographers from many different areas of specialty talk about the various avenues that led them into the profession and what specific qualities, skills, traits, desires and events contributed to their successful careers.

Since you're reading this book you are in one of these places: A) You are a student looking for a direction in education. B) You are a career person in search of a career change. C) You are an established photographer looking for inspiration to maintain, grow or diversify your business. D) You are reentering the job market or entering it for the first time.

People come to the photography industry from disparate places in their lives. One way to learn whether this business is for you, or to validate your choice if you're already "in," is to look at the way others have come into the field and created their photographic careers. Here are the stories of a few successful photographers and their different approaches to their careers. I interviewed several of the photographers for the last edition of this book and then touched base with them again to see how their business has changed. Some of the photographers I interviewed for the first time.

A portrait of California poet Lisa Teasley by Ibarionex Perello.

IBARIONEX PERELLO: A STORYTELLER

After many years working in the field of photography—from working in tech support for Nikon to writing and shooting for magazines to producing a photography podcast (The Candid Frame)—Ibarionex, with his partners, has started his own business.

How old were you when you decided to be a photographer?

I knew I loved photography when I was eight years old and I got my first plastic camera—I was hooked! But I didn't know until much later that it could be a career choice. I didn't know any photographers who made a living at it. I only knew of the masters, whose work I saw in books. And they seemed light-years away. So I started street shooting and working in the darkroom at The Boy's Club in Hollywood. Photography

became a normal part of everything I did. But it wasn't until I joined the newspaper in college that I realized I might be able to make a living at it.

In the last year, you and your partners founded a new business, Alas Media. It would seem on the surface that this would be a less than ideal time to start a business.

There's never an ideal time! Just jump in and do it. Don't get preoccupied with, 'money's tight.' There's always someone making money—it may as well be you! The biggest pitfall to avoid is worrying about all the stuff you don't know. You should focus on all the things that you *do* know! I waited years too long to go into business for myself.

But speaking for myself, the things I don't know (and especially the things I didn't know when I first started out in photography) are really scary! The things I didn't know, in fact, made me fall on my face in front of clients more than once.

Yeah, well, get over it! The creative process is full of risks. Life is full of risks. If you focus on your strengths, you'll build on that and learn the things you don't know as you go. Your strengths are and always will be what makes clients want you.

You're a writer and a photographer. Does being good at one job help with the other?

We're all storytellers. As a writer and as a photographer, it's all about using your skills and tools to tell stories. That's what a lot of companies are trying to do—it's a means of connecting with their potential clientele, to get them excited about their products and services. That's how I pitch my services to commercial clients: Let me tell your story.

You make it sound easy.

Its not easy, but if you have the fire in your belly, you can do it.

KERRY DRAGER: A RENAISSANCE MAN IN WORDS AND PICTURES

Kerry came to the business of photography with a bachelor's degree in journalism. At first photography was simply a side pursuit

for him—he took a grand total of one photography class in college! Kerry started his career as a part-time copy editor for *The Sacramento Bee* and a freelance writer.

How did you wind up becoming a professional photographer?

One day in 1980, the last straw occurred: Yet another roll of film failed to meet my great photographic expectations. That's the day my "visual quest" began. I started reading how-to books and camera magazines; taking workshops and seminars (alas, no online instruction back then!); analyzing the work of professional photographers; and doing a lot of shooting, experimenting and reviewing my photos. Eventually my images began to accompany my newspaper and magazine articles. I began a full-time life as a freelance photographer and writer. Later, I had three books published. I also began teaching photo workshops, and in 2004 my interests in photography, teaching, writing and editing came together when I joined BetterPhoto .com full-time as both staff member and instructor.

Detail of a 1965 Chevy Impala by Kerry Drager.

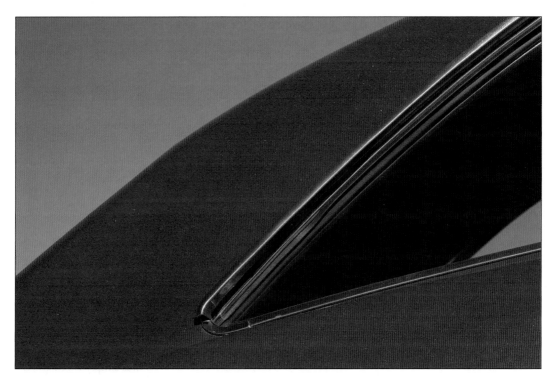

How did you know you had the right stuff to succeed?

This is really an important question. For a photographer, if you are studying the marketplace, there comes a time when you say to yourself: "I could do that!" or "Hey, if he can open a studio, then so can I!" Or "My work is as good as hers, so why is she getting published, and I'm not?" Comparison and knowledge really are the key factors in the path to photographic success, and that comes with learning all you can about the industry and then seeing how your own photography measures up with the work of the pros.

Did you ever have a "lightbulb" moment when you knew you were the real deal, a real professional photographer?

I actually had several of them, though some were more important than others! My first major magazine sale was a photo/article spread. The piece was an account of my solo trip in a remote backcountry area, consisting of text and nearly a dozen photos—mostly landscapes and self-portraits showing myself on the trail, beside a campfire. Thus began my appreciation of tripods and self-timers! Bigger steps in my career occurred in the late 1980s, when two of my images appeared in the competitive Sierra Club calendars. More turning points came in 1993 with the publication of my first book, *California Desert*, and then with a major profile piece about my work in the April 1994 issue of *Outdoor Photographer* magazine.

What's with all you guys who teach photography online, in colleges, in books and workshops? Aren't you afraid you'll put yourself out of business by creating more competition for yourself?

To me, teaching is fun, inspiring and eye-opening. Plus, I find it gratifying to help aspiring pros. After all, many photographers contributed to my own photographic and professional growth, many of whom I've never met! And there was certainly the influence from many other photographers I got to know personally at key stages in my photo career, and many of them remain friends. When my skills and experience reached a certain level, teaching just seemed like a natural progression—in print, in person and, more recently, online.

Do you have any advice for an aspiring professional photographer?

Beware of the "fear factor." Many budding professionals are afraid of being rejected, although rejection is a big part of professional photography. Some photographers whose work is turned down feel discouraged and give up. Other shooters also feel discouraged, but they quickly become energized by the rejection: They try even harder. Strive to be one of those people who views a negative (rejection) in a positive way.

KAREN MELVIN: FROM DENTAL HYGIENIST TO ARCHITECTURAL AND ADVERTISING PHOTOGRAPHER

Minneapolis advertising/architectural photographer Karen Melvin came to photography after a brief detour into dental hygiene.

"I knew I was making a wrong turn, but my mother wanted me there. She dragged me back to school. There were black heel marks all the way to Milwaukee." She laughs. Now, fifteen years into her career, she is just finishing up a bachelor's degree in photography at the University of Minnesota.

Why finish your degree now?

I have an eleven-year-old son. I didn't want him getting a degree before his mom did. Actually, I started it many, many years ago. But I got busy and life happened. I'm very excited about the courses I'm taking—they're very germane to my career. A course I'm facilitating is called, "Where art meets commerce—finding your value in your market." That's pertinent to anyone's career at any stage. Another is in digital imaging, which is an area where I'm light-years behind.

Backing up a bit—how did you learn to shoot?

I always photographed when I was selling on the road in my twenties. When I decided to make photography my career I took a crash course at a school of communication arts. I was lucky to have a commercial photographer as my instructor. He was a relentless technician. The other major influence was assisting the graduate school of photography.

Your husband, Phil Prowse, is an architectural photographer as well. Does that cause any problems?

What kind of problems?

Like, for instance, battling for the same clients?

Oh, no! Phil does his specialty, and I do mine. He does boy architecture, and I do girl architecture.

Please explain that!

Oh, I do residential interiors and lifestyle, and Phil does commercial buildings and exteriors, sort of …

Phallic?

Yes! Phil does phallic and I do the womb. It's nice because when I get a call for his specialty I refer them to him, and when he gets one for mine he refers them to me. Phil's learned to say, "I'm referring you to my partner," because it sounds more professional than, "Here, talk to my wife." I don't want to give the impression I'm sitting around the house eating bonbons. But we don't need a studio. All our shooting is on location.

A residential interior by Karen Melvin.

Has that helped keep your overhead low?

Yeah. I think I've survived in every economic market over the last fifteen years because I never had a studio. Location shooters who have studios tend to go under in a bad market or move back to their home offices.

How did your career start out?

I assisted first, my instructor from school, and others. All along I was showing my book. I marketed to architects and interior designers, but a lot of other businesses, too. Hospitals, public relations firms, anyone who used interior shots. Then along with other freelance jobs I got an internship at *Skyway News* that turned into a three-year stint as a professional wrestling photographer.

Another little detour?

Not quite as off the track as dental hygiene.

At any rate, you evolved into an architectural photographer, but you've honed your specialty even more, to residential interiors and lifestyle. Tell me about that.

To thrive in a tough market, I've had to refine my message, ratchet up my art to pull myself out of the fray. I do that by showing work where light is the hero. I use and create light as a theme in my work. So it's architecture, but with a message of light.

The level of specialization required in these times is extreme, but I think it works to everyone's advantage. By working deep, not broad, you get to create a career that's exactly in line with your vision. You may not get every job, but you'll get most of the jobs that are perfect for you.

If you could go back, would you change anything?

Only that I'd start to promote my work nationally earlier. It brings me more commercial clients, more advertising work. I love this field! It takes more legwork, but it has better production value and it pays better than editorial.

Any advice for the newbies reading this book?

You need to be persistent and keep reinventing yourself and your art.

Update

Now Karen says business is pretty good. "I can't complain. When the economy is down I always have to do more marketing. Lately I've been sending out e-mails with an image and a link to my website. I get a 5 percent return rate. That's really efficient.

"I also take very good care of my existing clients—good customer service."

Karen has also joined the ranks of digital shooters since 2004. "I resisted for a long time, but now I realize that it's a great tool."

STORMI GREENER: PHOTOJOURNALISM AND OCCUPATIONAL HAZARDS

I first interviewed Stormi Greener in 2004 for the first edition of this book. I caught up with her again for this book. Both parts of the interview are here to show how her career has changed and the photojournalism industry has changed.

"It's easier to shoot [pictures] in a war zone than to shoot weddings," says Greener. This from a woman who has been shot at in Bosnia, stoned in Afghanistan and beaten in Israel. No, she's not kidding. Not entirely.

"You go to war, and you don't think. You just do what you have to do. You're on adrenaline, on autopilot. But you go shoot a wedding …" She shrugs.

Does every photojournalist have to go to war?

No. I chose to. You could work on a large paper and never go overseas.

Do you still go overseas?

No! At fifty-seven, I do not want to go to war. I say to myself, "Would I rather be there than here?" and the answer is no.

Did you start your career doing this type of assignment.

No, I started out in Idaho, shooting fires, bike accidents, the usual.

You had a degree?

No, these days you have to have one, but in those days you didn't. My degree wasn't in photojournalism. I got the job not from what I knew but by being a pest. I didn't have

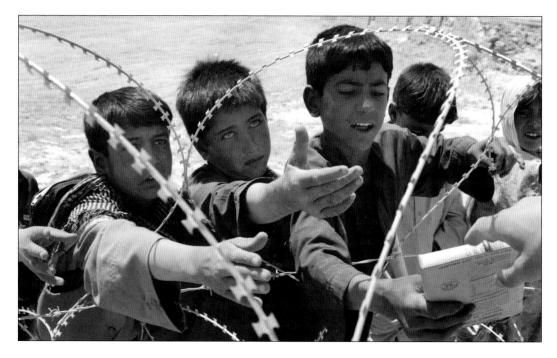

American soldiers handing out supplies to refugees in Afghanistan by Stormi Greener.

much photographic work, and what I did have wasn't very good. But I asked the publisher of the paper for the job. He said, 'Oh, you're not a photographer, go to work in the library.' It took me months to wear him down. Finally, he put me on for sixteen hours a week. I had assignments, and I found my own stories, too. One of my colleagues, Tom Freick, taught me so much—what a lens would do for me, how to walk into a situation and size it up immediately. I owe a lot to him."

I assume anyone starting out now in photojournalism would have to relocate to a very, very small market."

Yes, but it's not so bad working in Podunksville. If you're good, within a year you'll be getting plum assignments and movin' on up.

Aside from getting a degree and being a pest, what can you recommend to aspiring photojournalists?

Well, if you're on the young side, get a job on your yearbook staff and on the school newspaper. Look for a school with a

good program, find a mentor—someone who will help you is a must—do internships. Internships are never a dead end; they're always valuable. You get practical experience and you get to hang around professionals.

So you'd recommend your job?

Sure. I love it.

So regrets?

Well … that's a loaded question. If I could go back and do it over again, I would do a better job of balancing work and family. I didn't realize how much my job affected my daughter until she was grown and she made a video as part of a Nation Press Photographers Association "flying course." She talked about hearing the phone ring in the middle of the night and knowing that when she woke up her mother would be gone. She talked about wondering what would happen to her if I were killed on assignment. She basically blasted me.

How did you feel about her discussing this in a public forum?

It hurt, but it was important—hopefully it will help others learn not to let the business eat them up. That's the most important piece of information I have to share.

Update

Stormi left the *Minneapolis StarTribune* in 2007. But she hasn't retired! She stays busy shooting weddings, shooting and managing the images for Dakota County in Minnesota and doing various other projects.

Do you miss photojournalism?

Not at all! I thought I would, but the industry is in such an upheaval! The Internet has really changed everything—the Web has become the new focus. Now to shoot for a paper you have to shoot video, too. I have no interest in shooting video.

And you're shooting weddings! I thought the wedding industry was overcrowded and undervalued now that everyone's Uncle Louie has a DSLR.

If it is, that's news to me! Yes, everyone at weddings has their little point and shoot and they hold it up over their heads to

get a shot, so that makes my job harder—being way in the back and trying to get a shot of the couple without a sea of arms in the air. But I only shoot a fixed number of weddings a year, at a flat rate. Those are 14-hour days, you know! It's very physically demanding. So by limiting the number of weddings I do and having a flat rate, I know how much I'll make and I won't overdo it!

Isn't it hard to turn business away?

No. Years ago, I wouldn't turn down anything–I would take everything, every assignment. But now I control my time. I'm my own boss.

PATRICK FOX: A TEXTBOOK EXAMPLE OF COMMERCIAL PHOTOGRAPHY

I interviewed Patrick Fox in 2004 and reconnected with him to see how his business is growing despite economic downturn. Patrick Fox is a top-billed commercial photographer in Minneapolis: He runs a 6,000+ square-foot studio in the trendy warehouse district, and he shoots almost every day—a phenomenon almost unheard of in this medium-sized market. His seventeen-year career has weathered economic upheavals, dramatic fluctuations in the local market and all the usual stages that a business goes through when it ages, expands and adapts to changes in technology and market demands.

Patrick forged his career pretty much by the book: He attended Brooks Institute of Photography and holds an MBA in photography. After college, he assisted a food photographer for one year, worked in-house for five years shooting fashion and product for a department store and opened Fox Studio, which specializes in location fashion and product shooting, in 1987.

What got you interested in photography to begin with? Was it to meet girls?

(Laughs.) Yes, most guys in this business go through a stage I call the "I gotta shoot babes" stage.

But that stage doesn't last?

It can't last. This is way too tough a business to be in just to get dates.

A test shot by Patrick Fox for his portfolio.

But you do get to shoot babes?

Yes. You do get to shoot babes. But I'll tell you right now, anyone thinking of becoming a commercial photographer should take a good, hard look at themselves and ask: "Do I have vision? Do I have a good personality? Am I bright creatively and technically? Do I have the abilities necessary to run a professional business? Am I lucky?" It takes luck, but of course as you know, we make our own luck.

So maybe by luck you mean persistence? Passion? One of those P words?

Yes! Persistence.

What about talent?

Sure, you have to have talent.

How do you know if you have talent?

You have to show your stuff. Not to your mom or your friends—to people who know their business and will level with you. I personally know of several art buyers—people at the top of their fields—who will see your book if you call

and ask, and then call and ask again a few more times … if you're persistent.

So wait, let's back up. Say I want to be a commercial photographer. I'm talented. I'm creative. I'm technical. I'm a people person. I'm business savvy. I'm lucky. Where do I start?

Definitely school, or some extremely intensive training.

Photography school?

Sure, yes. But a liberal arts degree is great. That's what I look for—a well-rounded liberal arts grad, because you can teach someone how to shoot, but you can't teach them how to think.

So school, then the big time?

No! School, and you get a lot of feedback on your work. Then you make a portfolio or book. Then you get a job. When I first started, you only had to assist for about a year. Now you have to assist for five years. A lot of people think they're going to get a great job just out of school. But that doesn't happen. School is just the starting point. After that, the learning begins.

What kinds of images do I put in my book?

You show your ten best images, no matter what the subject. As you get new ones, rotate out the old ones.

But I want to be a successful photographer. Translation: I want to make the big bucks. So aren't there certain specialties, or types of images, that are more salable? And shouldn't I specialize in those hot areas?

No. Start general, then specialize as your career matures. You want to get to higher and higher levels of competition. When you first start out, you'll be competing against fifty other guys for the same job.

Then, after a while, it'll be you and twenty-five other guys. Then you and maybe five guys. Then ultimately, it might come down to just you and one other guy—your nemesis. Eventually, you will have to become highly, highly specialized. It's become almost ridiculous. To give you an example, I

was showing my book a while ago. The art buyer said, "This book is very 'springy.' Can you shoot Christmasy? That's how extreme it's gotten.

You said you were showing your book. Do you work with a rep?

Yes, but I only started recently. And it's not a conventional relationship. Normally, reps are paid a percentage of the jobs they sell. My rep is paid by the showing.

That's a pretty big change from the last time I worked in the commercial industry seven years ago.

There have been a lot of big changes since then. Like art buyers. It used to be the art director who chose the photographer. But now the art buyer is the gatekeeper—the art buyer's entire job is to hire artists and photographers. It's a better system. The art buyers know who's best for a job better than the art directors used to, because it's all they do. So far this trend is largely in the bigger agencies, but you see it in some smaller ones, too.

Speaking of changes—it seems to me that the eighties and nineties were a golden era for fashion photography. Shooters charged high fees and got plenty of work. Then it all dried up. Any insight?

I can only speak for this market. But, yes, we had a couple of huge clients in Minneapolis who made this a bigger market than the size of this city would dictate. But we had a very small talent pool (talent being another word for models) and the big clients took their shooting to other cities. Then there was a trickle-down effect, and other clients left, too. And then of course, what good talent there was moved to other markets.

Is that why you shoot product as well as fashion?

No. That was a lifestyle decision. To shoot all fashion I would have had to be willing to travel a lot. I'll travel some, but I like being here. I have a cabin up north. And I enjoy product work.

So what's the secret to your success?

There is no magic bullet.

But darn it, Patrick, as the author of this book I'm duty bound to provide a magic bullet: a recipe.

I was the president of American Society of Media Photographers for two years. Every once in a while I'd answer the phone and it would be a guy wanting to know the recipe. He'd want us to tell him how it's done. There is no recipe! What works for you is what works for you. I do things one way today because it's the right thing to do—today. Maybe tomorrow I'll do things differently.

That said, it certainly doesn't hurt to find out how other people do things and to get other people's opinions. But don't mimic them. Take what you learn and tweak it—make it your own. A person who only knows how to do what someone else does will not succeed. It's the person with vision—the person who learns how to cook and then writes his own recipes—who will succeed.

I notice that in bad economies there are photographers who shoot for dirt cheap fees just to keep the business rolling in. How do you compete with that?

I don't.

So a bad economy doesn't impact your business at all?

I can't say that. In bad times I'm not turning away jobs like I do in good times. There have been times when I've turned away 33 percent of the jobs I get called for. But in bad times I'm still shooting almost every day. So I can't complain.

In a nutshell, what really important advice would you like to leave us with?

Read. Anything and everything. Not just about photography. Read about stuff you don't like or have no interest in. For instance, my politics are liberal but I read *The Wall Street Journal* every day. Have an understanding of how the world works and how life and events all fit together. Then you'll be prepared for anything.

Update

Today we find Patrick as busy as ever. Unbelievably, 2007 was his best year ever by a large margin, and 2008 stacked up to be even better.

With the economy in a shambles, how do you explain that?

Partly it's because we're running really lean. I still use the same cameras from three and four years ago, and light stands, strobes and other equipment I've bought over the last twenty years.

I thought we were always supposed to buy the latest and greatest equipment?

No, we don't. If you're trying to compete based on your equipment, you won't get very far.

What's your advice for aspiring photographers?

Well, the realities of the economy are different from when we started out. It's a challenging career, and it's hard to break in. But what isn't hard right now? Is there any worthwhile career that isn't hard to break into?

LEE STANFORD: A LOST SOUL BECOMES A COMMERCIAL AND FASHION PHOTOGRAPHER

What brought you to a career in photography?

I'd had four years of college, and I still didn't know what I wanted to do. Marine biology seemed neat. I had an art minor. Then journalism seemed exciting for a while. I finally decided I was wasting my dad's money and stopped going.

So when did you go pro?

That's open for debate. Maybe in '85. I shared a studio with two designers and I shot model and actor head shots and comps. I started getting small jobs for local hair salons, and the business just grew by word of mouth. My first official commercial job was shooting girls in bikinis for a beer company. How cool is that?"

In 1986 Lee committed himself to larger fixed overhead by signing a lease for his very own 2,000-square-foot studio in the trendy Minneapolis warehouse district. He has never looked back.

Has every year been a good one, financially speaking?

I've had growth every year for pushing twenty years even in bad economic times. Can't complain about that.

That's steady growth for eighteen years with no rep and very little self-promotion. In fact, Stanford's experience goes against much of the information in this book. He must be the exception to the rule.

Since you yourself admit you're not very good at marketing, why didn't you get a photographer's rep to do it for you?

I tried to get a rep. No one wanted me. I guess my look is on the artsy side and most reps I talked to felt that would limit me too much. I hardly ever show my book. I hate that part. I know I should do it more, and I should schmooze more, but I don't. I probably lose some business because of that.

Have you done any formal study on the fields of photographic technique or business?

No. If I had to do it over again, I'd take a business class. Just for things like filing for tax exemption numbers and things like that. I had to teach myself business right along with the photography.

Do you regret skipping photography school or assistant work?

I learn faster when I teach myself. Essentially, I learned by cutting photos out of magazines and re-creating them myself. Some people come out of photo school with very rigid ideas about how things should be done. They're afraid to break rules. But school's not bad for everyone. As far as tech school versus art school goes, I know a guy who went to Brooks and a guy who went to a tech school and they both do really great work.

Would Lee recommend this career?

Yeah! I can't think of anything better! You get to make up your own job. You have flexibility—you can work nights or weekends if you want.

Update

Lee's studio is in a new, larger space, and he's weathering the economic downturn. In fact, he's raised his basic day rate (placing himself at the low end of the high-priced shooters, whereas before he was at the high end of the mid-priced shooters.)

That would seem to go against common wisdom—raising your prices when times are tough.

It's still about perceived value. I will knock it down a little for some clients, but then I have to charge for small stuff like, two hours of prelighting, so it all comes out about the same.

And you're shooting digital now. Has this changed anything for you?

Not really. Just turn-around time. We don't have the mark-up on film anymore, but I have to charge for file conversions, post processing, archiving—so again, it's kind of a wash.

Has digital capture made you a lazy photographer? Just knowing that if something isn't perfect, you can fix it in Photoshop?

No! I still want to get it perfect in the camera! But I can't believe how often I have clients say, "Don't worry about that! We'll just fix it in post."

When we last talked, you admitted to being guilty of not promoting yourself enough. Has the Web changed all that?

My website is my only promotional tool!

"Only" only?

Well, I still have my book and I show it maybe once every nine months. Someone will go to my website and then call and ask to see my book. That's good, because they'll tell me what they're interested in, like location lifestyle—and then I can tailor the book for them.

What's the main difference between Lee Stanford, newbie photographer, and Lee Stanford, seasoned photographer?

I'm smarter now, business-wise—I know how to make bids better because I know what it takes to get the job done, so I know what to charge to be sure I get compensated fairly.

Fashion would seem to be a very youth-oriented business. Does it hurt you, not being "young"?

I can't be the next new thing anymore—but I can produce very high-quality images efficiently and consistently.

When we last talked in 2004, you said you would recommend this business to aspiring photographers. Is that still the case?

Yes. But in this environment, I'd recommend a shorter learning curve than I had. 1) learn to take pictures, 2) learn to run a business; 3) learn how to get paid to run a business. You have to learn all of it all at once.

DAVID SHERMAN: NBA TIMBERWOLVES TEAM PHOTOGRAPHER

David Sherman came to photography relatively late in life, after working in the real world for eleven years. He holds two degrees in agricultural economics—not exactly an area that hints at his ultimate career choice.

What did you do before you began your photography career?
My first job out of college I worked in a bank marketing agriculture products. I was always interested in photography—I took one undergrad elective course. But I just didn't see it as a way to earn a living.

Often in creative work, we get to break the rules. The lens flare in this fashion image is intentional, and serves to heighten the edgy mood by Lee Stanford.

What changed that?

In 1991, I realized my work was just not making me happy.

Being dissatisfied with your job is one thing, and making the leap to becoming a self-employed photographer is another. How did you work up the nerve to take such an enormous risk as changing careers after 11 years?

I kept my day job! For more than four years. I started out doing Bar and Bat Mitzvahs and weddings on the weekends. After that I was ready to make the move to full-time. So I made a business plan in preparation for applying for a bank loan. But before I applied for the loan, I got lucky. I had a very generous cousin who believed I could make a go of it, and he financed me completely.

Did your strong business background help you build your successful photography business?

Yes. No. Yes. I mean, it helped prepare me for negotiating with clients and freelancers, anticipate personnel issues and understand cash flow.

Any regrets about shelving that unfinished business plan?

No. You'll be told that you must have a business plan, but that's bull. At the end of the day I'm still a photographer. I get paid when I work, and I don't when I don't. You can't really make a business plan for that.

If not your business background, then what factors did help contribute to your ultimate success?

I was very lucky, the NBA [National Basketball Association] did a wonderful thing for me, they paid me to learn on the job. So these league shooters led me around from game to game and taught me everything until I was ready to shoot: timing, angles, special equipment … everything. [For] every aspect they shared their experience and knowledge with me. They were great. And another thing that helped me get started is my easygoing attitude. A lot of my work I get because I'm easy to work with. I don't have much of an ego. For instance the Timberwolves gig—I got that job over other more experienced photographers who were willing to re-

locate for it. The reason I got that was because I'd done a little freelance shooting for the organization (not games, but crowd shots), and they liked me so they really went to bat for me—pardon the sports pun! I was willing to hang out at every game, assist for nothing ... so when the league ended their contract with their previous shooter, I was there, and I had friends in the organization.

What about desire as a motivator?

I wanted to succeed. I had to succeed, because I wasn't going to go back to the kind of career that I left.

Any regrets?

No, no regrets. But if I could do something different I'd have somebody—not an agent, but a partner, someone as committed to the business as I am, to field calls, make bids, produce jobs and show the book.

Would you recommend this career?

It depends on the economy. In bad times you find out which clients are loyal. A lot of them will start shopping price when times are bad, and go with the low-ball bid even if the quality isn't there. So that would be hard. But if the economy is good, go for it.

Update

David finds the biggest change in his business is his media–he now shoots exclusively digital capture. "It's final," he says. "I just sold all my film equipment. And all my clients are fine with it. Even the ones who initially dragged their feet."

Do you find digital workflow complicates your business, what with file formats, storage, backup, organization and all that?

My business has been simplified because of digital. It's now as straightforward as capture, deliver, archive.

You make it sound like capture, deliver, archive is simple—but I'm just getting the hang of it after two years.

I have two raid servers (redundant backup systems) and a bucketful of hard drives. That's way simpler and takes up less space

than negatives and slides. I don't have to touch the images as many times.

What about altering photos in Photoshop? Do you get bogged down with editing?

Most of my business is commercial now—I turn down most retail. So my commercial clients do the post themselves. But for retail, it's like this: When there was film, there were labs. The labs did the retouching and printing. Now there's digital, and there are labs. That's what labs are for, retouching and printing.

Do you think the proliferation of digital photography has created more good photographers?

No. It has created the myth that anyone can be a good photographer if they have a good camera. Nikon has proliferated this myth with their ad that says, 'with this camera, anybody can take great pictures.' I would never buy a Nikon, just because of that one offensive ad.

The Minnesota Timverwolves by David Sherman.

You mentioned you're turning down most retail work now. Do you ever have doubts about having made this move in your career?

Yes, but at age fifty, it's different from age thirty-five or even forty-five! My time is more important to me and being happy at work is more important to me. Yes, I still have to make a living, but I can do it on my own terms now.

What about your rates? Have you lowered them to stay competitive in this bad economy?

No. I actually raised my rates within the last two years.

Has that hurt or helped your bottom line?

It's definitely helped! I've never wanted to be high-end or low-end. I've tried to price myself to be favorably compared with other premium photographers in my market.

What's your advice for aspiring professional photographers?

If you want to make a living, don't give your work away. Charge a reasonable rate. Look, we all started somewhere, but not by doing free portraits or $300 weddings. When you do that, when all is said and done you're working for $2 an hour. There's no "up" from there. People will know you're a $2 an hour photographer.

PETER AARON: FILMMAKER TURNED ARCHITECTURAL PHOTOGRAPHER

New York architectural photographer Peter Aaron holds an MFA from the NYU Institute of Film and Television. He regularly shoots for such national publications as *Architectural Digest*, *Architectural Record* and *Interior Design Magazine*. Most recently he shot a two-part piece for *Architectural Digest* on the Andrew Wyeth family compound.

"The magazine has never done a two-parter with anyone before, and of course it was fun to meet and spend time with the Wyeths," says Peter.

You had planned to become a cinematographer. How did you wind up an architectural photographer?

I tried filmmaking for a while, but I just couldn't seem to find the right group of people [to become involved with]. Photography was always a hobby, so I thought maybe that would be a good way to make a living. I went to magazines all over Manhattan and showed my portfolio. And I got a few bites.

What kind of shots were in your book?

Everything. It was quite general. I was told that my interiors and exteriors were my strongest material, so that was how I chose architectural photography.

And so right away you started getting assignments?

Pretty much. Youth was on my side. I was maybe twenty-eight or twenty-nine. Magazines are youth-oriented businesses. The editors, the writers tend to be young. Young photographers should not be afraid to go to magazines and show their books. They are likely to get a friendlier reception than they might imagine. You should realize that the magazine isn't doing you a favor by seeing you—you're doing them a favor. They need photographers.

I assume that it's not enough just to be young.

Of course, it helps to be good.

And how did those early assignments go?

I did well on my first jobs, but I felt totally out of my depth. So I approached the most important architectural photographer of our time: Ezra Stoller. I was lucky—he allowed me to assist him, and he became my mentor. So for two years I went with him all over the world and learned a ton about composition and doing business.

And after those two years it was back to assignments?

Well, yes. At that time Ezra's daughter, Erica, decided this would be a nice milieu for her, and she joined Esto and became my rep.

Esto is an agency that represents architectural photographers?

Yes. At the time it was only intended for Ezra, but when Erica came on other photographers were brought in. I still had to market myself, because as yet I had no reputation. So Erica got

some of my clients and I got some—at the beginning it was about fifty-fifty.

What made you different? What was it that made you stand out from the others calling on those same magazines?

Historically architectural photographers shot with "soft light." They used only strobes. Coming from film school, I realized that you could light a room the same way you could light a set. I used tungsten to create expressive lighting. Side lighting and back lighting, lighting that's coming from where it should be coming from. I used pools of light instead of blankets. I guess you would call it low-key because there are shadows and shapes and depth. Now it's the norm, but at the time it was innovative. My work looked like I had just taken a snapshot—it looked natural. But it took a lot of work to get those natural shots.

So when you started out, you had youth on your side, and you were innovative. But you've been shooting for twenty-eight years. What's on your side now? Aren't there some advantages to being old and experienced?

Certainly. There was a time when I kowtowed to my clients and listened to their opinions on how to take a shot. But now my clients ask me my opinion. Of course it's harder to approach some of the magazines as an older photographer. They want the next new look.

What would the new look be?

It could be anything.

Cross-processing?

Yes, it could be that. It could be lighting with a handheld diesel-fueled flashlight. It's often something quirky. Usually it fizzles out quickly.

You have no desire to light with a flashlight?

None.

Well, obviously you don't have to. I see your published work all the time—frequently in *Architectural Digest*. That's a wonderful publication.

Yes, and I give them the copyrights! I'm actually not proud of that aspect of working with *Architectural Digest*. But the work is challenging and the published material is very well done, highly visible and excellent for my portfolio.

Are you shooting digital?

No. I'm not shooting digital at all. The technology is not wide-angle friendly. They do make digital backs for 4" × 5" (10cm × 13cm) cameras, but the minute you slap a wide-angle lens on there, you get fall off and color shifts, and other technical issues. So I'm shooting film and then making scans before the client sees the take. There are improvements that can be made—lots of improvements. I can take out exit signs and power lines and anything else that might distract from the building.

This ease with which images can now be manipulated thanks to digital technology—do you see this as a good or a bad development?

I think it's a real boon if you treat it well. The pictures look better—much better. But one shouldn't blur the truth. I don't make changes in a photo to portray anything that doesn't exist in the built world. That would be dishonest if, say, the photo were being entered in an award competition.

Aside from the ethical issues, isn't there another issue? Does the ease of correcting images digitally allow a bad or a mediocre photographer to make good images?

Interesting. I'm not worried about that, because you have to be able to light well. Even the very best Photoshop artist needs a well-lit image to start with, or there really isn't much he can do with it.

So you would recommend this business?

Yes, to a qualified person, certainly.

Update

Catching up with Peter, I found that he is about to receive a collaborative achievement award from the AIA (American Institute of Architects.) He is now shooting exclusively with digital capture.

What is the best thing about digital photography?

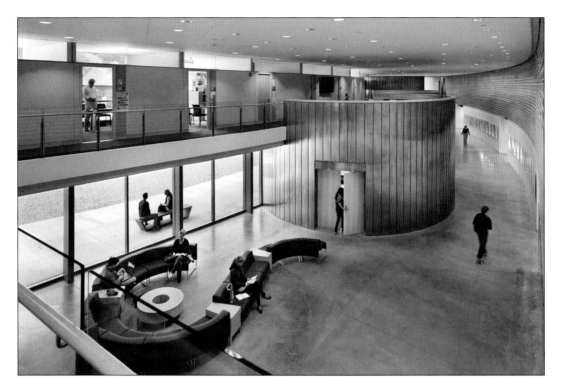

Everything! Now I can put crowds of people in my pictures, change the view out a window, create perfect color balance even with mixed light sources—I can make pictures that in the past would not have been possible due to the high cost of retouching [analog images.]

Interior of Bard College Science Museum by Peter Aaron.

So you're drunk with power?

Yes, I am. I used to make pictures with one layer, but now I use many elements from different pictures to create a final result. I have used up to twenty elements to make one picture.

Doesn't this add a lot of post-production time to your work?

Not really. I don't consider what I do "Photoshop." I label and prepare the images and then turn them over to my photo editor.

Has the downturn in the economy affected your business?

Not yet. I'm fortunate in that I have a captive audience. Architects always need good images of their work in order to sell themselves.

What about less established architectural photographers?

Actually, gifted ones can do quite well. For instance, Tim Griffith is an architectural photographer who does great work. He does about half on spec—he shoots iconic buildings at his own expense and then often is able to sell them to the architects. He's very ambitious. It's nice that if you stick your neck out, good things can happen. It doesn't always get chopped off.

JIM MIOTKE: A PARALYZED NOVELIST BECOMES A STOCK, PORTRAITURE, AND EVENT PHOTOGRAPHER

Jim Miotke graduated with an English degree from the University of California at Berkeley.

"I had my heart set on becoming a novelist, but I was completely immobilized by fear," says Jim, who can chuckle about it now. "I'd always liked photography. I took a few high school classes and one workshop. I picked up some knowledge working at a camera store and at a photo lab, but mostly I'm self-taught."

I assume nonfiction isn't as scary for you to write as fiction, especially since your how-to book, *The Absolute Beginner's Guide to Taking Great Photos* (Random House), is doing very well.

Yes, nonfiction, for some reason, comes easily to me. It was a natural thing to combine writing and photography. And I guess the teaching is a natural offshoot of that.

Yes, the teaching. Tell me about your website.

In 1996, I founded BetterPhoto.com. Then, in 2001, we started offering photography classes. All our teachers are published authors and are highly respected in their fields. I teach a beginner's class, of course. I look at my teaching work at BetterPhoto.com as a healing mission—to help people overcome their fear of equipment, of approaching a stranger, of business in general.

Through your website and your teaching you meet a lot of people who want to become professional photographers. What advice do you give them?

You need a great deal of humility—especially in any type of portraiture. It's really a service industry, more so than com-

mercial, fine art or nature. You need to be able to be comfortable with uncertainty.

Don't quit you day job! Know that you have to do a lot of other stuff besides shoot pictures. People are often not receptive to the idea that you don't just start out at the top of your field. Is there any field in which you can start out at the top? But all that said, it really is true that if you do what you love, the money will follow.

Update

Jim has published two more books since 2004, and produced two DVDs. BetterPhoto.com has continued to grow at a breakneck pace and has added website hosting and templates to the services offered to its members.

Why websites?

Whether you're a part-time or a full-time pro, a Web presence is absolutely essential. This has been true for many years, but never more so than now. The Internet is such a powerful

Jim Miotke graduated from Berkeley with an English degree—but in the field of photography, he is essentially self-taught.

communication tool for prospective clients and art buyers, every photographer should have one.

Has your advice for aspiring professional photographers changed since 2004?

No, it hasn't changed, but I'd like to add to it. In a saturated market such as this, the very first thing any talented amateur should do before attempting to go pro is to get a few good books on marketing (like this one). Focus on marketing and promotion right along with photographic artistry and technique.

Also, it's extremely important to open yourself up to getting help from others. Most of us photographers tend to see ourselves as somewhat shy people. If you can overcome any shyness, make friends with partners, contractors and other photographers and business owners, you will see your business grow at a much faster rate. And you'll have more fun … because life is more enjoyable when you share the ups and downs with friends.

LEO KIM: A LABOR OF LUST, COMMERCIAL AND LANDSCAPE PHOTOGRAPHY

In 2004, I talked with Leo about his work in the disparate specialty areas of fine art, landscape and commercial photography. I caught up with Leo again recently, and I've learned that even a brain tumor has not kept him from his first love—making pictures.

Leo Kim was raised in Shanghai and Hong Kong, lived for a while in Austria and was educated in America's heartland. He always loved photography from the time he was small—using his hand, he indicates a height of about knee level above the floor. But he graduated college with a degree in architecture and design. The photography had been temporarily abandoned.

"After I graduated, I started thinking, 'Just why was it that I wanted to go into architecture, anyway?' I kept thinking about the beautiful black-and-white photographs of [architectural photographer] Ezra Stoller, and the wonderful images of Austrian commercial photographer Ernst Haas—he likes to play with color—and they really inspired me to find my own visual style."

Like many of the other photographers featured in this chapter, Leo is totally self-taught.

Why didn't you go into architectural photography? With your background, it would seem to be a logical progression.

A lot of people ask me that. I don't have one answer. I love forms, shapes, textures. I love O-rings, I find them very exciting to look at. My style springs from arranging shapes to make a simple but beautiful picture. You can't really rearrange buildings! One of my clients once brought me garbage bags full of rubber parts. They were not labeled, not boxed—nothing. They wanted one 4" × 8" (10cm × 20cm) picture for a trade show. They told me I could do whatever I wanted to. So I made eight 2" × 2" (5cm × 5cm) images instead. Combining the shapes that way was much better than just one big picture. I shot them on black Plexiglas. The reflection on black is so deep!

Was the client happy, even though you changed the assignment?

Yes, they loved it. They hired me many more times to shoot their annual reports.

Do all your clients give you this kind of creative license?

Most. In my whole career I have had less than a handful of boring jobs. I believe you have to give the clients what they want but not in the same old way. It's our job to educate them, to say, "Let's do this job in world-class style!" Not with gadgets and contrived lighting, but we keep it simple. We do it with the visual style.

How do you get these amenable clients?

I have always believed in promoting myself. You have to be business first, before you are a photographer. I market my work.

Do you enjoy the business parts of being a photographer?

Oh, yes. It is a challenge. I feel I am still lagging behind at controlling my business. You have to control the business, or it controls you. One thing that has really helped me grow as a businessperson is publishing my book, *North Dakota: Prairie Landscape* (available through www.leokim.com). It has forced me to take new risks, to market and raise money, to keep

meticulous records—all things I was doing before, but I had to take it to a higher level.

It sounds like a real labor of love.

No. It was a labor of lust! I turned down some nice jobs when I was working on the book, because when my intuition told me to go up there (to North Dakota) and shoot, I went. You can't be in two places at once. Sometimes to be in one place at once is hard!

Have you even taken any business courses?

I was just getting to that. No, but I wish I had. Of course, it's all just theory until you practice it. You take classes, or you don't. You learn it one way or another.

Do you recommend this business to others?

Yes. I love my life. I love this business. Sometimes I am out shooting and the sky opens up and the light breaks through

A North Dakota Landscape by Leo Kim.

and it takes my breath away, and I say, "This is for me? I can't believe it!"

Now Leo still making amazing images both marco and landscape. Due to illness, Leo has been nearly homebound in his Frogtown coop in St. Paul, Minnesota. But even with his wings clipped, Leo finds amazing things to photograph. Lately, his focus has been on vegetables and autumn leaves.

"Not the typical autumn shots. I don't find my leaves on a beautiful mountainside—I find them in the gutter! On the street! I am looking for colors and shapes—very small pictures."

While Leo is still working in commercial photography, he has had several very well-received shows of his North Dakota landscapes in Germany. And he sells his images during the St. Paul Frogtown Art Crawl. Typically he sells out in the first few hours of the first evening of the crawl.

In the last four years, Leo has survived a host of medical difficulties, including a brain tumor that was diagnosed in 2005. "I'm very lucky to be alive," he says. "I live for my friends and for my next push of the shutter."

DOUG BEASLEY: A FINE ART AND COMMERCIAL PHOTOGRAPHER, NOT A STARVING ARTIST

In 2004, I talked to Doug Beasley about his unusual market niche— Doug is a fine art photographer who sells to a commercial market. A lot of shooters—myself included—would love to have his job.

How did you pull off being able to shoot what you want (fine art) but market it commercially and make a living? I thought you had to sell out to make it in a commercial market!

I tried to sell out, but it didn't work! When I try to shoot how I think someone else wants, my work is not as strong as when I shoot from the heart.

You enjoy an extremely high level of creative freedom.

Yes. In this business when you're just starting out, you have all the creative freedom in the world! You're shooting to build your book. You're shooting what you want, because you are

your client. You're shooting models' cards and actors' head shots. You have no prestige, but you're free. Then you get some commercial clients, and you lose a little. For a while you lose creative freedom as you become more successful. Then once you reach the high end, the creativity comes back. Because at that level, people are hiring you for your vision and not because you're a technician.

How did you break into the business?

I assisted for three or four years at some very high-end studios, and I learned a lot. I was very lucky.

Do you recommend assisting to someone trying to break into the market?

Yes, or an apprenticeship. Choose one person whose work you admire and learn how to do everything from them—how to shoot, yes, but also how to get and keep clients, how to show your work, how to run a business.

Speaking of running a business, does running yours get in the way of your art?

Not really. I'm looking for ways to get out of the office more, do paperwork less. But I really have no complaints. It's ironic, though, that part of the reason I wanted to become a photographer is because I didn't want to be a businessman. But that's exactly what I am.

Did you take any business courses, or have any other formal business training?

No. I learned the business by making every mistake there is—usually several times.

Do you recommend this learning method to others?

No! I don't recommend trial and error—but then again, things you learn this way are things you never forget.

You teach extensively through the University of Minnesota and through your school, Vision Quest. You must see a lot of raw talent, and a few clinkers. Can you predict who will be successful, who will make it in the business and who will drop out or fail?

Sometimes. Some just have *it*, but some can learn *it*. You can develop a visual language if you have passion and persistence, and you feed your passion.

How do you keep your passion burning?

You immerse yourself in your art. You surround yourself in it. You go into the darkroom and work. You shoot. You talk to other artists.

Has your passion ever ebbed?

Sure. In the mid-1990s I was disillusioned about the business. I was almost bitter. But I threw myself back into making images I love, and I found fulfillment again.

Can you describe what that entailed?

I simplified my method of shooting. I'm down to bare bones. When I go in the field I bring only my Hasselblad and an 80mm lens. Maybe a 120mm also—I do like shallow depth of field, but I don't want to waste energy managing equipment. I want to put my energy into engaging my subject and getting into the stream of life.

Any advice for the would-be photographer?

Recognize the beauty of this business, that you can control your own destiny; you can create your own life.

Update

Catching up with Doug, I find that he is shooting almost exclusively with digital capture for his commercial clients. But he still shoots film for his fine artwork—even in the field when he's leading workshops.

How has digital technology changed your life and your work?

It makes it harder to teach workshops the way I'd like to, with an emphasis on the process. Workshops are all about the process. But with digital capture, it can become all about the results. I encourage my students to take risks and even to fail. If they know that they'll be sharing their images, they have a tendency to do what's safe. They want to look good to the other people.

So you don't like digital capture.

I like it! It gives you immense control!

But you still shoot film for your fine art images.

Yes, because I like the look of film. But I like digital as well. They're both tools. It doesn't matter if you make a picture with film or digital or sitting in your cave with charcoal on the end of a stick. Good pictures are made with your heart.

So you don't look down on digital capture as an artistic medium. Do you think it has created more competition?

It has created more camera operators.

Not more good photographers?

I think there are still the same number of good photographers. It's crowded at the bottom. There's always room at the top.

What do you have to say to someone who is considering this profession?

It's a tough business. Don't get in because you want to make money. Do it because you have to express yourself photographically.

So there you have it. A few of our photographers knew what they wanted to do with their lives from the time they were children, but the rest came into the field via avenues such as marine biology, dental hygiene, banking, architecture and cinematography. They came to the industry as early as their teenage years and as late as their thirties. For some it has been their first and only career; for others

Doug Beasley explains the back story of this fine art image: "We were shooting nudes in the river and this was an afterthought. I love the unexpected juxtaposition of the velvet dress in the river. Working against expectations can be very powerful visually."

it's been a second or third. Many are self-taught. Some learned through the generosity of their colleagues or mentors. Others paid their dues at art or tech schools. Not only have they come into the business in different ways, each one has created a career, a specialty, a life that is unique onto itself. All have weathered economic upheavals, and some have survived phases of disillusionment, only to re-create themselves as stronger and better artists and business-people. Are there any traits they all have in common? Or is the camera their only common ground?

Perhaps they share a combination of traits: adaptability, desire, a willingness to take the grunt work along with the glamour, and, most importantly, belief in their own ability. How would your story look in this chapter? If you have these qualities, maybe you should find out.

T here are about as many ways to learn to become a photographer as there are McDonald's restaurants along the freeway. Some take years; some take eight weeks. Some are by the book, and some are unorthodox. One (or more) will be right for you. Since in modern life time commitment is often a big consideration, I will list them in order from the quickest to the lengthiest.

HIRING A CONSULTANT

A fast way to start your photography business is to hire a consultant—usually a successful photographer who operates an established studio in your chosen specialty area—to show you the ropes. Consultants generally charge $200 to $500 per hour, and that probably sounds hugely expensive at first blush. But consider the savings in time and money over attending even a two-year school—I've consulted for people starting their own portrait studios who learned all they needed after just three days to two weeks and a few follow-up calls.

Chris Darbonne's college degree is in engineering. But after taking online photo courses at BetterPhoto.com and studying intensively with established professionals, she opened up her own portrait studio, now called Darbonne Portraits LLC.

"This is only for people who have the resources and who are positive they know what specialty they want to pursue," says Julie Floyd. "You don't want to get through an $8,000 stint with a portrait photographer and say, 'Oops! I guess I really want to be an accountant.'"

INTERNET CLASSES

Photography classes available on the Internet would seem to be a perfect solution for those who have day jobs and/or family obligations that make it difficult to commit to a regular in-the-flesh class. The lessons come to you via e-mail, and you complete them at your convenience. Then you e-mail your results back to the site and receive critiques and feedback from your (highly credentialed) instructor, as well as from the rest of the class, which is usually chock-full of those talented amateurs we mentioned earlier in this chapter. You are free to remain relatively anonymous or to network and chat with fellow students as much as you like. I am, of course, biased, because I teach several classes at a fabulous site: www.BetterPhoto.com. While BetterPhoto.com was the first site to offer such classes, others have followed suit.

CAMERA STORES

Working at a professional photo store is one way to learn photography, make contacts and get paid all at once. Knowledge flows

Kerry Drager's education was in journalism. He only took one photography course in college, but by reading books, taking live workshops, and intensive practice, Kerry was able to become a professional photographer.

Stephanie Adams never even considered a career in photography until she became "a camera-happy mom!" A book she read led her to BetterPhoto.com, where she took numerous courses. She also attended live workshops. She started her location portrait business in 2003.

back and forth between store patrons and employees. And many professional shooters look no further than the guy or gal who sells him his film and equipment when he's in need of an assistant or apprentice. Sometimes clients will refer work to their favorite camera store helper when they get requests for shoots that are outside of their specialties. For instance, a commercial shooter who's asked to do a wedding might just pass along the business card of the person who sold him a new lens last week.

ON-THE-JOB TRAINING

Some studios, especially portrait studios and photo mills, will hire employees with no experience and teach them to shoot. There are advantages and disadvantages to this.

"You learn one standard style of posing people," says Laura Dizon, who once was a trainer for a national portrait studio chain. You learn how to handle the camera. But you don't learn how to be creative on your own. You have to shoot a certain number of head shots, with the head in a certain part of the frame … you don't get to touch the lighting and you don't learn what an f-stop is, because you don't have to know."

But there are parts of her training that Laura found very useful. "They teach you about the ability levels of kids at different ages. At six months they sit up, at nine months they crawl, a year they walk. I actually think I benefited a lot from my time at that portrait studio."

One perk: You get paid while you learn.

MENTORS

Finding a mentor, someone who is established in the business and is willing to show you the ropes and help you network and find clients, is a fantastic way to jump-start your career.

Minneapolis photojournalist Stormi Greener is mentoring a Maine wedding photographer who wants to learn to shoot weddings with a journalistic style.

"I was traveling up the East Coast on a job and stopped to shoot, and there was this woman standing in the middle of the road fiddling around with her camera," says Stormi. "I struck up a conversation with her." And that was the beginning of a great mentor/student relationship. But not everybody can rely on this type of serendipity to land a mentor.

Wedding photographer Hilary Bullock has dominated the Minneapolis wedding market for eighteen years, and she still solicits mentors from other complementary fields. "It's a great way to learn," she says. "I have a business mentor right now I'm working with. He's great, and I've learned so much from him." Bullock recommends sending your potential mentor a letter that is brief and professional. Be very specific: Tell the person what you are looking for in a mentor and why you chose them. Then follow up with a phone call. "By getting straight to the point," Stormi says, "you are showing that you have respect for

Kathleen Locke graduated with a B.A. in art history and worked in marketing and public relations—a perfect basis for starting a photography business!

the person, you understand that he's busy and you don't want to waste his time."

SELF-TEACHING

Many of the photographers whose opinions you're reading in this book are self-taught. They had no formal photographic training whatsoever. That's not to say they didn't have teachers; many had very generous colleagues who showed them the ropes, but it was on an informal basis.

Kathleen Carr was an art major when she realized that her true path was in photography. She transferred to a university that allowed her to use the color darkroom as an undergrad (something most schools wouldn't do).

A photographer who is homeschooling himself typically spends a lot of time pursuing all the informal avenues listed in this chapter, along with applying Karen Melvin's tech school mantra: Shoot, shoot, shoot.

"You shoot a lot," adds Lee Stanford. You try to re-create some technique you've seen or to create a technique to express an image that's in your head. The great thing about teaching yourself is that you make mistakes. Sometimes the mistakes are great—better than what you were trying to accomplish. I've heard it said that a good photographer is not one who doesn't make mistakes, he's someone who can *repeat* his mistakes."

The big drawback to self-teaching is that if you're not incredibly motivated, or if you're not 100 percent confident in your vision, you can fizzle out. While any method of learning photography requires strong motivation, the lone wolves among us need to be especially self-reliant in this regard.

APPRENTICESHIP

An apprenticeship can be a great thing for a young photographer. An apprentice assists a photographer for little or no pay and in return gets a mentor.

"I most certainly share more time and knowledge with an apprentice than with an assistant," admits an anonymous fashion shooter. "Even though I know they're both there for the same reasons—they don't just hope to archive my files, they want to learn the business—the assistant goes home at the end of the day with his $175 to $250. But all the apprentice goes home with is whatever knowledge and encouragement he gets from me. I take that seriously. I don't take on apprentices for slave labor and let them just scavenge whatever scraps of learning they can. That's why I only take on apprentices at certain times of the year, because when I'm too busy I just won't be able to hold up my end of the relationship."

Not all photographers take this commitment seriously, so if you choose to be an apprentice, meet with at least three or four photographers and interview them while they're interviewing you. You don't necessarily want to let them in on what you're doing. Don't start the interview by saying, "So, just what do you intend to do for me?" This will guarantee you don't get the job at that studio. Instead, listen to the photographer talk about photography. If he's passionate and excited about it, if he gets that fire in his eye, he'll probably be a good and generous mentor.

ASSISTING

Working as an assistant to an established photographer either after or during school is considered by many to be de rigueur, especially in the field of commercial photography. But while many shooters insist it's a necessary part of any budding career, others are equally passionate in their opinion that if your ultimate goal is to be a self-employed photographer, you should not assist.

These opinions seem to come from two different schools, similar to the schools of advice from which generous, concerned individuals volunteered guidance to me as I was entering college.

"Learn to type!" a well-meaning uncle encouraged me. "Then you'll always have something to fall back on."

"Never learn to type!" A female executive (and this was back in the days when there were few female executives) told me. "You won't succeed if you have typing to fall back on!"

"Some people do become professional assistants, and never go on to be photographers," acknowledges the anonymous fashion shooter. "But, hey, if they don't ever make it to the bigs, who's to say it was because they assisted? Maybe these guys wouldn't have had the gumption to do it in any case. And some people seem to like assisting. It's certainly less pressure than shooting."

Patrick Fox points out another less obvious drawback to assistant work: "A young person just out of school coming to work for an old workhorse and seeing a huge studio with lots of billings might just jump to the conclusion that that's how his life is supposed to be. It can be kind of a mindblower." Nonetheless, Patrick says assisting is an absolutely necessary step toward becoming a commercial photographer. "When I was coming into the business, you only had to assist for one to two years. Now it's five years, maybe more."

Fine art photographer Doug Beasley assisted at some very high-end studios at the beginning of his career, and he found the experience invaluable. "Whether you become a freelance assistant and work with a number of different people or choose one person whose work you admire to assist in-house on a semipermanent basis, learn how they do everything. Not just how they set up lights—learn how they get and keep clients, how they make an estimate, how they bill every aspect of the operation."

Fashion shooter Lee Stanford agrees variety is key. Though he never personally worked as an assistant, he sees it as a good way to learn if you stay freelance and work with a variety of studios. "Everyone does everything differently. Every studio has a different ambiance, a different way of relating to clients. Pay attention to the little stuff. I was at a shoot once where the client had to have Diet Coke. That was his biggest priority. So the shooter had Diet Coke there. On that shoot, the Diet Coke was more important than the take. As a photographer just starting out, I never would have guessed that could be an issue."

TECH SCHOOL

While tech school may not be as prestigious as fine art school or liberal arts college, it offers some real advantages for the aspiring photographer. You get hands-on experience with a full range of equipment and media, and you get to shoot a variety of subjects in the studio and on location. This is especially good for those who haven't decided what area to specialize in because you get a little taste of everything.

There are other advantages to tech school. The tuition is considerably lower than at other types of schools, and the programs are shorter (two years as opposed to four or more).

"I'm very, very happy with the education I got at tech school," says wedding and portrait photographer Kelly Mc-Swiggen. "We got to shoot constantly. I think I got an excellent technical background out of it. My only complaint is that there was absolutely no creative emphasis. We were taught only how to shoot what the teachers imagined our future clients would want and not how to develop our own style or technique. I had to teach myself that part. I guess they cram so much technical teaching into two years that there isn't room for creative theory."

Says architectural/commercial photographer Karen Melvin, "I'm thrilled with my choice to go to tech school. I wasn't going to wade around through a lot of theory. I wanted to get my hands on

Lee Stanford is a truly self-taught photographer with an emphasis on commercial and editorial fashion.

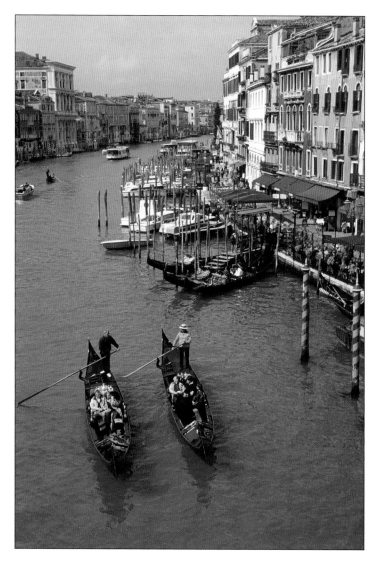

Brenda Tharp has a degree in computer science and worked full-time at Hewlett-Packard for years before she quit her "real job" cold turkey and began her photography career in earnest.

equipment! I wanted to shoot, shoot, shoot. And that's what I got to do."

PHOTOGRAPHY SCHOOL

Brooks Institute offers two- and four-year degrees in various fields of photography, film-making and graphic design. While a degree from Brooks bestows a certain status, it tends to impress other photographers more than it does potential clients. It's also expensive and intensive. Many photographers go to a liberal arts college for two to three years, and then transfer their credits to Brooks to complete their photography major.

ART SCHOOL

Where tech school emphasizes the correct way of doing things and tries to anticipate the desires of the ultimate client, an art school education will typically bestow a great deal of creative theory and practice, with no consideration of the client or end user of the photographs.

"Quite frankly, the art students can be great at fine art photography, but they tend to make lousy assistants," says the anonymous fashion shooter. "They want to do things their way, and they're not concerned about pleasing me or the client. They seem to be shocked at the typical day rate for an assistant, and their work ethic isn't the greatest."

CONTINUING EDUCATION

Photographers need to learn new techniques and business practices throughout their professional lives—not just at the beginning. The following are some suggested methods to help hone your skills and creativity whether you're starting out, building up or maintaining your photography business.

CLUBS AND PROFESSIONAL ORGANIZATIONS

Clubs for amateur photographers are easy to join, both on the Internet and in the flesh. While the word *amateur* may put you off (you are, after all, working to go pro), there are many exceptionally gifted nonprofessionals at these chat rooms and meetings who love to talk shop and who will answer all your questions until long after most pros would have gone home. Not everyone who's gifted actually makes it into the business. Some don't want to take the risk. Some are gear heads who like the equipment and media but don't have the motivation or the creativity to put their knowledge into action. Whatever their reasons, these folks are very accessible and happy to be of help.

Professional organizations can be harder to join—generally they want you to be in the business already—but check them out anyway. Even if they don't let you join, they may let you sit in on some meetings featuring topics of particular interest to you. And while you're there, you might make connections with some of the members. One of the great things about clubs and professional organizations is that they can be invaluable to you at every stage of your photography career, from the earliest to your golden years and all the years in

Stormi Greener had no background in photography and a portfolio of self-proclaimed "awful pictures" when she hounded a newspaper editor to give her a job as a photojournalist.

Lewis Kemper knew he wanted to be a professional photographer from the time he was in high school. The closest Lewis ever got to a job outside the field of photography was washing dishes at a hotel for four weeks.

between. And you can participate while you pursue any and all the other avenues listed in this chapter.

READING BOOKS

Reading books on the creative, technical, and business aspects of photography is a very helpful learning tool whether you choose some form of schooling or self-teaching. But I never recommend just reading books. You need to apply the theories and techniques you find in them. If they include lessons or workbooks, do them! Don't expect to retain what you read without hands-on experience to back it up.

Not every word of every book is going to apply to you. So when you read, keep a highlighter and a pencil nearby. Highlight the ideas and theories that are germane to your place on your creative journey. Write comments in the margins. Tab or dog-ear the pages that hold matters of interest so you can find them again. If you're one of those characters who likes to keep your books in pristine condition, get over it. Reading a book is like mining for gold. You have to sift out the sand and rock to find what you're looking for. The sifting part is critical, because if you don't wash

away the silt, there could be chunks of gold in your pan but you won't be able to see them.

Books don't always teach us new things. Sometimes they remind us about things we already know but have neglected to act on. Sometimes an idea in a book will inspire you to get your own idea and act on it.

READING PERIODICALS

Some wonderful photography magazines are available. Some are general—*Shutterbug* and *PopPhoto*, for instance—and some are specific to various specialties, such as *Studio Photography* and *Outdoor Photographer*. You can find some real gems of information in these magazines, and it's fun to get something in the mail besides bills!

PODCASTS, MESSAGE BOARDS, ONLINE CLUBS, AND YOUTUBE.COM

The Internet is an amazing place! A wealth of free information and instruction awaits those who are willing to search for it. For instance, my friend and colleague John Siskin, who teaches lighting courses at BetterPhoto.com, has several excellent lighting videos available on YouTube.com. Ibarionex Perrello hosts a highly rated podcast, "The Candid Frame." And Audri Lanford hosts the podcast "7 photography questions." These are all wonderful sources of information, and all absolutely free!

You can also find valuable information just by entering key phrases into your search engine such as "studio portrait lighting, aperture priority, shutter speed," and so on.

I just entered "photography how to" into my Internet browser and came up with over eighty-four million entries. That's the good news and the bad news. Good because there's a lot of great information out there; bad because there is a lot of questionable content to sift through. Remember to always be a discerning consumer—even when the product you are consuming is free!

WEBSITE HOPPING

You can also learn a lot by simply visiting the websites of other photographers. Aside from exposing yourself to visual trends and a variety of ways of seeing, you can get a sense of standard fee

structures and prices in your market and around the globe. Many photographers have blogs and articles that can be very inspirational and instructional. Bookmark the websites of the photographers whose work you particularly admire, and return to them periodically as you develop your own skills. You will find that you will be able to learn more and more from these images each time you return to them. And remember that it's fine to be inspired by another photographer's style but to be successful you will have to develop your own.

INFORMAL OR INFORMATIONAL INTERVIEWS

Another method to garner more information from established, successful photographers is the informational interview. Photo students or wannabe photographers call an established shooter and request a fifteen- to thirty-minute meeting in order to ask business, creative and technical questions. Sometimes the underlying objective of the interviewer is to land a job with the interviewee. Sometimes the interviewer is really just learning about the business, and sometimes he is fishing for a mentor. In any case, you can get a pretty interesting earful this way—if you can get your foot in the door. Be prepared for polite rejection. There are many, many people requesting this type of interview. I get three or four requests a week, and I can't possibly accommodate them all. Expect to be turned down by nine out of ten photographers you call. That's the bad news. The good news is that if someone does agree to see you, she's most likely willing to share a good chunk of time and knowledge with you, probably will give you a tour of her studio and perhaps will allow you to observe a shoot. Who knows—you might even get a job offer.

Any connection to the photographer you're trying to get in to see, no matter how tenuous it seems, will improve your chances. "I'm much more likely to see someone who calls me and says, 'Hi, I'm your friend Joanne's friend, Susie's daughter, and I was wondering if you might have time for a brief informational interview,' than someone who says, 'Hi, I'm Jane Doe, and you have no idea who I am, but would you clear some time on your schedule to meet me?' So don't be afraid to drop a few names. You prob-

ably have connections you aren't even aware of. Ask your friends and family if they know any professional photographers—I think you'll be surprised how many do. Just as with clubs and professional organizations and reading books, you can do informal interviews while you pursue other avenues of study.

Jennifer Wu graduated from college with a degree in photography. She jumped from food to weddings, and finally to her true love, landscape and nature photography.

In a relatively short time, digital technology has changed the world of photography in an irrevocable way. In 2004, roughly half of my students at BetterPhoto.com shot digital capture and half shot film. Today, less than six years later, fewer than one in one hundred shoot film. Of the photographers I interviewed for this book in 2004, 30 percent still shot with film some or all of the time. Now none of us shoot film with any regularity. It's not just camera equipment that has changed with the advent of digital photography. The way we shoot images, edit them, present them to clients and store them are all new. Many elements of the photo-

graphic process have become easier and cheaper.

The shift to digital photography created big, burning questions from professional shooters: Will this new medium make it easier for bad photographers to create good images? As digital cameras and equipment became cheaper, more advanced and readily available, professional photographers worried that more and more mediocre photographers would crowd the market. Now that digital technology has been around for a while and we are able to witness the consequences, what is the reality?

These images by Jim Zuckerman demonstrate the broad range of visual styles we can achieve using image editing software. On the left is a beautiful, classic visual treatment with minimal editing, and the one on the right has a creative treatment applied that gives it a very painterly affect.

"It's made everybody better!" says Peter Aaron. "We've raised the bar. Now bad photographers can do good work, and good photographers can do great work. I used to feel somewhat apologetic about my work when I encountered insoluble issues. Now we can do the impossible with Photoshop. One can put a gray scale right into a picture to help create perfect color balance. Two images can be taken from slightly different perspectives to eliminate a streetlamp. We no longer require color corrective gels on lights because we can shoot each type of light at its proper color balance and then merge the images together. Now no problem is too big."

Most of the change has ultimately been good for professional and amateur photographers, for the photography market in general and for the end users/clients. Let's look at how.

AFFORDABLE HIGH-QUALITY EQUIPMENT

Digital technology has made high-quality camera equipment affordable and easy to use. This gives the professional photographer better tools for her tool belt, and it allows the talented amateur easier

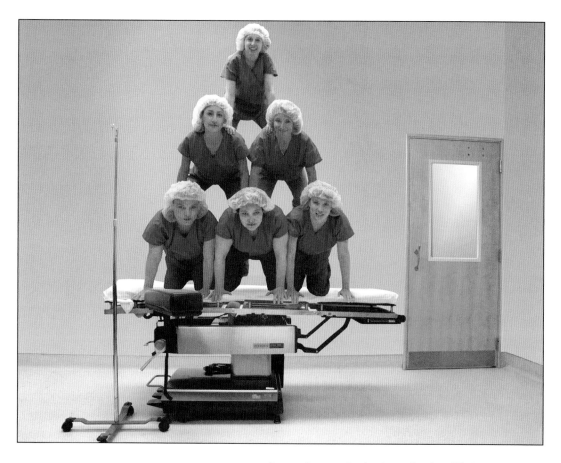

This image by Connie Cooper-Edwards, created to demonstrate teamwork in the workplace, is actually a composite of three images edited together in Photoshop.

access to quality equipment. In the days of analog (film) cameras (and even during the early days of the digital revolution), quality equipment was prohibitively expensive and often large and awkward to use (think medium format cameras, manual focus, and industrial tripods). Now DSLR cameras create equal or better quality images and are comparable in size and ease of use to 35mm SLR cameras.

VERSATILE CAPTURE OPTIONS

Digital technology allows the professional photographer many new freedoms simply not available with film capture.

- Image cards are reusable and unwanted images can be deleted in-camera or on the computer in an editing program, thus eliminating the cost of film and the cost of processing and/or printing unnecessary images. This allows the shooting of more images without the cost mounting up.

- Professional photographers now have the ability to change ISO at will: With digital capture the ISO is dictated by the camera body, whereas with film (analog) capture the ISO was determined by the roll of film itself. This way if you're shooting as the sun is going down and losing light quickly, you can go from a low to a high ISO just by setting a button rather then changing rolls of film.

- Digital technology has improved resolution. Now there are some cameras that shoot at 3200 ISO or higher with amazingly little loss of detail and quality. This makes it possible to shoot successful images with ambient light in very low light situations.

- Shooting in the RAW file format allows you to shoot now and then go back and change exposure up to two stops in either direction, as well as to change white balance and other aspects of the image without causing a loss of resolution.

FLEXIBLE PROCESSING OPTIONS

In the old analog days the professional photographer might have consulted with the guy at the lab about pushing or holding transparency film a half a stop. Even if she actually did her own processing it was by the batch—she couldn't process one image at a time. But with digital capture she can process one image at a time or batch process, as best fits her needs. And she can do it all in the light, with no toxic chemicals. She can enlarge the areas of the images she wants to see up to 200 percent and affect each area of tonal range and color individually rather than globally. She can make any number of originals so she can process and reprocess images and share originals to infinity and beyond!

ENHANCED RETOUCHING/ IMAGE EDITING CAPABILITIES

In the days of analog film, if an image needed retouching, portrait photographers sent it to the lab and had their retoucher take care of it. The photographer could get blemishes removed, wrinkles softened and glasses glare eliminated. More work than that was unusual

because the cost prohibited it. Commercial clients with bigger budgets could have their images airbrushed to make models seem prettier and products more appealing, but that was the exception.

Today, if a portrait photographer wants heads transplanted or subjects taken out of or added into an image he can do it himself using editing software—or farm it out. Either way, it's much more cost-effective. He can change backgrounds, eliminate clutter, bring families together who haven't been in the same room in years. In short, he can do the impossible and do it inexpensively.

GREATER PRESENTATION OPTIONS

All of the options can make it hard for the photographer to choose how to present preliminary work to his clients. Should he print hard copy proofs or make a projected slide show or show images in templates on the computer? Should he do only basic processing first and save the involved retouching for after the client has chosen her images? Should he include a press printed proof book with each order? When showing two or more images that will be edited together in the final product, how should he help the client visualize the end result short of doing the editing in advance? What if the client wants their images *today*—they want to walk out of your studio with all their images on a disk and they either don't want editing or want to do it themselves? These are all important questions, and ultimately all photographers must answer them for themselves based on the industry standards, their experience and their client demand.

For instance, a commercial photographer who shoots a 100-page hardware catalog has a client who probably wants all their images edited and ready to go in CMYK color space so all they have to do is send it along to their printer. An architecture magazine will want their editorial shots all edited and ready to print, as well. A wedding photographer may provide hard copy or digital proofs. These digital proofs could be available online for a limited amount of time so that the bridal couple's friends and family can order prints. Or he may hand over the e-files on disk or even on an external hard drive, edited or unedited, and allow his client to make prints at will.

GREATER CONTROL OVER
THE FINAL PRODUCT

Whether our final product is a photographic print, a press print, a laser print, an electronic file or an art print, the photographer is now a partner in the outcome. she needs to be proficient in understanding color space (CMYK for press printing, sRGB for Web use, to name just two) file type, resolution and file size—the list goes on. She has more control *and* more responsibility. Her role has changed. To learn about or stay abreast of important image output techniques, I recommend registering for forums and communities at www.adobe.com. You can also subscribe to *Photoshop User Magazine* and/or *Layers Magazine,* two great periodicals.

The high contrast, hand-colored looking portrait was created in Photoshop by Stephanie Adams.

MORE
SOPHISTICATED
ARCHIVING
OPTIONS

In the old analog days we stored negatives in acid-free materials and kept them safe from fire and water. In our new digital world, we need sophisticated, reliable, redundant storage systems so that if one part of the system fails, the other part of the system preserves our work. These systems take up a lot less space and are easier to organize and sort than negatives. We explore archiving in depth in chapter ten.

One of the beautiful effects made quick and easy with digital capture and editing is the image frame, like in this wedding photo by Hilary Bullock. Many are templates are available through professional printing labs, and they can also be purchased online from websites such as ittybittyactions.com, or you can create them yourself.

STREAMLINED WORK FLOW

Every step of the image-making, editing and preserving process falls into the category of "digital work flow." Work flow and digital asset management are such large and unwieldy topics that there are books, seminars and software programs all designed to aid us in this aspect of our work. While our work flow has become infinitely more complicated with the use of digital technology, it ultimately allows us to create, present, output and store superior-quality images.

In a nutshell: the basic work flow requirements for the beginning professional photographer

1. **CAPTURE.** Capture is what you do with your camera. It's what we used to call "taking the pictures." Anything that happens in-camera is capture. In order to capture images, all you need are a camera, a lens and an image card (also called flash cards).

2. **IMAGE BROWSER.** After you capture your images, you will want to view, rate and keyword or otherwise categorize them (by date, subject, client, etc.). You do this by importing the images from the flash card to your computer via a card reader or a USB cord attached directly to the camera. There are many great browsers available, including Adobe Photoshop Lightroom and iPhoto. Many cameras come complete with their own browser software, and many editing programs come with

browsers as well. For instance, Adobe Photoshop comes with the browser called Bridge, which is all I personally need for organizational purposes.

Digital editing allows photographers to incorporate text and borders into their images and to easily create image collages. These treatments are very popular with portrait clients. This example is by Vik Orenstein.

3. **EDITING SOFTWARE.** Examples of editing software are Adobe Photoshop, Picasa and Corel Painter. You can also purchase plug-ins that work with Photoshop and some other editing platforms to increase your capabilities. Some examples are Noise Ninja for noise reduction, Mystic Light and Color for artistic affects, and Blow Up from Alien Skin for enlarging files. Some clients want their image files unedited, but in this business environment you need to know how to do at least basic editing yourself or find a *very* trustworthy and affordable service to hire it out.

Fine art photographers have also benefited from the advances in photo editing software. This image was created by Kathleen Carr with a DSLR that was retrofitted to become an infrared camera, but similar treatments can be created with image editing software. The artist then colored the image.

4. **REDUNDANT STORAGE SYSTEMS.** With the freedom to create multiple originals comes the obligation to use them properly. You should always have at least two originals of each image stored on different computers or external hard drives. Ideally, these storage systems should be in different physical locations. For instance, I have one at home and one at my office. You should regularly back up active images and your computer and/or laptop desktops to your storage drive(s). Automated backup programs cost under $100 and are more reliable than human memory (at least my human memory).

5. **OUTPUT METHODS.** Eventually you will need to output your images. That means you will make photographic or offset prints, or burn CDs or DVDs to give to your clients. So you will need a lab, offset printer, CD/DVD reader/writer and/or some combination of these. E-files can

BUILDING YOUR PHOTOGRAPHY BUSINESS

also be sent electronically through online services such as YouSendIt.com.

THE EFFECT OF MORE PHOTOGRAPHERS IN THE MARKETPLACE

Yes, as feared there are more photographers competing in the marketplace. There aren't necessarily more top photographers. There are *certainly* more inexperienced and inexpensive photographers. As such, they are not really competing for the same pieces of the pie as the top dogs. For instance, a person who hires a wedding photographer off of Craig's List for $300 probably would never have hired a $3,500 shooter in any event. If anything, the $300 photographer saved the bride's Uncle Chuck from having to dust off his camera. And in the same token, a person who would hire the experienced $3,500 shooter wouldn't hire the $300 guy even in a bad economy.

There *is* something of a danger to the experienced pros who make their living in the photography biz from talented newcomers or amateurs who are willing to give their work away just to see their images in print. But this has always been the case and is not new to digital technology. So don't sell your work cheap—even if you're a newly minted professional. You'll only erode the marketplace for yourself and others, and the perceived value of your work will erode with it.

PITFALLS TO AVOID

All this digital stuff sounds like heaven, but every advantage that digital technology provides contains a hidden pitfall to avoid.

LAZY CAPTURE

The use of RAW capture is a great advantage when used carefully. But we can quickly turn into lazy photographers if we say to ourselves, "Gee, I can just shoot this now any old way and then fix it later in RAW!" While this is true to a degree, the best use of any image editing tool is to enhance an image, not to do damage control.

OVER RETOUCHING/IMAGE EDITING

It's important to remember that with every opportunity to improve an image with editing comes the possibility of going overboard and ruining it. For instance, digital technology allows portrait photographers to soften skin texture and sharpen eyes, two things that can contribute to the making of a great portrait. But overly softened skin tones and overly sharpened eyes can look artificial and even disturbing. Photographers have to take great care not to abuse these editing tools.

Architectural photographers can use Photoshop to populate an image with people. But again, one must not approach this type of editing carelessly. "There's no excuse for awkward poses or one-legged people," says commercial photographer Peter Aaron, in reference to the fact that when one shoots a person walking at about $1/25^{th}$ of a second shutter speed, often that person appears to have only one leg because one almost disappears in the motion blur.

Landscape photographers can edit their images to remove an excessively blue color-cast from an image. But as Jim Zuckerman points out, "What's wrong with a landscape with a blue cast to it? The sky is blue, the shadows have blue in them—should every image have a neutral cast? I don't think so."

So how do we know when to stop? Richard Lynch, author of eight books on image editing including *The Adobe Photoshop Layers Book*, recommends making an outline of what you plan to do in your edit and then stick to it. If you decide to experiment as you go, write your intentions into the outline and put a limit on them.

INADEQUATE STORAGE/BACKUP

It's wonderful to have redundant storage capabilities. The only problem with them is that you have to use them or they don't work. Unfortunately, I'm speaking from experience. I have a lovely redundant storage system, but for a full two years I had floated along never having had any computer problems at all, so I got lazy and went a period of four months without doing any backup. Then the motherboard on one of my Macs failed and every image

that was downloaded or edited on that computer was history. We were able to recover most of the files for a hefty $2,700 fee. Don't let it happen to you.

HAS ANYTHING STAYED THE SAME?

With all these changes, has anything stayed the same?

The answer is a resounding yes! After all, digital pixels, like film grain, are just different ways to record information. The essentials of good photographic technique haven't changed at all.

LIGHT

You still have to have great light, whether your image is a portrait, a product shot, a landscape or any other type of image. "Time of day is very important," says Peter Aaron. No amount of editing will make an image look like it was shot at dusk if it was shot at high noon.

FOCUS

You still need to have the appropriate areas of the image in focus. There is a certain amount of sharpening that can be done in Photoshop, but ironically images that are already sharp are the ones that benefit most from added sharpening.

CLARITY

We still want to create images with the highest resolution possible. With digital capture, we want the most megapixels, the largest sensor and the largest number of pixels per inch.

I originally tried to use face paint to create this "tattoo" for a Mother's Day portrait. The paint wasn't bright enough, but I went ahead and shot it, then enhanced the color using Photoshop.

Shooting at too high an ISO or at incorrect exposure can create low-resolution digital images, just as with film.

COMPOSITION

We still need to know how to place our subject in the frame and how to use background and foreground to create a pleasing composition. While digital technology allows us ease of cropping in the editing process, we still need to have good raw material to work with.

EXPOSURE

Yes, digital capture gives us more wiggle room than film capture when it comes to exposure. But again, any editing we do outside of RAW bruises pixels, so when it comes to exposure, it's always best to nail it.

While digital technology does not in any way lessen the importance of good technique, it does help make good technique easier to learn. Because we have instant feedback with digital capture, we can stand in the field and shoot the same scene with six different white balance settings or six different exposures and immediately see the results.

Digital technology has changed the photographic landscape forever, but it hasn't eliminated the need for great technique and creativity.

Here's another paradox, in a field fraught with paradoxes," says wedding/portrait photographer Bob Dale. "You should start out shooting everything. You should be a generalist. That's how you learn. But then you have to narrow it down. The market demands that you choose a specialty."

Says commercial/fine art shooter Leo Kim, "You have to find your own personal style before you can select a niche. You will start out emulating the visual styles of others whose work you admire. But sooner or later, your true self comes out. It has to. Then you will choose your niche accordingly."

In the good old days, when markets were smaller, a photographer used to be able to be a generalist. He could shoot a little tabletop, a little fashion, a little food, a little architecture. He was considered perfectly respectable if he shot a portrait in the morning and a building in the afternoon. But now in order to be successful, he has to specialize. If you're a food photographer, you shoot food. If you're a fashion photographer, you shoot fashion. Period. Nowadays, markets are larger and there's room to support specialty shooters, so if clients suspect that you'll shoot anything, you might seem desperate to them. They are looking for a photographer who feels as passionate about their subject matter as they do.

"I don't want to hire someone who shoots candy and girls," says an architect who often hires photographers to shoot his building projects. "I won't hire anyone who has anything other than architecture in his portfolio."

Says Patrick Fox, "We've been forced to specialize to a ridiculous degree. It's come to the point where you're not just limited to one specialty, you have to shoot one look or one technique within that specialty."

Jennifer Wu has created a highly specialized niche for herself—shooting starry skies.

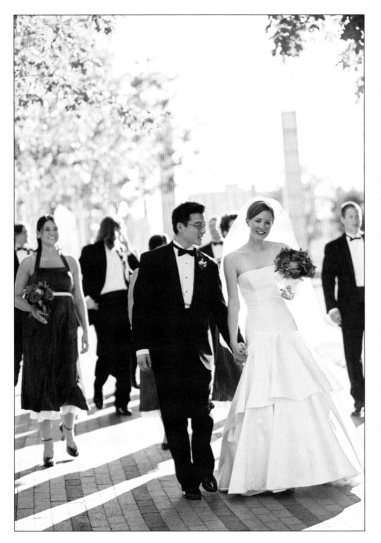

Hilary Bullock is a wedding photographer with over 20 years of experience. While she has adapted the best of new technology and creative techniques into her work over the years, her signature style is still classic and distinctive.

In smaller markets, your neighborhood generalist is probably still respected. But the larger the market you shoot in, the more specialized you'll be forced to be. So when choosing a niche, consider what you like to shoot. Who and what is your lens drawn to?

"You have to shoot selfishly to be successful. Shoot what interests you," advises Doug Beasley.

Jim Miotke, author, photographer, and founder of BetterPhoto.com, agrees, "Follow your bliss, and the prosperity will come. It's an organic process. You learn about yourself as you learn to shoot, and ultimately it all comes together."

The sentiment is shared by Patrick Fox, who adds, "You have to love what you do—this business is too tough and too stressful if you don't."

But don't you have to consider your market, too? What if you want to specialize in baby portraits but you live in a retirement community?

"Then you move," says Patrick.

"You have to create a balance," says Lee Stanford. "You have to weigh your interests against your market and figure them both together when you're deciding on a niche. Because, yes, you'll be miserable if you choose an area you dislike to shoot in, but if you never shoot because there are no clients who need your work, then you'll be miserable, too."

Personally, I like to advise aspiring photographers to "shoot what you shoot"—in other words, to find a niche in the area of

specialty in which they shoot for their own pleasure. For instance, I love to travel, and I love architecture, and I love nature. But when I went to Thailand for the very first time in 1994 and immersed myself in awe-inspiring temples and wildlife and landscapes, 70 percent of the images I came home with were of children. In the market, in the street, in the airports, at elephant camp, I'd taken more images of kids than of anything else. My travel companion commented, "I'm so glad for you that you're in the right career! But a few more landscape shots would have been nice."

But Jim Miotke advises not to be afraid to pay your dues. "Even Ansel Adams had to shoot portraits," he points out. "Avedon, Warhol, all those guys started out shooting portraits and commercial stuff."

So while you're busy following your bliss (swimsuit models) be realistic about your market (executive portraits). Assist, interview or observe people from different disciplines.

Personally speaking, I love shooting portraits so much I sincerely doubt I'd still be in the business if I had tried to force myself

A classic example of a shot from the travel niche by Brenda Tharp.

to shoot something else. I have assisted architectural photographers; I shot a little product (not very well) when I was starting out and afraid to say no to any kind of business whatsoever; and I shot actors' and models' head shots for several years. But none of that stoked my passion like portraits, especially portraits of kids and their families and pets. I believe I'd be long gone from the industry had I tried to make myself shoot anything else. It's not that I don't *love* looking at all types of images. I am deeply moved by the amazing nature, travel, photojournalistic, fashion and other images my colleagues make. But when I shoot, I shoot portraits.

THE OLD NICHES

Certain specialties come to mind when you're thinking about photography. For example, wedding, event, editorial, fashion, commercial, product, food, tabletop, portrait, fine art and sports. They all have their perks and pitfalls. For example, wedding photography requires the toting around of many pounds of equipment (Stormi Greener's minimum field pack weighs 30 pounds). You also many be forced to go eight or more hours without using a restroom, because in the wedding biz you don't get do overs! All in all, it can be very physically demanding. In contrast, a commercial photographer's clients come to him. So that means minimal equipment hauling, but it also means incurring the fixed overhead of a studio large enough to accommodate large sets and backdrops, and large products (like cars, for instance).

Each niche is demanding in its own way. That's why when choosing a specialty it's important to ask yourself not just "Which area pays the most?" but also "Am I athletic enough to cart my equipment around and am I really that into weddings?" and/or "Do I have the bankroll and the nerve to own a large studio?"

THE NEW NICHES

Digital technology has opened up several new niches, many of which don't require a huge financial commitment. In many businesses, such as real estate, portraiture, e-commerce, retail and

desktop publishing, there is a demand for inexpensive images shot with high-end consumer-grade digital cameras. The drawback is that if you enter this niche, you'll be competing with every other aspiring photographer who has a DSLR.

Another new arena is "lifestyle photography." Lifestyle refers to a style of photography rather than to a specific niche. It describes commercial, portrait and wedding images that are made to appear candid or photojournalistic in execution. "But," says Lee Stanford, "it takes a huge amount of setup to get those candid looking lifestyle shots."

MAKING YOUR OWN NICHE

I've never liked competition. I've always thought that if there were people already doing something, I should do something else. When I opened my first studio, everyone was still generalizing in my regional market. There was no one positioning themselves exclusively as a kid expert or as an exclusive expert of anything, for that matter, because common wisdom still held that if you specialized you'd lose out on a lot of work. But I figured I'd rather have a bigger portion of a small area than a small portion of a large area. Besides, I enjoyed shooting kids and not much else. In calling my studio KidShooters (now called KidCapers) and shooting kids and their families only, I didn't realize I had created a new niche or even that I was positioning myself within my market. I was just trying to do what I loved. I was lucky. It turned out that 1988 was a great year to start a kids' portrait studio. In addition to my portrait clients, national clients who wanted me to shoot their commercial work that involved kids began to call. This was a perk that took me totally by surprise. I got to shoot for Pentax, Nikon,

An example of a product or table top image by David Sherman.

3M, Hormel, Microsoft and more. I believe I would never have been considered for these jobs if I hadn't established myself as a shooter who was all kids, all the time.

You can create your own niche, too. Learn as much as you can about the existing ones, and zero in on the things about them you like. For instance, let's say you love pets and you'd like nothing better than to make a living photographing them. But you think, "There isn't a big enough market in my city to draw a large enough client base to support myself doing pet portraits. And who is going to pay me big bucks for a picture of their dog, anyway?"

But wait. Think about this. Sure, it might be difficult to make your living on pet portraits alone. But who else besides pet owners need photos of pets? A little research will reveal that there are breeders in your area who sell puppies and kittens on-line and need to regularly update their website images as the animals grow. Normally they might take a puppy and place him on their couch and shoot a direct-flash snapshot. But who's to say you couldn't convince them to hire you to come to their home once a week from the birth of that puppy until its sale and provide gorgeous available-light shots on pretty backdrops? And puppy and kitten images sell really well for stock. So there are two possible buyers for the same images right there. Then consider that perhaps the family who purchases the puppy from the breeder might like to purchase a collage from you. Perhaps six to eight images from the puppy's first weeks of life? (Maybe they'd like to upgrade to a framed piece or add greeting cards or "baby announcements.") Now you have three potential buyers for the same images. While you're at it, research the other professionals who come in contact with these puppies. I can think of pet groomers, trainers and veterinarians to start. These folks might also want to show off images of their furry little clients. Or they may appreciate having a trusted photographer to refer their clients to. Now you have four, five or six potential buyers for the same images, and this is starting to look like a living. And to think you almost didn't even try because you thought your little niche wasn't viable!

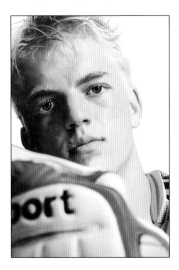

An example of a senior portrait by Vik Orenstein. This is an important niche for portrait photographers, because the demand for high-end, creatively rendered portraits of high school graduates is growing.

HOW TO BE SUCCESSFUL IN MULTIPLE NICHES

You may be a very well-rounded individual who feels passionate about shooting in two or even more different specialties. Or you may find that the market for your chosen specialty is drying up, getting flooded with competitors or simply hasn't turned out to be all it was cracked up to be. How can you get a toehold in a different area without losing the clients in your original field?

Be sneaky! Have different books (portfolios) for each specialty. Have different business cards, letterhead, invoices and promotional pieces. Keep your studio name noncommittal, like, "Joe's Photography," and not specific, like "Joe's Portraits, Food, Landscape and Product Studio."

An editorial fashion shot for *Minnesota Bride Magazine* by Lee Stanford.

Pay attention to the work you show in your studio. If you're shooting for a portrait client today, have only examples of your portrait work on the walls. Shooting a product? Display only product shots. And don't flap your jaw about your product shots to you portrait clients, or visa versa. If worlds collide and a client finds out about your other specialty, don't deny it. Just say, "Oh sure, didn't you know about that?"

And for goodness sake, don't mix up your clients by being a graphic designer who also shoots, or a photographer who also designs. Since the advent of the digital camera, I've noticed a number of listings in the yellow pages for "Joe's Photography and Design." When a savvy client sees that, she'll probably just conclude

A macro botanical photograph by
Maria Mosolova.

(and she might be right) that you're a designer with a camera and not enough to do.

So you have your work cut out for you—to choose a niche that holds both enjoyment and marketability for you. Seems like a tall order. But every successful photographer I interviewed either knew going into the business what they wanted to shoot or found that it all fell into place for them after a little thrashing about.

"Finding your niche is like falling in love," says architectural shooter Karen Melvin. "Once you find it, you know it's right."

BETH WALD: THE DANGLING WOMAN

Beth Wald created a very interesting, highly targeted niche for herself when she became a mountain- and rock-climbing photographer. She literally shoots while dangling from a rope over a 2,000-foot drop.

"It was a great time to start in this niche, because there weren't many other people doing it," she says (and I suspect that might be something of an understatement). "There were other climbers who would carry a snap shooter and take a few snapshots, but

when you're climbing you don't want to be carrying a big lens and camera body with you. I was one of the few who would take the time to set up a shot—find the right angle, the right time of day for the light."

Rock and mountain climbing were enjoying new popularity, with more and more magazines and catalogs to sell to.

It's hard enough having to think about lighting, exposure and composition on a shoot, let alone doing all this while hang-

A wildlife shot by Brenda Tharp.

ing from a rope. I wondered if Beth had ever been in danger as a consequence of combining her two passions of climbing and photography.

"Yes, I've been in danger-ous situations," she says, with-out hesitation. "Now that I'm established, when I go out on a shoot for a commercial cli-ent, I hire a rigger who sets the ropes, and I don't have to wor-ry about that aspect. But in the beginning it was hard to talk clients into budgeting for a rig-ger, so I was out there alone.

"Once I was in Nepal with a famous French mountain climber, and it was all ice. I use devices to go up the ropes—it's hard to explain to someone who doesn't climb—and these devic-es would slip on the icy ropes."

What led her into such a refined—and potentially dan-gerous—niche?

"Necessity! I wanted to figure out a way to make a living climbing—that was my

first passion. Photography became my second. I was just out of college and had decided against a scientific career—I'd studied ecology, plants, botany, because I thought it would be a great way to be in the mountains, but I discovered that was not the case. Most botanists are only in the field about one month out of the year.

"Now photography has become my first passion, and climbing my second."

She considered whether there is still a place in this narrow niche for newcomers in this unstable economic market. "It's a tough market. But I think it's incredibly important for people to get out there and create great images. There's always a place for talent."

So you need to find yourself a niche—the smaller and more focused, the better. But you also need to be flexible within the parameters of your specialty.

The business and creative models are changing constantly, so you need to be willing to change constantly, too. You must find ways to make great assignments happen. If you wait for them to come to you, you'll be waiting forever. You have to be passionate about the business and apply your creativity to it. Find new ways to get jobs, and get money to finance the jobs.

For instance, I did a shoot in Afghanistan for *Smithsonian Magazine*. The writer and I got together and pitched the story to the magazine. Magazines almost never consider proposals from writer/photographer teams—only from writers. They prefer to assign the photographers themselves. They told me outright that they'd never consider a pitch from a photographer. But we made that job happen. We had to combine several assignments to do it—*Smithsonian* couldn't afford to send us to Afghanistan. So we piggybacked a story for *Sierra Magazine*, and we got a small grant, and it all came together. So I say, "Never say never."

JIM ZUCKERMAN: A JIM OF ALL TRADES (AND MASTER OF THEM ALL!)

Photographer, author and teacher Jim Zuckerman is an exception (with a capital *E*) to the common wisdom regarding special-

izing. Jim doesn't limit himself to any particular market, subject, style or niche. A look at his website reveals images categorized by such varied heads as impressionism, conceptual, fine art, travel fantasies, natural life and people and cultures—to name just a few. He is equally at ease creating classic straight up nature shots as he is creating images that are digitally manipulated to portray dinosaurs sunbathing or unicorns rearing in front of bolts of lightning.

What's up with this, Jim? I thought we were supposed to specialize?

Most successful photographers do. I don't. I know a photographer who does nothing but shoot dia-

A blend of a botanical and a nude, this image seems to defy categorization. Jim Zuckerman calls this a "fantasy nude."

monds—he flies all over the world to do it. Another one makes tens of thousands of dollars just shooting baby clothes on a white backdrop because his clients like the way he arranges the clothes. But I shoot everything.

Should an aspiring professional photographer specialize or be a generalist?

(Reluctantly) Probably, he should specialize. Yes.

But you don't. So how, for instance, did you wind up making surrealistic images? Did you know there was a market for this?

No, I didn't. I did this series of images using mannequin heads. I was told not to shoot that, that it would never sell. So I submitted some of them to *OMNI* magazine, and they sold. They bought five covers in seven months. You see,

the deal is this. No matter what you shoot, you have to go out and market it. No matter if you specialize or generalize. Constantly! Perpetually! You never stop moving! Before websites, this was harder, because you had to literally go out and see people. I alleviated some of this by sending out proposals via the old-fashioned postal service. Now with e-mail it's even easier. And people go to your website instead of asking for your book.

You sell a lot of stock images. Is it perhaps a little easier to be a generalist in this market than, say, in assignment work?

Yes, I think so. Because when people are buying your work from a stock agency, they're not buying your name or your

An editorial image for The Minneapolis Children's Theater Company by Rob Levine.

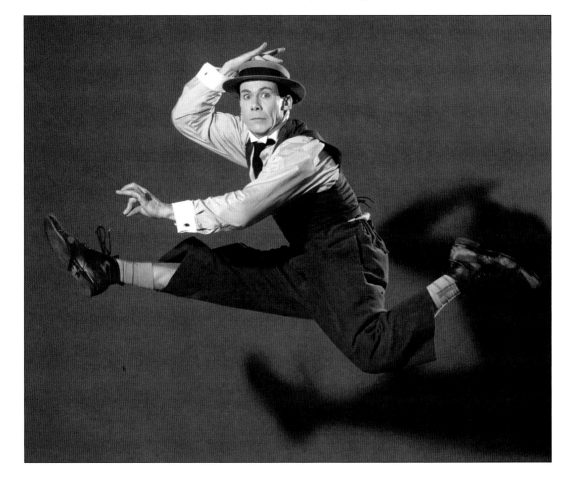

reputation, they're just buying your image. They don't care if you're a big name or a small name. They don't care where you went to school. They just want that image. That's what makes stock almost a must for new photographers. Because they're on a level playing field with established photographers like you and me.

So do you shoot what sells, or do you sell what you shoot?

I do both. I shoot what I love, but I also ask my editors (at my stock agencies) what they need. Ten years ago an editor told me they needed images of a worker fixing an air conditioner and of a lady being helped out of a limousine. So I said, "Oh, okay." So I went out and I hired models and I rented a limo and I spent a half a day and I shot it. Today, ten years later, these images still sell three to four times a month for $300 or $400. That's not bad for a half day's work!

And you didn't even have to market those!

No! That's the other beautiful thing about stock. Your agencies do the marketing for you!

JENNIFER WU: A NICHE FOR ALL SEASONS

Photographer and teacher Jennifer Wu has done a fair share of niche hopping. Now a nature photographer with a subspecialty in amazing images of stars and the night sky, Jennifer started out in photography shooting food and tabletop after majoring in photography in college.

What kinds of food did you shoot?

First, it was gooey desserts. I was eating them for breakfast! Then I got a seafood company, so that was good. I got to eat seafood. Mostly I did the styling myself, but sometimes I worked with a food stylist.

How did you get these clients? Did you market yourself specifically to food companies?

No! These jobs just came to me—they were referred to me by my school—people who were looking for students and

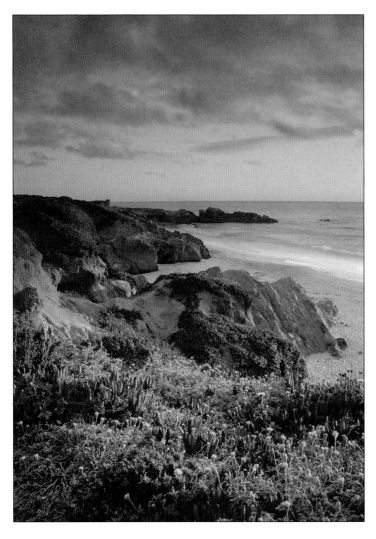

A classic landscape shot by Jennifer Wu.

former students to shoot for them inexpensively.

Did you like shooting food?
Not really. For me, there was no expression, no life to capture. So then I switched to weddings. In 1993, I shot around forty weddings.

That's a lot of weddings! Did those come as referrals from the school again?
Yes, so of course they were looking for someone inexpensive, as with the food. When I started out, I was shooting a whole wedding for $300. I knew I should raise my prices, but it was when I went to a wedding fair that it really became real—I saw photographers with booths there who charged thousands of dollars. So over the course of a year I raised my prices until a wedding was $3,000.

Wow! That's a big increase in such a short time.
Yes. It was hard at first because I felt insecure. But I was tired of working so hard for so little. I lost a couple of prospects when my prices went up but not many.

Then you switched niches again—from weddings to landscape and nature. Why did you make that change?
Because nature is so beautiful!

And you've been successful in your nature niche! Canon features one of your night sky/star images in a brochure! So which niche has been the most rewarding for you?

Oh, nature! Certainly! But the most lucrative is weddings. If someone wants to make a lot of money, I would say, "shoot weddings!"

KATHLEEN CARR: CASUAL FRIDAY MEANS WEAR YOUR HULA SKIRT TO WORK

Kathleen Carr loved photography from the time she was big enough to hold her father's Brownie camera in her hands. Yet she still didn't consider it as a profession until, as an art major in college, she took a fine art photography course—and she was hooked.

Though she worked as a photographer all over the world and even had her first book of photographs published in 1975, it took her until 1990 to really zero in on her true calling.

"Up 'til then I shot everything: events, weddings, births, portraits, dogs, horses, photojournalism, publicity, you name it. But in 1990, I was diagnosed with cancer. That made me take stock of my life. I realized I didn't want to do commercial photography anymore. I just wanted to express my creative vision. I started

A fine art image created by Kathleen Carr with a DSLR that was converted to infrared, and colored by the photographer.

out with my Polaroid transfers, which galleries picked up and sold very well. I loved the medium so much, I didn't want it to be just a passing fad. I wanted it to be a movement! So I wrote a book about it, and I put on some workshops, and they were packed! I went on to manipulated Polaroids and wrote another book. A year after that one came out, Polaroid stopped making the film. Imagine what that did for book sales!"

Just as she has done with many of her images and various mediums, Kathleen hand colors her art prints. (She works both by hand on the print and on the computer.) These days she is working heavily in digital infrared. Since this is an ethereal, finely textured look that originated with infrared film and regular digital capture can't do it, she has had two digital camera bodies converted to shoot it.

Kathleen now lives in Hawaii full-time and teaches photography online and at her own retreats and workshops, and she also leads photo tours and even swims with dolphins.

"Teaching is also a passion of mine," she says. "Working in cooperation and being of service, and experiencing camaraderie, –that's all a part of creating art for me."

A few of these brave souls forged original niches. A few went into established niches and bent them to their own will. And one, Jim Zuckerman, seems to be the exception to the rule. He shoots in a huge variety of specialties. Whatever niche (or niches) you choose to work in, ultimately your level of satisfaction and your level of success will depend very much on the amount of effort and passion you put into you work. Like most everything else in life, you will get out what you put in.

We covered the importance of finding your niche in chapter five. In this chapter we take a much closer look at the most common specialties and the requirements and expectations for each.

WEDDING PHOTOGRAPHY

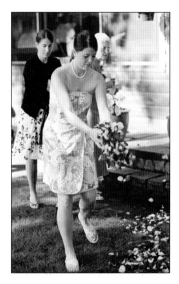

A candid wedding portrait of women scattering rose petals by Hilary Bullock.

• **LOCATION/STUDIO.** Often strictly location, although wedding photographers who have studios typically include studio engagement portraits and bridal shots as part of their services and packages.

• **COST TO BREAK IN.** Minimal compared to other specialties, since you don't necessarily need to lease and outfit a studio. You need a DSLR or medium-format camera, portrait and zoom lenses, a camera-mounted flash unit with extension cord and bracket, high-quality camera bag(s) to protect your gear with a minimum of added weight and bulk, a tripod, a computer, editing and organizational software, and a large amount of storage and backup space for your digital images. It's also a good idea to have a set of portable lights (strobes or hot lights) with stands and modifiers. This allows you to offer formal portraits as well as candid shots at receptions.

• **METHODS OF ADVERTISING/PROMOTION.** Photographers in different areas of specialty promote themselves to potential clients in very different ways. For instance, a portrait photographer might purchase a mailing list including the names, street addresses and e-mail addresses of families who fit her demographic. She might send out postcards to these families and then follow up via e-mail. Or if she wants to be green and save some trees, she might just stick to the e-mails and include a special offer and a link to her

website. A commercial photographer might rely almost solely on her website to woo art buyers, or she may have a bound, designer-created book to show prospective clients. An architectural photographer might use a combination of e-mails (but without the special offer) and website.

- **AVERAGE INCOME/AVERAGE RATES.** Income varies; flat fees for wedding, groom's dinner and reception range from $1,000 to $10,000, with the average falling at $3,500 in a medium-sized city.

- **INDUSTRY TRENDS.** As is commonly the case today, this market is crowded and soft. And yet, as long as there are weddings, there will be a demand for wedding photographers.

- **WHERE THE MONEY IS.** Partly because of the demand by clients to receive the e-files of their images and partly because of the labor-intensive nature of filling individual portrait orders and reorders from the bridal party and other friends and family, there is a trend toward offering packages that include the photographer's fee, one or more albums, one or more wall portraits, and CDs or DVDs of part or all of the images. All artwork/retouching, layouts for albums and collages, and any other additional costs are built into the package price. This can be great for both the photographer and the client. The photographer knows exactly how much she will make up front and doesn't have to fill those reorders. The client knows exactly how much she will pay, and she knows she'll be able to share images from her big day online with friends and family too far away to be there in person.

- **TYPE OF PORTFOLIO/SAMPLING OF WORK.** It's more important than ever for wedding photographers to have a strong Web presence. Photographers often hand out complimentary CDs with samples of their work. Bound photo books have eclipsed photo albums in popularity, so many wedding photographers show these at their initial client meetings.

- **PROMOTIONAL MATERIAL.** Ads in local general-interest and trade magazines, advertisements on websites such as TheKnot.com, targeted direct-mail pieces, wedding fairs.

An oceanscape at dusk by Jennifer Wu.

• **PREPRODUCTION/POSTPRODUCTION.** Preproduction may require some scouting, although once you've been in business in a certain area for a while, you become familiar with the popular churches, synagogues, reception halls, hotel ballrooms, etc. Postproduction can be very labor-intensive or very simple, ranging from batch-processing images and burning photo CDs to retouching, compiling proof books, laying out albums and producing print orders.

• **CONS.** Wedding photographers work weekends and evenings. No reshoots are possible in wedding photography, so if you make a mistake your client is stuck with low-quality images of her once-in-a-lifetime day, and that means more stress for you. Also, this work can be very physically demanding.

NATURE PHOTOGRAPHY

• **LOCATION/STUDIO.** Strictly location.

• **COST TO BREAK IN.** Start-up costs are low, given that this specialty does not require studio lights, backdrops or other related

equipment. Fixed overhead is low because you won't need a studio. Essentially all you need is camera gear: DSLR, medium-format, large-format, or a combination of these; lenses, including macro, long telephoto and everything in between; a tripod; a high-quality backpack designed specifically for camera gear; a laptop computer; editing software; and a system for storing and backing up digital images.

• **METHODS OF ADVERTISING/PROMOTION.** Nature photographers are often represented by stock agencies and galleries. Some work with photographer's reps. Many do their own pavement pounding, marketing their work to corporations, hospitals, dentist's offices and other entities that purchase wall art.

•**AVERAGE INCOME/AVERAGE RATES.** Potential income varies too much to postulate an average. Stock agencies pay $1 to $10,000 per image depending on the usage (a private individual might download an image to use on their desktop or cell phone, or a corporation could purchase rights to an image for a national or even international campaign). Greeting card and calendar companies pay $75 to $175 per image; fine art prints vary depending on the size and type of print and demand for the artist's work.

A high-key studio portrait by Vik Orenstein.

•**INDUSTRY TRENDS.** Like most other areas of photographic specialty, this field is crowded. And, just as in other fields, a higher and higher level of specialization is becoming required—while most would-be nature photographers imagine traveling the country or the world shooting exotic locales, the reality is that shooters have been forced to regionalize; for instance, Craig Blacklock, who in the 1970s traveled the country in partnership with his father, Les, shooting anything

and everything, now specializes in shooting the scenes of Lake Superior. Recent years have seen a downturn in this market. Clients once willing to pay $2,000 for the use of an image will now often use images from royalty-free CDs. There has been a slow, steady erosion of the market as amateur photographers gain access to better and better equipment. Talented hobbyists who don't need to make a living from their work will often sell an image for little or nothing just for the pleasure of seeing their image and photo credit published. Those who need to make a living from their nature photography must maintain integrity when pricing their work.

• **WHERE THE MONEY IS.** During hard economic times, the fine art market for nature photography suffers in comparison to the market for stock. But the stock field is so saturated that it seems likely the decorative and fine art market will be the place to be during economic rallies.

• **TYPE OF PORTFOLIO/SAMPLING OF WORK.** This will vary depending on whom the photographer is marketing to. Those interested in purchasing the work for decorative art may want to see finished framed pieces. Stock clients view the work on the Internet, at agency and photographer's websites. As with all photographic specialties, a strong Web presence is important.

• **PROMOTIONAL MATERIALS.** Primarily stock agency websites, photographer's websites and art fairs.

• **PREPRODUCTION/POSTPRODUCTION.** Very little preproduction is necessary since most nature photographers work primarily on self-assignment. Postproduction involves image processing; extensive organization, cataloguing and assigning key words; and creating or overseeing the creation of decorative and fine art prints, either digitally or by traditional methods.

PORTRAIT PHOTOGRAPHY

• **LOCATION/STUDIO.** Either or both. Some portrait photographers have regular retail or point of destination studios; some shoot in their homes; some go to the clients' homes and shoot editorial-style portraits of people in their daily life environments;

some go to the clients' homes with a portable studio (backdrop, lights, etc); still others use scenic locations such as orchards, rose gardens and beaches.

- **COST TO BREAK IN.** Can be as little as the cost of a consumer-grade DSLR and a portrait and zoom lens, to upwards of $50,000 for a fully outfitted retail studio.

- **METHODS OF ADVERTISING.** A strong Web presence is absolutely essential. Ads in local general-interest and parenting publications, displays in complementary retail establishments (hair salons and children's clothing boutiques, for instance), direct-mail pieces; client newsletters.

- **AVERAGE INCOME/AVERAGE RATES.** Income varies; rates range from $49 to $400 for a basic sitting. An 8" × 10" (20cm × 25cm) portrait can cost from $20 on the very low end to $200 for a hand-painted or giclee printed image.

- **INDUSTRY TRENDS.** This is another crowded market. There seem to be more editorial-style portrait photographers. The traditional in-studio posed, medium-format style is fading. One must have a signature style in order to stand out from the competition. Wall art falls in and out of favor, but photo albums and photo books are always in demand. Just as in the wedding photography market, bound photo books are gaining in popularity.

- **WHERE THE MONEY IS.** It's impossible for a small businessperson to compete at the low end of the market against national chains, so it's a good idea to position yourself in the middle to high end of your marketplace. Expectant moms and newborn babies are great target clients, because if they like your work, they will come back to you for years. To that end, specially discounted first-year baby packages have become de riguer. Offering holiday cards and birth announcements, while not very profitable in and of themselves, are another way to entice clients to shoot with you. A perk: Each card is a free advertisement if you put your logo and contact information on the back.

- **TYPE OF PORTFOLIO/SAMPLING OF WORK.** This will vary enormously, with photographers who have their own studios showing

finished, framed wall art, and those who work exclusively on location showing portfolios or proof books.

• **PREPRODUCTION/POSTPRODUCTION.** Shooting in a new location will require scouting—otherwise, preproduction is minimal. Postproduction involves processing; editing/retouching images; and printing portraits, either in-house or through a lab. Some small studios take advantage of labs that offer retouching services and thus are able to avoid the most time-consuming element of postproduction.

COMMERCIAL PHOTOGRAPHY

• **LOCATION/STUDIO.** Both.

• **COST TO BREAK IN.** This specialty can be expensive; medium-format cameras are the industry norm (a new Canon Mark VIII tops the charts at $8,000 just for the body, and digital Hasselblad models range from $10,000 to $43,000). Expect to spend $100,000 or more to build and equip a commercial studio from scratch.

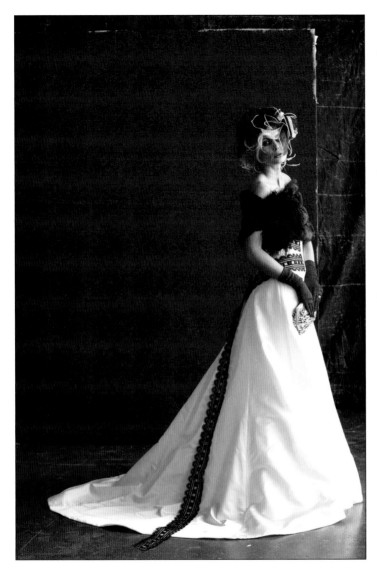

An editorial fashion image by Lee Stanford.

- **METHODS OF ADVERTISING.** Creative sourcebooks, direct-mail pieces, websites, ads in trade publications. Many commercial shooters let photographer's reps handle this.

- **AVERAGE INCOME/AVERAGE RATES.** Income varies; day rates average from $1,800 to $6,000 depending on the area and the market, though they can go much lower or much higher.

- **INDUSTRY TRENDS.** Unlike other specialties, this market has become a little less crowded. The bad economy—combined with overexpenditures on new digital equipment—has driven some studios out of business. While there are fewer shooters, there are also fewer jobs.

- **WHERE THE MONEY IS.** Resist the temptation to enter the price wars and lowball bids just to get jobs. The busiest studios right now are the moderate- to high-end ones who have stayed the course and resisted the urge to compete with the masses at the low end of the market.

- **TYPE OF PORTFOLIO/SAMPLING OF WORK.** Most art buyers use the Internet to find photographers, so a strong Web presence is mandatory. The bound book portfolios are also requested, though infrequently.

- **PREPRODUCTION/POSTPRODUCTION.** There is a lot of preproduction, or legwork, involved in this specialty. Working out the

cost estimate alone is time-consuming. Often locations must be scouted, sets built, props and accessories selected and rented or purchased, and talent cast. Sometimes the photographer even has to help the client refine or create a concept for a shoot. Established shooters farm out much of the preproduction to location scouts, casting directors, prop stylists and other professionals. Postproduction can be as simple as handing the client a CD.

FASHION PHOTOGRAPHY

• **LOCATION/STUDIO.** Both.

• **COST TO BREAK IN.** As little as $6,000 if you stick with 35mm format. Or as much as $100,000 to outfit a new studio. Identical to the costs of a fully outfitted commercial studio.

• **METHODS OF ADVERTISING.** Same as for commercial photographers.

• **AVERAGE INCOME/AVERAGE RATES.** Income varies; day rate varies depending on the market and whether the job is a commercial shoot, an editorial shoot or a shoot for a talent agency or a model's portfolio. Commercial jobs can average $1,800 per day, editorial as little as $250. Fashion shooters who shoot "head books" and/or large groups of models' composites for an agency generally give a volume discount. Models' head shots and composite shots start at around $350.

• **INDUSTRY TRENDS.** Just as with other specialty areas, fashion photographers feel the pinch in a bad economy. Unlike wedding, portraiture and architectural specialties, fashion shooters are not flooding the market. As in previous eras there are many fly-by-nights—only the tough survive.

• **WHERE THE MONEY IS.** Commercial jobs pay the most; editorial work carries a certain prestige, but the pay is typically low. Shooting head shots and comp cards for agencies and models is a great way to earn your bread and butter in medium and large markets.

• **TYPE OF PORTFOLIO/SAMPLING OF WORK.** As with commercial photography, a strong Web presence is a must. Bound book portfolios are occasionally requested.

ARCHITECTURAL PHOTOGRAPHY

- **LOCATION/STUDIO.** Location only.

- **COST TO BREAK IN.** Expect to pay $10,000 to $60,000 for equipment, including camera, perspective correction lenses, a heavy-duty tripod with a ball head, computer, software, and image storage and backup system.

An image by nature and travel photographer Brenda Tharp.

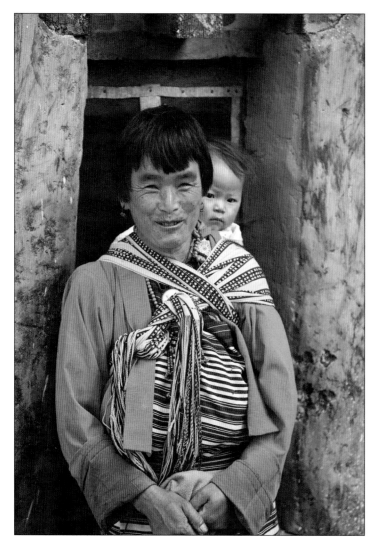

- **METHODS OF ADVERTISING.** A strong Web presence is mandatory. Methods that drive potential clients to your website are important, such as e-mails and leave-behinds (printed material with examples of your work and your contact information). In this specialty, one can still benefit from calling on architectural firms and magazines by phone and in person.

- **AVERAGE INCOME/AVERAGE RATES.** Income varies; day rates vary according to the market, the experience of the photographer and whether the jobs are for editorial or commercial clients. Generally, day rates for each type of job are similar to those charged for fashion work.

- **INDUSTRY TRENDS.** Some photographers who are newcomers to this field are successfully breaking in by shooting iconic buildings at their own cost (on spec) and selling them to the architects, designers and manufacturers involved in the project.

• **WHERE THE MONEY IS.** Commercial jobs pay the best. Market to ad agencies who represent building contractors and manufacturers of building and architectural supplies and materials.

• **TYPE OF PORTFOLIO/SAMPLING OF WORK.** Primarily websites and leave-behinds.

TRAVEL AND WILDLIFE PHOTOGRAPHY

• **LOCATION/STUDIO.** Strictly location.

• **COST TO BREAK IN.** This will depend on the format in which you choose to shoot; for most editorial work, a quality DSLR is fine, so you can get a camera body for $5,000. Expect to spend a lot on lenses—quality supertelephotos (400mm to 600mm) generally cost $6,000 to $9,000. Some photographers keep costs down by using a 300mm lens with extension tubes. Wider lenses are less expensive. You will also need a tripod, a backpack designed to carry photographic equipment, a laptop, software, and plenty of space for image storage and backup.

Taken by Jim Zuckerman, this is a travel and wildlife image in one: Giraffe Manor in Kenya.

• **METHODS OF ADVERTISING.** Strong Web presence is a must. Queries to travel publications are important.

• **AVERAGE INCOME/AVERAGE RATES.** Income varies; day rates are comparable to those for commercial and editorial work listed under architectural photography above.

• **INDUSTRY TRENDS.** Budgets are tight for editorial work, so sometimes you have to patch two or three jobs and grants together to make a trip happen. Travel assignments that once allowed ten days to complete now allow only five to six days. Magazines are asking for more and more printing rights for the same fees.

• **WHERE THE MONEY IS.** As in other specialty areas, commercial work pays better than editorial work. Stock is a viable market for travel and wildlife images.

• **TYPE OF PORTFOLIO/SAMPLING OF WORK.** The travel and wildlife photographer's best method of advertising is her website.

FINE ART PHOTOGRAPHY

- **LOCATION/STUDIO.** Usually location; some studio.

- **COST TO BREAK IN.** Varies; you could spend your whole career shooting with an analog pinhole camera made from an oatmeal box, a DSLR, a 16" × 20" (41cm × 51cm) format Polaroid or anything in between.

A classic wildlife image by Lewis Kemper.

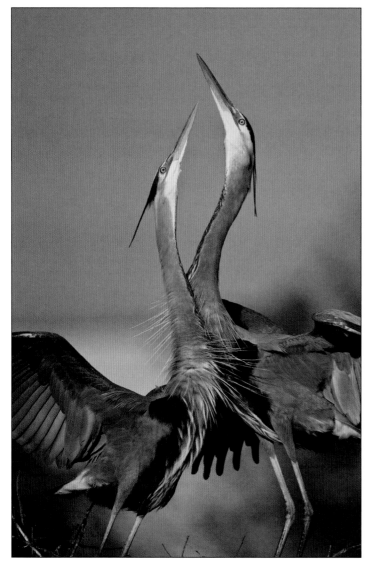

- **METHODS OF ADVERTISING.** A strong Web presence is essential for fine art photgraphers.

- **AVERAGE INCOME/AVERAGE RATES.** The average income for a fine art photographer varies too much to postulate.

- **INDUSTRY TRENDS.** Popular items are small (11" × 14", 28cm × 36cm) inches and smaller) color and black and white prints and greeting cards. Popular subjects are animals, flowers, landscapes, and macro and abstract images.

- **WHERE THE MONEY IS.** Being represented by stock agencies, publishers, brick and mortar galleries and online galleries such as Etsy.com—and marketing to commercial clients—are all ways to make a living in fine art photography.

- **TYPE OF PORTFOLIO/SAMPLING OF WORK.** Primarily websites and leave-behinds.

PHOTOJOURNALISM

• **LOCATION/STUDIO.** Strictly location.

• **COST TO BREAK IN.** A degree in photojournalism and the cost of a good DSLR, lenses, tripod and backpack.

• **METHODS OF ADVERTISING.** Since most editorial photographers work as employees for newspapers and periodicals, they don't need to advertise. They simply apply for their jobs.

• **AVERAGE INCOME/AVERAGE RATES.** Varies from market to market: You can expect a $20,000 to $85,000 income depending on the size of the publication.

• **INDUSTRY TRENDS.** Many newspapers now have websites, and on these websites they show videos. So now, in addition to shooting still photos, many photojournalists are required to shoot video, all on the same shoot.

• **WHERE THE MONEY IS.** Staff photographer for a daily newspaper in a large market.

• **TYPE OF PORTFOLIO/SAMPLING OF WORK.** Photo CDs.

• **OF INTEREST.** Photojournalism is the one area in which altering photos is strictly forbidden, so no Photoshop allowed here.

EDITORIAL PHOTOGRAPHY

• **LOCATION/STUDIO.** Mostly location. Occasional studio work.

• **COST TO BREAK IN.** Same as photojournalism.

• **METHODS OF ADVERTISING.** Most freelance editorial photographers start out by building their body of work with self-assignments, and showing their work to editors and art buyers. Websites and leave-behinds are the primary form of self-promotion.

• **AVERAGE INCOME/AVERAGE RATES.** Varies; national magazines pay about $400 for a day rate, and newspapers $250 or less.

• **INDUSTRY TRENDS.** It can take a while for an editorial photographer to establish herself and become recognized, but this

is a specialty where talent and persistence are your greatest tools for success.

• **WHERE THE MONEY IS.** Not here. Just kidding! Often editorial photographers must finance their first project themselves. After they have a body of work, they may apply for grants and/or publish their work in books and/or periodicals. They also may be represented by a gallery or galleries for the sale of their work as fine art prints.

A stock photo by Kerry Drager.

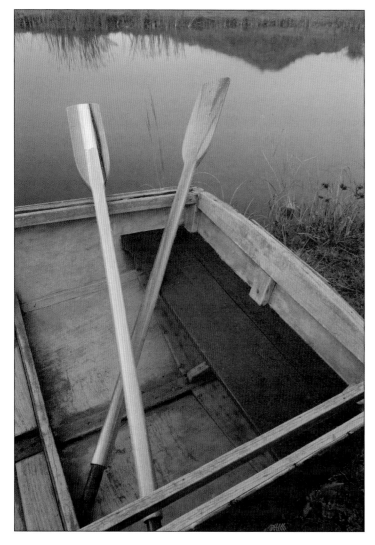

• **TYPE OF PORTFOLIO/SAMPLING OF WORK.** Websites and photo CDs.

• **PREPRODUCTION/POSTPRODUCTION.** Much time is spent writing grant applications and researching special subjects and projects. Postproduction usually involves image processing and editing, and creating or overseeing the creation of prints, books and distribution of images.

STOCK PHOTOGRAPHY

• **LOCATION/STUDIO.** Both.

• **COST TO BREAK IN.** Varies depending on whether you need a studio or shoot strictly on location, whether you use studio lighting and what type, and in what format you shoot. To break into stock photography you need a DSLR camera, a variety of lenses, a computer, software, and image storage and backup system.

A botanical image by Jim Miotke.

• **METHODS OF ADVERTISING.** Typically stock photographers are represented by one or more stock agencies, and the agencies promote their clients' work.

• **AVERAGE INCOME/AVERAGE RATES.** The average income for stock photographers in 2006 is listed as $12,000 to $50,000, according to various surveys. Individual images can sell for as little as $2 to as much as $20,000, depending on the usage and the client.

• **INDUSTRY TRENDS.** Both the Internet and digital image management systems are making stock photos more widely available than ever before. There's a new market in "mini stock" agencies, such as iStockphoto.com, which sell royalty-free images for as little as $1 for small files. In the past, a stock photographer needed to build up a considerable body of work before being accepted into an agency. While this is still true for agencies such as Corpus and Getty Images, there are newer Web-based agencies such as Alamy.com that accept as few as one image.

• **WHERE THE MONEY IS.** Commercial clients are most likely to use images repeatedly and in multiple markets, so typically they buy the most rights and pay the highest rates. Avoid mini stock and royalty-free agencies, as it's hard to make a living at $1 an image!

• **TYPE OF PORTFOLIO/SAMPLING OF WORK.** Some stock agencies, like Alamy.com, allow photographers to simply upload their images to their websites and if the images pass quality control inspection, you may make them available for sale.

• **PREPRODUCTION/POSTPRODUCTION.** Often stock photos result from self-assignments and require little if any preproduction; postproduction involves highly detailed methods of organizing, cataloging, keywording and storing images.

OTHER PHOTOGRAPHERS

There are many reasons to join a community of photographers: to network, shoot the breeze, commiserate, compare notes, share technique, battle creative slumps and to establish and maintain industry standards, to name just a few.

REFERRALS

One of the biggest ways my colleagues and I help each other is by trading referrals. This is especially important now that many of us have become very specialized. For my portraits, I shoot only black-and-white film and offer only high-end archival

A travel image by Jim Miotke.

pieces. I strictly do black- and-white, sepia or hand-painted portraits of kids, their families and their pets. No corporate head shots. No events.

Frequently I get calls from clients wanting a service or product outside of my specialty. Requests for weddings, model composites or product shots are common. In the past, I tried to accommodate these requests myself but was often less than happy with the results, preferring ultimately to work only within my limited specialty. So it's a great boon for me to know professionals who I'm proud to refer my clients to. And it's always nice to get a referral from one of my colleagues, of course.

MENTORS

Almost every successful photographer I've ever known has credited their success in part to the generosity of a more established shooter who helped them learn the ropes. There's no law that says an old dog has to teach a new dog his tricks. And there can be some risk in-

An editorial image by Stormi Greener.

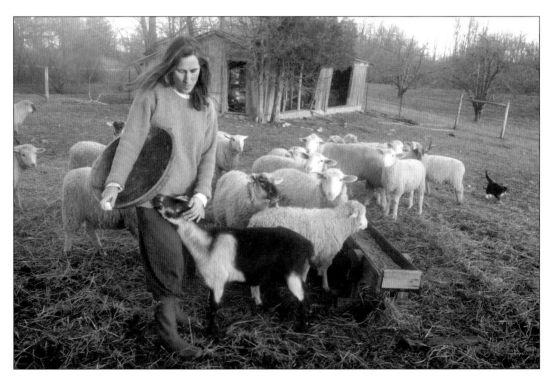

volved if the protégé turns into an upstart who runs away with part of the mentor's market. So why do it?

"It's for the joy of it," says Jim Miotke.

"It's a natural part of the life cycle," says Jennifer Wu. "You're born, you learn, you teach, you die."

PROFESSIONAL TRADES

I've traded shoots and offered and received shoots and prints at a discount from my colleagues. I received a beautiful art print from a nature photographer in exchange for shooting his family. I've done portraits for a wedding photographer in return for shooting my wedding.

EQUIPMENT SAVVY

Whenever I've needed a new piece of equipment, especially when it comes to new technology with which I'm unfamiliar, I ask for the inside scoop from my photographer friends. A commercial shooter taught me everything I needed to know about digital capture, researched the systems from me and helped me choose which one to buy. A fashion shooter taught me how to use strobes, an architectural shooter taught me about hot lights, and a photojournalist taught me that it's okay (and sometimes even desirable) to use mixed light sources.

In turn, I've helped some medium-format junkies break their addictions to fine grain and tripods; I've taught a commercial shooter how to get two-year-olds to stand in one spot for a 250th of a second; and I've shared my somewhat paltry knowledge of digital capture with a fellow film lover whose digital knowledge was even more paltry than mine. What goes around really does come around.

INDUSTRY STANDARDS

American Society of Media Photographers (ASMP) offers a book detailing industry standards for billing, determining usage fees and other practices. The book is invaluable. But ASMP, the society, didn't institute these standards. Individual photographers,

the guys in the trenches, created them. Industry standards continue to evolve as technology, the economy and our markets change. By networking with fellow shooters you can help create the standards.

CLASSES AND SEMINARS

Classes and seminars are good ways to meet other photographers. In addition to picking up some great ideas over the years, I've also met and remained in contact with several photographers this way.

CONSULTING

If you're going into a new specialty, making the transition to digital or hitting a marketing slump, you may need more than the casual assist that a colleague or a mentor can offer. You may need a hired gun. I've both worked as a consultant for other photographers and hired other photographers to consult for me. It's a way to significantly shorten up your learning curve when you need knowledge and you need it fast.

INTERNET CLUBS AND DISCUSSION GROUPS

Joining an Internet discussion group allows you to network with your brethren from all over the globe. You can put a technical, creative or business question out there and receive twenty different (and often excellent) responses from twenty different individuals in a very short time.

TALKING SHOP

Networking with colleagues allows you to check the pulse of the business. You can find out if others are slow or busy and whether they're sensing any new trends or having success with new equipment and technology.

You can also commiserate with those who understand your experiences. I try not to be negative, but sometimes I just need to do

a little venting and having an ear from a person who knows what you're talking about is a wonderful thing.

You can also use the grapevine to find out about studio management software, good vendors and labs, and studio sales where you can pick up used equipment for pennies on the dollar.

You can compare business practices, get the name of a good lawyer or accountant … you get the idea.

Some shooters are afraid to network for fear of having their clients, ideas or business practices stolen. And yes, it does happen. But in my experience, the gains far outweigh the losses when you share your time and expertise with your fellow photographers.

CROSS DISCIPLINE TRAINING

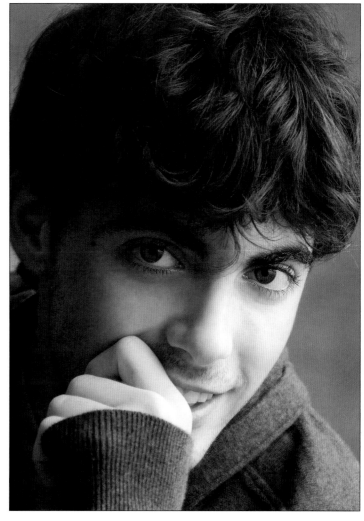

A senior portrait by Vik Orenstein.

I'm a portrait photographer but most of what I know about lighting I learned from architectural photographers, and my philosophy of photographing kids comes from a style prevalent among fashion photographers in the early 1980s. One way to develop a distinct visual style is to do things differently from the way your competitors are doing them, and you don't need to roam far afield or be intentionally clever or contrived to create a new look. All you have to do is pick and choose from established traditions in other photographic specialties. Networking makes finding new perspectives easy.

A portrait by Vik Orenstein.

HOW TO START

If you've never networked before, it may seem a little daunting. Many of us dislike asking others for their time or knowledge.

- **BE SPECIFIC.** I'm much more likely to take time out of my schedule to talk to a peer if she's specific about what kind of information she's looking for. For instance, I'm unlikely to go out of my way to meet with someone who just calls up and says, "I'd like to pick your brain about photography." But if someone calls and says, "I'm at the stage in my business where I'm forced to decide whether to scale back or expand my studio space and take on more employees. Since you have experience with this, I was hoping we could meet and discuss the pros and cons."

- **HAVE SOMETHING TO TRADE.** If you're looking for marketing ideas, for instance, you might say, "Hey, I have some

promotions I've been using with some success, and I was wondering if we might get together and bat some marketing ideas back and forth."

- **TELL THEM WHY YOU CHOSE THEM.** You're more likely to get results if you tell your colleagues why you chose them to speak with rather than appearing to have picked them out of the phone book. Say, "I've seen your work and I love your use of color, and that's why I'd like to ask you about your creative technique." Or, "I really admire what you've done with your business, and I'd like to hear your ideas on how to sell."

- **FOOD IS LOVE.** It's human nature—we feel more comfortable and relaxed when we break bread with someone than in any other setting. So suggest lunch, or even coffee. And pick up the tab.

PROFESSIONAL ASSOCIATIONS

As I've mentioned in previous chapters, I highly recommend you join your local chapter of ASMP or Professional Photographers of America or one of any number of other great organizations. You're looking for colleagues to network with. This is a way to find a whole room full of those who are primed and ready to talk shop. And don't just join—go to the meetings!

YOUR NEIGHBORS

In the first years of my career as a photographer I was lucky enough to have my studio in a warehouse building that was also home to tens of other photographers in different disciplines. When I was just starting out, I rented studio space on an as-needed basis from a commercial photographer, and he taught me all about medium-format equipment. All I had to do was go across the hall when I needed to borrow a sync cord (the photographer's equivalent of a cup of sugar). And when a client pulled a fast one on me and brought a reflective product to a shoot that was only supposed to involve kids, I excused myself, went up two flights of stairs and got a quick lighting lesson that allowed

me to do the shot unfazed. In turn, I helped a fashion shooter keep an uncooperative four-year-old girl on a white seamless background and get her to pose and laugh. (I stuck a raisin to the bottom of her foot and told her to say "diaper head.") Look around—there are no doubt photographers nearby who would be happy to network with you.

YOUR BLUEPRINT FOR SUCCESS

A business plan is, essentially, a document that describes your business; describes your market and how you intend to position your business within that market; and projects your operating costs. It also illustrates how many goods and/or services you have to sell (and at what price in order to make a profit), who will be your clients, how many clients you need at a specific average sale to sell enough goods and services to retire young on Bikini Island, and how long it will take to get those clients.

WHO SHOULD HAVE A BUSINESS PLAN

Almost all the photographers I interviewed agreed that everyone should have a business plan—and not just when you're starting out. I do a yearly business plan for each of my studios, and a five-year plan just for kicks and giggles. The plans are like a weather forecast—the further into the future they try to predict,

Maria Mosolova specializes in photographs of flowers and sells her images through several stock agencies and her website. Her business entity is a Sub-S corp.

the less accurate they are. But they aren't written in granite. I change mine when unforeseen challenges, like economic upheavals, occur.

"Who doesn't benefit from knowing what their profit margin is or needs to be? Or from knowing their market? Or from knowing exactly what their fixed overhead is? Anyone who starts a business without this stuff is foolhardy," says commercial shooter Patrick Fox.

I operated as a sole proprietor under the name KidShooters Portraits then KidCapers Portraits for 17 years. Ultimately I switched to a limited liability company.

All right, so everybody should have one. But what exactly goes into your basic business plan?

THE ELEMENTS OF A BUSINESS PLAN

1. The Name of Your Business
2. Your Mission Statement
3. Your Target Market
4. Your Products and Services
5. Your Fee Structure and Price List
6. Your Business Entity
7. Your Marketing Strategy
8. Your Financial Projections

Each of these elements is important to your business plan, and they all should be included in your document by the time you are finished creating it. But there are no rules about where you have to start. I often begin with an idea for products and services, choose a desired price point, then figure out my cost of goods (to see if I can offer the product at my desired price point). Then I determine my target market, and the rest falls into place. Often for me,

the name comes last. But frequently photographers start with their name—in fact, many select a name long before they decide to make their fantasy business into a reality. So start with whatever element you feel most strongly about and build from there.

YOUR NAME

Probably one of the first things you started to think about when you decided to go pro was what you would call your studio or business. It's fun to fantasize! But choosing your name is a very serious endeavor.

Check out other photographers in your market who work in your area of specialty; sometimes there are unwritten industry rules or standards you need to adhere to in order to be taken seriously. In Minneapolis, for example, commercial, architectural and upscale wedding photographers generally use their name and the word *photography*. For example, "Lee Stanford Photography," or "David Sherman Photography." You won't be taken as seriously if you call yourself "Jane Doe Photo" or "Doe Photography and Design." You might be able to get away with "Doe Studio," but that's pushing the envelope. So find out what the standards are in your market.

If you're a portrait or other retail studio, you have a lot more leeway. You can have a little fun when you're coming up with your name. But there are still a few rules to consider.

"First and foremost, your name should tell people what you do," says expert marketer Howard Segal. "Don't make them guess. You want your name to reinforce your product and your image."

I know from personal experience just how right he is: In 1994, I named my first retail portrait studio "Tiny Acorn Studio." The problems were immediately obvious—no one knew what we did. "I thought you were a frame shop," was a remark I heard often. A lot of people thought I ran a day care center. To me, *studio* meant photography, but to the clientele, it was synonymous with *art* and *gallery*."

So I changed the signs to read, "Tiny Acorn Portraits," took the little acorn off the logo and inserted a little camera instead. That helped people figure out what we did. But the problems didn't end there.

"We looked you up in the phone book and we called information, and 'Little Acorns' isn't listed anywhere," I was told. It hadn't occurred to me that "little" and "tiny" were totally interchangeable in many people's minds. But it was too late to do anything about that—changing the name of an established business should be done only under very extreme circumstances.

You also want to make sure your name of choice is timeless. Certain words and phrases will mean the same thing forever. But some slang terms come and go just like skirt lengths and what sounds hip or trendy today may sound trite or foolish tomorrow. For example, in 1988, the first supermodels were making the scene. Fashion terms, like "photo shoot" were very much in the pop lexicon. So when I called my new studio "KidShooters" in 1988, the name held no negative connotations. But as the years passed and school yard shootings became commonplace, some people started to flinch when they heard our name. After the tragic Columbine School shooting, we simply couldn't hold out any longer. We changed the name to KidCapers Portraits. We made an enormous effort to maintain continuity through the name transition, but to this day people still tell us, "Oh, you used to be Kid-Shooters? I thought you guys went out of business." Ouch! Those are not words a small business owner wants to hear.

So take your time and consider carefully before you commit to a moniker. It should say exactly what you do, it should be unambiguous and it should be short and sweet. Because hopefully you're going to have to live with it for a long time. What's in a name? Maybe not everything, but almost.

YOUR MISSION STATEMENT

Your mission statement is a synopsis of your entire business plan. It should be very short—one or two sentences—and should describe what you plan to do and how you plan to do it. It should be written in the present tense. It should include a description of what sets your business apart from all similar businesses. Here are some examples.

Stanley Kowalski Studios specializes in fine art hand-painted selenium-toned gelatin prints of streetcars in a high-end retail setting. We serve serious art collectors in the San Francisco Bay area at

our retail gallery and the world over on our website. *We hold our streetcar photos to a higher level of permanence and artistic integrity than any other streetcar photo studio and offer them at lower prices than our competitors.*

Goofy Goose Children's Studio specializes in white on white portraits of babies and toddlers, providing affordable portraits and photomurals to families in Minneapolis and St. Paul. *We are the only area studio to offer room-sized portrait murals and in-home design consultations.*

YOUR TARGET MARKET

Your business plan should state exactly who your target client is. For instance, if you're opening a studio specializing in high-end wall portraits of children and pets, your client profile would go like this: Families with children 0 to 16, average income of $150,000-plus,

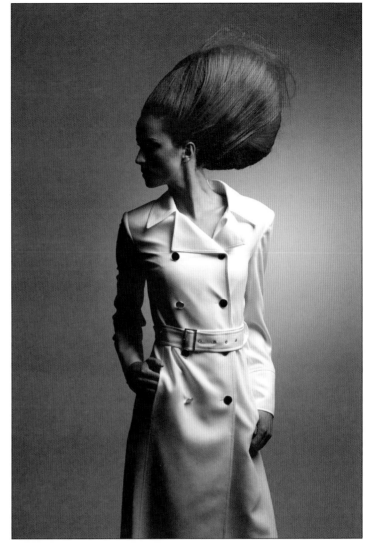

Fashion photographer Lee Stanford's business entity is a Sub-S Corp.

living in the northwestern suburbs, kids in private school, drive SUVs and so forth. If you're selling moderately priced small prints, your client profile might go something like this: Families with children ages 0 to 10, average income $75,000-plus; living within a 4-mile radius of studio, avid scrap booker or archiver, etc. The more targeted your client profile, the more successful your marketing efforts will be.

Not sure who your target market should be? That's okay. Much of this plan is speculation at this point. Make your very best guess based on diligent research and logic, then throw in a little

Nature, travel, and wildlife shooter Lewis Kemper operates as a sole proprietor.

optimism and a dash of realism, and know that you'll be changing your business plan six months to a year after you become fully operational to reflect the reality of your business.

YOUR PRODUCTS AND SERVICES

Your business plan should detail the products and services you intend to offer, and it should illuminate the special qualities that make these different from those already in the marketplace. Will your products be less expensive? More innovative? Of better quality? On different or better media or materials? What attributes will make people want to purchase your product over those of your competitors?

Will you offer more or better services, such as home delivery, framing design, free home décor consultations, custom sets or wardrobe, on-site shoots or faster turn-around, just to name a few?

YOUR FEE STRUCTURE AND PRICE LIST

Your business plan will include your fee structure: *How* and *when* you charge for your goods and services, and your price list—*how*

much you charge for your goods and services. This is covered at length in chapter nine.

Fee structure and price list are essential elements in every business plan because they lay out exactly when and how much you will be paid for your products and services, thus allowing you to project cash flow and to anticipate whether your prices allow you to cover your expenses—with the ultimate goal of having something left over for yourself!

YOUR BUSINESS ENTITY

When you go into business, you choose what type of legal entity your business will be. This will determine a variety of important variables, such as how and when you pay your personal and/or business taxes, how and when you pay yourself, what your exposure or liability is in the event someone gets injured at your studio, and more. You need to have a serious sit-down with a tax accountant or a tax attorney who can advise you as to what business structure will benefit you most. Often your tax expert will have a computer program that will project your earnings in a variety of scenarios, so you can compare them directly.

1. **SOLE PROPRIETOR:** A sole proprietor is also referred to as an "op-as" for "operating as." Joe Johnson owns a retail studio called Peek-A-Boo Photography. He has no separate business entity set up—no corporation, no LLC. So Joe is known as "Joe Johnson operating as Peek-A-Boo Photography." Joe is personally liable for any and all debt his studio incurs, and if anyone ever gets hurt on his leasehold property he is liable for that, too.

2. **LLC (LIMITED LIABILITY COMPANY)**: Joe still is a sole proprietor—he hasn't acquired any partners or investors, but he's starting to worry about liability issues. He's not planning on any financial shortfalls, but it's wise to be protected. So Joe becomes "Joe Johnson, President, Peek-A-Boo Photography, LLC. Now he is not personally liable for most debts or lawsuits filed against his portrait studio. Just as if Joe were still a sole proprietor, he pays no corporate income tax. Instead, all the profit passes

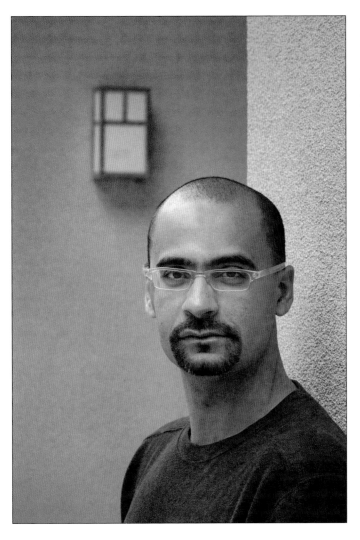

This photo is by Ibarionex Perello who founded Alas Media with several partners. Their business is an LLC.

through the LLC and is taxed as Joe's personal income.

3. **LLP (LIMITED LIABILITY PARTNERSHIP)**: Similar to an LLC, but it allows limited liability for more than one owner.

4. **GP (GENERAL PARTNERSHIP):** A general partnership is like a sole proprietor or op as, but instead of one owner there are two or more. There is no limited liability—all partners are personally responsible for the debt and actions of all other partners.

5. **SUB-S CORPORATION:** This entity is a hybrid of corporation and partnership—the tax implications are the same as for and LLC or LLP, but personal liability is limited and the corporation has shares of stock which can be sold to investors or divided among the owners.

6. **CORPORATION:** Corporations must pay corporate income taxes. They provide limited liability for owners and agents, and require a board of directors.

Please note that these are only the most rudimentary descriptions of various business entities, and before you hang out your shingle or enter into a lease or any kind of partnership or investor agreement, you should consult a business law attorney. Many new business owners are intimidated by the idea of consulting an expert on this topic or are unwilling to spend the money on their professional fees. By default, they often set

themselves up as a sole proprietor, but this isn't necessarily the best option.

YOUR MARKETING STRATEGY

A key element of your business plan is your marketing strategy. It outlines in detail the ways in which you intend to attract customers and build a client base. Successful marketing is a huge factor in your ultimate success, and having a plan for how to go about it will help keep you on task as you start your business. We cover marketing techniques in detail in chapter fourteen.

YOUR FINANCIAL PROJECTIONS

Your financial projections will help you learn approximately how much money you will need to get your new business started, how much your expenses will be, and how many clients and what size average sale you will need to pay those expenses (and ultimately pay yourself).

Projected Start-Up Costs

"All right," you're thinking. "Sure, it sounds like a great idea to lay out all these details in advance. The only problem is, how am I supposed to know what my start-up costs will be when I haven't started up yet? I have no idea how much it costs to install a business phone line, or whether I will need one line or two. Will I buy a copier/fax machine or run to the corner to Mail Boxes Etc., when I need to fax or copy something? Will I need one computer or two or three? Cable or DSL? Do I need a 50mm 1.4 lens for $300, or can I get by with a 50mm 1.8 for $125? Will I need to stock paper, ink, frames or packaging? How much does an ink cartridge cost, anyway?

I know it's daunting, but you have to start somewhere! Call some phone companies and find out what a business line costs. Start with one—you can always add another later.

Hold off on the fax machine/copier until you know whether you'll use it. Start with one computer—if you get busy enough to need another, that's a good problem to have! Spring for the

Freelance photographer and writer Kerry Drager is a sole proprietor.

cable—it's fastest. Go for the good lens because equipment is one area you shouldn't skimp. Don't stock anything, just buy what you need as you go along. Otherwise the money you save buying in bulk will be miniscule compared to the money you waste on stuff you'll never use (if you don't believe me, come over and see my collection of odd-sized mismatched stationery and envelopes, ink cartridges that don't fit any of my printers, and two inadequate all-in-one fax, scanner, copier printers).

Consider all one-time costs: incorporation fees, trademark expenses and name filing. If you plan to rent a studio, include possible build-out and moving costs.

If you don't know what something costs, find out. Not knowing is no excuse. Get on the phone and on the Internet. When making these projections you want to start out with as much knowledge as possible. When you're forced to guesstimate, lean toward the high end. It's always best to be conservative. You want to be surprised at the end of the year with a bigger income than you expected—not a smaller one or a deficit.

Fixed Overhead

The category of fixed overhead includes costs that you have to pay regardless of whether you sell anything in a given month or not. Studio rent, utilities, phone system, cable or DSL fees and business insurance are the big ones. Depending on your specialty and your business and creative methods and what services you provide, you may have more or fewer expenses in this category.

Cost of Goods (COGS)

This category includes every expense that goes into creating your product. For example, lab fees or paper and ink costs to produce hard-copy proofs; CDs or DVDs to provide clients with e-files; photographic printing including any lab charges, shipping and packaging; your travel expenses (including your mileage) in the event that you shoot on location. After you've been in business for six months you'll be able to look at your records for a more exact figure for these expenses.

Pass Through

This category includes ongoing expenses such as office supplies, postage, stationery, marketing and promotion, continuing education and workshops, and association dues.

Paying Yourself

Remember that your time has value. I have known small business owners who think they're operating in the black, just because they don't factor in their own time on the job. They're netting $25,000 a year, but they're working twenty-seven hundred hours. That means they're making only $9.25 an hour, without even taking into consideration self-employment tax or the lack of benefits such as medical insurance that you'd typically receive at a "real" job. It's an easy trap to fall into: When you first start your business, you're necessarily planning on making little or nothing during the first one to two years. You need to set your expectations low so you can plan to meet your financial needs with other funds while your business is getting established. But at some point, you need to start figuring your own time as an expense, along with all your other operating expenses.

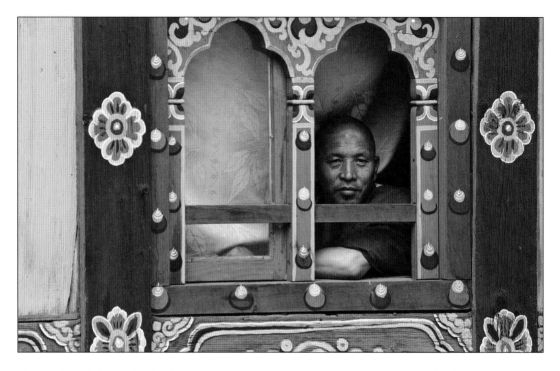

Nature and travel photographer Brenda Tharp is a sole proprietor, but plans to switch to an LLC.

The way the government categorizes the funds you pay to yourself varies depending on the type of entity you are. A sole proprietor, for instance, basically pays all her expenses and then keeps whatever money is leftover. An owner of a sub-S corporation is required to draw "a reasonable salary," and then receives the balance of the company's revenue as "profit." This is the way the IRS insures that you pay withholding taxes. Because the rules vary so much for disbursement of profits, it's even more important to enlist the guidance of a CPA and/or a business attorney before you write yourself a paycheck or take a draw from your business account.

INVESTORS, PARTNERS AND VENTURE CAPITALISTS

Your business plan should indicate whether you have solicited or intend to solicit partners, investors or venture capitalists, and spell out exactly what their involvement and compensation will be. There are many different types of partners and investors, and different ways to attribute ownership of the business and compensa-

tion. It's important to get it all in writing in as detailed a manner as possible. Advice from a business attorney is a must if you are considering bringing others into your new business.

One question I am frequently asked is, "How do I know if I need a partner or investors?" My advice is to never take on a partner or an investor unless they are bringing something new to the table. In other words, they should have something to contribute that you don't. If you have time and talent and you think you can run a business, but you have no money, you might want to consider bringing in a silent partner. If you have talent and money but no time, you might want to bring in a partner with business and people skills who can run the business so you can just shoot while she does every-

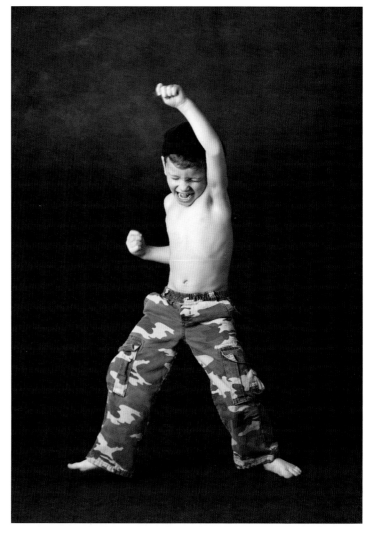

Chris Darbonne owns and operates Darbonne Photography, a retail portrait studio specializing in children and families. Her company is an LLC.

thing else. You don't need anybody who can already do what you do. If you're a shooter, you probably don't need another shooter. If you have money, you don't need an investor. You need to figure out what you are willing and able to do, and bring in another party (or parties) only if you are unable to do everything necessary to get your business off the ground. If you do decide you want to court partners or investors, your business plan will be a key tool for doing this.

I know this is a lot of work, and it is tempting to skip this part and just start shooting. But building your business plan is more than just an exercise, and it's more than just a guessing game. It

THE BUSINESS PLAN

can be an invaluable tool to get your business started on the most successful foundation possible.

AVOID UGLY SURPRISES

A business plan can help you avoid ugly surprises after you've already invested time and capital to start up your studio. For instance, let's look at my Tiny Acorn Studios. I had been in business for five years, and the stores were bringing in a healthy gross, but the net was less than I would have liked. Never having had a business plan, I thought that to start writing one after five years seemed a little like closing the barn door after the horses were gone. But I wanted a better picture of what was going on than I could discern from the quarterly reports from my bookkeeper. So I sat down to do a partial business plan: I wanted to find out what my average sale per client was for my break-even point, what my average sale was currently and what it would have to be in order for me to create a healthier net or profit margin.

BREAKING IN:
STARTING A NEW BUSINESS

Your very first step in starting your new business should be to go to the U.S. Small Business Administration website: www. sba.gov. They have a wealth of information on every aspect of small business from the planning stage on through to your exit strategy. Your next step should be to enter "starting a small business" along with the name of your state in your search engine. Most states have free guides to setting up small businesses, along with other resources including such things as low-interest loans. When searching, look specifically for government sites and avoid sponsored sites (the ones that appear at the top of the page highlighted in yellow boxes that run down the right side of the page). Sponsored sites will often charge you for information you can get free from your Department of Commerce.

Generally, the first thing you'll apply for will be your state business tax I.D. number. This number will allow you to purchase anything you resell without paying sales tax, as your client will pay the sales tax to you after they receive their goods, and you will then pay it to the state.

UNDERSTAND SALES TAX

You can wind up paying too much sales tax if you don't have a business tax I.D. number, or if you don't use it. This was perhaps the second most expensive mistake of my business career. I purchased film, paper, chemicals and other supplies from several local pro photo stores in Minneapolis. These supplies went into the making of my portraits, which were sold to my clients, the end users. I wasn't required to pay sales tax on these items. But as usual I wasn't paying attention, so I paid the tax anyway. Eventually, one of my vendors suggested I fill out a resale tax-exempt certificate and stop paying unnecessary taxes. That guy saved me tons of money.

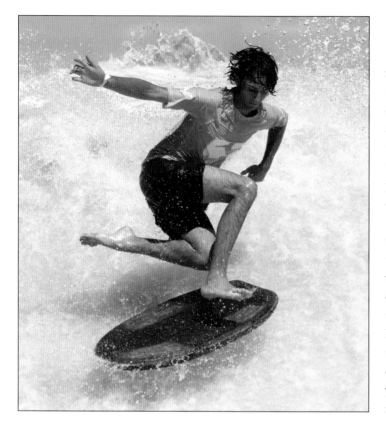

So, if you haven't already, file with your state for a business tax-exempt number. Then contact all of your vendors and ask for resale tax-exempt certificates. The vendors will keep these certificates on so you can purchase items for resale without paying sales tax.

Commercial and architectural photographers often find themselves in the vendor's role when dealing with ad agency clients (who resell photos to their end users). Be sure you keep resale tax-exempt certificates on file for them. Otherwise, if you are ever audited, you may have to pay a fine even if they hold tax-exempt status.

"Fierce Competitor" by Donna Pagakis.

UNDERSTAND USE TAX

I've made a lot of mistakes in my fifteen years in business, most of them of the, "Oops, oh well, life goes on," variety. But my most expensive—and therefore most memorable—mistake involved a little thing called "use tax." On the form that I fill out every month when I pay my sales tax, there is a line for "use tax purchases." I had no idea what it meant, so I blissfully assumed it didn't apply to me. For years I left the line blank. Then one day, I got a call from the Minnesota Department of Revenue: I was being audited by the sales tax division. No problem, I thought. I charged my clients and paid the state the proper sales taxes. That was when I found out what "use tax" is. When you purchase merchandise from out-of-state sources by phone, Internet or mail, they don't charge you sales tax because you are supposed to pay the sales tax in your home state. That's a use tax. (Use tax is figured at the same rate as your regular state sales tax.)

For years I'd been buying almost all my equipment, art supplies, props and other miscellaneous items via mail order, from companies in other states. These purchases over the course of those years totaled in the tens of thousands of dollars. Once the tax I owed, plus the penalties were tabulated, that little oversight wound up costing me thousands of dollars.

And it didn't stop there. I also did business with a local printer who created all my printed material. Some of the material—holiday cards, for instance—was resold to my clients, so I wasn't required to pay sales tax to the printer for those. The end user, my client, paid that. But this printer also did my stationery and some promotional pieces—items of which I was the end user—and therefore I should have paid the sales tax on these. But he assumed it was all for resale and never charged me sales tax, and I never paid any attention to his invoices. (I'm a photographer, not a businessperson, remember?) So there was another boatload of sales tax and penalties for me to pay.

Commercial photographers can also wind up in trouble when they don't charge their clients sales tax if the client is the end user. What is the moral of this story? Pay the state and charge your clients sales tax as required by law. Don't assume any lines on any forms don't apply to you. If you don't understand something, check with the appropriate government agency and have it explained. Yes, you will spend a lot of time getting to know your search engine or on the telephone on hold. But it'll save you money in the long run.

HAVE A RECORD-KEEPING
SYSTEM THAT WORKS FOR YOU

I don't know anybody who ever says, "Oh, goodie, I get to organize my files now!" And photographers are probably more challenged in this arena than most. So you need to give yourself a lot of help.

• **USE VISUAL CUES.** You're a very visual person, remember? So use visual cues, such as color and tab placement, to make it easier on yourself. For example, I put all my vendor invoices in blue files and put their tabs all the way to the right. My leases, rental invoic-

es and everything else that pertains to my spaces are in blue files, with their tabs all the way to the left. Banking-related documents: red file, center tab. And so on.

• **BE CONSISTENT.** Always keep your files in the same place. This might sound basic to some of you, but you'd be amazed at what some of the offices of photographers can look like. They're working on a file, so they take it to their desk or their couch or their copier, set it down to go do something else, leaving it there. Pretty soon something else gets laid on top of it, and something on top of that, and so forth, and suddenly the file is MIA. Depending on the depth of the stack, you might not find that file again until you retire and hold a going-out-of-business sale. So my rule of thumb is this: Always keep your files in the same drawers of the same filing cabinets when you're not using them. After you use them, put them back.

• **KEEP IT IN PLAIN SIGHT.** I subscribe to the old adage "out of sight, out of mind." So I keep everything that needs to be filed in an "in" tray on my desk, where I can't ignore it.

• **SCHEDULE A REGULAR TIME TO FILE AND ENTER RECORDS.** If you stay current with your record keeping and filing you'll avoid those nasty pileups that take days to sort out, and you'll never lose a file. I file once a week, every Friday evening before I leave the office. Once a day would be better. I record credit card batches, sales logs, framing logs, etc., every day. It's a lot like flossing. It's easier to remember to do it if you make it an everyday habit. And it's essential to your business.

• **KEEP LEDGERS AND LOGS.** Whether you keep your ledgers and logs on computer or the old-fashioned way—written in books—or a combination of the two, you should always keep your information absolutely up to date. This means when you make a credit card transaction, you should record it immediately if not sooner. It's a real bear to go backwards from your batch receipts and re-create the day's transactions. When you get your report from your credit card server at the end of the month, reconcile it the same day you receive it. Bank statements—same thing. The longer you

wait to update your logs, the longer you will have to spend entering the information once you get around to it.

And I always have redundant systems built into my record keeping. The client's name and phone number go into the computer on the mailing list, onto her invoice and next to her appointments in our schedule book. Credit card transactions are recorded in a credit card transaction log and in the client log. It takes a little longer, but it saves time when there is a question regarding a payment and you need to go back and look it up.

THE TAX MAN COMETH

Paying your income taxes is a whole new experience when you're self-employed. Kiss those handy little 1040 forms good-bye. You've entered the world of itemizing, of depreciation, of mysterious column *A*'s that you add to column *B*'s and subtract from column *C*'s. The first year of my business I was determined to do my own taxes. I sat down with the form for a short while before I put my tail between my legs and ran whining to a CPA who specializes in small businesses. I felt silly going to a professional accountant for my piddly little $38,000 gross studio, but, boy, am I glad I did.

My accountant, Jim Orenstein (no relation) was able not only do my taxes but to act as an advisor on such issues as disability and life insurance, whether or not to incorporate, and when

"Cardinals" by Judy Kennamer.

and how to expand. He gave me the heads-up when my net income hit the level at which I had to start paying my personal income taxes on a quarterly instead of a yearly basis.

He told me all about the dirty little secret that is self-employment tax. One of the more unpleasant surprises intrepid small business owners encounter is that on top of your regular taxes—which seem like enough, thank you—the

government claims an additional 7 percent on earnings up to about $87,000. Ouch! Cruel as it seems, there is a reason behind this. What many of us don't realize until we become employers (of ourselves or others) is that while the government is happily making off with a portion of the employee's earnings, the employer is also paying employment tax. So when you're both the employee and the employer, you get hit with a double whammy.

The moral of this story? You can live without an accountant. But why suffer?

CHOOSING A VENUE

You've budgeted for your studio space in your business plan, and now it's time to choose a door on which to hang your shingle. Whether you rent on an as-needed basis from another photographer or sign the lease yourself, the location where you set up shop will go a long way toward establishing your image in your clients' minds. Think about the identity you want to project: Do you want to be a trendy, artsy, edgy warehouse habitué? A suburban office park straight shooter? A downtown or uptown girl or guy? If your studio is a retail business, do you want to project upscale boutique chic or shopping mall sass?

Your work can be artistic and editorial as all get out, but if your studio is in a suburban office park, your venue will be undermining your message. On the other hand, if you're a photographer who shoots good, old standard catalog shots and solid mainstream product images, an office park might be just the place for you. Choose a location that complements your message, your *story*.

You also need to consider accessibility. Are you going to need to get big wheel monster trucks into your shooting bay? Or will you be shooting nothing larger than an earring? Will your clients have to park far away, and will they be willing to pay to park? Or do you need a building with free adjacent parking? If your studio is on an upper level, is there a freight elevator? Or will you be hauling equipment, sets and props up and down in the passenger elevator? Will you need access to your studio on weekends and after hours? These are all issues you need to resolve before you enter into any agreement or sign a lease.

If you rent as needed from another photographer, will there always be a shooting bay available to you? How far in advance will you need to reserve the studio? Or will you have standing days for which you pay whether or not you shoot on those days?

Working From Home

There are pros and cons to operating your studio, office or darkroom out of your home. The biggest pro, obviously, is that it doesn't cost you anything—assuming that you would have the home in any case. The drawbacks are twofold: It's harder to project a professional image when you bring clients into your residence; and it's darned hard to know when to stop working.

"You just work all the time," says Bob Dale, who ran a studio from his home for eight years before leasing a retail space. "I'd be in my pajamas and slippers sitting at my desk masking negs at midnight."

If you do choose to work from your home, ideally any area to which you bring clients should be completely separate from your living area, with a separate entrance if at all possible.

And don't take liberties with that fabled "home office deduction" on your income taxes. You can't just slap your laptop down on your dining room table and deduct that space as an office. For a room to qualify as home office space, it has to be separated from living spaces by a door that closes. The room must be dedicated solely to business use. If you do laundry in there or watch TV, it's no go. You should strictly adhere to the rules governing the deduction. So many people have been tempted to cheat in this area that simply claiming a home office deduction raises little red flags at the IRS and increases the likelihood you'll be audited.

Sharing Space

Since fixed overhead is the bane of small businesses everywhere, and rent will probably be your biggest fixed expense provided you don't have employees, sharing space either with another photographer or with someone in a complimentary business seems like the next best thing, cost-wise, to working from home. But it, too, has its pros and cons. Obviously, reducing your rent by half or more is a big plus. But having "studio mates" and "office mates" can be a lot like having roommates—or worse yet, spouses! There's the basic "Odd Couple" trap—one of you is a neatnick and one of you

"Swingers" by Donna Pagakis.

is a slob. Or one of you subscribes to the "what's yours is mine and what's mine is mine" theory of equipment sharing. Or one of you starts poaching the other one's clients.

Another complication is that the image or identity of your office mate's business will reflect on you and your business. This can be a drawback if your buddy's image isn't as high-end or as professional as yours.

If you do decide to share space, get an agreement in writing as to what you'll do in the event of a breakup. It doesn't need to be in legalese, but it should spell out who will be responsible for the obligations of the remainder of the lease (if any) and who will get to keep the space and any shared property. You also might want to have a written agreement divvying up the cleaning and maintenance duties. Or better yet, take some of that money you're saving by splitting the rent and spend it on a cleaning service.

Renting as Needed

The first two years I was in business, I rented a studio on an as-needed basis from an established fashion photographer. At first the

arrangement worked out spectacularly; he was a slob and I was a slob, so we were compatible on the cleaning front. At first I only needed to shoot on Saturdays, and he only shot Monday through Friday, so there was no disagreement. But as my business grew, I started needing more shooting days. The day rate I was paying him for the use of his space was 20 percent of his monthly rent. So if I shot more than five days in a given month, which began to happen more and more often, I was paying him more than what it would have cost me to have my own space in the same building. And then his busy season kicked in, and suddenly the studio wasn't available to me when I needed it. So after two years, we parted ways.

Would I do it again? In a heartbeat! It was the only way I could have a whole warehouse studio to use without the big risk inherent in signing a lease. But my advice to anyone considering such an arrangement—from either end—would be to have an agreement to revisit your "terms of engagement" every three to six months, with the option for either party to end or alter the relationship at that time.

Partnering

Taking on a business partner can be, in my opinion, a great idea, but very few photographers ever try. I think we're all just a bit blind to the importance of the business aspect of our work, and we think if we can shoot, the rest will take care of itself. Just as in any business, the photographer should only partner with someone who has something to offer that the photographer does not himself possess: capital, sales experience, business experience, clients, etc.

Of course, a partnership is in many ways like a marriage, so you'll want to be sure you like and trust anyone you plan to go into business with. And there's always the possibility that the partnership could end before the business does, so you'll be wise to have a prenup, i.e., a "buy/sell" agreement that spells out who gets to buy whom out in the event of a split, and what the terms will be.

LEASE AGREEMENTS

It can be very scary the first time you sign a lease for a studio space. Most property companies require a minimum of a three- to five-year commitment. There's usually a page in the agreement that

says the exact amount you'll owe for the life of the lease, and I guarantee you the number will be higher than you can count on your fingers and toes.

Beware of the personal guarantee. If you have incorporated your business, you probably did so to avoid personal liability in the event that the business fails and you can't pay your creditors. But landlords know this, and they don't want to leave you any outs. So most of them will ask you to sign a personal guarantee that insures you will pay the remaining rent as per the terms of your lease even if your corporation, or entity, is dissolved. If your business is new there may be no way around this. But if your business has a sound history, you may be able to avoid it. One way you might eliminate the personal guarantee is to offer to pay a two- to three-month deposit instead. This way, the landlord is covered for the time it may take to lease your space in the event you can't fulfill your contract, and you aren't on the hook for up to five years of rent.

Most commercial spaces are rented by the square foot and by CAM (common area maintenance) charges. Rent is rent; when you are quoted a price per square foot, that is exactly what you will pay. But CAM charges are different. At the beginning of the year, the landlord projects what the CAM charges will be for the next twelve-month period and bills you accordingly. If his projections are off and the actual cost of maintaining the building is lower than he anticipated, you will receive a refund at the end of the year. But if his projections are low, and it costs more than he projected to maintain the property, you'll get a bill at the end of the year. I've been hit for as much as $3,500 in CAM adjustments, and I can tell you, it's a rude surprise.

There are many factors that can make the CAM charges go up: snow removal, gas or electrical prices, special assessments and unplanned repairs such as reroofing. Even the occupancy rate of the property will affect how much your CAM charges are because the more tenants there are to spread the cost among, the lower the cost is per tenant.

Before you sign a lease, be sure to add it all up. Take a look at the landlord's projected and actual budgets for the last three to five years. Have his projections been relatively accurate? Ask how old

the mechanicals are, and the roof and any other pertinent items. Is he anticipating any repairs in the near future? The more information you have, the less risk you'll assume.

"Four Cherries" by Susana Heide-Theissen.

BUYING AN EXISTING STUDIO

Rather than starting from scratch, some photographers opt to purchase an existing studio from a shooter who is retiring or going out of business.

The benefits of this are that you can get a client list, a complete setup (including photographic equipment, backdrops, props and office equipment) and take over a space that probably needs little or no remodeling or construction (also referred to as build-out) all in one fell swoop.

There are drawbacks, too. There might not be as much value in the studio as there appears to be at first blush. Buying a photographic studio can be a little like buying a private practice from a dentist or a lawyer. Without Dr. Livingstone, D.D.S., there is no Livingstone Dental Clinic, even if there is an office, a chair, a client list and a drill. That's because when Dr. Livingstone leaves, his

clients just might leave, too. Businesses are built on relationships, remember, and Dr. Livingstone's patients have a relationship with him, not with his office. And not with you.

It can be a workable arrangement if you don't pay too much for the business, and if the retiring photographer stays on and works with you for a year or two, part-time, to smooth the transition and help you win the trust of his clients.

BUYING A FRANCHISE

Buying a franchise can be a safer bet. A franchise is like a business in a box—the planning and product development and name selection and logo—everything down to the minutiae is already in place. Just add your time, money and talent! Before a business is offered as a franchise it has to have a working model that's proven reliably successful and repeatable. For example, suppose you want to open a bagel shop. You could go into business as Anita's Bagel Bakery and try to break into your market with no name recognition and untried business plan, or you can buy a Bruegger's bagel franchise and open your doors with instant name recognition and a successful business plan. As a franchisee you'll have the advantage of a proven guide for every aspect of operation and a product that you know can be sold. You also get comprehensive training up front.

But like any other avenue into the world of business, this one has its drawbacks. It can be expensive to start up, and the company takes 5 to 10 percent of your gross for a minimum of seven years. The very benefits that make you want to buy in—those proven systems—may dampen your entrepreneurial spirit once you've got some experience and you want to try out some systems of your own.

CONTRACTORS, EMPLOYEES, NEPOTISM AND DOING IT YOURSELF

When you're just starting out it's wise to keep your fixed overhead to a minimum. There are various ways to do this.

You can hire independent contractors on an as-needed basis. You just have to make sure they actually are contractors, and

not employees, or you could wind up paying some stiff penalties. There are a couple of big indicators that a person is a contractor and not an employee. The person does the same job for other clients besides you. Examples of this would be a housekeeper who cleans homes for various clients, a photo assistant who works for more than one photographer or a bookkeeper who works for other clients in addition to you. Another, stronger, indicator is whether the person is hired on a per job basis. You've got a big shoot coming up for MegaHuge, Inc., that's going to last two weeks. You hire the assistant for that job only. After the job is done you part ways.

While you don't have to file W-4's or take withholding for contractors, you do have to file a 1099 if they earn over $600 from you for the year.

Nepotism, the practice of hiring one's friends and relatives, can be an arrangement that works out like a dream—or your worst nightmare. When family is involved, there's a greater likelihood that you could wind up taking advantage of them as your employees or that they could take advantage of you as their employer. "Oh, I can get Auntie Frances to answer the phone for minimum wage, she'll just enjoy being able to get out and about, and talk to people," you think. Whereas Auntie Frances is thinking, "Oh, I can work for Stanley and he won't mind if I come in late when traffic is bad or the weather is nice or my gout is acting up."

It's also more difficult to tell friends and family when they're doing something wrong. When an ordinary contractor or employee botches an order, it's relatively easy to say, "You know this Parsons wedding order you sent in? You ordered 1,620 five-by-sevens instead of 57 sixteen-by-twenties and your mistake cost us $9,400." It's harder to say that to your mom.

That said, I have to admit that my mother worked full-time for me for six years and continues to work part-time. My cousin and close friend work for me full-time and at various times my sister has helped out on a temporary basis. My motto, for those who have good communications skills, is, "A little nepotism never hurt a nepit."

"Well, I'm not afraid of hard work," you're thinking. "I'll just save a whole wad of cash if I do everything myself. Who needs

contractors and employees?" And when your business is new, that may well be the case. But after a certain amount of growth—and that amount will vary from business to business—it is actually counterproductive to do everything yourself. After my business was about two years old, my accountant told me not to do anything myself that I could get someone else to do for $20 an hour or less. This is somewhat of an oversimplification, but his point is this: Your time is valuable. If you own a growing business, the time you take emptying your wastebasket or balancing your check register is time away from refining your marketing message or developing new products or spending quality time with clients—all things that you must do! You can't afford to delegate these tasks. You need to learn to set a value and ability level on each task and delegate the least valuable and least challenging ones. Otherwise you'll be working hard, but not working smart, and your business will suffer. Sure, it might seem like a large or an unnecessary expense to hire a cleaning service or a bookkeeper when you can do these things yourself, but like the old cliché says, your time is money. So plan on delegating some of your duties at some point down the road.

When do you make the leap from doing it yourself or using contractors to hiring a permanent employee? Employees come with a much bigger commitment than contractors; you need to give them benefits and promise them a certain level of employment, and if you can't deliver on your promises and you lay them off, you have to pay them unemployment benefits. (Frequently you wind up paying unemployment compensation even if you justifiably fire them.) You pay worker's compensation insurance, social security and Medicare deductions for them, and unemployment insurance. In return, they give you their talents and most importantly, their time.

I take my commitment to my employees very seriously. By taking the opportunity to work for me, they are passing up opportunities to work elsewhere. There are few things harder then telling an employee they don't have a job anymore, even when the dismissal is justified and necessary.

I went from contractors to employees when my studio met the following criteria: It had realized at least 20 percent growth

every year for four years; it became more practical to hire people who would stay around for a while instead of having to repeatedly find and train new contractors; and the workload became too large year round for me to handle alone.

I have discovered over the years that one excellent employee can accomplish ten times more than a merely adequate one—and those excellent workers are worth keeping around.

PROTECTING YOUR NAME

If you are using your own name as your business name, you don't have to worry about trademarking it. Your name is yours to use. The downside of that is that anyone else whose name it is can use it, too. So if your name is Stanley Kowalski and your studio is called Stanley Kowalski Photography, and the guy down the street is named Stanley Kowalski,

"Onions" by Susana Heide-Theissen.

too, and he calls himself Stanley Kowalski Photography, there's nothing you can do about it. This could be especially troublesome if, say, you shoot high-end editorial fashion and he shoots cheesy boudoir photos for ads that appear in the back of swinger magazines. You could lose clients if they confuse the two of you, and there would still be nothing you could do about it.

While you don't have to trademark or service mark your own name, you do need to reserve your domain name as soon as possible. Since it is, after all, the World Wide Web, there's a good

chance that some other Stanley has already purchased your name of choice. You may be forced to use Stanley J. Kowalski Photography or even Stanley James Kowalski Photo.

THE REASONS MOST SMALL BUSINESS STARTUPS FAIL

I hate to bring up an ugly word like *failure* when you're just getting started, but the fact is that roughly 80 percent of all new businesses fail. I'm not trying to be pessimistic or even cautionary, just pragmatic. I believe that if you're aware in advance of the reasons others before you have failed, you'll be able to avoid repeating them yourself.

• **A LACK OF KNOWLEDGE.** Failure can result when the new business owner hasn't done his research. Not just research into his market as it exists in the present, but the history of the market and the names of all the major players. Knowing where your colleagues have been will help you steer yourself where you want to go.

• **A LACK OF PASSION.** No matter that you try to have realistic expectations going into your new business venture; no matter that you've intentionally taken off those rose-colored glasses to face the glare of reality; no matter how well you try to prepare yourself, starting up your own studio is going to be harder than you think. Really. So unless you have that big fire in your belly, unless you love creating images so much that you wax rhapsodic just thinking about it, don't bother. Because you will find the sacrifices too great and the rewards too few, and you'll go sprinting back to that "real" job before you can say "Bruce Weber and Annie Leibovitz."

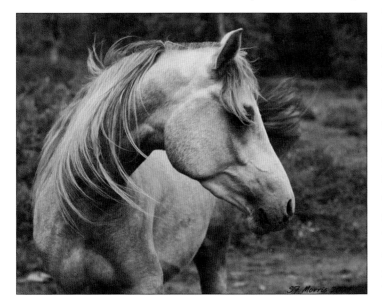

"Profile" by Sharon Morris.

• **THAT LITTLE FOUR LETTER WORD: FEAR.** Human beings are funny animals. We fear failure. We fear success. And in either case, that fear can make us abandon ship.

• **LACK OF ADAPTABILITY.** The market changes. Technology changes. Fashions, styles and trends change. Your maturity level (and that of your studio) changes. The economy changes. Your financial needs change. All this requires you to adapt. Just as in Darwinian theory, it's survival of the fittest—evolve or become extinct.

• **QUITTING TOO SOON.** Giving up and giving in—it's horrible and wonderful at the same time. The faint of heart ride the cash flow roller coaster and the first time there's no money in the till, they assume the worst! "I'm not profitable, I'm operating in the red, I'm failing, I have to cut my losses!" and they jump ship. But the fact is, cash flow and profit are two different issues. It commonly takes new businesses about two years to become profitable. If that seems like too much uncertainty to you, stick with your day job.

• **WORKING HARD, BUT NOT WORKING SMART.** Some of us bind anxiety by being busy. We think if we're in constant motion we're moving ahead, when in fact we're only spinning our wheels. Sometimes the best thing you can do for your business (and for yourself) is to take some time off, go sit still and clear your head, set your subconscious to percolate on your studio's biggest priorities and get some recreation. You'll be more productive when you go back to work, you'll work smarter and you won't be as likely to suffer from burnout or make bad decisions.

THE MYTH OF BUSINESS-CHALLENGED PHOTOGRAPHERS

All right, I'll admit that I am one of the culprits who has bought into the "I'm a photographer, not a business person" myth. I actually like to think I'm bad at business—it makes me feel more artistic. But as my less artistic, more business-oriented friends point out, I must be good at business or I wouldn't still be here after twenty-one years. Erica Stoller, owner and operator of ESTO Photographic, Inc., said it best: "Photographers clearly have a visual bias, but I'm often

surprised at how well they deal with the written word (a skill important in every profession). And how good their instincts are for business. But there's a strange cultural divide: art versus business. In fact, business arrangements can be creative and not all that difficult." Erica posits that the trouble comes in when the photographer/business owner is wearing both hats at once because "… it is hard to concentrate on one job while thinking about the last job and worrying about the next."

I agree with Erica—the too-many-hats syndrome is an affliction I think most entrepreneurs suffer from, whether in professions commonly regarded as creative or not. But how do you ease the burden? Erica recommends having someone who makes your arrangements for you: someone who negotiates fees, sets up jobs, and who "… has the [emotional] distance to present your work with enthusiasm and some hyperbole and who, if the going gets rough, can say no."

For those working alone, Erica emphasizes that it's important to create a system or protocol that allows you to move forward without reinventing the framework for each assignment. A standardized approach to bids and estimates can be useful, and forms for this purpose can be found on the Internet and from associations like the ASMP.

KEY INGREDIENTS FOR SUCCESS

I've already stated emphatically in earlier chapters that there is no recipe for success. However, there are some essential ingredients. Since I've told you some of the things that can help you fail, it's only fair I highlight you some of the things that can help contribute to your success.

•**ADAPTABILITY.** Imagine you started out shooting family portraits in 1988. Direct color, white on white was big. It was so big you didn't take out your canvas backdrop for four years. You even named your studio Blanc de Blanc (not a particularly good name choice, since not everyone speaks French). You never thought you'd have to shoot anything else ever again. You set your sights on coasting into retirement as a one-trick pony. But business dropped off and you studied your market to see what everybody else was up to. It ap-

peared that black-and-white fine art prints were enjoying a resurgence. You told yourself that you are adaptable, you can learn how to change with the market—and you did just that. You did it before you needed to take out a loan just to keep the doors open, and before you became a dinosaur. You changed your business name, but not too much: Blanc Avec Negra, perhaps. You went back to school, or back to the darkroom, or back to square one—whatever it takes to learn how to make top-quality black-and-white art prints. And business picked up again. You have adapted. And you didn't have to rise out of your own ashes.

• **COMMON SENSE.** Over the years I've learned that common sense is a real premium. If you have it, you're in the minority. If it goes without saying that you pay your bills on time, keep adequate records, answer your phone, return all your calls, provide the best product you know how at an appropriate price and view every client as a person as well as a source of income, you can parlay this unique sensibility into a successful career.

• **TALENT.** Talent is important. It is necessary. If you don't have talent, you won't be able to deliver a satisfactory product, and you'll never have a repeat client. Talent is the yin to your good business practice's yang.

• **A GUT YOU CAN TRUST.** Common wisdom is usually right, but sometimes it's wrong. You need to know what common wisdom holds. Check it against your gut and decide whether to follow the pack or to break away and do something new. That's how markets evolve. For instance, common wisdom states that one should be a generalist, then one day someone stands up and decides to specialize. The rest of us hold our breath, watching him and waiting for him to fail. But he doesn't fail—he laughs all the way to the bank. Then the rest of us think, heck, we'll specialize, too. New and better ways of doing business are born. Trusting your gut can give you a reference point, so you can decide whether to take a risk and veer off course or stick to the path.

• **CREATIVE PROBLEM SOLVING.** We become photographers because we want to do something that's creative, but then we often forget to apply our creativity to our business operations. Cash flow,

A high-key portrait by Chris Darbonne.

record keeping, client relationships, sales and marketing are all areas that seem dry and boring until we look at the problems they present in a new way and create solutions to these problems. By bringing our creativity not just to the making of our images but to the making of our businesses, we'll not only be poised for success, we'll enjoy every aspect of our profession.

It can be daunting. Entities, tax-exempt numbers, choosing and protecting a name, and leasing space is just the beginning. This is not exactly the stuff you had in mind when you were dreaming of becoming a photographer. But the very trait that makes you want to make images creatively can be applied to your business endeavors to bring your financial goals to fruition. It seems that creativity is not, after all, a handicap for a photographer running his own business, but a necessity.

SUCCESS STORIES

Sure, starting a new business is a huge endeavor and starting a creative business seems to add another layer of scary (at least it seems so to me!). Because your whole heart and soul is in your work, you *are* your product, and if you were to fail, it would be that much more heartbreaking. Add to that the uncertainty of a volatile economy, and who could blame *anyone* for not wanting to play, for taking their ball and going home? But there are a few brave souls who have recently (in the last four years) done just that. I've talked to six of them. Like the established pros we heard from in chapter two, they entered the field via very different avenues. They are tenacious, talented and inspiring. Here are their stories.

CHRIS DARBONNE:
ENGINEER TURNED PHOTOGRAPHER

In 2001, Chris left her job designing vehicles for a major American auto manufacturer to open her own retail children's portrait studio (formerly Charming Snapshots, now Darbonne Photography) in a trendy shopping district in Detroit. Chris describes her work as "full-time plus some."

Did your educational background in engineering help prepare you in anyway for this big career change?

I have an associates degree in vehicle design. It seems totally unrelated but it's not. It's a mixture of technical and creative. In addition to that, I've met with a couple of photographers who have mentored me. I've read a bunch of books and taken courses online and I've practiced a lot and dissected images that I like (whether or not I took them).

What are some of the reasons you left a "real" job for the uncertainly of starting your own business?

My favorite thing about owning my own business is the feeling that I'm in control. Having been in a huge corporation before this, you feel like you're being shoved through life and I feared that I'd wake up one day at my retirement party wearing Velcro shoes, a mullet, holding a cocktail wiener—having been on auto-pilot the whole time. However, the control is not unlimited. Obviously there are certain factors that are out of your control—but you do have the power to nudge things in your direction through trial and error. I love that if I feel strongly that something should be done or a priority should be changed, I just do it. No checking with anyone, no presentation to give. Just do it.

How is running your business different from what you first envisioned it might be?

There are a lot more details than I imagined. The details can really bog you down if you let them. From employee taxes to sales tax (what, I don't get to keep that?) to shoveling the pathway to the door in the wintertime. Silly stuff can really add

up when you may have had this image of your business from 5,000 feet. It's really more 'in the weeds' than you might first imagine. It's very much a balance of left brain and right brain.

Do you shoot what you love or whatever sells, or both?

I'd say both. I really don't do much of what I don't love. If I don't love it, I really can't sell it. I like it when the photographs sell themselves since I'm pretty crummy at sales (don't tell anyone!).

Is there anything you wish you would have done differently?

Yes, I absolutely jumped in with both feet and running. I spent a lot of money I didn't need to—primarily on advertising. I wish I had been a little more patient! I wanted out of my home studio immediately once I decided to quit my job. I had a lot of downtime and a lot of expensive advertising blunders. Also, I should have put "By Appointment Only" on my door *immediately*. I have had such a freedom with those three words. I was in a retail area and *still* made that change eighteen months in. … It was like an anvil was raised off my chest.

How do you keep your competitive edge photographically?

Every so often I ask myself, *if I were my competition, what would I nail as my weakness?* It's almost always a technical detail so I try to figure out how to improve in that area. I ask for opinions, read books—whatever I can do. Sometimes I get in a rut creatively. I can tell it's happening when there's an age that I look less and less forward to shooting. It's happened to me with newborns. I was tired of all the old stuff so I had to change it up. I had my assistant bring in one of her daughter's baby dolls so I could think of different things we could do while they're tiny.

Where does your fee structure and pricing fall within your market: high-end, low-end or middle?

High-end. All of our pieces 12" (30cm) and larger (priced by the long side) leave the studio archivally framed with a signed mat.

How important is your website in your promotion of your studio?

It's the most important marketing tool I have without question. We get all kinds of clients from it. I'd heard early on

that most people don't get new clients from e-mail correspondence, but I really do. A fair percentage of clients book without ever speaking with us. Sometimes it's all e-mail.

What other means of promotion have you used, and what has been the most successful?

I've used direct mail, a big referral bonus to encourage word-of-mouth, displays at like-minded businesses, print ads, partnership marketing with like-minded businesses, newborn welcome baskets, open houses, charity drives. Hands down, the most successful is referrals. We offer a free 8" × 10" (20cm × 30cm) to the new clients and the referring client for every referral. My favorite thing about referrals is that the clients are prepared for the price. It's not an obstacle—they already know. Our website is a very close second. Partnership marketing has to be third. We partnered with a swim school and did both partnership marketing and a display of giant canvases in their huge space. It's gotten us quite a few calls. The top two tools that work the best are also the least expensive.

What's the single most important piece of advice you have for an aspiring photographer who is just starting out?

Define yourself and stick to it. I'd recommend doing this early on. Don't start selling four-by-sixes to clients for fifty cents and then charge $93 two months later. Do your homework (even if you don't feel like it) and see what's in your area. One of the first questions I was asked (to my surprise) when I was signing up for the local chamber of commerce was "What makes you different?" Thankfully, I had an answer but the answer has evolved since then. I didn't have a solid identity initially and I was experimenting with too much all at once. I was so anxious to get started that I forgot to perfect the basics, which would have saved me a lot of grief. I would've had far fewer growing pains.

Is there anything else you'd like to add?

Know what you're worth, charge what you're worth and don't apologize for it! You need to have respect for yourself and for

your work or your clients never will. Not only as an artist, but as a business owner. You should practice what I call approachable arrogance. It sounds like an oxymoron but it's really not. Approachable arrogance means you're supernice, you're very accommodating and you're generous with your time and attention. But you know you're good and you know you should be paid well for it. This isn't easy. I'm still working on it!

MARIA MOSOLOVA: A BLOOMING STOCK PHOTOGRAPHER

With a Ph.D. in mathematics and a day job as a software engineer, it would seem unlikely that Maria would be a flower photographer. And yet, here she is, selling her images through stock agencies and her website.

What inspired you to become a professional photographer?

I always loved growing plants, especially flowers. Flower beauty is so short-lived, I turned to flower photography as a way to try to make flower beauty last.

What is your favorite thing about your photography career as is stands right now?

The favorite thing, I think, is the fact that I can concentrate now not on the technical side of shooting but on what I actually want to do creatively. Of course this still means learning every day, just learning different things.

What is your least favorite thing about your photography career?

I think the fact that I still cannot make my whole living as a photographer is my least favorite thing.

How much time do you spend shooting versus attending to other areas of your business?

I have a huge backlog of classified but unprocessed images. Which means that I have not found the balance yet. I'd say that for one hour of shooting I spend three to four hours on postprocessing. The rest takes about 5 percent of the time.

How did you learn to shoot?

I've just counted, and I have taken forty-one classes on BetterPhoto.com! I've participated in several of author/teacher/photographer Tony Sweet's workshops. Networking with other photographers is essential when learning online. That is why year-long classes are my favorites. We learn from one another a lot.

What's the most important piece of advice you can give to aspiring professional photographers?

Keep climbing.

MICHELLE FRICK: A FORMER ARMY BRAT

Michelle Frick opened her children's portrait studio in 2005. She has a bachelor of arts degree in humanities. As an undergraduate she was pre-law, and her studies covered everything from impressionism, Shakespeare and Civil War studies. During and after college, she worked in marketing and advertising for Dell Computer Corporation. In this role, she attended commercial photo shoots, but it never occurred to her that she could be a photographer by trade.

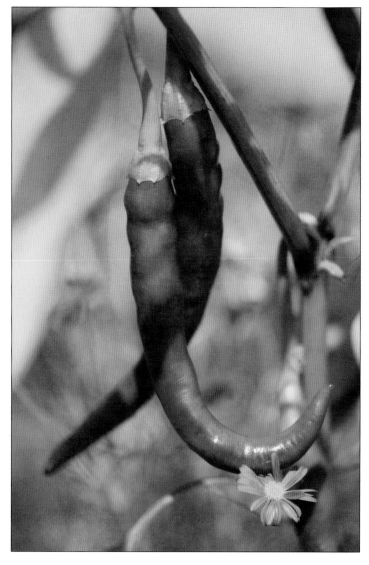

A botanical image by Maria Mosolova.

Is Michelle Frick Creative Photography a full-time job?

Hmm. How do you define this? I work my own hours, and I certainly am not a nine to five business. However, if you factor in how much time and energy I put into taking and edit-

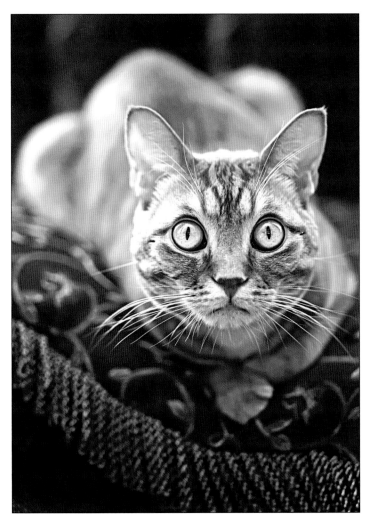

A pet portrait by Michelle Frick.

ing my images, I'd have to say it's pretty all consuming. Being a perfectionist and having so many tools and options at my disposal, it's very difficult to know when to say when sometimes.

What inspired you to go pro?
Growing up as a military brat and moving about all my life, my images were a way of holding onto precious memories of people and places that I had been. Images were my way of staying connected to the things that were important to me. Photos were and continue to be a tangible way of hanging onto all the moments I can't imagine living without.

Once I had my first child, photographs took on an even bigger role in my life. I didn't want to risk missing a moment. I think my daughter was photographed in each and every outfit she wore for at least the first three years of her life. I became known as the mom that always had her camera at every party and each school event. It got to the point that my friends began asking me to take their holiday portraits and then I had a friend who wanted maternity pictures, which of course, led to baby pictures. I had never charged for my work up until then. And, at first, it was a difficult thing to do, particularly since most of my early clients were my friends.

You read books and take online classes to polish your craft. Anything else?

I am a member of PPA (Professional Photographers of America), several online photo clubs, and I'm active on two Yahoo boards dedicated to photography. One is open to all types of shutterbugs at all levels, and the other is limited to portrait photographers.

What is the good, the bad and the ugly about having your own photography business?

One of the great things is being able to control my own schedule, which allows me to have a job I enjoy while still being available to be a full-time mommy to my children. My least favorite thing is the record keeping and the mind-boggling details that go along with running a business.

How is this economy affecting your business?

I think I've been lucky. My clientele are incredibly loyal. I also think it helps that by photographing families and children, I am providing a service that fills an immediate need. Children are little for such a short while, and parents don't want to miss out on capturing those precious memories.

Do you shoot what you love or what sells, or both?

I am lucky enough to shoot what I love. Of course, I love shooting just about everything, but I haven't found a flower that can pay my session fees yet.

Is there anything you wish you would have done differently?

I wish I had believed in myself more up front. It took me awhile to see myself as an artist and to understand my value in the market. A lot of the business side is perceived value and it helps you sell yourself if you go into it knowing you are providing a service that not everyone can provide. I actually had a client once tell me that photographers are a dime a dozen. Now, while I will agree that you can find almost anyone to take your pictures, and you can find people at all price ranges, I don't believe you get the same quality of service from just anyone out there. So knowing what you offer and what sets you apart will help you in the market. Your time and your talent are intangible, and only you can decide what those are worth.

Where does your fee structure and pricing fall within your market: high-end, low-end or middle?

I would say my fee structure is probably near the middle of the market in my area. I am about average on session fees and lower than average on my print pricing. I offer some competitive plans for expectant and new parents. I think it's important to know your market. I try to pick up the latest local papers and magazines to see what other photographers in my area are charging for their services and the quality of their work.

How important is your website in your promotion of your studio?

My Web presence is my best promotional tool other than word of mouth. My clients and potential clients like having a place to go where they can view my work. I will say, though, that the majority of my business has come from and continues to build through word of mouth. I have advertised in school directories and have contributed to silent auctions for my children's school and to our church.

What's the single most important piece of advice you have for an aspiring photographer who is just starting out?

Do as I say not as I do! This is just like my mother used to tell me, and now I get it. I think it is vital early on to set up a fee structure that you can live with for years to come. When I first began, I didn't really have a set plan. I basically gave away my images for a flat fee, and that's not ever going to make you much money. When you consider all of your time, equipment, software and all the other intangibles, you have to realize that you are providing a valuable resource and service that is worth charging a price that will allow you to grow your business (not to mention eat and buy that new camera or lens you covet!).

STEPHANIE ADAMS: A SNAP-HAPPY MOM

Stephanie Adams started her location photography business in 2003. "I was really a camera-obsessed mom," she confesses. "My photography started with my loving to take pictures of my young children and grew into family and friends wanting me to take pic-

tures of their children and families and so on and so on. And taking my camera with me wherever I go allows for me to grab stock shots for my agency at any time! Right now my photography business is part-time because I balance it with being a mom. I'd like to progress to full-time as my children get older and I have more time."

Has being a professional photographer been a good job for you to have while raising your children?

Yes! What I love is that I am able to be a mom. Having no studio allows for me to be outdoors, and I am still able to be home when my children need me. I edit my work while they are in school or in bed and for me, it can't get much better than that!

Is this economy affecting your business?

Actually, it isn't hurting too much and I am fortunate to also have a stock agency in Spain that I shoot for, so that generates sales.

Do you shoot what you love or what sells, or both?

I get to photograph what I love. When shooting portraits, my favorite is children, and when it comes to my stock, I photograph what my eye catches and what interests me and I'm fortunate it sells.

A portrait by Stephanie Adams.

Is there anything you wish you would have done differently?

I would have believed in myself and put more effort into the business end much sooner.

Where does your fee structure and pricing fall within your market: high-end, low-end or middle?

Middle, but when I've worked more and learned more skills, I would like to aim for higher-end.

What's the single most important piece of advice you have for an aspiring photographer who is just starting out?

Just get out and use your camera! You learn best by doing and seeing for yourself what works for you. And believing in yourself.

KATHY LOCKE: PHOTOGRAPHY IS CHILD'S PLAY

Less than a year ago, Kathy Locke opened her business, Child's Play Photography. With a B.A. in art history and work experience in the areas of marketing and public relations, her background is a solid foundation for her new career. She works part-time by choice, so she can raise her three young children at home.

Kathy says that since her business is not quite a year old, she still feels like she's just having fun taking pictures of kids (as she has been doing for several years), and that getting paid is just a perk.

When did you realize you were really a pro?

One big "aha" moment happened at a benefit auction where people I did not know were having bidding wars to win my donated photo package.

It also helped to see my work finally go up on my own website. There's a value to seeing your own professionally or-chestrated website, especially in such a visual business.

Did you quit your day job to be able to become a professional photographer?

No. It wasn't until after I had retired, and my fourth child was in school, that I decided to audit photography classes at a university. I fell in love with the darkroom and shooting black and white. My teacher often criticized me for always photograph-

ing my children, which he considered boring material. He suggested that I study Sally Mann if I was going to shoot my kids. I decided Sally was not my style (although I do love her work), but I fell in love with fashion photographer Arthur Elgort's candid photos of his children. When Chicago photographer Julie Floyd of Classic Kids took my eldest daughter's portrait, it was a fun experience for all of us, and I thought, "I can do this." Julie really encouraged me and pointed me to the online photo classes at BetterPhoto.com.

How is running your business different from what you first envisioned it might be?

It is much more rewarding personally than I would have dreamed because of the relationships I have built with my clients. I *love* getting to know the kids as well as the parents during the shoot, then ultimately delivering finished prints that they enjoy.

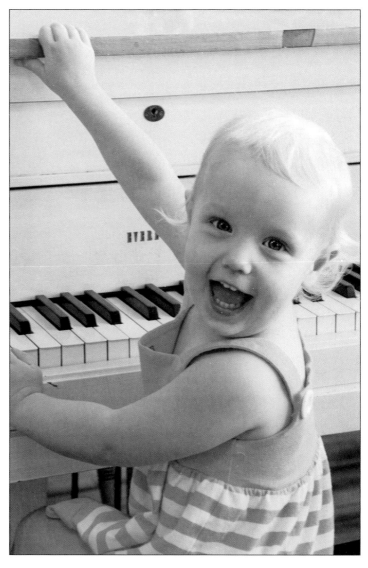

A location portrait by Kathy Locke.

How is the economy affecting your business?

Since I do not have a "before" it's difficult to compare. However, it really hasn't slowed me down during my busy season. I also think I was lucky to price myself a little higher than most of my competition, but not too high that it's not affordable. We are in central Illinois where people have always been

conservative with their spending, but they're still willing to pay a little more for quality.

Do you shoot what you love or what sells, or both?

Hmm. I have tried to develop a style that is fun and candid, so I like to think people come to me because that's what they want. However, I also feel it's important to listen to what your client wants, and I've altered my typical style on occasion. And I am surprised sometimes how I wind up liking the end result and find that I always learn something. Overall, it is my driving force to make my clients thrilled with the end product. Sometimes that is a slight compromise, but I haven't delivered a finished print yet that I wasn't thrilled with.

Is there anything you wish you would have done differently?

My daughter Emily is my assistant. She picked the name of our business, Child's Play Photography. It was important to me that she felt ownership, and I liked the name. I have found, however, that there's a much larger senior portrait business than I anticipated. I love the senior photo shoots, too, and the name doesn't lend itself to teens. Nonetheless, word of mouth seems to be the driving force behind senior picture business.

How important is your website in your business promotion?

Because I do not have a storefront studio, I feel a good-quality website is vital. This not only lets my clients see the variety of work I do but also validates the quality of my work and justifies my pricing. I have just launched my website and have already received new business. Let's face it, photography is a visual business so the quality of the website reflects the quality of the photographer. I paid top dollar because I feel it is important to establish the right look for my product. I also have a little game on my website called the "sock monkey friends gallery." We have a variety of sock monkeys we use to get grins from our little clients during photo shoots. I take a photo at the end of every session with the sock monkey of their choice in a crazy pose, and then I post them on my website. This gets not only the client to view the site but their friends and family, too. I think it's working.

What's the single most important piece of advice you have for an aspiring photographer who is just starting out?

Both you and Julie Floyd recommended keeping my overhead as low as possible. You both suggested finding a spot to rent space as needed. I am very lucky to work with our local arts center. They allow me to use one of their classrooms on prescheduled days and kindly allow me to make a donation based on my percentage of sales. It's a pain to haul the equipment, set up and tear down per session, but it has cut that huge expense down to doable proportion to start a business. The rest I do out of my home. I look forward to having a storefront studio someday, but I don't have the income—yet.

CONNIE COOPER-EDWARDS: NURSING HER PASSION

Connie started her stock and child photography business in 2005. She works full-time as a registered nurse and as of now her photography is a part-time endeavor. Her husband bought her a DSLR five years ago, when he noticed that she was making great images with her point-and-shoot manual camera, and he thought she'd get even better results with a better camera. Connie says she didn't know anything about photography, but she couldn't leave that expensive camera just sitting in its box. She went out and bought books, read them and also practiced shooting. She took online courses and joined The National Association of Photoshop Professionals (NAPP) to learn how to edit her images using Photoshop. She attended live workshops. Ultimately, she started with stock agencies but has now branched into portraits and also shoots images for the company for which she works as a nurse.

What inspired you to go into portrait photography from a start in stock?

Two years ago in Seattle, when I saw you demonstrate kid wrangling at the BetterPhoto.com workshop, I thought, "Well, I can do that!" So now I'm shooting two to four families a week, and sometimes more.

A vineyard shot by Connie Cooper-Edwards.

What are your favorite and least favorite things about being in business for yourself?

I really enjoy the freedom it gives me to go out and make images and know that I might sell them for stock. My least favorite thing is knowing that, if I don't do it, it won't get done. Nothing will get accomplished. It all depends on me!

How is running your business different from what you first envisioned it might be?

I had no idea what it would take to run a business. I have always been an hourly employee, never taking or wanting to have any kind of management positions. So it has been really hard for me to see all the aspects of what is needed to run a business and to succeed in business.

How is this economy affecting your business?

I have never been busier. But then, I am really working hard and concentrating on scheduling more sessions to increase sales.

Do you shoot what you love, or what sells, or both?

I shoot whatever is in front of me. Whether I want to or not.

Is there anything you wish you would have done differently?

One thing that amazed me is how much I need to know about the computer and Photoshop in this business. I wish I would have known this before I went out and bought my camera equipment, because by the time I was up to speed on image editing, my camera equipment was outdated. If I'd known this, I could have used the money more wisely or waited to get better equipment.

Where does your fee structure and pricing fall within your market: high end, low end, or middle?

I think I'm in the low end right now—I'm still working my day job and my clients are my friends and coworkers. I have a hard time charging them high-end prices. But I'm moving toward outside clients and I'm planning to charge them mid-range prices.

What other means of promotion do you/have you used, and what has been the most successful?

All my clients are word of mouth. I'm afraid that if I advertise I'll get too busy and then I couldn't keep up with all my other commitments.

What's the single most important piece of advice you have for an aspiring photographer?

You have to love shooting images of all kinds. Photography isn't an easy thing. Early mornings for sunrise, dinnertime for sunsets, crawling on the ground, lots of weekend shoots, carrying heavy gear, spending lots of money on the latest and greatest piece of equipment. If these things don't stop you, you will succeed!

What are some of the highlights of your photography career so far?

I have highlights all the time. The first stock image I ever sold in 2006 was one. Recently when my boss used the images I had shot in her PowerPoint presentation and they looked really good—that was another! And when Laurie Excell reviewed my portfolio at PS World '08 and she looked up at me and said, "You need to quit your day job."

You might see yourself in some of these stories—I know I do! What strikes me more than anything else about each and every one of these newbie photographers is their work ethic. They are all driven, not just to make images, but to make the best images they can, to please themselves and their clients, and to keep on stretching and growing, professionally and creatively. It seems clear to me that whatever avenue each pursued into the photography business, whether they are part-time or full-time, whether they shoot nature, or people, or both, their internal impulse to excel is the key to their success.

LIFE TO AN OLD BUSINESS

Congratulations! Your photography business has survived the treacherous start-up stage. You've learned how to weather the cash flow roller coaster, you know how to win and keep clients and you've been profitable for several years—more so than you had dared to hope! You're out of the woods, right? Or is there a little voice in the back of your head whispering, "Famous last words?"

DROPPING THE BALL

Oh boy, you've been in business for a while and people seem to know who you are. You call prospects and say, "Hi, I'm Stanley Kowalski," and they say, "Oh, yes, Stanley, I've seen your work." You have a solid client base and it's been a long time since you've gotten that fluttering, sick feeling in the pit of your stomach when things are a little slow. Maybe your business has even shown good growth every year since you started. Maybe you're even turning away work. You're enjoying the prime of your business life. So what do you do? You relax a little. You don't send out that spring postcard. And it doesn't matter; spring is just as busy as you expect it to be. Then you skip the newsletter, and you stop sending those thank-you letters to clients who send you referrals. Still no adverse effects. You don't leap at the phone anymore when it rings, and you get a little lax in your costumer service. You stop putting new work in your book. A year of this and still no ill effects. Two years, and your gross isn't up anymore, but it's stable. Three years: You're not turning away jobs anymore, but you're not worried. But the four-year mark comes, and suddenly you're wondering where everybody went. Where are your loyal clients?

When you're not on top of your game, you won't see an immediate drop in business. It's gradual erosion that often is not

When I started my studio in 1988, I shot only small children with their pets and families. I offered only black and white, sepia-toned, and hand-colored images to my portraits clients. Not being a big fan of direct color film, I shot color transparencies for commercial clients only (and only shot for commercial clients when the project included kids).

When I embraced digital capture and learned image editing, I was finally able to offer color prints that I felt looked beautiful enough to hang on a wall. This was stimulating for me creatively, and it gave me a new product to introduce to my clients helping me maintain an edge in my marketplace.

apparent until it's too late. You'll be like Wile E. Coyote when he chases the roadrunner off the edge of a cliff, but he doesn't realize he's already doomed to plummet to earth until he looks down.

By the time you look down, you'll be scrambling to get a marketing plan back in place, freshen up your portfolio, renew acquaintances with old clients and glad hand a few new ones, and brush up those customer service skills, all just in the name of damage control.

If only you hadn't dropped the ball, you'd still be growing your business right now instead of trying to build it back up again.

Avoid the mistakes complacency breeds.

- **KEEP MARKETING**—even McDonalds still advertises. As successful stock photographer Jim Zuckerman says, "You have to market constantly. Perpetually. You never stop moving."

- **KEEP YOUR WEBSITE UP TO DATE**—you still need to show the world the best face you possibly can. And if you're a commercial or fashion shooter, your portfolio needs to be up to date as well, even if you don't show it much anymore. You never know when someone is going to ask for it.

- **ANSWER YOUR PHONE AND REPLY TO E-MAIL PROMPTLY**—they are still your most powerful sales and marketing tools.

- **KEEP UP THE CUSTOMER RELATIONS**—they're still the reason you're in business.

- **REMEMBER, YOU'RE ONE OF THE LUCKY ONES**—you're living your dream.

DISILLUSIONMENT

Another pitfall the owner of a newer studio can encounter is disillusionment, and even bitterness. The honeymoon is over; you're living with the day-to-day reality of a photography business. The work isn't always as creative has you'd hoped it would be. You're working in the studio and in the office more than you'd anticipated. Some of your clients have proven to be less loyal than you thought they were. The paperwork is a pain in the backside. It's sometimes hard to collect payment. You're still shooting solid, technically excellent pictures, but some of the market has moved onto the next new thing. The new thing isn't as good as your thing, and it'll only be a flash in the pan. You know this, you've seen it before, but it still insults your integrity. Other shooters are leapfrogging past you and snapping up some of "your" market. You aren't in touch with the beautiful parts of the business anymore. You can't remember what made you want to get into this. You are disillusioned.

Disillusionment is a very dangerous place. If you don't change your attitude, your business will fizzle away.

• **TAKE A BREAK.** If you're like most entrepreneurs I know, the word vacation isn't in your vocabulary. Your work is your life. You find relaxing more tiring than working. You worry that if you leave town one big client is going to up and leave you. Or that you'll miss out on the mother of all jobs because you weren't there to answer the phone. Or some competitor is going to spring up across the street while you're gone. Probably you believe your studio will burn down if you're not there to protect it by sheer force of will. Get over it. The burnout you'll suffer from working without a break will be worse than anything that could happen to your business in your absence.

I speak from experience. I worked five to seven days a week with almost no reprieve for the first five years after I opened my studio. I loved my job. I had boundless energy. But then, during Christmas season number five, I suddenly hated everybody. My clients, myself, my neighbors, the person in line ahead of me at the supermarket, the other drivers on the road, my friends and

family—everybody! I hated going to work. I started to fantasize about going back to waiting tables, marrying rich and winning the lottery. I'd had it with photography.

I really thought that my work was my problem. But a conversation with a friend who was a Pediatric ICU nurse—a woman who, needless to say, knew a lot about stress and job burnout—told me what was really going on.

"You need a vacation," she said. "You've got job burnout. You go away, you come back, you like your work again."

I thought she was nuts—and right at that moment I didn't like her too much, either. I didn't take her advice until six months later. By then I didn't care if the studio burned down while I was away.

She was right! I went to central Mexico for two weeks to visit friends who lived there. I saw original works by Freda Kahlo and Diego Rivera; I visited pyramids and artists' colonies and ate fruit my friends called "snot grenades." It was a very exciting and intriguing trip, but in reality it probably wouldn't have mattered if I'd been holed up in a Motel 6 with nothing else to do. The point was taking a break from work. When I came back, I loved my clients, I loved myself, I loved my work—although I still didn't love the other drivers on the road.

• **VOLUNTEER.** We experience disillusionment when we reach a point in our careers in which we feel our business isn't giving us enough. Ironically, one surefire way to overcome this feeling is to give more to the community and the world. Volunteer to teach photography to low-income kids or physically challenged people and see how fast you're reminded of the magic and the beauty of the darkroom, of the view through your lens. You needn't limit your volunteer efforts to photography-oriented work. If you need a total break from your regular grind, do something totally unrelated. Join an adult literacy program; become a Guardian Ad Litem; read to the blind. Are you missing the chaos and action you experienced when your business was new?

• **TEST SHOOT.** Part of your disillusionment may stem from one of the paradoxes with which the photo business is fraught; you open your studio because you want to do creative work but as

you become more successful you do less and less of what you really love. So take some time for yourself and do some personal work. It may be hard to motivate yourself at first, since you're used to being driven by the client and by the almighty buck. Shooting something for pleasure will seem alien at first. But do it. It'll breathe life back into your drudgery.

- **COUNT YOUR BLESSINGS.** Sure, it sounds trite, simplistic and vaguely religious. But it works. Make a written list of all the things you're thankful for that your business has brought you: a good income, the freedom to be your own boss, job stability (you're not likely to lay yourself off, are you?), some creative expression, the satisfaction of knowing that people are willing to pay you for your creative vision … I bet you can think of a few more. Save the list and consult it from time to time.

As my client base aged and their kids grew up, I wound up shooting senior pictures for the kids that I had worked with since they were babies. I found that direct color images really appeal to teenagers.

- **EXPLORE ALTERNATIVES.** Go career shopping and see what's out there. You may find a totally different field that you'll be even happier in. Or, more likely, you'll come back to your list of blessings with a few more to add.

- **HAVE A GOOD OLD-FASHIONED GRIPE SESSION.** For years, I used to meet with a group of photographers for happy hour on Fridays after work. Inevitably the conversation would turn to all the aggravations we'd encountered at work that week. It always started out negative, but by the time we'd complained a little bit,

we'd all wind up laughing and jocular, and ready to face another week of business. It's not a matter of dwelling on the negative; it's a matter of letting the negative pass through you so you don't wind up carrying it around.

EXPANSION/CONTRACTION

Sooner or later your growing business will come to the point where it's almost unmanageable. You're at a crossroads. Do you take on more employees and a larger studio to accommodate additional business? You're doing well, so you can, but should you? Before you make the commitment, ask yourself the following questions.

Seniors love anything new and different, so working with them allowed me to exploit new artistic treatments in Photoshop that weren't possible before.

WHAT DO I WANT MY ROLE TO BE?

Up till now you've been a photographer: you shoot, you sell, you do the books, you empty the wastebasket, you do what you must to keep your batteries charged. But the bigger you get, the more removed you will become from these day-to-day, hands-on realities of operation. You will become a manager. You will oversee people who will do your shooting, do your books and empty your wastebasket. You will have to help them keep their batteries charged. You will become one step removed from your product and your clients. If this doesn't sound good to you, think twice before expanding.

Not sure if you view a role change from photographer to

photographer/manager as a positive or a negative? Answer the following questions true or false.

1. It's easier to do something myself than to try to explain to someone else how to do it.
2. No one else will be able to do my work as well as I do.
3. There's only one way to do things: the right way.

If you answered "true" to any of these statements, you might not be manager material. It's true that in the short-term, it's easier to do things yourself than to shift down a gear and teach someone else how to do it, but ultimately it will save you time to delegate many of your responsibilities.

And while it's true that no one else will do your work exactly the same way you would do it, they may still arrive at an equally good or valid outcome.

There's always more than one way to do anything. If you think there's only one way, you probably shouldn't be a manager; you should keep flying solo. Remember, though, even Batman had Robin.

CAN I MAKE DO WITH CONTRACTORS?

Is it possible for me to take on temporary help in the form of contractors to get through this busy time? Or do I need permanent employees? If your surge in business is thanks to just one or two huge clients, you may be wise to tough it out by hiring temporary help and renting extra temporary space as needed. I've seen many small businesses make the mistake of thinking all they need to justify expansion is that one big client because that client will be theirs forever. *Nothing* is forever. On the other hand, expansion may be warranted if your business has been growing steadily over time and if your client base is diverse.

AM I MAKING ENOUGH MONEY NOW?

How much money is enough money? Is there ever enough? Human nature dictates that there is not. And yet—are you happy with your lifestyle? Because expansion is a risk. You may or may not increase your income by expanding. It's no sure thing. But what is a sure thing is that you'll be increasing your fixed overhead—the

kiss of death for many businesses. If you're happy with your liveli-hood now, you may want to leave well enough alone, as difficult as that may be to do.

IS THERE SOME OTHER WAY I CAN INCREASE MY PROFITABILITY WITHOUT TAKING ON ADDITIONAL FIXED OVERHEAD?

If you're so busy you're turning away business (you poor thing!) maybe the answer to your problem is not to expand but to raise your prices. That way, the clients who can't or don't want to afford your services will naturally fall away and you'll be doing the same amount of work (possibly even less) and making more money. Or perhaps instead of taking on more staff or a bigger studio you could generate more business by going on location or selling your existing images for stock, greeting cards, fine art or other applications.

WHY BIGGER ISN'T ALWAYS BETTER

"You can be a big small business, cruise along and do fine for years," says wedding/portrait shooter Bob Dale. "But then say a large corporation comes into your market and they have a billion dol-lar marketing budget, they can suck up all your business and they don't even have to be profitable to survive."

Obviously if you have a bigger business and it's operating prof-itably, you'll realize more income than a smaller one. But when bad times hit—and there will be bad times—the operations with larger fixed overhead can be more vulnerable to failure than the smaller ones.

Reduced margins are the blessing of small businesses. I enjoy being a manager—I love to motivate, teach and coach. I like in-teracting with my employees as much as my clients. So it was no hardship for me to evolve in my role as my studios grew. But I discovered a disturbing trend after several years: The bigger my business got, the smaller my profit was. In my first year in busi-ness I had one studio and I only grossed $8,000, but I was almost 90 percent profitable. In my twelfth year, I had three studios and grossed $2 million, but my profitability dropped precipitously. It

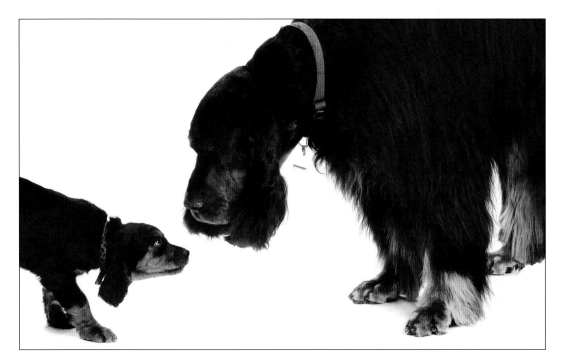

is possible to have a huge business, work really hard and still have a smaller net profit than the other guy who stays small and works half as hard. In my experience, the larger the operation, the higher your fixed overhead (rent for three retail locations instead of one, for instance), and the layers of employees and managers required increases.

Here's an example: Mom and Pop open a portrait studio in a trendy retail district. They own and operate it, and after two years they are making a net profit of $150,000 each year. It's a huge success! So much so that they decide to open another portrait studio across town. To do this, they need to hire employees to run the old studio and do all the things they used to do themselves. They need a manager, a photographer, an assistant and possibly even more employees. So they wind up with $90,000 worth of extra payroll, and they still have to spend time not only opening up the new studio but overseeing the operations of the old studio. Now they're working more hours than they did before. As it turns out, the new location isn't quite as profitable as the old one. It earns a net profit of only $40,000 each year. Now Mom and Pop are working more hours for $50,000 less a year. If the economy goes through a tough period or a big construction project blocks traffic

I noticed that many of my clients bought pets when their kids were about to go off to college. So when they brought their seniors in for portraits, I recommended that they bring their new family members, as well.

for a few months at one of their locations—or any number of other unforeseen difficulties arise—their profit margin may go down even further, but they'll still be working just as hard.

Sometimes small businesses wind up contracting rather than expanding. There's no shame in this—and it could make you more profitable. The trick here is to close one of the studios before the situation is desperate. Don't wait until you have to file chapter eleven and crawl away wounded. Make the move before your profitability drops to dangerous levels.

"At one time I had four studios," says commercial/fine art shooter Doug Beasley. "And I'm a location shooter! Imagine. Now I only shoot on location, I have no studios and I'm much happier."

LEARNING BY REPETITION

When I became an employer, I had the naïve notion that I would have to train each employee only once, tell them their job description once and send them off to work. Then they'd know what to do and they'd do it. Imagine my surprise when I realized I actually had to train them repeatedly for the same tasks and remind them what their jobs were over and over again.

Then I realized I operate the same way my employees do: I need to retrain myself, relearn lessons I already know and tell myself my job description ad nauseum. We're all human. We need to brush up occasionally. We need continuing education.

It's easy for me to continually educate my employees. I hold meetings or in-service sessions during the slow times of the year. These workshops cover the brass tacks, answering the phone, closing a sale, selling up, customer service—all the basics. At the beginning, I was afraid the employees would rebel. "Why are you telling me all this stuff again?" I thought they'd do what my five-year-old does when I repeat myself. She rolls her eyes, crosses her arms, tips her head, and says, "Mommy, I already know that." But to my surprise, they seem to enjoy the meetings. I suppose the coffee and doughnuts don't hurt either.

It's harder to reteach yourself. First, you need to realize that you've forgotten to practice some key policy, procedure or philosophy—ideally before your business begins to suffer for it. Then you

have to figure out where to go for a refresher course. Can you do it yourself or do you need the inspiration and motivation that a more formal setting, like a seminar, can provide?

• **SURF THE NET**. This is one time when surfing the Internet isn't a waste of time. Start with an open mind and enter a few pertinent words: photography +business+marketing+sales, for instance. Then go where your search engine leads you. You'll probably find many sites that lead you to classes, seminars, clubs and groups, and books and periodicals.

• **WRITE OUT YOUR JOB DESCRIPTION.** Sounds silly, doesn't it? Why on earth would you need a job description? You're probably thinking, "I know what I do, and the only person I have to report to is myself." But do you really know what you do? And since it is yourself to whom you're reporting, how do you hold yourself to a high level of accountability?

Another new product I've been able to offer due to digital technology is press-printed holiday cards and birth announcements. New services give clients yet another reason to come back.

I didn't always know exactly what it was that I did. I found out when I went to apply for disability insurance. The insurance company needed to know, not just what my title was, but what my functions were, in order to determine what it would cost to replace me.

"I'm a photographer—I take pictures," I told them.

"What else do you do?"

"Well, nothing, really."

"Who does your marketing?"

"I do."

"Who does your product development?"

"I do."

"Who does your sales?"

"I do." And so on. It suddenly occurred to me that I was doing more than I thought I was. I rushed back to my office and wrote myself a job description. By writing down and categorizing what I did, I was able to figure out what things I could or should be doing more, and what things I needed to start doing that I wasn't currently doing at all.

So take a minute to sit down and list all the functions you perform in your business. Then decide what areas you may be lagging in, and punch 'em hard. I look at my old job description and create a new one once a year.

• **TAKE A SEMINAR.** Chances are if you've been in business for a number of years, you're not going to learn much that you don't already know by attending a seminar—possibly a few tidbits or possibly nothing. But what a seminar will do for you is reinforce those things you already know, and remind you to practice them. I regularly attend marketing seminars for instance. I have attended the John Hartman Marketing Boot Camp twice. I usually don't leave these meetings saying to myself, "Oh boy, that's news to me!" But I do say to myself, "Oh, yeah! I forgot all about doing that. I should start doing that again." And I do.

• **REVISIT YOUR PAST WORK.** Sometimes you can be your own best mentor. Dig out your old promotional material, your old schedule books, your old lighting notes—anything that documents how you've done things over the years. You may be surprised to find that some of the things you used to do were pretty darn good. Maybe even better than the things you're doing now. Reincorporate them into your repertoire.

• **TEACH SOMEONE ELSE.** Nothing reinforces what you already know better than teaching someone else. I always wind up energized, recharged and on my game after teaching classes on business and creative techniques. I learn—and relearn—as much or more than I impart to my students. If you're not into stand-

ing in front of a class full of people, you can take it one student at a time by becoming a mentor, or taking on an apprentice or an intern.

- **JOIN BUSINESS AND PROFESSIONAL GROUPS.** Becoming involved in business networking and professional groups, you'll find opportunities to both speak and be spoken to on a variety of germane topics, and you may expand your client base in the bargain. I've given talks to groups that focus on women in business, church groups, the Junior League, the Woman's Club of Minneapolis, Kiwanis Club, small business owners and many others.

- **READ (OR REREAD) A BOOK OR PERIODICAL.** Pick a book or magazine. It could be on sales, marketing, public speaking, motivation, management, general business practices, relationships—anything that you can apply to your business. You can skim, speed read, open up the book and start reading on the page that falls open, or do the whole in-depth, cover to cover thing. All that matters is that you tickle those memory cells enough to refresh your perspective on your day-to-day business.

TRACKING PERSONAL ECONOMY, INDUSTRY ECONOMY AND NATIONAL ECONOMY

In order to really see how your business is doing, you need to separate out the layers of different economic states that are effecting its development. In this way you'll be able to get a clearer picture of where you've been, where you are now and where you're likely to go. Let's say you've been in business five years now. Make yourself a graph. From left to right, start with the year you opened your doors and progress to the present year. From bottom to top, indicate units of measure. Now use a red line to chart your personal economic progression. Use a different color line to indicate what the national economy was doing that year. You can use different factors in determining this: consumer index, unemployment rate, the stock market, etc. Or you can factor them all together and create your own subjective impression of the economy over your years in business. Use a third color to create a line indicating your local industry economy. Did your market lose any major clients in a given year? Did any agencies start shooting out of town?

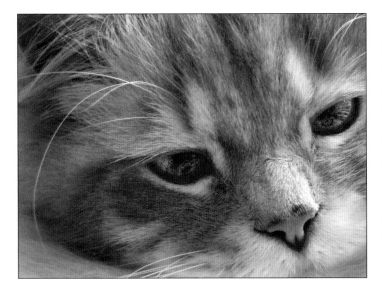

Did a big corporate competitor come to town, or did a big crop of small studios open up near you? When you've finished all three lines, take a good look at them and see how you did. Did your personal economy grow even in years when the national economy was flagging? Did your personal economy flag when your local market was growing? Spot the trends. Adapt accordingly.

A pet portrait by Vik Orenstein.

PROS AND CONS OF MIDDLE AGE

Just as with anything in life, there's always a trade-off. You give up one thing to get another. The thrill and anxiety of youth gives way to the confidence and boredom of middle age.

Topping Out

Eventually your business growth will level out. It will have reached maturity, much like a child who enters her young adult years and stops getting taller. I didn't believe this until it happened to me. I had at least 20 percent growth every year for twelve years. No matter what the economy did, no matter what my competition did, no matter what my local market did. I thought that "topping out" was just a nasty little rumor—an urban myth. (But then, there was also a time I believed I was never going to die, either.) Then, in year thirteen, the growth started slowing down. In year fourteen, it stopped altogether. My business had reached maturity. This is good, because I'm stable, I'm secure, I can anticipate what my income will be from month to month and year to year. But it's also bad, because the excitement of watching the growth is over. Gone are the days of looking at quarterly comparisons and saying, "Oh my gosh, look how much we're up over last year!" Ironically, this mature, stable stage was what I eagerly looked forward to when I was a start-up. Now I look back fondly at the start-up stage. There's just no pleasing some people.

Fear and the Lack of It

When you're new in business, everything is scary. There are monsters under your bed. Are you good enough? Is someone else better? Will there be images on the film when it comes back from the lab? How do I file those government forms again? What if the client doesn't like my work? What if the client doesn't pay? What if I can't take the pressure and I wind up in at a nature retreat weaving baskets with my toes? What if I fail and I have to go back to my day job? What if I fail and I can't get another day job? What if I lose my life savings?

The fear is with you all the time. You have to face it down every morning when you get out of bed. You wear it all day and you go to sleep with it at night. And that's the good news!

The fear certainly is a powerful motivator. It's hard to live with but it makes it easy to keep on keeping on. Sometimes I think fear is just another word for enthusiasm. When you've been in business long enough to be really confident in your abilities you need to replace the fear with satisfaction as a motivating factor.

"I was outside a church prior to a wedding, and I watched the photographers shoot it," says sixteen-year wedding photography veteran Hilary Bullock. "There were two young girls, all dressed very hip and edgy, and they descended in a frenzy on one big floral arrangement and shot it crazily from every possible angle. I would have taken just one shot, because I'd know the shot I got would be 'the one.' Enthusiasm or experience, either one will get the job done. But, boy, they sure look different from the outside."

DEALING WITH LOOK-ALIKES

If you stay in business long enough, eventually someone is going to imitate one of your innovations—whether it be your visual style, how you sell, your fee structure or how you position yourself in the market. Take heart! When this happens to you, you'll know you've arrived. It means someone is impressed enough with your work to want to go out and do it themselves. Imitation is the sincerest form of flattery, and all that. But it can be aggravating, too. Especially if someone swipes your idea, and a little piece of your market goes with it. What can you do to stay ahead of the folks who want to jump on your bandwagon?

- **RAISE THE BAR.** Refine your art and hone your market to pull yourself above the crowd. Make yourself the best darn photographer in your market.

- **KEEP INNOVATING.** By the time you've been doing something long enough for a competitor to take notice and knock off your concept, it's probably time to do something else anyway. That way, when you see someone imitating your old visual style or your old marketing methods, you can honestly say, "Oh, that. I was doing that three years ago."

- **STAY THE COURSE.** Almost always, the original of anything is the best. Those who come after can try to re-create your work—and your success—but it will often result in a pale imitation.

- **PUT IT IN PERSPECTIVE.** As we've often heard it said, "There's nothing new under the sun." Ideas and inspiration go around and come around. I once thought I was doing something really original and unique by grouping portraits into diptychs, triptychs and other arrangements and framing them together. One day I went to a friend's home and saw a similar grouping hanging on her wall. "Aha! Someone is copying me!" I thought. But upon closer examination I realized I was wrong. It would have been tricky for this photographer to have copied my idea. As it turned out, this was a popular look from the 1930s into the 1960s. Oh well. At least I was in good company.

FINDING SATISFACTION AND EXCITEMENT OUTSIDE OF WORK

In the early years of my business, my work was my life and my studios were my babies. It was easy to throw myself into every aspect of photography, because I was hungry, I was passionate, I was energetic—and I was scared. I never really believed I had any images on my film until I got it back from the lab—and then I breathed a huge sigh of relief. At the time I didn't realize it, but I was having the most fun of my life. I never appreciated that

early stage when I was in it; all I wanted was to be around long enough to stop being scared, stop feeling like an impostor, stop scrambling and basically be able to say, "Hah! I've arrived. I'm the old kid on the block." I was like a little kid wanting to grow up too fast.

And let's face it: You can't go home again. You simply can't re-create the excitement and the rewards you derived from your business when you were a upstart and it was a start-up. But you still crave that excitement—I'll even venture to say you need it. So, after you've been around for a while, you need to get it elsewhere—outside of the studio, outside of the office and even outside of the field of photography. It's imperative that you fight boredom at all costs. A bored photographer is a bad photographer; a bored entrepreneur is a bad entrepreneur.

This is a great time to develop a Plan B—a side business or investment that can help build your nest egg or float you through the tough economic times. If you already have a Plan B, now is the time to take it out of the closet, shake it off and fluff it up.

Wedding/portrait photographer Bob Dale knew he wanted to be a photographer since he was in the eighth grade, but he has never limited his entrepreneurial focus to the photography business.

"All along I've been into other things," he says, "like the stock market and real estate. I'm probably not going to have a salable commodity when I retire. I hope to, but I can't count on it. And I'm not counting on social security for a comfortable lifestyle. So I've always looked at my studio as a way to generate cash to make investments."

Or perhaps this is the time for you to finally write that novel that's been simmering on your back burner. Or make a sculpture, or dust of that cello—dabble in a complementary creative field and you'll probably feel refreshed.

END GAMES

Typically, middle age is when you start to think seriously about your retirement. Many entrepreneurs in other fields open their businesses with the intent of one day selling them. In fact that's often when they make the big bucks—not when they're actually

growing the business. But if you're a photographer, what exactly will you have to sell?

You have a client list. You have goodwill, as its called by those in the legal profession. You either own a building or you hold a lease on a commercial space. You have equipment, props, backdrops, etc. You have an image (also referred to as "corporate identity"), a proven system of operation, a product, and you have your expertise. You also have some big problems.

- How do you arrive at a price for your business?
- How do you find someone who can afford to buy your business? "Who has fifty, sixty, one hundred K or more lying around?" asks Bob Dale.
- How can you convince your potential buyers that your client base will stick around even after you're gone?

There are many different formulas for determining the value of a business. My personal favorite is to figure out your average net for the last four years and multiply that by three to five.

Your accountant, lawyer or a business broker can give you an opinion on how to value your business. Be forewarned: A business appraisal can cost up to several thousand dollars.

Finding a buyer can be another sticky wicket. CPA Jim Orenstein has some suggestions on how a photographer might target a qualified buyer and make the transition between owners successful and beneficial for everyone involved.

He recommends dealing with someone you know. It could be a person you already employ or even one of your clients who may have expressed an interest in learning to do what you do. Chances are you'll need to finance them partially, but don't loan them the entire purchase price. If they have some capital invested up front they'll work harder to make a go of it.

Jim's method of passing on the business takes roughly two years from start to finish. The original owner/photographer brings in the new owner as a sort of partner, maintaining a presence while teaching the newbie the trade and helping him build credibility in the minds of his clients. The new owner earns a livable salary while paying the balance of the profit to the original owner toward the purchase price of the studio. Of course, until

it is paid off, the loan from the original owner to the new owner is accruing interest. Commercial/fine art photographer Leo Kim calls this the "someday this will all be yours" approach to selling your business. He has very gradually begun to do this with a protégé who is not yet a photographer but who has business experience and has shown a talent for visual art. "He really wants to be a photographer," says Kim, "and he already has the business experience. In six or seven years, when I turn it over to him, I think he will do very well."

Just as the start-up has its hazards, so does the middle age of a small business. But if you apply the same energy and ingenuity to your studio when it's in its prime that you did when it was new, you might just find that this stage has its rewards, too.

BREAKING AWAY: EXPLORING NEW NICHES

There are any number of reasons photographers leave one area of specialty for another, or add a new specialty to their existing one. The realities of their market may cause them to steer their careers away from the type of images they feel passionate about, and so they come back to their desired subjects and styles later in their lives. They may love the subject matter/images they get to create but dislike the particular industry or marketplace in which they are forced to compete. Their market, interests or the economy might change and force them into new areas. They may lose the physical stamina required for location work and turn to studio photography. They may crave a new creative outlet and new challenges.

AND NOW FOR SOMETHING COMPLETELY DIFFERENT—OR SOMEWHAT SIMILAR

Entering a new niche doesn't have to mean switching from underwater fish photography to weddings or from architecture to head shots. Often the change is much less extreme. A wedding photographer, finding his market suddenly crowded with upstarts willing to give away copyrights, might make a shift into lifestyle shooting—an area that requires a similar style and the same equipment but sells to a different market with a different fee structure. For a period of about five years I added child commercial shooting on top of my child portrait work—same subject but different market, fee structure and style. An architectural photographer may keep shooting editorial work for design magazines but also market to commercial architectural suppliers—same work, different market. Often finding a new niche involves some tweaking, not wholesale changes.

WHEN TO MAKE THE MOVE

It doesn't matter whether you're in the beginning, middle or later stages of your career—if your existing market falters, if a golden opportunity presents itself or if your heart wanders in a new direction—you should follow your gut. Of course, changing or adding new niches will create different pros and cons depending on what career stage you're in. A change at the beginning of your career, while it may prove necessary, will probably be extra difficult, given that you'll still be in the learning stages regarding both your art and your business. But on the pro side, you're young, you're supple, you're energetic and you're willing to do anything to succeed. You don't yet have a huge ego involvement or emotional tie to your original area of specialty, so you're freer to try new markets.

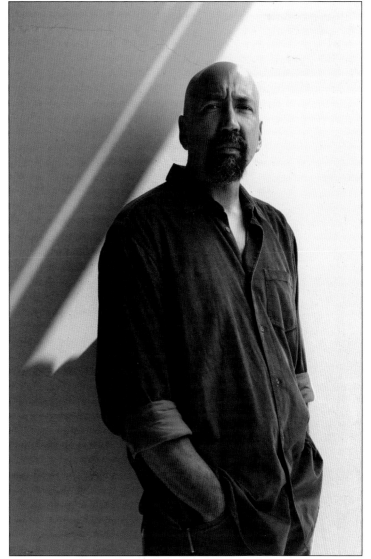

Ibarionex Perello fuses his talents for portraiture, storytelling, and street photography to create portraits of California Poets. This is Gar Anthony Haywood.

Making the change in your business' midlife can come with a bigger emotional price tag—you're committed to your specialty and your business is probably still appreciating significant growth, even if your market or the economy is failing. So making a change at this stage of life is cause for pause. Is this really necessary? You'll have your doubts. On the other hand, you're well into your career, and while the learning never really stops, you've got enough experience and enough resources behind you to make this kind of a transition easier.

Doug Beasley's fine art images are well received by his corporate and commercial clients, like this one of Torji Gate, Miya Jima.

Changing niches late in life can be a godsend or a heartbreak, depending on the motivation for the change. If you're making the change to pursue your dreams and make the images you've always imagined you'd one day make, then it will be easy. But

if you're a well-established shooter with a glorious career whose market suddenly dries up and forces you to start over in some new niche, well, that's heartbreak. You're used to being a big dog; now you're practically starting over with the little dogs again. But there's a hidden plus here: Once you get over the angst, you might actually like starting over. Some of that good wholesome fear, that thrill of the unknown that you had at the very beginning, might come back. It could provide a new lease on your creative life.

CRAIG BLACKLOCK: A NATURE PHOTOG-RAPHER MAKES A NATURAL TRANSITION

Craig Blacklock's late father and partner, Les, was one of the pioneers in the field of nature photography. When Craig joined his father in 1974, they were like kids in a candy store, shooting anything and any place they desired. There was always someone out there willing to pay top dollar for their images. While they didn't take assignments, they did keep their audience always in mind. "To be an artist is not just making yourself happy, it also means communicating with your public through your images," says Craig.

Blacklock creates two different kinds of images for two different kinds of art appreciators: "I have my more abstract work, which people buy for its artistic merit and as an investment. And I have my more literal work, which appeals to people who appreciate it for its regional value—they spent part of their summer on Lake Superior and they want to extend their vacation."

As the nature field became crowded and its practitioners increasingly disregarded standard industry billing and copyright protocol, it became very difficult to earn a living. Blacklock loved and cared deeply about his subject matter, so he wasn't about to give up nature photography. But he responded to the grim realities of the industry by creating new markets for his work.

"I opened two art galleries: Waters of Superior and Blacklock Gallery," says Blacklock. Thus he created his own retail market for his fine art photos. And as the calendar market faltered, with fees for images dropping up to 65 percent, Blacklock began to publish his own calendars and books. "I still sell images for editorial use and to designers and corporate art consultants, the people who do interior

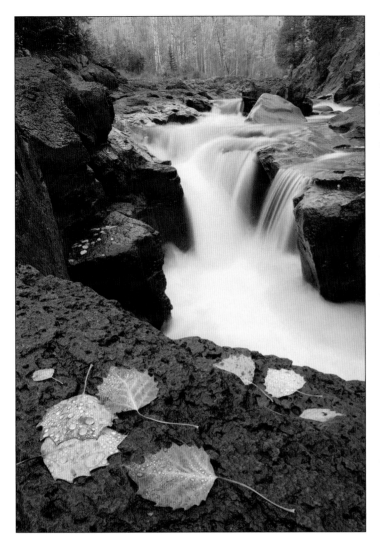

Craig Blacklock's fine art nature images sell well as decorative art for hospitals and hotels.

design for places like hospitals and banks. And I'm with Larry Ulrich Stock Photography, Inc. But to continue to thrive in this field, I've had to add to the ways I sell my images."

By applying his creativity to his business as well as his art, Blacklock has managed to thrive and to maintain his integrity in an increasingly difficult market. He has found a large high-paying niche in artwork sales to institutions, with the surprising addition of nature video sales.

"The biggest upside for me has been hospitals and hotels buying large numbers of prints. I am now complementing that work by doing nature videos that are played in hospitals. This is a niche I've worked in for many years, and now that many hospitals are remodeling or expanding, they're using more video—it is really paying off. Some sales have come in directly, but most sales come from art consultants that take 40 percent of the sale—and they are worth it! I've worked with some of these consultants for around thirty years. I always try to deliver ahead of schedule, and they know they can trust that when they place an order, their client's expectations will be exceeded."

Blacklock's large increase in sales to institutions has helped offset a drop in his sales to individual photography collectors, though there are still a few serious collectors buying large numbers of prints. And this has also served to offset the dwindling market for fine art books and stock images.

"Over the past decade or so I've put more and more emphasis on my print and self-published book sales. Stock continues to sell but is a very small part of my overall income. The biggest change recently has been the drop in high-end book sales. Last year I came out with a $60 book that included a three-hour DVD. It was a good value, reproduced very well, won awards and got many good reviews, and the movie played on public television. But the economy tanked, and with it, high-end book sales."

VIK ORENSTEIN: SAME BAT TIME, DIFFERENT BAT CHANNEL

I opened up my first studio, KidCapers (then called KidShooters) in 1988. My portrait prices were by necessity higher than those of studios that specialized in direct color or even standard black-and-white work because of the labor intensity of creating hand-processed, hand-painted fine art prints. My average client spent over $2,000 at that time on a photo session, portraits and frames, and I developed a reputation for being expensive.

The reality, though, was that I offered my hand-painted portraits at a price substantially lower—per portrait—than my closest competitors. The myth that my studio was expensive arose from that high average purchase; it wasn't that my portraits were more expensive, it was that my clients made bigger purchases. For clients who both desired and could afford the best, this was no problem. But my friend and at that time, employee, Pat Lelich, noticed that quite often we were losing clients because of this perceived expensiveness. Since it wasn't possible to offer our current product at a lower price and remain profitable, we became partners in Tiny Acorn Portraits, Inc., and opened our first retail studio in 1994. Tiny Acorn portraits were still custom hand printed and hand colored, but we eliminated much of the labor by simplifying the product. The prints were not sepia-toned and were not otherwise stabilized, so were not strictly archival. The coloring was done with transparent watercolor pencils rather than artist's oils (oils are more difficult to manipulate and take much longer to dry), and we offered pre-made frames rather than the extensive custom design and framing services offered at KidCapers. The result was

Even such a seemingly straightforward specialty such as portraiture can be established in a variety of niches, from point of purchase to retail; from wall art to photobooks; from fine art prints to machine prints. Here's one of my portraits.

A popular category for stock is "funny animals." This one is by Jim Zuckerman.

a product that we could sell for nearly 50 percent less than the product at our original point of destination studio.

At first there were a lot of doomsayers. "You're competing against yourself!" "Everyone will go to the cheaper, more visible and convenient retail studio and no one will come to KidCapers anymore!" and "Are you crazy?" were some common comments.

I didn't feel I was competing against myself at all, though the portraits offered at both studios were hand painted, the similarities stopped there. Each business had a different niche, a different price point and therefore a different client base. (Although it's true, there was some client overlap.) Only time would tell. At the end of the first year, the Tiny Acorn Studio had paid back its initial start-up costs and was even nominally profitable—a really successful start, in my book. And during that year KidCapers enjoyed the same growth rate of 20 percent that it had for the previous four years. So the doomsayers were wrong. Tiny Acorn Portraits was a legitimate new niche. Sure, it looked similar, but ultimately it proved to be different.

Tiny Acorn Portraits became such a successful business that in August of 2008, I was able to sell it to a current and a former employee who now own and operate it. I continue to own and operate KidCapers Portraits. Both businesses are successful.

KAREN MELVIN: ARCHITECTURAL INTERIOR PHOTOGRAPHER CREATES A MARRIAGE OF CONVENIENCE

When Karen Melvin started her career in architectural photography, she marketed herself primarily to local architecture firms and magazines. She also marketed to local hospitals, banks and any institution that might need architectural images. For the most part, she focused on generating editorial work. While the editorial field in general offers better than average creative freedom and prestige, typically editorial rates are far lower than commercial rates.

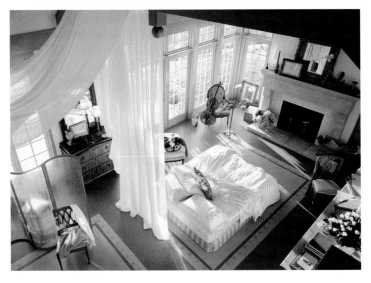

An interior photograph by Karen Melvin.

So eventually Karen started to market her work nationally to product manufacturers such as window and tile companies who supply architects and builders. The results thrilled her. "This niche pays more, and there's a bigger client base to draw from. There's more production value, more legwork—and I love that part!"

Karen still shoots editorial work that winds up in such acclaimed publications as *Architectural Record*. She has successfully wedded her editorial and commercial specialties. But more and more, her work is in advertising.

Any regrets?

"Only that I didn't plumb this niche earlier," Melvin says.

ROY BLAKEY: COMMERCIAL PORTRAIT AND FINE ART PHOTOGRAPHER SHOWS NAKED AMBITION

After teaching himself photography in the army (he bought his first camera in the PX [post exchange store] in Germany) and traveling the world as a professional ice skater in the touring show

"Holiday on Ice," Roy Blakey came to live in New York in 1967. He began his photography career shooting head shots for actors, dancers and models. "It was wonderful. I was the very person for it because I cared so much about these people and about making them look their most beautiful." Blakey shot his share of celebrities, including Chita Rivera, Tommy Tune, Felicia Rashad, and Debbie Allen. Eventually his work wound its way into such magazines as *Time* and *Gentleman's Quarterly*. He loved his work and yet there was a new fine art niche he wanted to try: the male nude. "There was no market for it, obviously. When I had a body of work I started calling editors to see about getting it published. They told me I was crazy," recalls Blakey. So he self-published *70s Nudes* in 1972. He presold all five-thousand-plus copies he had printed. Exactly thirty years later—to the day—the book was reissued to critical acclaim. Referring to the fact that his subjects were dancers and models at the peak of physical condition, Blakey says, "We used to joke that the book should be called, *Blakey's Bird's Eye Boys—Frozen at the Peak of Perfection!*"

Blakey's foray into this niche was made early in his career. After his initial print run sold out, he stored his nude photographs in boxes, forgotten until another fine art photographer found them and encouraged Blakey to find a publisher to reissue them. While the huge majority of Blakey's career was—and still is—spent making commercial head shots, his brief detour into the world of the fine art male nude gave him a new creative outlet and a place in the history of fine art photography.

ROB LEVINE: PHOTOJOURNALIST AND COMMERCIAL PHOTOGRAPHER—FROM STAFF EMPLOYED TO SELF-EMPLOYED

Rob Levine began his career in 1983 as a photojournalist, working on staff for the Minneapolis *StarTribune*. Now he is self-employed, sharing a warehouse studio with another photographer, and shooting publicity and commercial images. He also hosts websites where photographers can display and sell their images, including stock, and he sells studio management software through GripSoftware.com. While it was Levine's dream to be a photo-

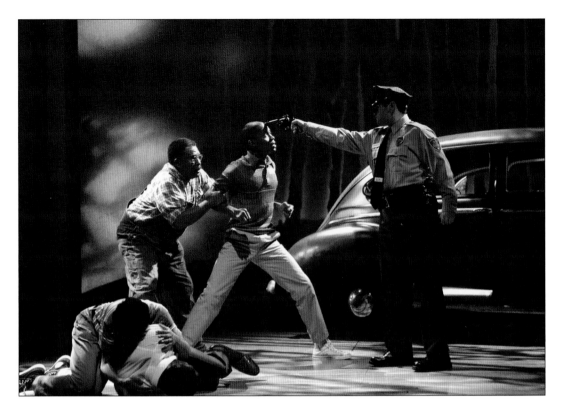

journalist, the realities of working in the industry left him cold. "I just didn't feel they were treating me very well," he says. When asked why he didn't try to work for a different newspaper to see if working conditions were better elsewhere, he says, "Because the *StarTribune* was one of the best in that regard."

Far from the gritty, grainy black-and-white images of his earlier specialty, Levine now shoots incredibly colorful high-resolution publicity stills for the Children's Theatre Company of Minneapolis, Minnesota. He gives this client maximum bang for its buck by hosting their website. "The site contains literally hundreds of media contacts. People can sign in to browse or use the images, and when there are new pictures, we send out e-mail notifications to the whole list. It's a very efficient and cost-effective way of publicizing the theater."

While Levine is passionate about his career as it is today, he says his heart is still in photojournalism. "It's all about going out alone, and I love going out alone," Levine says. "But I'm very happy with my career now. I have no regrets."

Rob Levine eased naturally from photojournalism into editorial photography, creating images like this one for the Minneapolis Children's Theater Company.

Leo Kim had worked for years in macro and landscape photography. When an illness forced him to stay in his home more than he liked, he found compelling subjects to photograph right in his own kitchen, and now he creates decorative wall art.

RANDY LYNCH: A PORTRAIT PHOTOGRAPHER GOES FORENSIC

When Randy constructed his home in 1990, he built in a home studio. His intention was to shoot portraits there—and for a while, he did. He also took a job as a forensic photographer with a county sheriff's department. The home studio became a playroom for his kids, never to be used again.

Randy is a genuine, extroverted people person. You can see how he'd be successful at portraiture and every aspect of that business. But when he talks about his experiences as a forensic photographer, he gets fire in his eyes. Words like *nanometer*, *omni chrome* and *luminal* sprinkle his speech, and he's too engrossed with his topic to notice that those who are listening might get lost in his dust.

I asked him if it didn't get boring, taking hundreds of pictures of one pair of jeans, each with a different filter, trying to illuminate blood or semen stains.

"It's never boring," he states emphatically. "When you find blood or semen, you've helped to stop a murderer or a rapist. How can that be boring?" Randy worked for the sheriff's department

for ten years and ultimately left because of political and personality issues within the department. "If it weren't for those issues, I'd still be working there today. I loved it."

But just as his issues with his forensic job were coming to a boil, he was offered an opportunity to buy into a photo lab in the busy Minneapolis skyway system.

"It was perfect," he says, "because there's one big crunch time when everybody drops off or picks up their film in the skyway, and that's lunchtime, so that's when I'm at the lab. The rest of the time I spend visiting commercial clients and taking care of business."

Randy also has established himself in a third photographic niche—he shoots weddings.

"Nobody ever asks me for the negs," he says, "because I'm their lab! A lot of my wedding clients are my regular lab clients, so I've printed their work for them for years."

These are some great success stories. But trying a new niche is no guarantee of a happy ending. I once tried to offer a less expensive direct color product at KidCapers Studio. Not only did no one buy it—not one family—but the very existence of this new product confused some of our clients and spurred rumors that the studio had gone out of business.

And you'd think that going from a huge, glamorous market like New York to a medium-sized market would be a breeze— that your little niche would be right there waiting for you. But when Roy Blakey brought his head shot business from New York to the Midwest, "It took forever for people to catch on to me. They all knew Ann Marsden (the reigning head shot queen of the time) and no one knew me. But I stuck to it, and now it's back to business."

GUARANTEE? WHAT GUARANTEE?

While adding or changing to a new niche is no guarantee of a heftier income, there are precautions you can take that will increase your chances of success:

• **KEEP YOUR FINGER IN THE PIE.** This is the photographer's mid-career equivalent of the warning, "Keep your day job!" Don't

drop your original specialty until your new one has proven lucrative enough to warrant it.

• **DON'T ROB PETER TO PAY PAUL.** Do not, I repeat, do not enter into a new niche if doing so requires that you take needed resources away from your original one. If becoming a dirt bike–racing photographer requires you to buy equipment with money you would have otherwise used to send out your spring portrait mailing, don't do it. Or if going out and becoming a field photographer leaves no one at your studio to answer the phone, forget it. The risk won't be worth it.

• **CATEGORIZE YOUR NEW NICHE.** Is it a simply a new product you can offer at your old studio or a whole new business that requires a new venue and identity? Is it an entirely new specialty area or just a different market for your current work? Is it a different product for your existing client base or a similar product for an altogether different client base? Once the answers to these questions have solidified in your mind, you'll be better able to create a business plan, just as if you were starting out from scratch, as outlined in chapter five.

• **QUESTION THE MASS MIGRATION.** When your market becomes saturated and other photographers head for greener pastures, you might want to stay put and bide your time. You may find yourself (happily) alone in a suddenly less crowded specialty.

You can see the logic in the progression of the niche-jumping photographers whose stories I've shared with you in this chapter. That's because their stories have already happened and we know how they come out—that's called twenty-twenty hindsight. If you're contemplating a similar leap, you don't have the luxury of knowing whether you'll have a happy ending. But then again, neither did they.

PRICING YOUR WORK

Within the different specialties of photography, there are very different fee structures and methods for pricing work, but photographers in every discipline share one characteristic: We have all, at one time or another in our careers, charged too little for our work, or we've given up usage rights and copyrights for little or no compensation.

To be fair, it's not just photographers who have trouble exacting their fees. I think its common among entrepreneurs and self-employed people across the board. I have a psychologist friend who jokes that she's going to teach a seminar for other psychologists that will consist of nothing but three days of repeating the same phrase over and over: "That'll be $200, please."

Fine art/commercial photographer Doug Beasley says, "It's somewhat arbitrary. I make up a number. Sometimes I check it against the ASMP (American Society for Media Photographers) guides and it's usually pretty close to what their standard is. I simplify the process—figuring out usage can be so complicated. I give away more rights than I should, but I'd rather live that way than live in fear of being ripped off."

Fashion/commercial shooter Lee Stanford credits part of the success and growth of his business to his ability to become savvier about charging for usage and setting his prices. "I used to give away too much. Now I go by the industry standard, and no one flinches. I think clients expect to pay for good work, and they don't appreciate you any more if you give it away than if you charge a fair price."

Though usage fees don't often come into play in my portrait business, there are gray areas when a portrait client wants to use a portrait for a business application, or a business owner asks to sneak in a few portraits of her kids during a commercial shoot. Early

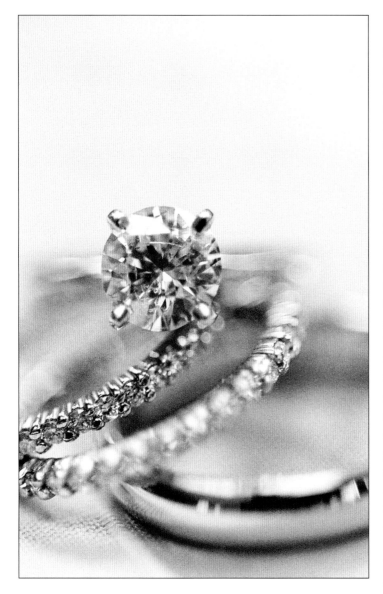

Most clients want to receive their digital files along with any photo albums, photo books and prints they order, so photographers like Hilary Bullock tend to charge an up front fee that includes the shooting fee, a photo book, and DVDs of part or all of the images.

in my career, I just swallowed my tongue—and the monetary losses—and allowed my clients any little favor, even if it violated my copyright. But now I, too, go by the book.

HOW TO SET YOUR FEE STRUCTURE

Fee structure and pricing are entirely different animals. Fee structure refers to what the client pays for and when he pays it. For instance, this is the fee structure for one of my studios: The sitting fee is required at the time of the booking; the cost of the sitting is determined by the number of subjects; the sitting fee covers expenses (the client doesn't pay extra for film, processing, proofs or anything else); the portraits are payable 50 percent upon placement of the initial order and 50 percent upon delivery.

That's my fee structure. Notice that there aren't any dollar amounts in there—that would be my price list.

Fee structures vary markedly from one area of specialty to the next. My fee structure is fairly standard for portrait studios. But a standard commercial shooter's fee structure would go something like this: A commercial photographer charges a standard day rate. The client pays the photographer's fee by the eight-hour day— usually there is a half day minimum; the day rate will fluctuate based on the usage of the photos (higher exposure usage results in

higher shooting fees); the client pays for materials and expenses, usually with a 15 percent markup.

You can see that a commercial photographer's fee structure is decidedly different from a portrait photographer's. Each different area of specialty will have its own little quirks in its way of billing for services.

You need to find out what the standard is for your specialty in your geographic location, and use it with integrity.

PRICE STRUCTURE

Your price structure refers to what you charge for your products and services. Here's the price structure for one of my studios: The basic sitting fee starts at $145; a black-and-white 5" × 7" (13cm × 18cm) portrait costs $89; a hand-painted 20" × 24" (51cm × 61cm) costs $850, and so forth. A commercial shooter's price structure might look something like this: A basic day rate is $2,500 for limited usage; higher exposure usage doubles the day rate to $5,000; travel time is billed at 50 percent of the day rate.

How do you know how to price your work when you're just starting out? First, you want to find out what your industry and market standards are. That is, what are other photographers who work in your city charging in your area of specialty?

PROFESSIONAL ORGANIZATIONS

One way to get up to speed fast is to join a professional organization like the one Doug Beasley mentioned earlier—American Society for Media Photographers. Not only do members receive a wealth of information on all aspects of the business, including how to figure usage charges, they also hold monthly meetings on issues like this very topic. If you attend these meetings, you can network with the people in the business, find out what they're charging and get a feel for the pulse of your market.

If you're a portrait photographer, you might consider joining Professional Photographers of America (PPA). They have a beautiful monthly magazine that covers all aspects of the portrait photography business, including creative, technical and business.

APPRENTICESHIPS, INTERNSHIPS AND ASSISTANT WORK

Of course one of your goals, if you do an apprenticeship or work as an assistant, is to learn this aspect of the business. Remember the advice of our seasoned photographers: Don't just learn how to set up lights when you assist—learn it all. When you work with an established photographer you get to see the how they put a price on their work, when they flex on a fee and when their fee is nonnegotiable.

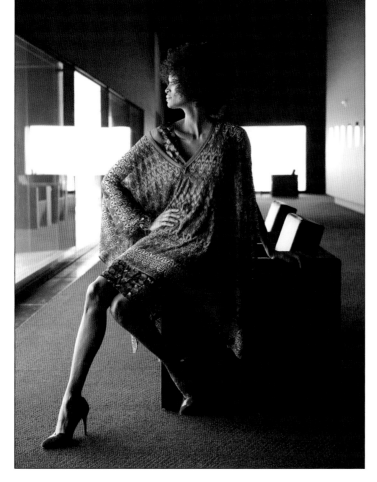

Fashion photographers like Lee Stanford generally charge a day rate that averages from $1,200 to $8,000 depending on your market. Editing/retouching and archiving may be built into the day rate or may be charged separately.

INFORMATIONAL INTERVIEWS

Informational interviews can be instructive in setting up your payment structure. You can also phone a few shooters and/or their reps and inquire about their basic day rate. Some may give you this information up front. Others may hesitate to make a blanket statement, preferring to make bids on a job-by-job basis.

PICK UP THE PHONE OR CRUISE THE WEB

Often photographers in portrait or wedding photography list their fee structures and prices on their websites. If they don't, try e-mailing them or calling on the phone to ask for pricing details.

Whatever you do, level with the businesses you approach. Sometimes people who are learning the market with the intention of starting up their own shop call my studio and are afraid to

tell us they are our would-be competitors, so they pretend they're potential clients.

Generally we can spot them right away, and this approach makes my coworkers and me feel extremely disrespected. We are more than happy to send out information to anyone so there's no need to invent stories. Our pricing is public record—it's no secret.

Speaking of secrets, some shooters, even seasoned established professionals, "secret shop" the competition from time to time. This is an especially common practice for national chains. I guess they like to see what we little guys are up to.

I have personally been shopped by three local photographers and one national studio, Lifetouch Inc. (They revealed their shopping trip to me and shared their impressions with me.)

I have never employed this practice, although I have been tempted. It is intriguing to find out how other people work.

BARGAIN BASEMENT, CARRIAGE TRADE AND EVERYTHING IN BETWEEN

Once you've discovered what the range is for prices in your market, you need to decide where within that range you want to position yourself.

Let's say you're an architectural photographer in Minneapolis. There are established shooters—people whose names you see on photo credits in local magazines—whose day rates range from $1,200 to $2,000 for editorial work, with the average falling around $1,600.

This macro nature image by Brenda Tharp could sell as stock and/or as decorative or fine art prints. The same image can be re-sold, so it's possible for a single successful image to make a lot of money for the photographer.

"I'm new," you think, "I'm just breaking in, so I should come in under the market, let's say at $800 or $900 per day, just until I get established." But that could be a bad idea for several reasons.

PERCEIVED VALUE

If your billing rate is below market, potential clients will think

your work is below market quality. This is because your prices tell the client how to perceive the value of your work.

It's different when you're selling a television, for instance. The television has an established value; it sells for $500 at a big electronics store. If the television goes on sale for $425, the consumer will be ecstatic! He'll know he's getting a great deal because he is getting a television that's worth $500 for $75 less. Your work has no established value, other than what you charge for it. Your clients have no other way to appraise it, unlike the television.

"The client is probably not looking for the cheapest deal," says Pam Schmidt, a former photographer's rep turned art buyer. "Usually they want someone whose estimate falls somewhere in the middle. Low-ball bids give the impression the work will be poor quality, and high-end bidders just aren't for everyone. There *are* clients who are simply price shopping—they're not concerned about quality, they just want a deal. But in my experience, you really don't want to be working with those guys. They want more for their dime than a regular client wants for their dollar, and they're really aggravating."

So where should a newbie position herself on the pricing ladder?

"Somewhere on the lower end of the middle—using your example range, I'd say just under the $1,600 mark. Don't go for the low end, or not only will your perceived value be less but you'll be competing with a huge pool of shooters. Remember, it's crowded at the bottom. And don't go for the high end, because you can't justify that—at least, not yet—and you'll take yourself out of the running for a lot of jobs," says Pam.

It's different for retail studios because their location gives them a certain perceived value, a niche. For instance, my Tiny Acorn Studios offer a hand-colored 8" × 10" (20cm × 25cm) portrait starting at $79—much below what you'd expect to pay. But because the studios are located in high-end boutique-style shopping areas, the product doesn't strike our clients as cheap, it strikes them as a boutique product at a shopping mall price.

Perceived value as it affects your market position is an important factor to consider when pricing your work, but there are many other concerns to add to your equation, too.

COGS, FIXED OVERHEAD
AND YOUR TIME

All your expenses including start-up, COGS (cost of goods), fixed overhead, pass-through and your own time, need to inform your pricing decisions. You have to charge what you need to stay in business, or you won't be in business for long. I hear from many people who say, "Oh, I'd just be doing this anyway as a hobby, so if I just mark up the costs of my prints a little bit, I'll be fine." But as Stacey King, fledgling wedding photographer discovered, that isn't often the case.

"When I first started shooting weddings, I thought I was really going to rake it in just by charging my clients $20 per hour and a 100 percent markup on my prints," Stacey says. "I thought I was going to make an outrageous fortune. I felt so magnanimous I was throwing in extra shots for free—after all, heck, digital capture is free, right? But when I revisited my first three jobs, I realized that not only wasn't I making any money, I was losing it! I had forgotten to figure in things like gas and mileage, recovering my initial investment in equipment, the costs I had to eat when brides ordered shots they didn't pay for, my dedicated business phone line, office supplies … you name it. It all seemed so insignificant at the time, but oh, baby, does it add up!"

PRICE POINT APPEAL

There's a whole psychology to pricing that could be the topic of several books all by itself. For some reason, $19.99 sounds cheaper than an even twenty. And 10 percent off gets just as many people just as excited as 15 percent off—but up the ante to 20 percent and watch them come out in droves. Two sweaters for the price of one doesn't bring out as many shoppers as "Buy one, buy the second one for a nickel." I don't pretend to understand it. Sometimes the human animal is just a mystery.

I never worried about price point appeal when I opened up KidCapers Portraits. I was running on caffeine and blissful ignorance. But six years later, when I opened my first Tiny Acorn Studio, I had a specific price point in mind that I thought would be especially attractive to my client base: I wanted to offer a hand-

colored 8" × 10" (20cm × 25cm) for $49. That sounded like such a deal! A hand-painted portrait for under $50? Amazing! So I went at the whole pricing process backwards—instead of figuring out my COGS, fixed overhead and time, and basing my prices on that, I noodled my expenses around to fit.

OH, THE DRAMA OF IT

Given that money is a very sensitive, emotional issue for many of us—photographers as well as clients—how can we make these transactions easier on everybody?

• **GIVE ALL THE BAD NEWS UP FRONT.** Hiding or downplaying costs may get you a client, but it will never keep one. It'll be easier to collect your fees and you'll stay on good terms when the job is done if you give your client all the bad news up front. Reveal all fees that the client might incur in the process of his shoot. For instance, at all my studios there is an extra charge for the painting of additional figures in a portrait. Each subject after the first costs an additional amount. So, if the basic cost of an 8" × 10" (20cm × 25cm) is $50, and each additional subject is a $15 painting fee, then an 8" × 10" (20cm × 25cm) with three kids in it would cost $80: $50+$15+$15. We tell our clients about the additional painting charge before they book their photo session. It's also stated boldly on our price lists and in our promotional material. This way the client never gets any rude surprises—and neither do we.

• **KNOW THE DIFFERENCE BETWEEN BIDS AND ESTIMATES.** In order to be considered for a job in such photographic specialties as commercial or architectural shooting, when the photographer is in essence acting as a contractor for the client, he will be required to give either a bid or an estimate of how much he will charge for the job. A bid is generally "written in granite." Here's a sample bid situation: *Winsome Woman Magazine* needs six outline shots for their May issue. Stanley Kowalski figures out what he thinks his time and expenses will be to do the job (if he's smart he adds 10 percent on top of that, because after all, surprises happen), and he agrees to shoot the job for that amount. That's it—if it rains and he gets

stuck on location with a trailer full of rental equipment and damp talent, tough cookies. He eats the extra costs—he may even wind up taking a loss on the job. But if he gets lucky and gets the job done in half the time and half the material costs, he still gets paid the amount of his original bid.

An estimate is a little different. Stanley figures it will take him two full days to shoot at $1,600 a day. Archiving and post processing will run $450. Any bad weather days will cost $800. So Stanley's estimate for the job is $4,080, give or take a rain day. Technically, because this is an estimate and not a bid, Stanley is allowed to have his final bill come in at up to $4,488, or 10 percent more than his original estimate Conversely, if Stanley gets the shots he needs in only one day and half the material costs, he should only charge the client $2,040.

• **GET IT IN WRITING.** Never make a deal on a handshake. No matter how good intentions are, misunderstandings can and do crop up even with clients with whom you share a long, happy relationship. Having a written agreement doesn't imply that you think your clients are going to try to cheat you, anymore than the person who takes out a life insurance policy thinks he's going to die prematurely. It's simply insurance. Just create your estimate or bid on paper with the parameters of the job and the terms of payment clearly explained. Sign and date the document, and ask the client to sign and date it upon acceptance.

• **BILL FOR PARTIAL PAYMENT UP FRONT.** Believe it or not, this practice benefits the client as well as you. Obviously, it helps you insure that you'll receive at least partial payment, and it also helps you cover your expenses up front. But it also helps your clients with budgeting when the payments are spread out over time. It's human nature to put off until tomorrow what you can pay today, but when the final bill comes, it can be a nasty reality. Paying bills is sort of like childbirth—after it's over, we forget the pain. So if a client pays you $500 up front for a $1,000 job, he forgets the ouch from that first $500. And after the job is done, and he gets his final $500 bill, it hurts less than that $1,000 would have.

Leo Kim sells his macro food images as 3" × 3" prints in classic gallery frames for about $20. He also sells them for stock through various agencies.

DON'T APOLOGIZE

I don't know many people who feel comfortable asking for money on their own behalf. It's almost always uncomfortable. But whatever you do, don't apologize! Don't shirk or cower, or say, "I'm sorry, the bill is $450." It goes back to perceived value: If the client thinks you don't believe you deserve your fee, he won't, either. You did an honest job, and you collect your honest fee. Period.

DON'T GIVE AWAY THE INTELLECTUAL PROPERTY FARM

It's always been difficult to protect intellectual property, and never more so than now. While more and more photographers are giving away their copyrights, it's more important than ever not to join the pack. Not only will you be losing money on the reuse of the images you give away, you'll be devaluing the quality of your work (your images could be reproduced shoddily and nonetheless they will still represent your work), and you'll be devaluing your own image (you'll be perceived as a bargain basement shooter and clients who are looking for the best photographers won't hire you).

Stick to your guns when it comes to retaining the rights to your images rather than offering complete buyouts. It can be hard during periods of bad economy and when your market is crowded, but in the long run, everyone will be better off.

WHEN A CLIENT VIOLATES YOUR COPYRIGHT

Don't assume that every copyright infringement is intentional—sometimes it results in a lack of knowledge on the part of the client, and sometimes, as when the client is a large corporation, it's a simple case of one hand not knowing what the other hand is doing.

If a client violates your copyright agreement, what should you do?

I recommend taking action but giving the client the benefit of the doubt. When you approach them the first time, leave your big guns at home. Take the position, "I know this was an oversight/accident/misunderstanding, but …" Be prepared to tell the client exactly what compensation you require, and explain how you arrived at your figure. Most of the time, whether the violation was intentional or accidental, the client is willing to comply.

If you meet with an uncooperative response, the next step would be a little chat with your lawyer, which we will deal with in detail in chapter eighteen.

Not all fee violations are as obvious as copyright infringement. Sometimes clients carry away the photographer's profits a few crumbs at a time, like ants at a picnic. One big way they do this is by squeezing extra shots into a job after you've already arrived at a price. It used to happen to me all the time when I shot commercial jobs. I was hired to shoot twenty-five cutout shots of kids and the client shows up toting thirty-five assorted play tables, sandboxes and art easels, and says, "Gee, we forgot to have the product photographer shoot these, can you just sneak these in between the kids shots?" The correct answer to this question is, "Sure, we can work those into the schedule! The shoot will go an extra four hours, so that'll run another half day." But they're standing there with the furniture they've lugged all the way up the freight elevator,

smiling at me hopefully and I know they want me to "just throw it in" and they know I know, so it's a standoff.

Another little profit crumb gets carried away when a job that was supposed to run regionally suddenly turns out to be national. Or a job that you shot for one local store gets picked up by one of the store's vendors and used all over the country. Often these infringements are carried out in markets that the photographer never sees, and you never find out. I don't know of any way to keep tabs on all the markets in the world. If you do find out, you should first approach the offender and request remuneration. In the unlikely event that the request is denied, the next step is legal action. If this is the case, you should consult an intellectual property law attorney. Many people give up at this point, intimidated by the financial and emotional cost of a legal action. But if you follow through, you'll be doing a great service to your fellows in the industry.

RAISING PRICES

Many businesses have formulas they use to figure out when and how much to increase prices. I had one vendor that raised prices 10 percent uniformly, across the board, every year. It had nothing to do with actual inflation, their COGS or the economic environment—they just did their 10 percent increase each year, come hell or high water.

In some years inflation is nominal and the consumer index drops, so many businesses hold off on price increases temporarily. On the other hand, the cost of medical insurance, worker's comp and rent in some areas have skyrocketed. So what's a photographer to do? When and how much should she raise her prices?

A slow, steady increase is best. I made the mistake of going six years without a price increase. I'd like to tell you it was part of a brilliant marketing scheme, but the fact is, I was simply not paying attention. My COGS and fixed overhead were going up every year, but my business was growing every year, too, so my income was increasing even though my margins were dropping. Then suddenly, I woke up and smelled the coffee. My trusty accountant told me, "You know Vik, you should be hanging on to more of this money you're bringing in." So I checked around my mar-

ket to see what my competitors were charging and raised my prices about 20 percent overall.

That seemed like a great solution until a long-standing client came in and threw a fit. She felt betrayed. "How could you do this? I've been coming here forever!" she said.

At first I just wanted her to leave my studio and never come back. But after some contemplation I realized she was actually doing me a favor. I realized that if she felt this way, there were probably other clients feeling this way, too, only they weren't telling me about it. They were just ticked off and maybe they were even taking their business elsewhere. My solution was to honor the old prices for old clients for one year. That way I could have my much-needed price increase, but my old clients felt pampered and appreciated. And now I keep my eye on my margins, so I make small increases when necessary instead of big ones when the situation is about to turn ugly.

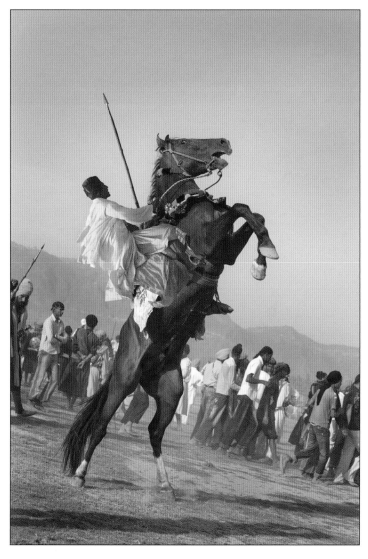

Jim Zuckerman sells editorial travel images such as this one through stock agencies.

I wouldn't recommend raising prices just because another year has gone by, but don't wait until you're just doing damage control.

The bottom line on pricing your services is this: Always do an honest job for honest pay. Learn what your industry standards are and position yourself within those standards according to your ability and experience level, taking into consideration your costs and the realities of your market. Don't let your emotions get in the way of collecting fair fees.

Ibarionex Perello says it very well: "You need to charge enough for your work to get your clients to give over their complete and total trust in you. Not only that, but the less you charge, the harder you'll work, because your clients will respect you less. You may think you should charge less than market value because of what you don't know. But you should charge based on what you *do* know."

Don't give away your copyrights. Intellectual property is still property—you wouldn't give away your house after all! And keep your price increases slow and steady. Do all this, and your clients will respect you, and you'll respect yourself.

YOUR BODY OF WORK

Y ou thought your big job was going to be creating your images, right? I'll bet you never dreamed you'd take more time organizing, archiving, showcasing, packaging and just generally handling your originals than you did shooting them. It's a dirty job, but we've all got to do it. Because the way we display our images tells others how we regard our own work. A misfiled, mislabeled or unlabeled original may as well not exist. A corrupt file, a missing file or a file in a format that's too small and suffers resolution loss each time it's opened is worse than no file at all. So most of us need to get our images off of our main computer hard drives and onto a backup of some sort. Not only that, but every photographer should have a redundant storage system—one that duplicates your backed-up files. Storage and backup systems can be manual or automatic.

STORAGE

Image files take up a lot of space—especially the large high-quality formats such as RAW, TIFF, and the highest-quality JPEGs. You can very quickly clutter up your computer's hard drive and use up valuable memory. Not only that, but if your computer crashes (and that happens more often than any of us like to think!) you may lose everything on it. Sure, there are forensic recovery services that can try to retrieve the files for you, but the expense is high and you still might not get everything—or anything—restored.

CDS, DVDS, EXTERNAL HARD DRIVES, JUMP DRIVES AND RAID SYSTEMS

• **CDS AND DVDS:** Before external hard drives became cheap and large (today you can get a terabyte of storage for less than 250GB

As a photojournalist and wedding photographer, Stormi Greener has accumulated millions of images over the last 30 years —such as this one made in Afghanistan. Stormi finds digital originals much easier to organize and archive than negatives.

cost four years ago), CDs and DVDs were popularly used to archive digital images. The drawback to disks is that they are not all created equal, and you can't tell simply based on how much you paid for them whether you've got good ones or bad ones. Regardless of whether your CDs or DVDs are high quality, they won't last forever. Some even have a life expectancy of less than five years. Not only that you can easily forget to label them, misfile them, lose them, and scratch them. I don't recommend using them for storage at all. They are great for delivering e-files to your clients. Beyond that, you need a better solution.

• **EXTERNAL HARD DRIVES:** An external hard drive, also called a storage drive, is a great way to back up the images on your computer's hard drive and to use for long-term storage. I recommend having one for daily backup. I keep all my active image files on my desktop, and I have an automatic system that copies the contents of my desktop to my external hard drive every night at midnight. It overwrites the previous day's transfer, so if I have to go back to it to find my work, I don't have to guess which day's version

I find. If you're a well-organized person, you can manually back up your images each day. But the automatic backup programs are inexpensive, and it's one less thing to think about if it's automatically done for you.

Flash drives are small, portable external hard drives. Generally these are used to transfer files from one computer to another, and not for long-term storage.

A RAID (redundant array of independent disks) system automatically saves your images in two or more places, so even if you lose one file, the other still exists. All image files are loaded from the card reader to the desktop of one of the three computers, and from there, immediately to the RAID system. This way, the images are accessible from any of our computers, and they are backed up.

• **LONG-TERM STORAGE:** Every January, I copy all of my image files from the past year onto two separate 250GB hard drives. I keep one onsite and take one to a storage facility. I could get a bigger external hard drive and store more years on each drive—but then if one of them fails I've lost even more files. And dividing up the images into tidy one-year groups makes them easier to manage. Some photographers use online services for their off-site storage. I personally prefer to manage all my image storage myself. In the past I've had some trouble with archive services, such as difficulties with the image transfer process. External drives are so small and easy to store, and so inexpensive, that I see no reason not to do the archiving myself.

FILE FORMATS

High-end consumer cameras and professional DSLRs all offer image files in the following formats.

• **JPEG FORMAT** comes in a range of quality levels and requires the least amount of storage space. I can get over one thousand JPEG images on the same image card that will only hold 383 RAW images or two hundred TIFF images. JPEG is also the file format used for uploading images to the Internet. JPEG files are not lossless. That means that every time you open a JPEG file, and every time you edit the file and save, you damage pixels and your image

suffers some resolution loss. To avoid this loss and create a lossless original, you should save a version of your JPEG file as a TIFF or PSD (Photoshop document). These formats never suffer damaged pixels from opening, editing and saving.

• **TIFF** is the largest file format. They provide you with exceptional high-resolution images, but the unwieldy size requires a lot of space on image cards and storage systems. This format was designed for desktop publishing and is still the image format of choice for publishing and offset printers. Some photographic printers are now able to print from TIFF files. TIFF is a lossless file format.

• **PSD FILES (PHOTOSHOP DOCUMENT)** are also a lossless format. PSD format allows you to save your images in layers. Layers allow you to have different versions of your image in the same document and to use different tools in Photoshop to create different artistic affects. To save images in every other format, the layers need to be flattened first, so it becomes difficult (and sometimes impossible) to go back and undo editing work. When you save a version of your work as an un-flattened PSD, you can go back to this file again and again and create different versions of your image.

• **RAW FILES** are incredibly versatile because the information they contain has not been converted into pixels yet. Before the raw file is opened in Photoshop or any other editing platform, you are able to adjust your exposure up to two-plus stops brighter or darker, crop, adjust white balance, and use a host of other tools, all without causing *any* loss of resolution whatsoever! There are two drawbacks to the RAW image format. One is the large size of the files. The second is that each camera manufacturer has its own RAW file converter. This forces Adobe to reverse engineer their RAW converters each time Canon or Nikon comes out with a new camera model. Therefore, it's quite possible that at some time in the future, those RAW images that we have so carefully preserved may become impossible to read.

• **DNG (DIGITAL NEGATIVE FORMAT)** was created by Adobe to unify the raw file format. You can get the latest DNG converter for Mac and Windows free of charge at www.adobe.com.

Many professional photographers shoot in RAW or RAW-plus JPEG for the largest, highest-quality file possible. But those in specialties that require shooting a large number of images in a short time (such as wedding and photojournalism) often shoot in fine JPEG. Do some research and testing to decide which format(s) are right for you.

Brenda Tharp uses Photoshop Lightroom to organize and edit her stock images.

ORGANIZING

No matter what media you choose to archive your work on, the organization of your files is enormously important. If you can't find a photo when you need it, it's worthless!

PORTRAITS, WEDDINGS, AND SPECIAL EVENTS

Customers are likely to reorder images from time to time, so a retail photographer benefits from archiving his originals in two ways for easy cross reference: by the date they were shot and by the client's name. If you do more than one shoot for the same client in a given year, a brief description is helpful.

I use a 250GB RAID system for active images, and external hard drives for "deep" storage. I always keep two sets of originals, one at my studio, and one off-site. I backup my desktop (with all active image orders on it) every day.

STOCK IMAGES

If there's a chance you'll use your images for stock, you'll need to organize them by descriptions and categories (keywords). Some stock agencies keyword your images for you, and some require you to keyword them yourself. More keywords equals more sales in the world of stock. There are many excellent software programs to help manage organization and keywording of stock images, from Picassa (a free downloadable program) to Adobe Lightroom.

ASSIGNMENT WORK

Some commercial photographers archive assignment work for their clients. Labeling with the client name, the name of the agency (if applicable) the name or purchase-order number for the job, and the date should keep your ducks in a row.

HANDLING

It's easy to become casual or even cavalier in the handling of your originals when you do it every day. You can save yourself some huge heartache if you remember to follow a few simple rules when storing, accessing and transferring your images.

- **ALWAYS BACK UP IMAGES IMMEDIATELY.** As soon as you move your images from your camera to your desktop, al-

ways immediately copy them to another location as well. This could be an external hard drive, a CD or DVD, a RAID system, or even a flash drive.

- **WATCH THAT DRAGGING AND DROPPING.** The drag-and-drop feature makes filing and accessing your files amazingly easy. Unfortunately, that also makes them enormously easy to lose. I have "lost" entire client files only to find them a year later, tucked into another client's file. A tiny wrist spasm can move Stein 2008 into Stern 2008 without so much as a splash.

- **ALWAYS CHECK TO BE SURE A TRANSFER WAS MADE.** After you transfer those images from your desktop to that DVD or external hard drive, check the DVD or hard drive to be certain the files are all there and intact. Be patient! Don't click on that file until the transfer is complete or you'll have to start all over again.

WHAT TO DO WITH YOUR OLD ANALOG ORIGINALS

Most established pros (and amateurs, for that matter) have made the transition from film to digital capture by now. So now we not only have to deal with our current digital work, we have masked negatives and sleeved negatives and mounted slides and assorted prints to deal with. And each take has a client who commissioned it or a stock category it belongs to. Most of them you may never have a cause to look at again. But is it okay to dispose of them?

"I don't think so," says sports and commercial photographer David Sherman. "Last summer I had an intern and we spent three months going through all my negatives and offering them to the clients for $25. But you have to consider the price of doing that. Time and labor organizing the images, finding the current addresses of the clients, postage for sending each client a postcard asking them if they want to purchase their negatives, packing them up and mailing them out... even this is expensive. But I'd hate to have someone need their negatives and not be able to have them just because I threw them out."

I personally have never destroyed or purged a single negative from any of my studios or my personal work. Some clients have come back to me years later for reprints due to personal tragedies, such as divorce, a house fire or the loss of a family member, and they are very grateful for this. The joy of being able to provide these people with photos of their families during a crisis is more than enough compensation for archiving the originals.

Ultimately, you must examine your own point of diminishing returns, i.e., the likelihood that you (or your clients) will at some future time want or need to reuse your originals versus the cost of the space and the labor involved in retaining them. In any case, if you do decide to retain originals, do it right.

- Meticulously label the originals and storage containers with all pertinent data, including the date shot, the client name, job or P.O. number, and subject matter.

- Use only acid-free archival storage receptacles.

- Organize your archives in a fireproof, waterproof storage area.

- Consider employing a hierarchal system of archiving similar to that used on most computer programs. More recent or more frequently used originals could be maintained in easy access—even on-site at your studio, with older and less frequently called for images stored off-site or in "deep" storage.

STORAGE FOR VARIOUS ANALOG ORIGINALS AND PRINTS

There are standard ways to store various types and formats of originals that maximize their longevity and minimize potential damage.

Anything needing to be archived, such as photographic originals or prints, should always be stored in sleeves, files, boxes and envelopes that are acid free. Archival storage products are available at professional photo stores and via mail order or online from such catalogs as *Exposures* (www.exposuresonline.com).

There are several types of storage systems for 35mm slides. Transparent, acid-free plastic sleeves are designed to hold up to twenty slides and fit nicely into three-ring notebooks for easy pe-

rusal. Acid-free cardboard slide boxes hold slides in the original boxes they come in from the lab, or just in the storage box itself without the lab boxes. These are not as convenient as the sleeves, in my opinion, and should be used only for deep storage.

Medium-format transparencies, like 120mm, are most easily stored in acid-free plastic sleeves. These are much like the sleeves used for 35mm transparencies, but they hold twelve images (one roll).

Four-by-five-inch and larger negatives and transparencies are housed each in their own individual acid-free plastic sleeve, and I find the most convenient storage boxes for these to be the boxes the film is packaged in. Additional boxes for this purpose can be purchased at professional camera stores.

Stock photographers not only need to organize and archive their images, they need to label them with as many keywords as possible so that a potential buyer doing a search at a stock agency or on the Internet will be able to find them. For instance, this image by Kerry Drager could be described using the following keywords: birdhouse, sunset, silhouette, pink clouds, sky, and even horizontal and space for text.

ACID IS THE ENEMY

Have you ever noticed how old newspapers turn yellow and brittle over time, until there comes a point when they turn to dust at the slightest touch? This is because the paper contains acid, and the acid causes the paper to self-destruct. Or, as an avid archiver once told me, "It eats itself." The same fate awaits even

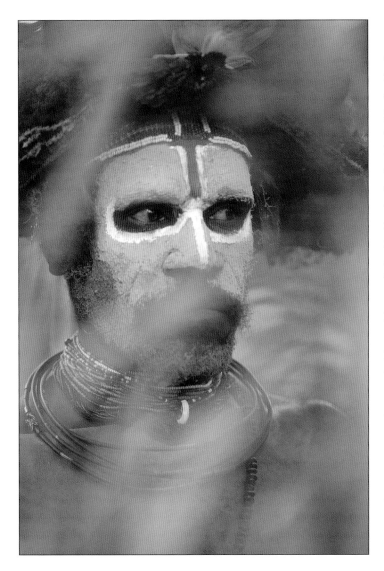

acid-free photographic prints if they are framed or stored in contact with acid-containing paper mats, file folders, paper envelopes and cardboard boxes. Professional acid-free storage containers cost a little more but are well worth it if you plan on using your originals in the near future or in years down the road. Even if you don't foresee a use for them now, you may be surprised later.

Roy Blakey was. "After I published my book of male nudes and sold all the copies, I completely forgot about the whole project for almost twenty years," he says. "I moved to Minneapolis and [the negatives] sat in boxes on the floor in a closet in New York, until one day a colleague found them and said, 'Hey, Roy, these should be re-released,' and he helped me find a publisher.

The new edition came out thirty years to the day after the

In Photoshop Lightroom, photographers can organize their images not only by categories and keywords but also on a scale of 1 to 5. This feature can save time when it comes to editing the best images for submission to stock agencies and wedding, portrait, commercial, and architectural clients. This image by Jim Zuckerman can fit into many categories.

first. And it never occurred to me that those images would be revisited until this fellow found them and dug them out."

Even if you don't reuse the originals, someone else might. Henry Larsen was a gifted amateur photographer who shot a wild array of subjects in the 1940s, 1950s, and 1960s—everything from salon-style nudes and pet parades in Iowa to oil slicks on parking lot water puddles. He carefully organized, labeled and archived every negative he ever shot, and when he died these images were passed down to his grandson, who is also a photographer. Many of the images have been reprinted and given various treatments,

including hand coloring, to be resold as stock and fine art images. Larsen's photographs are quirky, whimsical and they don't fall into any particular market. He simply shot for the joy of it and never expected his photos to reemerge after his death, becoming a gift to later generations of photo enthusiasts.

BEWARE THE WRATH OF FIRE AND WATER

Whether you store your images digitally on disk or archived in plastic sleeves and boxes, your storage space must be reasonably fireproof and waterproof. If you don't have a lot of originals, they'll probably fit well in a safe that can be purchased at an office supply store.

For a larger volume of originals, you may want to investigate off-site storage, especially if your studio is in a pricey commercial space (you don't want to pay retail rent for cold storage).

There are storage companies that specialize in this service, or you might look even closer to home. For instance, the building in which you rent your studio space may have basement or interior space that is undesirable for other uses (and therefore inexpensive to rent) which could be made into adequate fireproof, waterproof storage areas.

PORTFOLIOS

Commercial, architectural and fashion photographers use portfolios, or "books," as a means to display their work to potential clients. Each market or geographical area will have its own very rigid written and unwritten rules about what is required for the appearance of your book. Expectations and industry norms evolve over time. Often the requirements or standards that describe an adequate book seem ridiculous or unreasonable.

Ten years ago, the last time I had a commercial portfolio, the standard in my market was to show 4" × 5" (10cm × 13cm) transparencies of your ten best images. The transparencies had to be mounted inside two 11" × 14" (28cm × 33cm) sheets of KYDEX—a plastic product used inside of suitcases. There were only two places that you could get it, and it was expensive and very, very difficult to cut. My professional frame shop mounted

ten images for me in KYDEX and handed me a hefty bill with a warning never to bring them that stuff again. There was one fellow photographer in town I finally found who would cut KYDEX at a reasonable rate, but right after I found him, he moved to Alaska.

I thought that was about as bad as it could get. But the portfolio requirements in this market now make commercial shooters yearn for the good old days of KYDEX.

Today you have to hire a designer and a bookmaker to create a high-quality bound book for you. The goal is to make a portfolio that looks like a very expensive coffee table book. Forget about the quality of the work inside—the competition is fierce to have the most unusual, best-designed book. The covers are made of everything including, but not limited to, metal, leather, fur, bookmaking fabric and wood.

"It's pretty outrageous," says Lee Stanford. "Especially now that people only call for your book once or twice a year. But you've got to do it."

To find out what the requirements are for portfolios in your market, join the ASMP, call art directors at local ad agencies and ask what they like to see or do some assistant work or informational interviews inside of an established commercial studios to see what kind of books they are showing.

PACKAGING THAT CERTAIN SOMETHING

No matter what your area of specialty, you ultimately deliver something into the hands of your client—either a CD, a proof album, a print or even a framed piece of art. No matter what it is, the way you package it will have an effect on the client's satisfaction.

• **DISKS AND CDS FOR CLIENTS:** Present your disks and CDs professionally. "Some photographers deliver disks with the P.O. scribbled on them in Sharpie [permanent marker]," says an ad agency traffic director. "Others have gorgeous matching labels for their envelopes, disks and CD cases. It's just really classy and it adds value, and also gets people talking around the agency, when the package is nice."

- **PORTRAITS AND PRINTS:** Packaging was never an issue for my KidCapers Portrait Studio because most of our clients purchase framed, finished wall art from us. But in the early days of my Tiny Acorn Portrait Studios, before we did our own framing, clients picked up their hand-colored photographic prints right at the studio. Never one who appreciated the value of good packaging, I had my employees send our prints off with the clients in whatever was handy—photo paper boxes and sleeves, envelopes from the lab, file folders, you name it. Thankfully, a very helpful (albeit disgruntled) client called me to voice her displeasure. "I can't believe it," she told me, "I paid so much money for these beautiful hand-painted pictures of my babies and she [my store manager] just threw them in a file folder and tossed them at me!"

Now, I knew the employee well enough to know that she did not treat them with any disregard. But the client perceived a disregard for the portraits on the part of the employee because of the disregard with which I chose the packaging. Thanks to this client, I had packaging printed with our store name and logo and instructions on how to care for the prints while they were in their unframed state.

- **WEDDING PORTRAITS:** Wedding photographers have built-in packaging in the form of folders, albums and photo boxes. Some wholesale companies, such as Art Leather and ZookBook, offer such beautiful presentation albums, it almost makes me want to get married again (almost being the keyword here). I believe wedding shooters do well to build the cost of a proof book and album or photo box into their fee structure and deliver their product complete—the perceived value is enormous.

And just as awful packaging can make a good product look bad, good packaging can make a great product look even better.

If there is a moral to this story it's this: The regard with which you display, package and otherwise showcase your images tells others how to regard your work as well. If you spend a little extra thought, planning and sometimes money to present your work in its best light (pun intended!) you'll be rewarded with a healthier business.

I'm going to go out on a limb here and issue a statement that might make me unpopular in certain circles: Speaking strictly in monetary terms, great marketing and sales ability are more important to one's ultimate success than great photographic and artistic ability. This isn't fair. But it's true. I speak from my twenty-plus years in the business, observing my own and my colleagues' studios. There are photographers who are more talented than I am whose studios have failed. There are photographers who have little vision whose studios are thriving. The factor that separates the "Captains of Industry" from the photographers is simply the ability and the willingness to put yourself out there and forge and maintain relationships. In other words, those who are willing to market and sell.

"You don't just find a client base, you have to get out there and create your own client base," says Karen Melvin. "I think having a marketing plan is even more important than having a business plan, because if you have clients, you have business. You can have a business plan, you can have talent, you can have equipment, you can have a studio, but if you don't have clients, you're out of business."

"You really do have to sell. It's essentially like being a sales guy who's strictly paid on commission. When you don't have a guaranteed salary, you only get paid based on what you sell. And to sell, you have to be likeable. It can almost be like a congeniality contest more than like a talent show."

A holiday direct mail postcard for Darbonne Portraits.

You are your own product. Like it or not, when you're wooing a client you're not just selling your services or your products—you're selling the experience of working with you; you're selling your image, your personality.

It sounds so simple! If selling is the key to success, why are so many of us reluctant to get out there and just do it?

"Shyness," says Lee Standford. "There is a reason we like the back end of the camera instead of the front. It's scary to put yourself out there."

Makes sense. But how does one get over it?

Peter Aaron suggests that a young photographer does well to remember that the potential client welcomes the opportunity to see good photographs. "Call them up, and say, 'I've got some interesting pictures I'd like to show you and I'd like to meet you and see what it is that you guys do.' You'll be surprised at the warm reception you'll get. They welcome it; it's a break in their day."

But be aware that not every call or visit will lead to an assignment or a new client, at least not right away. "I call it 'planting seeds,'" says Patrick Fox. "You make a contact, you're nice to the person on the phone, you're nice to the person at the reception desk. You get your book out there. Sometimes it results in a job right away. Sometimes it takes years. You have to plant a lot of seeds."

KNOW THYSELF

Every good salesperson knows her product inside and out. She knows its history and its use. She knows what makes it unique. She knows how to tell its story. Before you can market yourself, your services and your product, you need to know exactly what it is that makes you different from all of your competitors.

"This is so important, now more than ever," says Karen Melvin. "More people want to be photographers than ever before and the market is soft. So you really need to stand out; you need to be specialized. You need a story about yourself."

Every successful photographer has something that makes her stand out among her peers, she knows what it is and she knows how to get her message out.

A gift certificate from KidCapers Portraits, distributed to guests of Peace House Foundation at their annual dinner and silent auction.

HAVE A RECOGNIZABLE MESSAGE

When I started my studio in 1988 my own message went like this: I am the only photographer in town who specializes in wall portraits of kids. I only shoot kids (parents and pets welcome when accompanied by a child). I only shoot black-and-white film, and I only offer black-and-white, sepia-toned and hand-painted prints. I only shoot kids acting natural, both in action and at rest. I use no traditional posing. I capture the true spirit of your kids. I am the kid specialist.

Ibarionex Perello's story is *about* storytelling. "I'm a writer and a photographer. But no matter which medium I'm working in, it's all about storytelling. My clients are all trying to woo their own clients, trying to find a means to connect with them and get them excited. Each individual person has their own unique and powerful story to tell, and each company is made up of people. So my clients hire me to find their story and then to tell it."

Karen Melvin is an architectural photographer who specializes in commercial shots of architectural products. Her message is all about lighting. "I use light to tell a story, and therein lies my uniqueness," she says. "When I take someone on a tour in my picture, the light is our guide. Each element in the photo has a different value as told by the lighting and the composition. It evokes a feeling. People respond emotionally to a picture in which light tells a story. They may not realize it; it's on a visceral level."

Once you have refined your message, what's the next step?

Says Karen, "You have to hit 'em with it until they get it."

BE PERSISTENT

Usually people aren't going to call you up and hire you the first time they hear your name. You have to get under their skin. They need to be exposed to you and your message multiple times before they take action. So you need patience, you need persistence and you need a lot of ammo.

FOCUS YOUR EFFORTS

Back before the days of e-mail I decided to do a direct-mail piece. I wanted to spread my budget as far as possible to reach as many people as I could. I was determined to purchase a mailing list of five thousand households and send them each a postcard. But my contact at my mailing service was insistent that I take a different tack: Buy a list of twenty-five hundred households and send them each two postcards, about two weeks apart. I hated that idea! I couldn't get over my naïve impression that more households equaled more bang for the buck. Apparently a lot of people think that way. But in the world of marketing, common wisdom holds that people need to see your name five and a half times before they will buy from you. So hitting a few households (or architects or art buyers or ad agencies) repeatedly will yield better results than a blanket approach.

Whatever method(s) you use to get your message out, concentrate your efforts on a small hand-selected group of potential clients for the biggest return.

TELL THEM WHY THEY NEED YOU

You've told them your message, the story of what makes you unique. Now you need to tell them why they need your special talent. You need to tell them how they will benefit from working with you.

"It goes like this," says Karen Melvin. "I would call an art buyer and say, 'Hi, I see ABC Window Company is one of your clients. I shoot a lot of architectural products and lighting is my thing—I

imagine great lighting is very important to showcase your product. I'd like to come in and show you some of my work I think you'd find germane."

CHARGE YOUR BATTERIES

Marketing takes a lot of energy and inspiration. You've heard it said, "You can't create in a vacuum." You can't market in a vacuum, either. Keep your batteries charged by sharing marketing ideas and woes with other business people. Don't limit your contacts to other photographers. I recently sold my house and through a few casual conversations got a boatload of interesting marketing ideas from my realtor, and he got a few from me.

Take a class or seminar now and then on marketing. Again, don't limit yourself to offerings targeting photographers. Cross train. It'll help you be as creative about selling your work as you are about making it.

Even examining your junk e-mail and snail mail from a student's perspective can give you a little inspiration. Instead of throwing it away without opening it, study it. Does anything about it appeal to you? Attractive graphics, a nice layout, a call to action, a compelling story, a special offer? Make a file to save the promotional pieces that contain some aspect that inspires you, and refer to it when you create your own mailings.

SET GOALS

In order to be successful at marketing and sales, you need to set quotas for yourself. If you give yourself a goal to make twenty-five cold calls a week, or send out twenty-five e-mails, you'll be much more likely to follow through than if you say to yourself, "Well, I think I'll make some calls each morning between nine and ten." It's unbelievably easy to find other things to do and to never get around to those calls or e-mails. Ditto for printed material: Set a goal of say, four postcard mailings and one newsletter or blog entry a year. If, after a little time goes by, you find the goals you've set prove to be either too easy or too tough, adjust them. It may seem somewhat arbitrary, but the point is to have

a realistic, workable marketing plan. If you set the bar too low, you're only cheating yourself. If you set it too high, you won't stick with it. So set it at a level at which you're comfortable, and maintain it.

Be sure your goals relate to the action and not the result of your marketing. A goal of making ten cold calls or sending ten queries a week is more measurable and gratifying— and therefore more conducive to success—than is a goal of getting one new client a week, which may or may not happen regardless of how many calls you make.

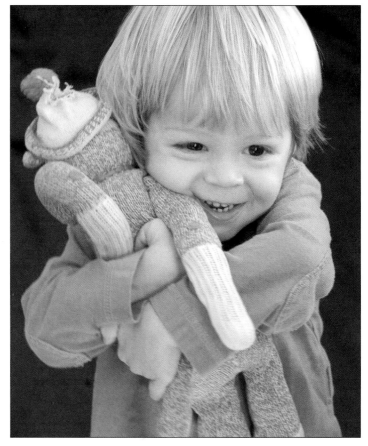

DRAW ON YOUR LIFE EXPERIENCE

For a fun promotional tool, Kathy Locke of Child's Play Photography makes pictures of every child she shoots with her studio mascot—a sock monkey! She posts the images on her blog.

You have marketing and sales experience. You might not realize it, but you do. Have you ever applied or interviewed for any job? Then you have sold yourself. Have you ever worked as a server in a restaurant and recommended the daily special or suggested a special glass of wine to complement a meal? Ever worked in a library and recommended books? Then you have sales experience. In fact, I'd be hard pressed to name any job that includes people contact that doesn't involve selling.

"All of my marketing and sales experience I drew from jobs I had when I was in my twenties," says marketer extraordinaire Karen Melvin. "I did cold calls for Block Drug, and later for a photo finisher. It's dialing for dollars. That's where I learned everything I needed to know about marketing."

That's not to say that you shouldn't study sales and marketing in a more formal setting. But don't overlook your own experience.

MARKETING TOOLS

In the years since the first edition of this book came out, the marketing tools available to the photographer (in every specialty) have changed as dramatically as our camera equipment. In the past we talked about directing mailings, buying spots in creative sourcebooks, showing portfolios, making cold calls on the telephone and making printed brochures, postcards and other material to use as leave-behinds. This was all very expensive (consider four-color printing, postage and paper costs) and it required a lot of fortitude to follow through and follow up with your prospects. Not so in this day and age.

Printed paper mailings are widely known to be bad for the environment and seriously frowned upon by much of the public—it's known as junk mail for a reason. There are now lists one can get on that prohibit advertisers from sending catalogs, thereby saving a lot of trees and avoiding the aggravation of recycling unwanted solicitations. Creative sourcebooks, in their printed forms, don't exist anymore. While they still exist online, none of the photographers I spoke with felt they had gotten any work from their participation in these sites—although admittedly that is hard to track, because a sourcebook visitor who likes a photographer's work will in all likelihood go to her website for a closer look at her images and information. Cold calls are generally viewed as an intrusion and are often screened so that you can't get to the decision maker. Most commercial photographers I spoke to say they still maintain a portfolio but that they only show it once or twice a year, if that. And if you aren't going to physically see your prospective client and show your book, a leave-behind is a moot point.

So many of the old marketing avenues are blocked; but there are new ways to get the word out that are kinder to the environment, faster, more efficient, more cost-effective and easier. That's the good news and the bad news—now *everybody* can have equal access to art buyers, decision makers and other prospective clients. Here are some of the new marketing tools and ideas for how to best use them for your business.

WEBSITES

While websites aren't really new (when the first edition of this book came out in 2004, many photographers already had them), they are now *absolutely necessary* for any photographer who wants to be in business, whether full-time or part-time.

"A website can be a wonderful marketing tool. It opens more doors because you can drive potential clients to your site to view your work instead of threatening them with the thought of spending fifteen or twenty minutes sitting down with you face-to-face and looking at your book," says Karen Melvin. "And another plus is that they already know your work, your philosophy and what makes you stand out in your market when they call and want get a bid. They're probably not just 'browsing'—they are already sold on you."

Rob Levine hosts several photographer websites. "People expect a photographer to have a website. Your website is you. It's what your portfolio and your printed pieces used to be. But you don't have to go out and show it in person or pay printing or mailing costs, and you can change it at will, and the changes are instantaneous. It's a great way to get your work out there. Where some photographers mess up is in thinking they need to have a huge, hard-to-navigate, unwieldy site. Your site should be simple and clean, and easy to use."

You don't have to be a computer whiz or spend a fortune setting up a site or maintaining it. There are several online websites including my favorite, BetterPhoto.com, that sell ready-to-use out-of-the-box websites complete with domain registration and hosting. The rates are amazingly reasonable, and the templates are so easy to use even I can do it (and that's easy!). Even well-known commercial photographer Patrick Fox has switched to a template after years of maintaining a custom site. "It's a little boilerplate, but I'm selling my images, not my web-design skills," he says.

You can maximize the marketing value of your website by encouraging your visitors to sign up for a newsletter or special informational e-mails.

Be sure no one downloads your images by using watermarks and/or low-resolution scans. You don't want anyone to use your

work without giving you credit *or* without paying for the privilege, and you don't want a low-quality example of your work to be passed off as a good example of what you do. Many website templates for photographers are designed so that you have the option of automatically watermarking your images when you upload them. Photoshop and Elements both have watermarking capabilities, so if your website doesn't have an automated option, you can do it yourself while editing your images for the Web. I've noticed that some photographers use their logos for their watermarks, creating yet another way to present their brand to potential clients, and the logos actually look beautiful rather than looking like a mark that is solely intended to make the image unusable.

Link your site to related professional organizations for greater exposure. If you're an architectural photographer, you might provide links to architecture firms, designers and stylists. If you only do interiors, you might want to provide a link to someone who does exteriors. If you're a portrait photographer, you might include links to clothing stores, toy stores, interior designers and anyone else who might give you referrals. I like to blog about my clients and include links to their websites in my articles.

And, very importantly, keep your website up to date. Your potential clients will feel like they're lost in space if they visit your site and the images and information are years old. I'll never forget in the spring of 2001, when I was surfing the Net for a kitten for my daughter, one breeder's home page read, "… visit us in October 1998 to see our new litter of babies!"

MAXIMIZING YOUR WEB PRESENCE

Having a website is your first priority. Driving people to it is your next priority. It's all about how many people find your site while they're cruising the Web. Say you're a portrait photographer in San Francisco. There are a lot of portrait photographers in San Francisco, so how can you make sure that when a prospective client goes to her search engine and enters, "portrait photographers San Francisco," your site will pop up right at the top of the list?

• **SETTING UP YOUR DOMAIN:** If you use a hosting site for your website, they will register your domain for you and you won't

have to do anything at all. If you want to register your domain yourself, godaddy.com is a great, low-cost resource.

- **CHOOSING KEYWORDS:** Keywords are words or phrases that will lead people to your site. Be sure to choose your keywords thoughtfully and you will be rewarded with many more hits (people visiting your site) than if you ignore this part of your setup. Pretend you are your client for a moment—you are going to use a search engine to try to find a photographer. What words will you enter? Use as many as possible that are descriptive of what you do. For instance, my keywords for my KidCapers website include: children's portraits; family photography; baby pictures; Minneapolis, Minnesota; Mpls.; St. Paul; contemporary; classic; traditional; hand-painted; hand-colored; black and white; creative; custom created; hand created; location; studio; kids; kid; kid's portraits; senior portraits; and pets; pet portraits.

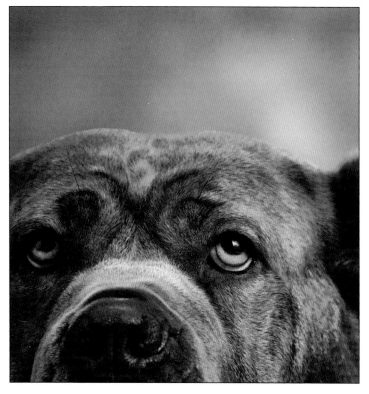

"A Big Mug" by Vik Orenstein.

- **LINKING TO OTHER SITES:** The more sites you can link to, the more hits you'll get. Again, let's pretend you're a San Francisco portrait photographer. Are there local clothing boutiques you recommend to clients? Toy stores? Dog groomers? Portrait photographers in other markets you admire? Include a link to their websites on yours, and encourage them to return the favor. It's a surefire way to increase your Web traffic.

- **PURCHASING KEY PHRASES:** The big search engines will allow you to purchase key phrases for a fee. For instance, say you want to come up first on the list when someone goes to Google or Yahoo and enters "San Francisco family photographers." You can

buy that phrase. Then everyone who enters that phrase into their search engine sees your site first. When more than one photographer purchases the same keywords, then the order in which the "sponsored" names come up rotates.

• **SPONSORED LINKS:** You can also buy a sponsored link. You know those ads that come up at the right side of your computer screen whenever you do a search? Those companies are there because they have paid to be there. The cost to purchase keywords and sponsored links varies depending on the words you chose and the size of the market share you are seeking. Often you can have a choice of different fee structures based on the number of "clicks" or "click-throughs"—that is, the number of people who enter your site via the sponsored link or search. These links and key phrases can be worthwhile even for small fledgling businesses. To find out more, search Google Adwords, Yahoo search marketing and keyword advertising.

• **BLOGGING:** I was skeptical at first that blogging would in anyway help bring more traffic to my site. After all, who except my closest friends and maybe a few clients would want to read my ramblings? But having a blog can drive many, many more visitors to your site. And on top of that, it's one more way to get your story out.

• **FOLLOW YOUR STATS:** Many services are available that will help you find out who, when, how, why and from where people access your site. I use Google Analytics. GoStats.com and Joomla .org are others. By using a service such as this, for free or for a minimal fee, you'll be able to see that someone in England came to see your website at 3:00 A.M. on Saturday, November 12th, looked at your streetcar gallery and your prices, stayed for 1.6 minutes, and got there from a Yahoo search. If that's not truly amazing I don't know what is! You can use this feature to keep tabs on what brings visitors to your site. For instance, whenever I add a client's portraits to my galleries or blog, I tell them to take a peek at their photos online, and they tell their friends, and it results in a spike in both new and previous visitors—and every visitor is a potential client.

THE SECRETS TO SALES

S ales is much like marketing, except that instead of selling a potential client on using your studio, you are selling goods and services to a person who is already your client. Think of marketing as "outside sales" and sales as "inside sales." Only certain specialty areas deal with inside sales, primarily portrait and wed-

A nature image by Jennifer Wu.

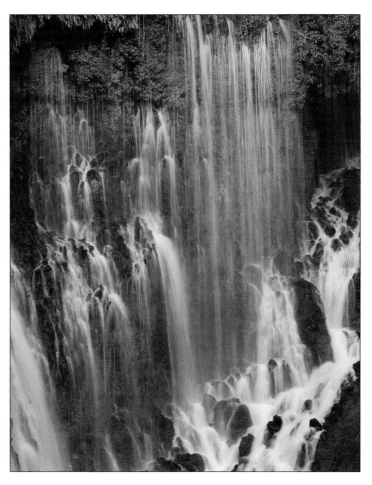

ding photography. However, even if your specialty is not one of these, you'll be able to use most of the theories and practices outlined in this chapter in your marketing work—so don't skip it!

LET THE SELLING BEGIN

When I train new employees in sales, the first question I ask them is, "When do you sell the portraits?" Often they respond with the answer, "at the proof viewing," or what we call "the design consultation." Then I make a sound like "Oooonk!" and I say, "Thanks for playing!" The correct answer is that you sell the portraits from the moment the client calls you for information or comes through your door as a walk-in or a scheduled studio visit all the

way until they've taken their pictures home, hung them on the wall and received your thank-you note in the mail. Every moment of client contact is a moment that you are selling portraits. Or, if you neglect to create a positive relationship with your client, these can turn into moments when you are unselling portraits.

ANSWERING THE PHONE

Do you know what your single most valuable marketing, sales, PR and customer relations tool is? Neither did I when I started my first studio. It's your humble old telephone. Every call you receive is a golden opportunity to get, keep or satisfy a client.

But simply answering your phone can be a challenge when you're a one-horse operation and you need to be in the field, in the studio and out pounding the pavement. Especially when you do all this and keep your day job, too. But getting a real live human being at the other end of the line can be a strong positive influence on your potential clients and can sometimes mean the difference between turning them into your next booking or driving them to one of your competitors. Realistically you won't be able to answer your phone every time it rings when you're just starting out. So what can you do to make sure you don't lose clients who get your voice mail when they call?

• **HAVE A PROFESSIONAL, UPBEAT OUTGOING MESSAGE.** State your studio name, your specialty and the time frame in which you will most likely get back to your caller. If your studio is in your home, it's doubly important to have a professional sounding outgoing message. Don't try to be cute or clever. Ideally you should have a phone line dedicated to your business so family members don't accidentally answer your business calls.

• **RETURN CALLS WITHIN THREE HOURS.** If you're on location or at another job, return calls during your lunch or on a break.

• **CONVEY TO YOUR CALLERS THAT YOU'RE HAPPY TO HEAR FROM THEM**. Even if you're in a rush to get back to your shoot or your job, you should appear as if you have all the time in the world. Being harried or seeming busy will not make potential cli-

ents think they're important or otherwise impress them—it'll simply put them off.

• NEVER GIVE ONE-WORD ANSWERS.

"Do you photograph birds as well as dogs and cats?"

"Yes."

"Should I bring more than one outfit for each child?"

"Yes."

"I don't see any kumquats in your book. Have you ever shot kumquats before?"

"Yes."

Do you see all the opportunities being thrown out the window here? The inquisitive potential client got an affirmative response in each case but was not engaged and was given no reason to choose that photographer to do her pictures. The conversation should have gone more like this:

"Do you photograph birds as well as dogs and cats?"

"Why yes—in fact, I shot a cockatoo last week. It was a beautiful bird. I did some macro shots of his face—it's amazing how expressive a bird can be, especially considering they have no lips."

"Should I bring more than one outfit for each child?"

"Oh, yes! Bring a bunch of things, and we'll pick out the most photogenic outfits at the studio. If you want to do some really dramatic shots, bring black clothes for each kid. And swimsuits can be a lot of fun for a whimsical shot."

"I don't see kumquats in your book. Have you ever shot kumquats?"

"Yes, I shot kumquats and pomegranates for Megafruit International, and I did a kumquat catalog for the Fruit of the Month Club. We did some really creative shots and even dressed the kumquats up in little Santa suits—it was the fruit for December."

See the difference?

• DON'T JUST ANSWER THE CALLER'S QUESTIONS—ASK YOUR OWN. How many kids do you have? How old are they? Are they into any sports? Tell me about the history of your widget division. What types of images have you used in your annual reports in the

past? The more interest you show in them and the longer you keep them engaged, the more likely they are to hire you.

- **REPEAT WHAT THE POTENTIAL CLIENT SAYS IN YOUR OWN WORDS.** Let him know you have heard his message and understand his needs by repeating whatever he tells you, but in your own words. Don't just parrot it back to him or you'll come off as insincere.

"My first priority for this catalog is to show all the different colors the widgets come in. I want the widgets to look as large as possible. And we need to be able to show them in a way that makes them look special, because people see widgets every day and they look at them without really seeing them."

"I understand. We'll highlight all those designer colors, and we can get a hand model who has very small hands—that will make the widgets appear bigger. And you want us to shoot the widgets in a very graphic, dramatic way, so that the widget buyers actually stop to look at them and appreciate them instead of glancing right over them."

- **SHARE A TIDBIT OF INFORMATION ABOUT YOURSELF.**

"I have a collection of antique widgets I inherited from my grandfather."
"When my daughter was your daughter's age, she liked to ice skate, too."
"I started shooting with a Brownie when I was only six months old."

Sharing information about yourself helps the potential client see you as a person, identify with you and feel a connection.

- **DON'T ACCEPT CALLS WHEN YOU CAN'T GIVE THE CALLER YOUR FULL ATTENTION.** In these days of the cell phone, it's tempting to take calls in the field or at your job. But the only thing worse than getting a message machine is getting, "Oh, hi, I'm on a shoot, I can't talk right now, I'll call you back." That, or a lot of ambient noise, a connection that's cutting in and out or a distracted photographer who's trying to drive, groping for her palm pilot and cursing other drivers all at the same time. So unless you can devote your full attention to a call, let the machine get it. When you return the call, make it worth the wait.

And here's my pet peeve: When you do answer the phone, don't say, "Studio, this is Stanley." Tell them what studio! It's another opportunity to expose them to your name. "Kowalski Pho-

tography, this is Stanley, how may I help you?" This conveys the impression that you're professional and friendly.

"Building Reflections" by Kerry Drager.

TAKING CONTROL

We all want control. Every single one of us, all the time. It's just that some of us take the direct approach—insist on driving, for instance—and some of us are more subtle: "Gee, why don't you drive?" Or, "Oh, shouldn't we take the freeway instead of the side roads?" The folks who you assume don't want control are often the most controlling of all.

The desire for control does not make you a bad person. It does not mean you have a personality flaw or a character disorder. It just means you're human. Taking control in situations where it's appropriate is not only generally a very good idea, it's also welcomed—especially by those who are counting on your expertise.

When you are doing a proof viewing, you are the expert. You're at the wheel—you should drive, confidently and unapologetically. Yes, of course, selecting portraits is a very personal thing, but while your client knows when she has a positive emotional

response to a picture, she probably doesn't know as much as you do about what visual elements make a good portrait, how to group different shots together to tell a story or what sizes and treatments will look the best on her walls. She wants and needs your guidance. I've found very few employees who were unable to become good salespeople with training, but the ones who never succeeded all shared one thing in common: They believed nothing they could say would influence (i.e., control) the outcome of a sale.

"People are just going to buy whatever it is they want anyway," one young design consultant told me. Clearly, I needed to prove her wrong in a very tangible way. I decided to figure out what our least popular product was—our wallet prints—and instructed everyone at all the stores to sell that product hard for the next four weeks. As an added incentive, I gave away a cup of Starbucks coffee for each set of wallets sold. We wound up increasing the wallet sales by 500 percent, thus proving to the pessimistic employee that what we say to our clients does affect the outcome of a sale.

The point is, we can and should take control of the proof viewing and share our professional opinions with our clients about their portraits. We'll make bigger sales, and the client will be happier with her portraits. I guarantee it.

SERVICE, NOT SELLING

When it comes to customers, there are two types: those who expect and want service, and those who expect and want anonymity. I learned this one day from an employee who was attempting to learn sales. She was in her eleventh hour: If she didn't improve her performance soon, I was going to have to let her go. She was especially bad at information calls and walk-in visits.

"Approach them, greet them, acknowledge them, chat with them, ask them questions, tell them about the studio—engage them," I told her. "Treat them the way you would like to be treated."

She giggled timidly and said, "But I'd like to be left alone."

My employee craved anonymity.

I asked her to describe how she would like the visit to go if she were a potential client who dropped into our studio to decide if she wanted to have her children's portraits taken there.

"I'd like to take a peek at the walls and see what the pictures look like. I'd like to get a price list, and maybe a brochure, and take them home with me and decide for myself whether I wanted to shoot there or not. I wouldn't want anyone schmoozing me or selling me." She viewed any greeting or attempt at engagement as an intrusion, and the service people as the intruders. She couldn't imagine what life was like for the other type of customer—those who want and value service.

"If I came into the studio and no one engaged me, I'd feel slighted," I told her. "I'd want the full-service treatment: the greeting, the story of the studio, the questions about the names and ages of my children, and suggestions on creative ways they could be shot. If I were treated like that, I'd probably book a shoot on the spot."

From that moment on, I stopped telling my employees to treat people the way they'd like to be treated. I started telling them about the "two types," and that no matter which type they were, they needed to learn to view their actions in engaging the clients and potential clients as providing a service and not as intruding. I think we all need to start with this assumption and approach each potential client as if she were a full-service type. Try to connect by making small talk (no, *small talk* is not a dirty word, it's an art!) "Do you have children?" "Is it still nice and warm outside?" Then if she gives you a one-word answer, a cool smile, averts her eyes or seeks out another part of the studio, at least she knows you're available should she have any questions.

WHAT MOTIVATES YOU?

We are all motivated by different things. Some of us are motivated by money. We have mouths at home to feed or we need a new yacht. Some of us are motivated by our own or some external concept of success. Some of us are motivated by the need to feel liked or to be viewed as a good person. While each of us is motivated to some degree by all of these things, usually one motivational factor overshadows the others. No matter which it is for you, you can make it work in creating a successful sales career.

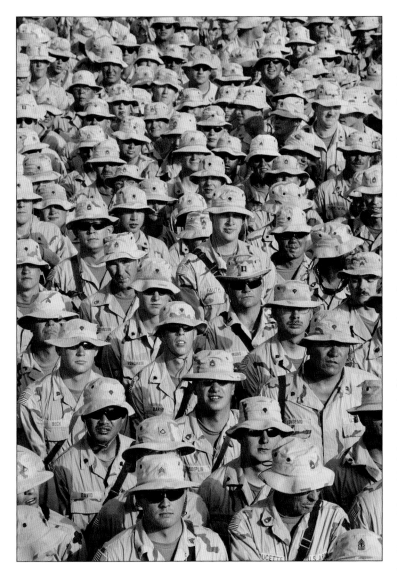
"U.S. Troops" by Stormi Greener.

MONEY

It's great if the carrot at the end of your stick is the green stuff. My money-motivated design consultants tend to be extroverted and energetic in the extreme—qualities that are a real boon for people in sales. The potential pitfall for our money-motivated brethren is that they sometimes start to see their clients as giant dollar signs. These guys need to slow down, take a beat and remember to enjoy their relationships with their clients as much as they enjoy getting their commission checks.

SUCCESS

Like money, success is a powerful motivator. For some, success is having the highest average sale. For some, it's generating the most leads or closing the most sales. I had an employee who judged her success with a given client by whether she got a hug or not when the client was through with the portrait process. (She almost always got a hug, and probably *not* coincidentally, she had a very high satisfaction rating from the clients and a high average sale.) One employee I had noticed that people seemed to be happier with their overall experience at our studio if she taught them one little thing about our philosophy or product each time she saw them. She liked to explain to them why one image might have a superior composition to another very similar image in their

take, or why we do tri-tones instead of straight black and white, or why we like to place the eyes of a subject in the top third of the frame. By teaching them something, she was able to connect with them on a level that was both personal and professional, and give them added value. Whenever I'd say to her, "How's your day been going?" she'd say something to the effect of, "Great! I taught a client about the rule of thirds today!"

BEING LIKED

Those of us who are motivated by the need to be liked can turn this desire into a successful sales career if we recognize that the key to being liked is to know what our customer wants and needs—even when she herself sometimes doesn't.

SELLING UP

"Selling up" is a technique whereby you establish the client's comfort level—usually they will tell you when they come to their photo session what size and number of portraits they have in mind—and then guide them gently past it. My old boss at a theme party company was a master at selling up. Her clients would come to her with a theme and a budget in mind. "We want a Hawaiian Luau and we have $2,000 to spend on decorations," was a typical request.

Kristi would put together a proposal showing them what they could get for $2,000. Say, four Tiki huts, four sun gods, a hundred leis and ten floral centerpieces.

"Great, we love it, let's go for it," the client says.

"I also put together a proposal showing you what we could do for you for just $500 more—it would really fill up your meeting area beautifully," says Kristi.

Suddenly the client has a visual of her party with everything included in the original proposal, plus twenty tropical-colored streamers, floral centerpieces with tropical fish in the vases and two potted palms with twinkle lights.

"Wow," says the client. "It's only $500 more than we were planning to spend, let's go for it."

"And I can throw in a dugout canoe to hold your roasted baby pig for $150," says Kristi. And so on.

If Kristi had started out by telling her client, "Yes, I can do a Hawaiian Luau for $2,000, but I think you'd be happier with our $2,650 version," the client probably would have insisted on sticking to her original budget. But by showing that she was willing to do a good package for $2,000, and then showing what could be done for an additional fee, she was able to guide the client into a higher comfort zone.

The same principle can be applied to the selling of photographs. Say your client is interested in getting one-year birthday portraits of her son. She wants something to hang on the wall over her mantle that will really show his personality.

"You mentioned you were looking for a 16" × 20" (41cm × 51cm) for over your mantle. I've picked out one shot that I think is a lovely stand-alone image," you start out.

"Yes, I love that one!" the client agrees.

"And this image *is* strong enough to stand on its own. But if we use this image as the centerpiece of a collage with this serious expression on the right and a laughing shot on the left, we can show off more of his personality," you continue.

"Oh, I like that, too," says the client.

"And these three-quarter-length shots could be mixed in an alternating pattern to create a collage of nine shots to give us both a range of expressions and some action, and this would have great visual impact as your focal point for your living room," you finish.

You've shown your client exactly what she's asked to see, and you've opened her up to some of the other possibilities that may give her even more of what she is looking for.

MEETING OBJECTIONS

When you first start selling your product, you'll hear objections from your clients—reasons why they can't buy that specific product at that specific time. You'll probably think each objection is new and unique. But after you've been selling for a while, you'll realize that you're hearing the same few objections over and over. With a little experience you'll be able to overcome these objections, because you'll know exactly what to say when they arise. Of course, the objections you hear will be determined by your specialty and

position in your market. Don't be afraid to use the same answers over and over again to overcome objections if those answers work for you. You may feel like a broken record each time you repeat yourself, but you have to remember that it's news to your client. To give an example, a common objection heard by any photographer/designer who sells wall art is, "Oh, a 16" × 20" (41cm × 51cm) is just too big. I only want an 8" × 10" (20cm × 25cm)."

A possible response: "Well, it's interesting about sizing for wall portraits. Most people hang pictures that are way too small for their walls, and the portrait looks like its just swimming there all alone. An 8" × 10" (20cm × 25cm) would be an appropriate size for a powder room or as an easel back for a desktop or shelf, but you said you were planning on hanging this portrait over your couch? An 8" × 10" (20cm × 25cm) would really get lost."

That's a mouthful, and you may feel silly repeating it several times a day, but it's true. The client will understand what you're saying, and you'll sell them a 16" × 20" (41cm × 51cm) that will look dynamite on their walls, and they'll send you endless referrals.

LOOK AND LISTEN

If you listen carefully and pay attention to body language and attitude, your clients will actually communicate to you exactly what it is they want to hear. Think of their words as the text, and their other, nonverbal cues as the subtext. There is as much, if not more, to be learned from the subtext as from the text.

MIRRORING

Often when two people are getting comfortable with each other and start to establish a rapport, they will start "mirroring" each other—one crosses her right leg over her left, the other crosses her right leg over her left; one leans in, the other leans in; one scratches her nose, the other scratches her nose. It happens all the time, but we hardly ever notice it. Start to look for examples, and you'll be amazed at how often you see it. Usually it is impossible to tell who is originating the action and who is mirroring it. After a while it becomes like a dance, and the action flows back and forth between the two people.

SETTING THE TONE

Instead of falling into the mirroring dance unaware, begin the client contact with the intention of setting the tone and creating the mood of the meeting yourself. Encourage a feeling of rapport by smiling, leaning in toward your client and making a comment to which the client will likely respond by nodding or agreeing. (Isn't there a nice breeze out today? Are you going to the fair this year? Isn't it easier getting downtown now that they broadened the freeway?) Ninety percent of the time, you'll find that the client will follow your lead and mirror your rapport-fostering behaviors.

This was graphically illustrated for me once—by, of all people, a graphic designer. I was half an hour late for my appointment with her, the air-conditioning in my car was on the fritz and I'd been stuck in traffic on the way to her office. When I got there, I was agitated, hyper and smelly. But after spending fifteen minutes with her, I felt strangely calm and unstressed. I commented to her on my way out the door that she must be an unusually calm person to have had that affect on me. She laughed so hard she snorted through her nose. "I'm sorry!" she said. "I'm not calm by nature—I'm a bundle of nerves! But when you came in I knew you were wound up, so I intentionally visualized myself calm and at peace, and I deliberately behaved in a calming manner."

Her graphic design was almost as good as that one little piece of insight she shared with me.

DEVELOP YOUR OWN STYLE

I have seven different design consultants who sell portraits at my various studios. They're all excellent—and they're all very different. One gal struck me as too timid to do sales, and I instructed her store manager not to let her do any design consultations. But as fate would have it, we were short-staffed during the holiday rush and the manager had no choice but to call upon this employee to sell. I bet you can tell where this is going—the employee had the highest sales average of the company. Her soft-spoken manner and genuine love of her child subjects helped her create instant rapport with the clients and inspire absolute trust.

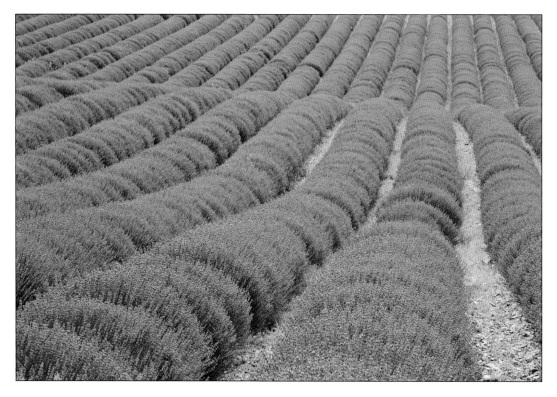

"Lavender Fields" by Brenda Tharp.

Another design consultant with a great sales average teases the clients and uses something of a harder sell, but in a joking way. "Oh, come on, how can you live without this shot?" is one of her common comments. Our clients love her—they ask her to come to their houses for dinner and tell me that whatever I'm paying her isn't enough. Now, if one of these gals tried to imitate the sales style of the other, I'm convinced that her sales average would drop precipitously.

"You have to do it your way, or it's not sincere and it won't float," says photographer Abby Grossman. "If it's not you talking, and if you're not talking from the heart, you won't sell anything."

ASSESS YOUR PERSONALITY

Think about your personality traits and determine which you consider to be assets: Are you funny and outgoing, serious and compassionate, supportive and encouraging? Use these assets to find your own personal ways to develop rapport with clients.

People buy from people they like. And people like people who like them. I look at every stranger as my friend—I just haven't met

them yet. I use my natural enthusiasm and silliness to establish bonds with my clients. You need to define your personality traits and cultivate them. This will help you in all your relationships—not just your business ones.

PAINT A PICTURE WITH WORDS

When you're selling wedding photos or portraits, it's a harder sell than most because the very things you're trying to get people to give you money for don't even exist yet. Your client is looking at proofs, which are either small photographic machine prints, thumbnail images on a computer monitor or a PowerPoint presentation. You need to be able to paint a picture with words for your client about how these images are going to look enlarged, framed and hanging in their homes, or in photo boxes on their coffee tables.

You can't just say, "This would be a nice grouping," or "This would be a great 16" × 20" (41cm × 51cm)."

You need to say, "Framing an individual shot of Billy and one of Debbie with the kissing shot of the two of them in the center would give you a lot of visual impact, and it would really tell a story about their relationship. If you framed them together in a vertical format, it would fit on a wing wall or in your powder room. And this family shot would be so elegant against your marble mantle piece with the earth tones you're all wearing." A picture is worth a thousand words, but when you don't have the pictures yet, sometimes you need a thousand words to describe them.

SUGGESTIVE SALES

"Do you need a little easel-back shot for your husband's office? Father's Day is coming up."

"Do you think the kid's grandparents would like this shot?"

"I bet you could take care of half the people on your Christmas list right here right now!"

"This would make a great Valentine's Day gift."

These are simply suggestions. There's no hard sell involved. And yet, when you plant these seeds in your clients' minds, you're

sure to harvest a larger sale. My employees wait until the client has already selected their own portraits. Then they tuck in the suggestions while they're writing up the order. This helps keep confusion to a minimum—they're not trying to select portraits for their homes, offices, friends and relatives all at once. It also gives them a last-minute excuse to pick out one or two more of the shots they liked and wanted but almost took a pass on. In my experience, the last-minute shots picked out for Grandma or Dad never wind up in the hands of their intended recipients. Mom keeps them for herself.

HOW TO KNOW IF YOU'RE MAXIMIZING YOUR SALES

When I opened my studio I did my own design consultations for the first three years. I always had a great time working with my clients, they were thrilled when they got their pictures and often they placed a healthy reorder down the road. I thought I was doing a great job. My average portrait sale was $1,400.

When my business got too big for me to keep doing sales, I was apprehensive about delegating this duty. I didn't think anyone else could do it as well or have the kind of rapport with my clients that I did.

The first person I hired to take over design consultations had worked in the retail industry as a buyer and had never done sales of any kind, but obviously her practical experience served her well, because she quickly brought the studio's average sale up to $2,200. Still, her clients very rarely placed reorders, and with alarming frequency, she'd get morning-after calls from clients with buyer's remorse wanting to reduce the size of their order.

I secretly thought that my result was the better one, until one day the two of us attended a seminar on portrait sales sponsored by Art Leather. The speaker asked the attendees, "Do your clients place a lot of reorders?" Many of us answered in the affirmative. "That's good, right?" he asked. "That's like extra money." He paused, looked over the crowd and said, "Wrong. If you're getting regular reorders, that means you're not maximizing your sales. Do you ever have clients call you back the next day and

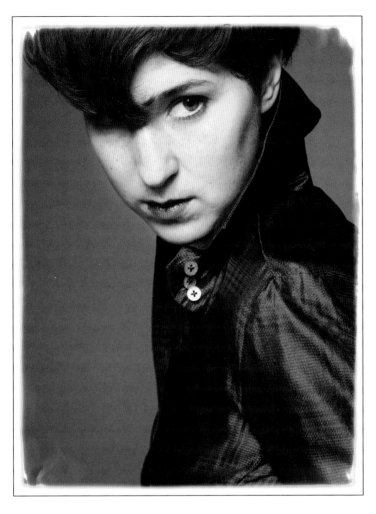

A portrait by Ibarionex Perello.

wish to reduce their orders? That's good, because it means you're maximizing your sales."

LOTS OF LITTLE SALES ADD UP

Everybody loves making a huge sale. It's fun! It's exciting! And for some reason, the clients who make the really big purchases are usually the easiest to work with.

But if we put extra effort into making every small sale just a little bigger—by turning a diptych into a triptych or a 5" × 7" (10cm × 13cm) into an 8" × 10" (20cm × 25cm) or simply by getting them to spring for that Christmas gift for Grandma—over the course of a month this effort can add up to more than a little extra cash flow.

For example, let's say you own a portrait studio and your average sale is $100, the equivalent of three 5" × 7"s (13cm × 18cm). You have an average of fifty clients a month, giving you a gross of $5,000. If even just half of them add one extra shot, upsize from a 5" × 7" (13cm × 18cm) to an 8" × 10" (20cm × 25cm) or add two sets of wallets, your average sale is suddenly $120 for a whopping $1,000 bigger monthly gross. That means increasing your gross 20 percent without a single new client walking through your door.

ADD-ONS

Add-ons are additional products that complement your portraits: premade frames, wallet books, photo boxes and albums, mats, greeting cards, etc. Having add-ons available for purchase can fur-

ther increase your average sale and give your clients a higher level of service.

DON'T MAKE ASSUMPTIONS

I once had a woman come into my studio for an informational visit to decide whether she wanted to shoot with me. It was a gorgeous summer day, one of the three or so we get in Minnesota in a given year, and all I wanted to do was go to the lake with my dogs and enjoy the weather. The woman, I'll call her Jane, was ten minutes late. The lake was calling me. The dogs were milling around my legs and whining at the door. By the time Jane arrived, I was milling around and whining at the door. I took one look at her, sized her up and decided she wasn't worth a lot of my time. I assumed she wouldn't spend a lot of money on portraits. So I didn't bother asking her the names and ages of her children. I didn't ask her how she'd heard about me or where she'd seen my work. I didn't bother with relating to her at all—that would have taken away precious lake time, after all. I tried to rush her through the studio visit and I didn't even offer to schedule a shoot for her. I steered her toward the door and said, "Well, if you don't have any more questions, I'll walk out with you."

Luckily for me, Jane wasn't going to let me get away with it. "Am I keeping you from something? You seem distracted," she said.

The words *wake-up call* flashed across my brain in giant letters. I suddenly was able to look at my behavior through Jane's eyes— rather than mine own or my dogs'—and the picture wasn't pretty.

"I am so sorry," I said. "Please, let's sit down and I'll go over the information packet with you and we can look at the schedule book." I backed up, took a breath, and asked her to tell me about her kids and the person who referred her to me. We had a nice visit, she booked a shoot and the woman who I had assumed wasn't going to purchase a lot wound up being my biggest sale that year. And came back in subsequent years until her kids graduated from high school.

Ultimately, to be successful at sales, you need to be good at relationships, expressing yourself verbally and listening to both the

text and the subtext. You should be able to take control, be self-motivated and both lead (set the tone, guide the client to the best purchase for her) and follow (repeat to the client in your own words what you hear her say). If you can do all of this not only will you benefit financially but you'll have lots of happy repeat clients as well.

P ublic relations, or PR, is all about community—your city community, your professional community, and your neighborhood or merchant community. By getting your business involved in all of these communities, you get to do some good works, get the story out about your business, network and get face time with potential clients, and weave your history into the history of these various communities.

HIRING A PR FIRM

When you hire a PR firm, you get to take advantage of all of their contacts. And that old cliché—it's not what you know, it's who you know—proves itself true.

IT BOILS DOWN TO RELATIONSHIPS

I can write a press release as good as the best of them. But all my best exposure (local newspapers, speaking engagements and magazines) has always come through PR guys, not through solo efforts.

A stock photo by Jim Miotke.

PR people have established relationships with reporters, editors, club presidents and often local politicians. Tribalism is simply human nature: We take care of our own. People are much more likely to do a story, engage a speaker or promote a cause if it's connected to someone they know. When you hire a PR guy, his friends are your friends. It's a pretty

slick arrangement, but professional PR help doesn't come cheap. Since the goal is to make contacts—to plant seeds, as commercial shooter Patrick Fox says—it's more difficult to track the results than it is from your website or an e-mail promotion. That doesn't mean it's not a good investment, though.

THE PLACE WHERE STORIES ARE BORN

Pick up your local newspaper and look at the business section. You'll see articles featuring local businesses. Each story has a different spin—i.e., the angle through which the story is approached. They may be about women in business, or small companies with unusually large growth rates, or successful franchisors. Now look at the variety section: You'll see stories about local moms who have turned their hobby of recycling used mittens into teddy bears into businesses grossing $2 million a year, profiles about local children's book authors and illustrators, or stories about local organic farmers.

I used to think there were ambitious reporters out pounding the pavement, researching their local markets to ferret out these stories. I was wrong: PR people pitch these stories to the reporters and editors. The reporters don't go out to find the stories—the stories find them. That means if you want to have a story written about yourself or your business, it would behoove you to have a professional to pitch it.

HOW TO FIND A GREAT PR PROFESSIONAL

Just as when you're shopping for any other professional service, get referrals. Word of mouth is not only the best way to build your business, it is the best way to find other people to do business with. Ask for references and follow up on them. Make a few phone calls and see what kind of goodwill the PR professional has generated for himself among his own clients.

DOING IT YOURSELF

It's possible to do your own PR and get adequate results, but you'll have to be self-motivated. Just as it's difficult to track the results of a hired gun, it'll be difficult to track your own. Be prepared to work hard to make connections—whereas a professional PR per-

son already has contacts at every local newspaper, magazine and professional organization, you're an unknown entity and will have to seek out contacts of your own.

A hired PR person can pick up the phone and call the editor-in-chief at *Townsville Magazine* and say, "Hey Brian, how've you been? How does Petey like going to college in Boulder? I've got a really interesting local photographer I'd like you to meet, and I want to show you her work. Her studios have set a new industry standard, and I think there's a story here that your readers would be very interested in."

This call is going to go very differently if you make it yourself.

"Hello, this is Vik Orenstein, may I speak to Brian Jackson, editor-in-chief, please?"

"One moment, please." Then you're connected to his voice

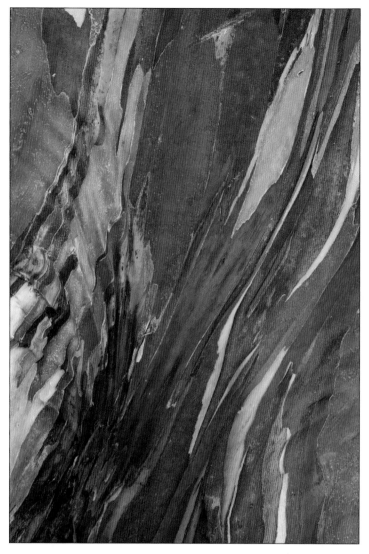

A macro nature shot by Lewis Kemper.

mailbox. You struggle to think of a message that doesn't sound dopey.

"Oh, hi, this is Vik Orenstein, I'm a local photographer—I own KidCapers and Tiny Acorn Portrait Studios. I'd like to show you my work and discuss a story I think your readers may have an interest in." If you're lucky, your call will be returned—by his personal assistant—who will inform you that you need to contact the story editor. So you will contact the story editor, who will tell you that the person you really need to speak to is the photo editor, who's out of town until after the end of the month.

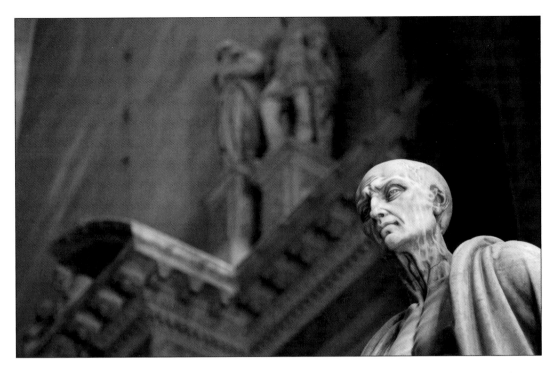

A travel image by David Sherman.

If your timing is excellent and the magazine is hungry for stories, you'll most likely be asked to send a query letter, or proposal, before you get any face time with anyone.

So you can see that being your own PR professional can be done, but it's not the most efficient route. I've learned this from experience.

Nevertheless many photographers starting their own businesses can't afford to hire someone for PR. Here are the tools you need to get the word out and connect with your community.

PRESS RELEASES

Press releases are very brief announcements that are sent to newspapers and magazines to cultivate stories about your business. They're easy to write. Max Fallek, of Fallek and Associates Public Relations, outlines the elements of a basic press release:

- Centered at the top in bold, in 16- to 18-point font, write the words: NEWS RELEASE.

- Below that and flush left, include a line that tells the recipient when the story should be released. For example, FOR IMMEDIATE RELEASE or FOR RELEASE JUNE 1, etc.

- Directly across from the release date, flush right, include a line that says, "For further information," with a contact name, phone number and e-mail address.

- Next, flush left, place the headline. The headline should never extend past the center of the page, so if it's longer than half a page, go back to the left and add a second line directly underneath the first. The headline should never be more than two half lines long.

- Below the headline, flush left, write a line that tells where the story originated, i.e., Minneapolis, Minnesota.

- Double-space the body of the story, with three to four spaces between paragraphs. A press release should never be more than one and a half pages long.

- Whenever possible, a photo should be sent along with the press release, with a caption running along the bottom describing the subject(s), e.g., "Stanley Kowalski, owner of Streetcar Named Desire Photography Studio."

"You can write your own press releases and have some success at it if you remember two things," Fallek says. "You have to have a great headline. It should be a real attention-getter, it should be bold. And second, you should be fearless! Publications need you more than you need them—they have to have stories or they're out of business."

Where to send your press releases? Standard Rate and Data Service (www.srds.com) and Cision (http://us.cision.com) both list every periodical publication in the country.

Of course, nowadays you can send press releases via e-mail, but queries should still be sent snail mail. Not every decision maker accepts press releases via e-mail, and there's always the danger of getting caught in the spam filter.

PRESS KITS

Once you've gotten a few articles, speaking engagements and publications under your belt, you might want to put together a press kit. A press kit is like a press release on steroids. Rather than a

single page announcing one event or story angle, a press kit is a folder (embossed with your logo or sporting a sticker with your logo) which contains the following:

- copies of recent articles written about you, your business, or that you have written for publication;

- photos of you, your place of business and/or any recent newsworthy special events you/your business has hosted;

- your biography (one half to one full page), which should include a list of any public speaking, charitable and pro bono work you've done;

- your business card and your PR person's business card tucked into precut slots on the pocket of the folder;

- a one page or less time-sensitive press release of the type described above.

CHARITABLE ACTIVITIES

A great way to generate a good buzz about yourself and your business is to sit on a board for a charitable organization. Try to find a charity that affects your client base. If you are a family photographer, look for an organization like a crisis nursery or a children's hospital—a charity that makes life better for families.

"Yeah right, in all that spare time I've got," you're probably thinking. "Maybe I'll just make a donation." While a donation is better than nothing, remember that your main goal is to make contacts, to network, to get to know people and let them get to know you. A donation gets your business name out there, but heading up the decoration committee for the annual ball or editing the newsletter will get you out there personally, where you can connect with people and those people can put a face with your name.

PUBLIC SPEAKING

Speaking to groups and organizations also helps you make connections and promote your business. Not only do people see your face, they hear your message.

Public speaking can be a challenge. I enjoy public speaking about as much as I enjoy putting a lighted sparkler up my nose and twirling it around. Perhaps I exaggerate. It's the anticipation of the public speaking and not the act itself that I can't stand. Beginning about three days before any such engagement, I fret. I sweat. I worry. I get stomachaches. I practice my delivery and fret some more. The morning of the engagement I mentally berate myself for getting into such a horrible situation.

But then I get to the hotel conference room, or ballroom, or church basement, or women's club, or wherever the meeting is held. I see all the faces—friendly faces—and I relax a little. Then I start my speech with a joke and I get a laugh (which is one of the things I live for), and suddenly I'm having fun. My cottonmouth miraculously goes away, my lips stop sticking to my teeth and when it's all over I think, "Gee, that wasn't so bad." If you share my secret shame—the unnecessary fear of public speaking—there is help for you. Toastmasters International, among other groups, can help you overcome the fear of opening your mouth and winding up with one of your feet in it. Rest assured overcoming your hesitation will benefit your business.

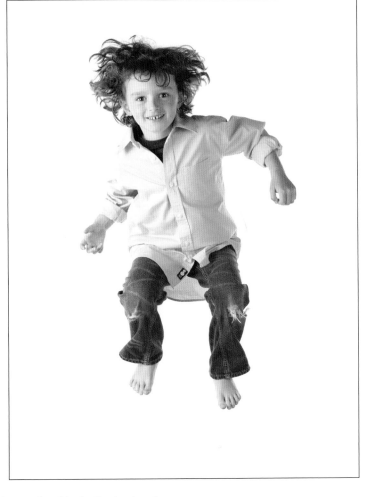

An action portrait by Chris Darbonne.

PROFESSIONAL GROUPS

Instead of just speaking to professional groups, you could actually join one. Pick a group that has members from all different industries

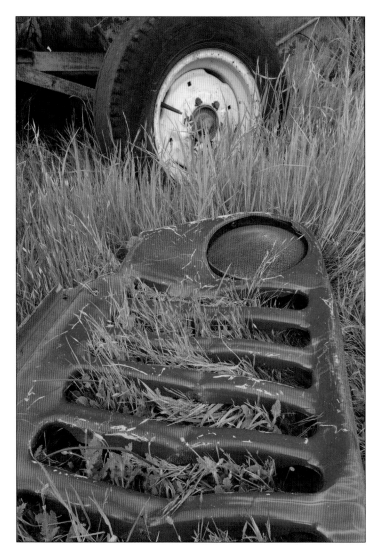

A stock photo by Kerry Drager.

and businesses. That way, not only will your fellow members think of you when they need photographs, you'll be able to choose someone who you know and trust next time you need a CPA, a lawyer or a PR person.

PRO BONO WORK

Doing pro bono gives something back to the community that's helped make your business a success. As a photographer, your work can be used in annual reports, promotional material, newsletters, posters, press releases and even wall art. Again, choose charitable organizations that serve in areas complementary to your specialty. If you're an architectural photographer, shoot pro bono for a group that advocates for the preservation of landmark buildings. If you're a nature shooter, do something pro bono for a conservancy group, such as shooting a local landscape destined to become a strip mall.

There are different ways to become involved in your community, generate some goodwill for your business and do some good deeds in the bargain. Whether you go it alone or hire a professional, the benefits will be many.

I don't know why there are so many lawyer jokes and almost no accountant jokes. My Certified Public Accountant (CPA) is a pretty funny guy. His name is Jim Orenstein (no relation). When I first started working with him twenty years ago, I had just opened my first studio and my gross that year was about $9,000. A couple of years later, he said, "Hey, I think you're going to break six figures gross this year." A couple of years after that, he said, "Looks like you're going to break half a million gross this year. If you do that, I'm going to start telling people we're related."

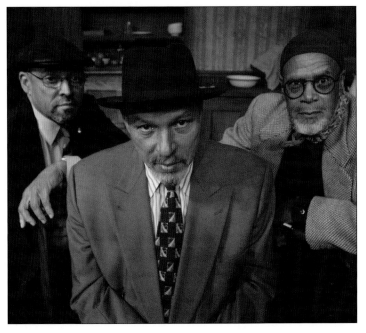

A portrait of playwright August Wilson by Stormi Greener.

But I guess that's not an accountant joke, it's an accountant making a joke. Maybe there are no accountant jokes because having a good CPA is the keystone to building your successful business—and that's not a laughing matter.

GET THEE TO A CPA

"Most people go to a lawyer first when they're looking to start up their own business," says Orenstein. "That's a mistake. You need to start with a reputable CPA who specializes in small businesses. He can start you out from ground zero: getting a tax ID number, helping you structure your business, choosing what

type of entity you should be. Going to a CPA first can save you some needless expenses. Then, when he's got you up to speed, he can refer you to the other professionals you'll need to help make your business successful."

NOT JUST ANOTHER PRETTY FACE

You don't just want an accountant—you want a CPA. And you don't want just any CPA, you want one who specializes in small businesses like your own. Preferably someone whose firm is also relatively small.

"Larger firms can't afford to put experienced CPAs in their small business divisions because they can't charge them as much as they do their big clients, so the small business person gets the newbie, who can't offer the same level of service a more experienced person would bring to the table, and who might not even be at that firm next year. If you choose a CPA with a small firm, you'll pay less for a higher experience level."

HOW NOT TO FIND A CPA

Do not pick one randomly out of the yellow pages—that doesn't give you enough information to make one of your most important business choices. Do not pick one because he's in the neighborhood. You don't pick your doctors or your dentists because they're close by, you pick them because you trust them with your health and your teeth. It should be the same with your CPA.

A macro nature image by Kerry Drager.

THE BEST WAY: WORD OF MOUTH

The only way to choose your CPA is through word of mouth. Get referrals from people you know and trust, and who have businesses of a similar size to yours. Then once you have your CPA, he can help you assemble that team of advisors you're going to need.

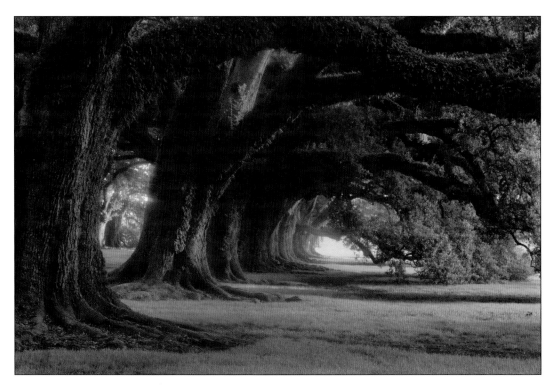

IT TAKES A VILLAGE

A landscape by Brenda Tharp.

Orenstein says you need a team of advisors to help you in your business. Your CPA should be the director of this team. "He's the one you see the most—well, hopefully he's the one you see the most, if you see your lawyer the most there's probably something wrong," Orenstein says, exhibiting that accountant humor once again.

Who comprises the rest of the team?

YOUR FUTURE: BE SURE
YOU CAN BANK ON IT

"Your banker is very, very important to the success of your business. Not just the bank, the institution, but the person," says Orenstein. "You should get to know him, socialize with him. This is one guy you should take out for lunch and establish a relationship with so when you need him, he already knows and trusts you and he'll help you out." Most people never talk to their banker until they're in trouble, and that's a less than ideal time to establish rapport. Pick a banker who will be around for a long time. Typically,

A nature image by Lewis Kemper.

larger institutions have higher turnover. So choose an established individual who's affiliated with a small- to medium-sized service-oriented bank.

SOMEONE TO KEEP YOUR DUCKS IN A ROW

Perhaps as important as your banker is your bookkeeper. "In all likelihood you won't need a full-time bookkeeper, you just need an independent contractor. You need someone called a 'full charge' bookkeeper. Not someone who used to foot columns for [a department store]," says Orenstein.

There is no "full charge" certification for bookkeepers, so you'll have to rely on your CPA's recommendations about who to hire—another reason it's essential to have a CPA you trust. Beware the CPA who offers to do your bookkeeping for you himself—a full charge bookkeeper can do anything your accountant can do for you for much less.

What about all those stories about bookkeepers running off to Brazil after embezzling the company funds? "You never give the bookkeeper access to cash—never," says Orenstein. He also advises keeping separate duties. The person who collects the money

shouldn't be the one to disburse it. People are less likely to collude than to act on their own to siphon funds.

Your bookkeeping is best done by a hired hand rather than a family member. "People will come in here and say, 'My wife is going to do the books. We bought QuickBooks, and that's going to save me loads of money over having to hire a bookkeeper.' But that's penny-wise and pound-foolish. Doing bookkeeping is not where you make your money. Creating, marketing and selling your product is where you make your money, and where you should focus your time and energy."

Orenstein also warns against the allure of programs like Quick-Books. While they're efficient tools for some situations, they often take time and energy from your main focus—creating, marketing and selling your work.

SPECIAL AGENTS

The next folks to add to your village are insurance agents—several of them.

• **LIFE INSURANCE AND DISABILITY INSURANCE.** What do you think you need more—life insurance or disability insurance? Yes, this is a trick question. "Everybody thinks they need life insurance," says Orenstein. "Everybody has life insurance. Hardly anybody has disability insurance. But you are much, much more likely to become unable to work than you are to die prematurely. So disability insurance is much more important to have. You need an insurance agent who will assess your personal needs and honestly guide you to the best products for you. Buying insurance is like buying a car: They can load it up with accessories that drive up the cost unnecessarily. For instance, you can buy an inflation rider. But that's ridiculous. Because if inflation goes through the roof, wouldn't you just buy more insurance? They're asking you to insure your insurance! That's why you need an honest agent, someone who will tell you when you really don't need the bells and whistles."

• **BUSINESS INSURANCE.** Many items fall under this category: worker's compensation, unemployment insurance, liability insurance; health/medical insurance and casualty insurance. "You

want a good agent who knows how to write a plan that covers everything you need covered," continues Orenstein. "For instance, let's say all your cameras are stolen or destroyed. You go to make a claim, and you find out your cameras weren't covered—your most important tool for your business!"

No matter what type of insurance you're buying, you need an agent who isn't loyal to just one company, because he only gets paid if he sells you their products. You also want someone who stays in touch with you, who calls you now and then, and checks to see if your situation has changed—your needs can change, and insurance products are changing all the time.

LEGAL EAGLES

You will need a lawyer or lawyers. There's a whole smorgasbord of different specialties, including employment law, tax law and others. Is it okay to use a generalist for your business law needs?

"I think it's fine to do that," says Orenstein, "because a good, reputable generalist will point you in the direction of another professional if they find themselves in over their head." Another advantage to using a generalist is that you'll see them more frequently than if you have a whole stable of attorneys for different issues, and you'll establish a better relationship. We'll look more at lawyers and legal issues in chapter eighteen.

WHAT ABOUT A FINANCIAL PLANNER?

"Ideally your CPA also acts as your financial advisor," says Orenstein. "I don't believe in financial planners—the person advising you shouldn't also be making commissions on investment products he's selling you. Often the brokerage houses underwrite the stocks they're selling."

Orenstein recommends picking a solid-performing stock in each of several different industries: energy, medical and technology, for instance. Then buy the shares, stick them in your safe-deposit box and forget you have them. Stay in for the long haul—the only person you'll make rich by doing a lot of buying and selling is a broker.

"The best place to invest your money is in your own business. That's where you're big returns will be," Orenstein concludes.

GET A CREDIT LINE BEFORE YOU NEED ONE

Early along, when your business is showing a healthy profit and regular growth, you should establish a line of credit. It doesn't cost you anything, and you may never use it, but it should be there if you need it. If you wait until you're in trouble, no one will extend you credit. It's the old "you can get it if you don't need it, but you can't get it if you do need it" routine.

TO BORROW, OR NOT TO BORROW

Let's say you want to open a photo studio and you've already got some adequate camera and lighting equipment. It's not pretty, but

A portrait by Vik Orenstein.

it does the trick. Thing is, you'd like some nicer, fancier stuff so you can put your best foot forward when you open your new business. Is it justifiable to take out a loan to cover this expense?

"You have to make realistic projections," says Orenstein. "Let's say you've been working at a big studio for a while, and you have some loyal clients who will follow you when you open your own place. They amount to maybe $30,000 worth of business each year. You figure that to make your business expenses that first year, and to feed your family and have enough to live on, you need to make $75,000. Then you go month by month and figure out what gross you can expect. $1,500 the first month because it'll be slow to begin with. $2,500 the second month, because that's the beginning of your busy season. $3,500 your third month, because you'll have picked up one new client by then. With some luck, hard work and marketing, you'll be able to realistically turn that $30,000 worth of clients into $40,000. That still leaves you $35,000 short. So you march down to your banker and you get yourself a line of credit, but you don't use it if you don't have to. Wait on that fancy equipment until you see your projections and your basic expenses being met. Then you'll be able to justify that kind of equipment purchase. But not right away. You need to prepare yourself for your worst-case scenario."

Your CPA has the business knowledge and experience to make accurate projections. Trust him to help you, and you'll avoid stretching your funds too tight.

It's fun to make jokes about lawyers—until you need one. Then the fun is over. The fact is that a good lawyer is like a good friend: You tend to take her for granted until you really need her.

COPYRIGHT AND INTELLECTUAL PROPERTY LAW

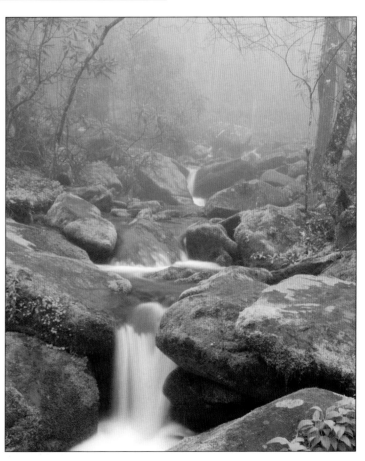

A nature image by Jim Miotke.

"The entire premise of copyright law is that if you don't give artists protection, they will have no incentive to create," says business attorney Janet Boche-Krause. "Unfortunately, there is more copyright infringement going on now than ever before. The new digital technology just makes it so easy to copy that users don't stop to think, 'Oh, is this a copyright violation?' I am convinced that there are a whole lot of people out there who really do want to do the right thing and are not intentionally stealing intellectual property."

Similar transitions affected the movie business, with the advent of VCRs; the music business, with the advent of CD burners; and the publishing business, with the humble

283

A macro nature image by Lewis Kemper.

Xerox machine. But there are still filmmakers, music CDs and books, and that gives me hope that photographers can ride out this transition, too.

Just as the consumers of photographic images contribute to the increase in copyright infringement, so do photographers themselves. "You must be vigilant and informed as to the rights you are giving away when you sign a usage agreement," says Boche-Krause. "For instance, when you sign off on print rights, what does that mean? Perhaps you believe you're only selling the rights to paper prints, and the user believes he is buying e-print rights, as well. If the agreement is full of broad, all-encompassing language, the buyer might be right."

Boche-Krause recommends making the agreement as specific as possible, such as, "I grant Doe Company, Inc., the right to use said images in this issue of this printed magazine." That way, there is little room for dispute.

When there are no contracts, Boche-Krause looks for verbal agreements. "If there is no written contract, then we go back and look for what is called a verbal contract. 'Okay, I'll shoot these dog treats for you and you can use them in your dog treat brochure,' is an example of a verbal agreement. It can be very difficult to go backwards and piece together a verbal agreement. Get it in writing."

If someone violates your copyright: "Invoice them. Call them up and say, 'My image ran in your magazine on such and such a date without my permission. Normally I'd charge you $300 for this, so I'm sending you a bill for $300.' Since most people want to do the right thing, you'll probably get results this way," says Boche-Krause.

If the client is still uncooperative, Boche-Krause suggests you "let them know you'll need to address the issue of their copyright violation," she says.

When someone uses your work without your permission, it's easy to feel violated. But you should always try to negotiate some resolution. Litigation should be a last resort. As Boche-Krause says, "It's very expensive to sue and win. And winning the case and collecting your winnings—which may not even cover your court costs—are two different issues."

Most clients don't sneak behind your back and steal your copyrights—some of them just try to take them up front.

"It's certainly become more Draconian," says Beth Wald, mountain-climbing shooter. "It used to be that most magazines were small companies with whom you could trust a gentlemen's agreement. But, today, most magazines have been bought by huge corporations. There's less personal responsibility. Some magazines will try to get you to sign away your copyrights after you've already been given the assignment, and some will even try to make this a condition you have to meet in order to get paid."

These tactics are largely illegal, but obviously they work some of the time or magazines wouldn't be employing them. When in doubt, contact your attorney before you sign.

EMPLOYMENT LAW

Whether you hire independent contractors or permanent employees, there are important tax and legal implications to consider. To start with, you need to know the difference between a contractor and an employee. An employer's obligation to an employee is greater than his obligation to a contractor. You may have someone working for you who you believe is a contractor, but if this is ever disputed and the state decides that the individual was actually an employee, you may be liable for taxes, penalties, unemployment insurance, worker's comp and more.

Even if you have an employee and you both know he's an employee, there is still the question of what type of employee he is. Different types have different rights under the law. Is he full-time? Part-time? Temporary? Seasonal? Hourly or salaried? The category into which he falls will determine if or how much paid time off, medical coverage, overtime and other perks he is entitled to by law. For instance, you are not required to pay a salaried

employee overtime. However, you also cannot require this salaried employee to work certain set hours. He is supposed to be able to get his job done and receive his set pay whether it takes him twenty hours a week or eighty. On the other hand, you are required to pay an hourly employee time and a half for hours worked over either 40 or 48 hours in a given week, depending on the size of your gross—except on Tuesdays during a full moon if you twirl three times and spit over your right shoulder.

All this sound confusing? And that's just the tip of the iceberg. Yes, if you're diligent and know what questions to ask and are willing to wait on hold for hours at a time, various government agencies can answer your questions regarding employment issues. But in my experience, it's easier, faster—and if you factor in the value of your own time—cheaper to consult a business lawyer.

Your friendly neighborhood attorney can provide you with a boilerplate employment agreement or customize one as needed to reflect your situation. He can provide you with incomplete agreements in which you fill in the specific details. These little documents can be very important to photographers who are hiring other photographers. He can help you determine what category of contractor or employee you can/should hire for maximum profitability and minimum risk. He can also help you avoid potential lawsuits by advising you on how to handle interviewing, hiring, disciplining and firing employees.

PROTECTING YOUR NAME

Some photographers neglect to protect their business name, much to their detriment. Perhaps they don't understand the necessity, or maybe they simply don't want to spend the money. While it isn't cheap—the name search alone (to establish whether someone else already owns the rights to the same or a similar name) runs about $400—it's money well spent. Protecting your name from the start will save you issues in the future if someone infringes on your rights. If you have legal documentation from the start, it's much easier to prove your case. Plus, if your business name is registered, other businesses—if they're doing their research—will be less likely to chose it in the first place, eliminating the need for an argument.

HOW TO FIND THE LAWYER WHO'S RIGHT FOR YOU

Like photographers, lawyers can be very specialized or maintain more general practices. What type of lawyer you'll be most compatible with is something you need to explore for yourself. Take a look at the specific needs of your business and think how you want your relationship with your lawyer to function. Then ask around for references and research the lawyers in your area.

I once had different lawyers for trademarks, employment law, tax law, real estate law and corporation partnership issues. I now have one lawyer who handles 95 percent of my legal work. If I have an issue that is outside of her specialty, she refers me to someone else, and I've always been happy with her colleagues. Her philosophy and her approach to my legal issues are practical, straightforward and firm but noncombative. She saves me money rather than costing me money. I have not always been this lucky.

An architectural detail by Kerry Drager.

The first attorney I used for employment law was with a huge firm that had a great reputation. He most certainly knew his stuff, but dealing with a case of employee theft cost me $8,500—slightly less than the employee absconded with. When I questioned his bill, he immediately knocked $1,000 off of it. Maybe I'm perverse, but this made me feel less trusting of him, as if he were padding the bill and chalking the effort up to the "you can't blame a guy for trying" school of thought.

Then when I asked him for a basic, generic employment agreement, he fired off an eighteen-page document. (No, I'm not exaggerating.) It certainly didn't fit what I needed for my business. If I were a potential employee I never would have signed it, so I couldn't in good conscience ask my potential employees to sign it.

While the big firm legal eagle was not a good fit for me, I stayed with him for a number of years because I didn't realize there was anyone out there who practiced law differently. It wasn't until I worked with my second lawyer on employment issues that I

A war photo by Stormi Greener.

realized lawyers are as different as snowflakes. Do a little shopping around, and you'll find one who's right for you.

TAX LAW

A tax attorney is the specialist you consult when choosing what type of entity your new business should be. (Your CPA can assist you here, too, see chapter seventeen.)

And if you're ever audited by the IRS or the sales tax division of the state in which you live, you may want to consult this specialist—even if your nose is clean! It's nice to have a professional advocate when you're venturing into an area in which you have little or no experience, especially when your money is at stake.

REAL ESTATE LAW

My first three studio leases I signed without the benefit of consultation with a real estate lawyer. I lucked out: My landlords were fair, the lease agreements were standard and relatively easy to understand, and they were based on rent per square foot plus CAM (common area maintenance) charges. Whenever one of them came up for renewal, there was a reasonable percentage increase that reflected the state of the market, and I signed again, and that was that.

But then lease number four came along. This landlord was considerably more ambitious. He wanted major concessions I'd never heard of before: a deposit and a personal guarantee, a percentage of profits (not an uncommon practice for landlords with properties in very trendy, high-traffic locations), the right to enter the premises and examine my books at any time, and the list went on. My initial response was to stomp my foot and walk away. But the space in question was perfect for my studio—it needed hardly any build out [remodeling or construction.] And the location was primo. So I was stymied. I finally consulted a real estate lawyer who assured me that while the lease was heavily weighted to benefit the landlord, the terms and dollar amounts were not unreasonable for this prime retail location. He recommended a few changes (the deposit or the personal guarantee, not both). I signed the lease, and all is well. Yes, it cost a couple of hundred dollars to have the lawyer read the lease,

but it saved aggravation and worry. So whether you're renting or purchasing your own commercial property, a visit with a real estate attorney can grant you great peace of mind.

PONYING UP

There are as many different fee structures for lawyers as there are, well, lawyers. Most charge by the hour, with rates ranging from $100 to $700. Generally lawyers with the big firms charge the highest rates. You can usually find excellent lawyers in smaller or solo practices who charge less. As with other expenses, fees tend to be higher in bigger cities. Lawyers with a particular expertise may charge more than general practice lawyers. Make sure you're clear on what your lawyer's fees are and how they're billed so you can make sure they're manageable for your business.

WHEN TO LAWYER UP—AND WHEN TO GO IT ALONE

We tend to glamorize the "Little guy all alone against the big guy" approach to life. We love the idea of a lone photographer going into court, facing off against a big ad agency and winning the case. I admit I know a couple of photographers who have done just that. But generally, if you're going anywhere but small claims court (where you're not allowed to bring a lawyer), I personally believe you're doing yourself a disservice by not having professional counsel. A photographer going into civil court without an attorney is a lot like an amateur with a snap-shooter trying to take professional portraits. Quite frankly, if I were a judge sitting on a case where one of the parties showed up without representation, I would think said party wasn't taking the proceedings very seriously. If you do decide to represent yourself in court, either due to financial necessity or personal choice, take time and make an effort to prepare yourself. Learn the court rules and procedure—you can get information on these from the court clerk and from the Internet. Don't hesitate to ask questions in advance. Bring your evidence and witnesses, and be ready to explain your side of the story clearly and succinctly. Stick to the legal issues, and check your emotions at the courthouse door.

Many legal issues can be settled out of court. I've discovered that a letter from my lawyer gets a quicker and more desirable response than a letter from little ol' me, especially when the topic is copyright infringement or uncollected fees.

Now that I have an attorney that I like personally and professionally, I find lawyer jokes a lot less funny. So hold the humor and find a good generalist with a small—even a one-horse—operation, who can help you with your day-to-day business issues and point you to a specialist for those occasions when it's called for.

A small business goes through growth stages similar to those of a child. Each stage has its unique joys and challenges. Parenting demands that you adapt to the wildly fluctuating needs of the child—there are times you have to do absolutely everything for the child and completely control his environment, and there are times when you have to let go of the control and let the child function on his own. Most of us are best at one stage or another; those of us who are great at caring for a baby, for instance, probably have a harder time allowing their child to spread his wings and take risks when he's older. These parents will also be the business owners who will have a difficult time learning to delegate responsibility and let go of control when their business reaches the stage of development that requires it. On the other hand, those who are good at relinquishing control will be especially challenged by the stages when their businesses require their absolute attention to even the smallest of details. So no matter what type of parent/small business owner you are, you will find some periods of growth difficult and some rewarding.

GESTATION

Gestation is an exciting time. You're picking out names and furniture, making grand plans and you're full of hope for the future—whether you're expecting a baby or starting a small business.

There's also trepidation: What if something goes wrong? What if this is the wrong time? What if you can't handle the responsibilities, the

A travel image by Stormi Greener.

changes this new addition will bring? What if you fail? What if your dreams are dashed? You really do want to do this, or do you?

You have to make a conscious effort not to let your doubts get you down. I once asked a pastor if he ever had doubts about God. He said that doubts are to belief as ants are to a picnic—you can't have one without the other. You just need to keep the ants off your food.

In spite of ants, gestation is one of my favorite stages of business. I like it so much I go through mini gestation drills when I need to recharge my batteries. I create an entire new studio (on paper, not in the real world): I pick a name, a market, a location, a corporate image, promotional material and a marketing plan, products, fee structures and price lists, type of business entity and so on. Some of these little drills result in marketable concepts, and I file them away for future reference. Some of them are just plain clunkers. But it allows me to flex my business and creative muscles, keeps me thinking on my feet and lets me spend a little time in that wonderful gestation reverie.

INFANCY

When I was expecting my daughter I made some grand plans for all the things I'd get done while I was at home with baby. I was going to get twenty years worth of snapshots labeled and into albums, clean and organize all my kitchen cupboards and closets, write a book, and catch up on my reading. I mentioned this to a client, a mother of four, and she laughed so hard she nearly wet herself.

"Darlin'," she told me, "You won't be able to do anything except take care of your baby. Even Wonder Woman wouldn't be able to do all that."

I smiled politely and nodded, while I secretly tagged her as a wimp.

As it happens, she was right. All I did for the first three months after my daughter was born was feed her, sleep when she slept, change diapers, bathe her and accept hot dishes from charitable neighbors, friends and family. I guess that's not all I did—I actually got to watch reruns of *Gunsmoke* once in a while when I was feeding her.

A portrait of Garrison Keillor by Stormi Greener.

The drill is the same for a newborn business. It will consume all your time and energy. If you don't like hard work, don't start your own photography studio because during this phase, you'll be doing almost nothing but working.

"There's a reason why employees account for 90 percent of the population," says CPA Jim Orenstein. "That's not bad, it's just how it is. Not everybody has the drive or is willing to live with the risks of starting their own business. Some people like to leave their work at 5 p.m., go home and not think about it again until 8 a.m. the next day."

In the infancy of my first studio, I often worked sixty- to seventy-hour weeks. I hadn't yet learned the value of delegating or the way to go about it. My business fluctuated seasonally, so I knew I couldn't commit to permanent employees, but many of the functions I needed to free myself of were simply not those that could be considered for independent contractors. I ultimately suffered from burnout, and with my 20/20 hindsight, I realize that if I'd gotten things into balance earlier and worked smarter, not harder, I could have been more profitable earlier. And yet, when I look back at that time of my life/business, I look back with fond-

ness—nostalgia, even. Possibly I'm experiencing selective amnesia, and I've simply blocked out the agony. But it was a happy, exciting time for me,. Not that I would choose to go back and relive it exactly the same way.

POSTINFANCY

Toddlers are dangerous to themselves and others. Their foreheads are exactly the same height as the edges of tabletops, and they never look where they're going. They fear monsters under the bed, but not a 20-foot drop from a window. Biting and hitting are parts of a normal developmental stage. It's amazing to me that any of us survive into adulthood at all, let alone without facial scars.

The toddler stage of business is equally fraught with dangers. This is when we entrepreneurs have enough mobility and can get enough momentum going to plow our heads smack into that table edge.

When I was a business toddler I had enough capital and enough knowledge to feel a little cocky and make some very costly mistakes.

I'd had good responses to several direct mailings. I'd been conservative and mailed to only 2,500 highly targeted families. I'd used 4" × 6" (10cm × 15 cm) postcards sent at the bulk rate and meticulously followed tried-and-true marketing wisdom, including a special offer, call to action and timely expiration date.

In good old American fashion, I figured if some was good, more was better. I created a new, 6" × 9" (15cm × 23cm) postcard. I broadened my target and mailed the postcard to ten thousand families, even though most didn't fall into my prime demographic. I neglected to include a special offer, call to action or expiration date. If all that wasn't enough, I also got really lazy, and rather than go to the trouble of the presorting and bundling necessary to mail at the bulk rate, I went first class. Can you see where this is going? The previous mailings had cost about $1,500 each total and had resulted in about $9,000 of additional business. The 6" × 9" (15cm × 23cm) postcard mailing cost $4,200 all told, and resulted in three—yes, three—inquiries. I don't remember if any of those callers actually booked. It was a disastrous result. According to direct-mail expert Rick Byron, even the worst mailing piece sent out to households randomly selected from the

phone book should result in a .05 percent return. So I'd set a new record—but not the one I was hoping for.

That was the dangerous-to-myself part. The dangerous to others part involved the entrepreneurial equivalent of biting and hitting. At a certain point, after I'd had steady growth for a while and felt confident that it was going to continue, I decided that if I didn't like a client, I didn't have to give her good customer service. In some cases I even decided I didn't have to work with people I didn't like. Fortunately, just as with real toddlers, this stage didn't last long, and I quickly came to realize that everybody deserved great customer service and that I really could get along with, and even like, anyone if I wanted to. It's interesting to note that many small businesses fail in their second year—when they're two. Toddlers are reputed to be most difficult at the same age, hence the phrase "the terrible twos." Coincidence? I don't think so.

THAT AWKWARD STAGE

I love to photograph preteens—ages nine through twelve are especially delightful. The kids are all elbows and knees, their faces haven't grown into their teeth, and they're not sure whether they want to be treated as grown-ups or little children. Their mothers describe them alternately as Jekyll and Hydes, disdaining their parents and craving their affection. They're as likely to bring their favorite teddy bear to a shoot as to polish their nails, beg their mothers to let them wear makeup and try out some rock star poses in front of the camera. They're alternately insecure and full of themselves.

Businesses go through a similar phase. Sometimes you feel like the new "it" girl—you're the wunderkind, the precocious youngster who broke away from the pack to bring your new product and your new voice to your market. Lots of people know who you are and some of them tell you they love your work. Others see your book, they're impressed, and they say, "Gee, why haven't I heard of you before?" You're confident.

Sometimes, though, you realize there's a lot you don't know. You lose out on a job and you wonder if the potential client saw

through you, if he figured out that you're really an impostor, that sometimes you're out of your depth technically and you're making it up as you go along.

Everyone goes through this—you're not alone. It's the preteen version of the gestation parable of the ants at the picnic. Keep them off your food and you'll be okay.

"Prom" for the Minneapolis Children's Theater by Rob Levine.

YOUNG ADULTHOOD

Now you're not having the mood swings, doubts and insecurities you experienced in earlier developmental stages. Your business is stable, but you're still excited and engaged. Each job is a challenge. You realize you don't know everything, but you also realize you can learn whatever you need to know to meet the demands of each new job. You're still experimenting with new products; nobody has to remind you to change out images to freshen up your book; you look forward to visiting with your old, loyal clients and marketing to new ones. Your business is still growing, although

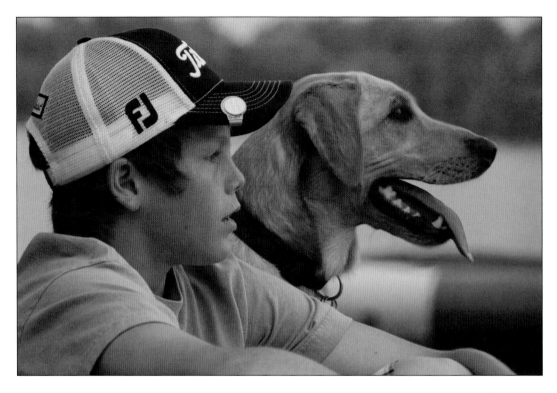

"Best Friends" by Vik Orenstein.

not at the rate it once was. Still, there's enough growth that you feel strong, and life is good.

MIDDLE AGE

Yawn. You're coasting. Everything any job requires of you you've done successfully many times before. Your growth topped out some time ago, so while you're making a good living, you're not increasing your income level each year like you were before. You can't remember the last time you put new shots in your book—you can't remember the last time you showed your book. You're content to work with the clients you long ago established relationships with. Long ago you forgot that happy feeling you got when people asked you what you did for a living and you got to say, "I'm a photographer!"

You're still at the picnic, but there are no ants, and you can't believe you miss them but you do. This is the time you need to create new challenges for yourself. You need to bring back the risk that you might fail at something. That's what keeps life interesting.

Develop a new product. Mine a new market base. Explore new areas of specialty.

THE GOLDEN YEARS

Now you're winding down. Unlike other types of businesses, yours probably isn't salable. So your exit from the business you've worked in for so long might not involve that big, final deal that results in more feathers for your retirement nest. It'll be more a matter of riding out the end of your lease and selling off your equipment, props and backdrops. Ideally you'll have planned for this likelihood and you'll have saved enough money to keep yourself comfortable.

This might feel like an anticlimactic ending. When you're self-employed, there's no one standing at the end of the road holding out a gold watch or serving cake and punch. You might want to plan your own retirement party, some way to mark this milestone for you, your family, your clients and vendors. Or perhaps you want to celebrate a business life well lived by taking a special vacation.

There you have it—cradle to grave. If you're lucky and you work hard, your life as a photographer will probably look something like this. If this picture looks good to you, you're in the right place.

A portrait by Chris Darbonne.

Now that you've spent a little time reading this book, do you have a let-down feeling, knowing that the life of a photographer is not all hearts and flowers? Or do you have a steely resolve to work hard and meet all the challenges and rise above the competition to one day be tops in your photographic specialty of choice?

Maybe you're thinking the fantasy photography life you'd envisioned wasn't all that great, and the reality isn't all that harsh. Maybe you're thinking, "Hey, I can do this."

I can be a businessperson: I can make projections, get a tax ID number, protect my name, get invoices out on time, and anything and everything else necessary.

I can fulfill the obligation to fully and passionately tell the stories of my subjects whether they are two-year-olds in ribbons and bows holding bunny rabbits, or war-torn refugees.

I can be my own product, my own message. I can leave my clients not just with beautiful images but with excitement about the experience of working with me and about the special understanding and creativity I brought to their project.

A baby portrait by Vik Orenstein.

I can put my clients at ease, earn their trust and build strong, intimate working relationships with them.

I can hang on for the creative ride from the highs of learning to the thrills of mastery to the valleys of boredom—and bring myself back to the highs of learning all over again.

I can reinvent myself when the economy, the marketplace, the trends and the technological advancements dictate the need—and I can feel good about it.

THE STORIES OF THOSE WHO HAVE GONE BEFORE US

Learning the stories of those who have established photography careers can give us a context for our career choice and validate that choice. Understanding the disparate places in their lives from which these people all entered the same creative field helps us understand that we are, each of us, both more unique and less alone in our visions and our desires than we had thought.

Having the luxury of seeing the ways in which they built their careers and beat the odds gives us hope that we can do it, too.

In frankly sharing their mistakes and fears as well as their victories with us, they allow us to identify with them, to see ourselves in similar lives one day, and allow ourselves to have fears and to make mistakes, too.

HOW TO BECOME A PHOTOGRAPHER

There are so many ways to learn the craft and art of photography that any aspiring shooter should be able to find one or more that suits his personal style and that he can easily fit into his life.

He can work as an apprentice, assisting a photographer. He'll make little or no pay, but if he's observant and asks questions, he can learn it all—creative technique, technical know-how and business protocol—from the inside.

He can work as an assistant, making $175 to $250 a day, and get a bird's-eye view of an established shooter's business.

Going to a two-year tech school is a relatively quick option that allows the student down-and-dirty hands-on experience with the whole range of equipment and in a variety of disciplines. It may not hold the prestige of art school or photography school, but it sure gets the job done.

A top-notch school like the Brooks Institute offers two- and four-year programs that are intensive and expensive. Many shooters

start out in liberal arts college and then transfer credits to finish their photography major at such schools.

A photographer with an art school education can do well if he remembers to consider his clients' satisfaction into his equation of how to do business.

Clubs and professional organizations, including online discussion groups, can provide a great forum for new and established photographers to network and exchange knowledge and information.

A liberal arts degree creates a well-rounded person with good general knowledge, who knows how to study and how to think—an excellent platform from which to dive into the photography business.

Many of the photographers profiled in this book are self-taught. This doesn't mean they learned the business in a vacuum, without teachers or mentors. It simply means they had no formal photographic training. If you're incredibly motivated and confident in your talent, you might be able to make self-teaching your platform into the photography world.

Working in a camera store gives you exposure to a lot of different professional photographers, intimate knowledge of equipment and a natural forum to discuss every aspect of the business with fellow employees and store patrons.

If you can get informal informational interviews with established photographers, you'll get to spend a little time in the inner sanctum and get some answers to questions that are burning in your mind.

Reading books on photography can nicely supplement any other avenues for learning you choose to pursue. Just don't read a book and assume you've learned its lessons; you need to take the lessons out into the field and apply the theories and techniques you read about to your actual shooting experience.

To really shorten your learning curve, you can hire a consultant at $200 to $500 an hour, to show you exactly how to run a business in your specialty area. For people who have the resources and know precisely what they want to do, hiring a consultant can actually result in a huge savings in time and money spent compared to a two- or a four-year program at a photography school or an art college.

Aspiring portrait photographers can learn some of the ins and outs on the job at chain studios and photo mills. You can get a lot of practical hands-on experience dealing with clients and a variety of subjects, and learn some technical basics while getting paid.

"A Snail at Dusk" by Connie Cooper-Edwards.

Of course finding a mentor can really jump-start your career. An older, more established shooter who takes an interest in your career is worth his weight in gold.

People who want to learn photography but who have day jobs, families, or other pressing obligations, often find Internet classes to be a perfect solution. You can complete the lessons at your convenience and receive invaluable feedback from highly credentialed instructors, as well as from the rest of the class.

FINDING YOUR PLACE

With the fierce competition in every photography market in every part of the country, now more than ever before it is important

to choose a specialty and refine it so that you distinguish yourself from the pack. Clients should be able to look at your work and know that it's yours without ever seeing your credit line.

In choosing your specialty area, you need to weigh your interests—what it is you love to shoot—against the realities of your market, i.e., what people will buy. It's important to consider your desires. The photography business is too tough to be in if you don't love what you do. But it's equally important to consider your market. If you can't make a living, you'll be just as miserable as if you're stuck shooting in a field you don't like. So you need to do some soul-searching and then commit yourself to a narrow area of expertise.

DIGITAL TECHNOLOGY

I love film, and I have an inherent mistrust of digital capture. But I'm gradually learning to embrace digital technology as a valuable tool in certain circumstances.

Afghanistan, 2006 by Stormi Greener.

Simply put, digital capture is a different information storage method. Film stores visual information with grain. Digital stores visual information with pixels.

Digital technology cannot make a bad photographer into a good one or a poorly lit image into a work of art. What it can do is allow you to remove those nasty power lines from your exterior architectural shot or that blemish off the face of the model in your fashion shot.

It can give your clients faster turn-around time—sometimes you can just hand them a photo CD as they're walking out the door after your shoot. It can sometimes save you money on media, savings you can pass on to your client.

In some situations and for some methods of reproduction or distribution, digital images can look as good or better than film.

But digital equipment can be very expensive, and it becomes outdated quickly. If you already have an established film-based business, you need to do some number crunching to determine whether the addition of a digital system is justifiable financially. Will your $50,000 new equipment purchase result in $50,000 worth of increased sales or increased media savings? If the answer is no, you need to wait.

Is it really time to go digital or die? No. Is film dead? No. Digital technology is not a magic bullet, it's not Satan's little helper—it's just another tool in our belts.

NETWORKING

There are many reasons to network with your fellow photographers. You can help set industry standards, refer clients to one another when you get a request for a job that is outside of your area of specialty, find a mentor, trade secrets, and learn techniques from other specialties that you can use in your own. It's like cross-pollinating.

Places to network include professional organizations, online discussion groups and seminars and workshops.

PLANNING FOR A BOUNCING BABY BUSINESS

A business plan is a document that describes your business, your market and how you intend to position your business within that market.

It projects your fixed overhead, cost of goods, and the quantity of goods you'll have to sell, and at what price, to make a profit.

Your business plan spells out exactly who you are, what your products and services are, what makes your products and services better than your competition's, and who your targeted clients are.

Your business plan will help you test the feasibility of your economic goals, thus helping you avoid ugly (and costly) surprises.

In doing the research necessary to complete your business plan, you will learn about your competition and your market. This knowledge will help you make your business more successful.

Likewise figuring out exactly what and how much you need to sell can help motivate you to meet financial goals, in the same way that quotas help motivate a salesperson.

If you intend to apply for a bank loan, or woo potential investors, your business plan is an invaluable sales tool.

STARTING UP

When you're starting up your own business, your to-do list is going to be really, really long. Don't let it daunt you. You have to be unflappable. You have a lot to do.

You need to choose the type of entity, or business structure, that's right for you. You need a professional to guide you. Kids, don't try this at home! Consult a CPA or a tax attorney.

You need to choose a name for your business, and you need to protect that name by getting a trademark for it, unless you're simply doing business under your own name—you don't need any protection for that.

You need to file for a tax ID number; you can't do business without one, and you need it so you don't have to pay sales tax on items for resale.

You need to learn when to charge your clients sales tax and when not to, and when to pay sales tax and when not to. This can be trickier than it seems.

You need to establish a record-keeping system that works for you and get into the habit of keeping meticulous records.

Figuring your own taxes and filling out the 1040EZ form are now a thing of the past for you. You need to hire a CPA.

You need to choose a location for your business. Do you want to work from your home? Open a point of destination or a retail studio? Share a space, partner or rent on an as-needed basis from another photographer?

If you sign a lease, you should understand rent plus CAM (common area maintenance) charges.

Considering the purchase of an existing studio or a franchise? Learn the pros and cons of each.

Recognize the difference between employees and contractors, and hire the one(s) that are appropriate for your business needs.

REJUVENATING YOUR EXISTING BUSINESS

Just when you think you can coast, it's time to start pedaling again. Sure, your business has survived the treacherous start-up stage, and you've experienced some real success. But now is not the time to relax.

Keep up your marketing. Keep your portfolio up-to-date. Use that phone—it's still your most valuable customer relations tool.

And speaking of customer relations, keep those up, too. Don't start taking those people, who are the very reason for your success, for granted.

Some photographers find this stage of their business life to be a time of disillusionment. They've come, they've seen, they've conquered—and now the excitement is gone. Fight this pitfall with a variety of tactics: Take a vacation, volunteer, do some test shoots or pursue your personal work with extra ambition. And count your blessings—remember, you're one of the lucky ones. Explore alternative careers. You might find one you that you're more suited for, but the more likely result is that you'll reaffirm the choices you've already made. Finally, vent your spleen! Do some good old-fashioned griping. Get it all out.

Having more business than you can handle is another dangerous milestone in the life of a small business. You have to decide whether to grow or whether to contract—and possibly turn business away.

You need to examine your role—it will change if you expand. You'll become more of a general and less a soldier in a foxhole, supervising rather than doing. Some photographers like this; they naturally find their own management style and they don't mind delegating. Others like to stay on the front lines. Which one are you?

Ask yourself: Am I making enough money right now? Because if you are, it might not be worth the risk of the added liability and exposure to expand. Sure, a larger well-run business will pay bigger dividends during a good economy, but bigger isn't always bet-

ter. Profit margins are smaller, and when the bad times come (and there will be bad times), your risk is greater.

There are pros and cons to this stage of business life. As someone once said, being old is better than the alternative. But you're not growing anymore, you've topped out. The thrill is gone. You need to recharge your creative batteries. Maybe you need to find greater satisfaction and excitement outside of work. Or maybe this is a good time to explore new niches within the photography industry.

EXPLORING NEW NICHES

There are a host of reasons to change your niche or add one at every stage of your photography career: a market shifts, your personal preferences change, you get bored, you lose the physical stamina for location work and come home to the studio.

Changing niches can be extreme (from outdoors/travel to studio portraits), or it can be slight (editorial architecture to commercial residential interiors). It may involve a total shift in technique and subject, or it may involve doing the same work but marketing to a different client.

Making such changes can be done at any stage in your business life. When you're just starting out, you're hungry and you're flexible, and you'll do whatever is necessary to succeed. When you're middle-aged, you might resist making changes because you're comfortable in your habits, but on the other hand, you've mastered photography and you have resources to make the transition easier. When you're in the later stages of your career, changing niches could be a godsend or a heartbreak, depending on the reason for the change. If you're going back to the subject matter you always wanted to shoot, then the change is a godsend. If your market dried up and you are forced to change to survive, that's the heartbreak. But then again, you might find you like the new challenge. It might bring back some of the thrill that you were missing.

Whatever you do, hedge your bets. Give yourself a safety net. Don't quit your old specialty until the new one has firmly taken root. Don't rob Peter to pay Paul; taking resources away from one

to put into another is dangerous and foolhardy. And don't follow the crowd—if there's a mass migration out of your specialty area, wait it out. You may find yourself surprisingly and happily alone.

PULLING NUMBERS OUT OF THIN AIR

Sometimes that's what it feels like when you're trying to determine what to charge for your products and services. But there are standard fee structures and price ranges for every industry. You need to research the standards in your area, and there are several ways to do this. You can join a professional organization for photographers in your specialty, such as ASMP (American Society of Media Photographers.)

Within your industry there is a range of price levels in which to compete. You have to decide where to position yourself within that range. If you're just starting out, you probably want to be somewhere in the middle of the range, between bargain basement and carriage trade. If you charge too little, you're competing with the masses and your work may be perceived as shoddy. Charge too much, and you limit yourself to a very small portion of your market.

Remember to consider your costs of goods (COGS) and fixed overhead when setting your prices.

And consider price-point appeal: $19.99 sounds a lot cheaper than $20. Don't ask me why, human beings are funny animals sometimes.

Small, steady price increases over the years will serve you better than sporadic, sudden increases. Your clients will be happier and you'll cover your inflationary expenses better in the long run.

THE PHYSICAL REALITY OF A BODY OF WORK

You probably thought your biggest job was going to be making your images, silly you! Actually one of your biggest jobs is going to be keeping track of them: organizing, archiving, distributing, showcasing, packaging and just generally handling your originals and prints.

"A Boy and His Dog" by Vik Orenstein.

Presentation is everything! When you're showcasing your work, whether it's on the wall, in your portfolio or in its package, do it right. The way you present your work tells your clients how to regard it. Great work can look like terrible work if it's presented poorly.

Organizing originals is a huge task all by itself. But a mislabeled or lost original may as well not exist at all. You need to know exactly where every image is, all the time.

Storage is another big deal. You need to have adequate archival storage containers and cost-effective, fireproof and waterproof storage areas for your originals.

Some photographers purge their negatives or originals after a period of time has passed and the likelihood of the client reordering has passed.

GET OUT THERE AND TELL YOUR STORY

The ability to be a good marketer is more important to your ultimate success than your ability to make great images—you probably don't want to hear this, but it's true. You could be a fantastically talented photographer, but if you don't get out there and spread your message and show people your work—and your face—you won't be in business long.

You don't just find a client base—you make one. You may not realize it, but you are on commission. You are essentially a commissioned salesperson, just like the one who sells you your clothes at the mall or sells you your waste-management services.

You have to know what makes you and your work stand out from the crowd. Make up a clear and recognizable story about it, then get out there and spread your rap.

A nature shot by Lewis Kemper.

Be persistent. It takes more than one contact with you before a client will hire you. Even if your contacts don't result in jobs right away, keep going back. It's like planting seeds. It can take a while for germination.

Target your audience. Market to the people who are likely to use your products and services. You don't have to get your message out to everyone, just the right ones.

Set goals, so you can track your progress.

There are many different marketing methods. Some are hard, some are easy. Some cost nothing, some cost a lot. You'll probably benefit most from a combination of methods. Direct mail, websites and cold calls are just a few.

Have a marketing plan and a marketing budget. It's even more important than your business plan. If you have clients, you have a business. If you don't have clients, you're out of business.

SELL IT, BABY

Sales is like marketing, but instead of selling a potential client on using your products or services, you're selling a person who is already your client your products or services. I look at marketing as outside sales (going out and getting the clients) and sales as inside sales (selling your clients your stuff).

Remember that sales is all about customer service and relationships. People buy from people they like.

Don't be shy about taking control of the sales meeting, design consultation or any other client situation. Your expertise is not an intrusion, it's a service. It's added value.

One way to take control is to set the tone. Often we unconsciously mirror the behavior of the people with whom we are dealing. If the client comes in flustered or defensive, we reflect this back to them. But instead of just reflexively taking the clients' lead, you set the tone. Demonstrate a relaxed, positive attitude and the client will relax and become more positive, too.

You should learn the little tricks of the trade: selling up, meeting objections, repeating the client's concerns in your own words. But ultimately you have to develop your own sales style, based on your own personality and the specific things that motivate you.

PUBLIC RELATIONS

Public relations is all about community. By creating a presence in your community you foster goodwill and make your own story a part of your community's story.

You can do your own public relations work, writing and sending out press releases and drumming up opportunities for public speaking, or you can hire a PR firm.

Other ways to establish a presence in your community include getting involved in charitable activities, joining professional groups and doing pro bono work.

LAWYERS

There are a lot of lawyer jokes, but they're only funny until you need legal advice. Then you stop laughing.

There are a lot of reasons photographers need lawyers. More than ever, we need help protecting our intellectual property. We need help deciding on what type of entity our businesses should be. We need help trademarking our names and understanding employment law and tax law—both areas where a misstep can cost you big-time.

Find a good lawyer by asking for referrals and interviewing potential candidates. Look for a generalist in a small firm or a sole practice, who has the integrity to refer you to a specialist when it becomes necessary.

ACCOUNTANTS

The first professional you hire should be your CPA. He will be the director of the team of professionals whose services you will use to grow your business. Your accountant will not only do your taxes, he will act as a financial and business advisor, and help you put together your team. You'll need a banker, bookkeeper, insurance agents and lawyer.

To find a good CPA, look for one in a small firm that specializes in small businesses like yours. Ask people who have similar businesses (and that you know and trust) who they use, and just

as with the attorneys, don't be afraid to ask for an interview with potential candidates.

"Nude and Pool" by Kathleen Carr.

CRADLE TO GRAVE

The life cycle of a small business goes something like the life cycle of a person. Gestation is an exciting and scary time. You're full of hopes and yet full of fear and doubts. What if something goes wrong? Will I be able to handle this new responsibility?

Infancy is hard—there's no joy in Mudville. You'll be working long hours, and often every day of the week. But you'll be able to see the payoff coming.

Toddlerhood is a dangerous time: You have some mobility now, and you've built up some momentum, which is the good

A portrait by Vik Orenstein.

news and the bad news. If you go toddling off in the right direction, you'll be okay. But if you toddle off in the wrong direction, you'll make the business equivalent of smacking your head on the table edge—investing your resources unwisely or focusing your energies in the wrong place.

The preteen stage is awkward. Sometimes you'll feel like the new wunderkind on the scene, and sometimes you'll feel like an impostor impersonating a photographer.

Young adulthood is great—you're feeling secure but still challenged and engaged, and you're still growing a little.

Middle age arrives and the thrill is gone. You need to consciously find ways to charge your creative batteries.

Our golden years might not be as golden as those of other entrepreneurs. Unlike other businesses, which are conceived with the intention to one day sell them, we might come to retirement stage with nothing to sell.

LIFESTYLES

Some people seem to think the lifestyle of a photographer is glamorous and easy. Others seem to think that if you decide to be a photographer you just have to accept that you'll always be poor and never quite make it financially. The truth tends to be a little of each. There *is* some glamour—but the work isn't always easy. In

many specialties, you wind up working nights and weekends. Often the work is physically demanding. The work can be seasonal or sporadic, so at times you'll be working eighty-hour weeks, and at other times you'll be wondering if you'll ever have another client again. You have to save for a rainy day, because just as the work comes in spurts, so does the money.

But if you can handle uncertainty, the payoff is big: You get to make pictures.

RESOURCES

PROFESSIONAL ORGANIZATIONS

ADVERTISING PHOTOGRAPHERS OF AMERICA, NATIONAL

office@apanational.com

www.apanational.com

ADVERTISING PHOTOGRAPHERS OF AMERICA, ATLANTA

info@apaatlanta.com

www.apaatlanta.com

ADVERTISING PHOTOGRAPHERS OF AMERICA, LOS ANGELES

office@apa-la.org

www.apa-la.org

ADVERTISING PHOTOGRAPHERS OF AMERICA, MIDWEST

ceo@apa-m.com

www.apamidwest.com

ADVERTISING PHOTOGRAPHERS OF AMERICA, NEW YORK

info@apany.com

www.apany.com

ADVERTISING PHOTOGRAPHERS OF AMERICA, SAN DIEGO

membership@apasd.org

www.apasd.org

ADVERTISING PHOTOGRAPHERS OF AMERICA, SAN FRANCISCO

info@apasf.com

www.apasf.com

AMERICAN SOCIETY OF MEDIA PHOTOGRAPHERS (ASMP)

www.asmp.org

AMERICAN SOCIETY OF PICTURE PROFESSIONALS (ASPP)

www.aspp.com

THE ASSOCIATION OF PHOTOGRAPHERS

general@aophoto.co.uk

www.the-aop.org

BRITISH ASSOCIATION OF PICTURE LIBRARIES AND AGENCIES

enquiries@bapla.org.uk

www.bapla.org.uk

BRITISH INSTITUTE OF PROFESSIONAL PHOTOGRAPHY (BIPP)

info@bipp.com

www.bipp.com

CANADIAN ASSOCIATION OF JOURNALISTS

caj@igs.net

www.caj.ca

CANADIAN ASSOCIATION OF PHOTOGRAPHERS & ILLUSTRATORS IN COMMUNICATIONS

info@capic.org

www.capic.org

CANADIAN ASSOCIATION FOR PHOTOGRAPHIC ART

capa@capacanada.ca

www.capacanada.ca

THE CENTER FOR PHOTOGRAPHY AT WOODSTOCK (CPW)

info@cpw.org

www.cpw.org

EVIDENCE PHOTOGRAPHERS INTERNATIONAL COUNCIL (EPIC)

EPICheadquarters@verizon.net

www.epic-photo.org

INTERNATIONAL ASSOCIATION OF PANORAMIC PHOTOGRAPHERS

iappsecretary@aol.com

www.panoramicassociation.org

INTERNATIONAL CENTER OF PHOTOGRAPHY (ICP)

info@icp.org

www.icp.org

THE LIGHT FACTORY (TLF)

info@lightfactory.org

www.lightfactory.org

NATIONAL ASSOCIATION OF PHOTOSHOP PROFESSIONALS (NAPP)

www.photoshopuser.com

NATIONAL PRESS PHOTOGRAPHERS ASSOCIATION (NPPA)

info@nppa.org

www.nppa.org

NORTH AMERICAN NATURE PHOTOGRAPHY ASSOCIATION (NANPA)

info@nanpa.org

www.nanpa.org

PHOTO MARKETING ASSOCIATION INTERNATIONAL

PMA_Information_Central@pmai.org

www.pmai.org

PHOTOGRAPHIC SOCIETY OF AMERICA (PSA)

hq@psa-photo.org

www.psa-photo.org

PICTURE ARCHIVE COUNCIL OF AMERICA (PACA)

pacnews@pacoffice.org

www.stockindustry.org

PROFESSIONAL PHOTOGRAPHERS OF AMERICA (PPA)

csc@ppa.com

www.ppa.com

PROFESSIONAL PHOTOGRAPHERS OF CANADA (PPOC)

ppoc@rogers.com

www.ppoc.ca

THE ROYAL PHOTOGRAPHIC SOCIETY

reception@rps.org

www.rps.org

SOCIETY FOR PHOTOGRAPHIC EDUCATION

speoffice@spenational.org

www.spenational.org

SOCIETY OF PHOTOGRAPHERS AND ARTISTS REPRESENTATIVES (SPAR)

info@spar.org

www.spar.org

VOLUNTEER LAWYERS FOR THE ARTS

www.vlany.org

WEDDING & PORTRAIT PHOTOGRAPHERS INTERNATIONAL (WPPI)

www.wppionline.com

WHITE HOUSE NEWS PHOTOGRAPHERS' ASSOCIATION (WHNPA)

www.whnpa.org

PUBLICATIONS PERIODICALS

ADVERTISING AGE

www.adage.com

Weekly magazine covering marketing, media and advertising.

ADWEEK

info@adweek.com

www.adweek.com

Weekly magazine covering advertising agencies.

AMERICAN PHOTO

www.americanphotomag.com

Monthly magazine emphasizing the craft and philosophy of photography.

ART CALENDAR

www.artcalendar.com

Monthly magazine listing galleries reviewing portfolios, juried shows, percent-for-art programs, scholarships and art colonies.

ASMP BULLETIN

www.asmp.org

Newsletter of the American Society of Media Photographers published five times a year. Subscription with membership.

COMMUNICATION ARTS

www.commarts.com

Trade journal for visual communications.

EDITOR & PUBLISHER

www.editorandpublisher.com

Monthly magazine covering latest developments in journalism and newspaper production. Publishes an annual directory issue listing syndicates and another directory listing newspapers.

FOLIO

www.foliomag.com

Monthly magazine that focuses on trends in magazine circulation, production, and editorial.

GRAPHIS

info@graphis.com

www.graphis.com

Magazine for the visual arts.

HOW

www.howdesign.com

Bimonthly magazine geared toward the design industry.

NEWS PHOTOGRAPHER

magazine@nppa.org

www.nppa.org

Monthly news tabloid published by the National Press Photographers Association. Subscription with membership.

OUTDOOR PHOTOGRAPHER

www.outdoorphotographer.com

Monthly magazine emphasizing equipment and techniques for shooting in outdoor conditions.

PHOTO DISTRICT NEWS

www.pdn-pix.com

> Monthly magazine for the professional photographer.

PHOTOSOURCE INTERNATIONAL

info@photosource.com

www.photosource.com

> This company publishes several helpful newsletters, including *PhotoLetter*, *Photo-Daily*, and *PhotoStockNotes*.

POPULAR PHOTOGRAPHY & IMAGING

www.popphoto.com

> Monthly magazine specializing in technical information for photography.

PRINT

info@printmag.com

www.printmag.com

> Bimonthly magazine focusing on creative trends and technological advances in illustration, design, photography and printing.

PROFESSIONAL PHOTOGRAPHER

www.ppa.com

> Monthly magazine emphasizing technique and equipment for working photographers.

PUBLISHERS WEEKLY

www.publishersweekly.com

> Weekly magazine covering industry trends and news in book publishing; includes book reviews and interviews.

RANGEFINDER

www.rangefindermag.com

> Monthly magazine covering photography technique, products and business practices.

SELLING STOCK

www.pickphoto.com

> Newsletter for stock photographers; includes coverage of trends in business practices such as pricing and contract terms.

SHUTTERBUG

www.shutterbug.net

> Monthly magazine of photography news and equipment reviews.

STUDIO PHOTOGRAPHY

www.imaginginfo.com/spd

> Monthly magazine showcasing professional photographers. Also provides guides, tips and tutorials.

BOOKS & DIRECTORIES

ADWEEK AGENCY DIRECTORY

www.adweek.com

> Annual directory of advertising agencies in the United States.

ADWEEK BRAND DIRECTORY

info@adweek.com

www.adweek.com

> Directory listing top two thousand brands, ranked by media spending.

ASMP COPYRIGHT GUIDE FOR PHOTOGRAPHERS

www.asmp.org

ASMP PROFESSIONAL BUSINESS PRACTICES IN PHOTOGRAPHY, 6TH EDITION

www.asmp.org

> Handbook covering all aspects of running a photography business.

BACON'S MEDIA DIRECTORIES

www.cision.com/media-directories.asp

THE BIG PICTURE: THE PROFESSIONAL PHO-TOGRAPHER'S GUIDE TO RIGHTS, RATES & NEGOTIATION BY LOU JACOBS

www.writersdigest.com

> Essential information on understanding contracts, copyrights, pricing, licensing and negotiation.

BUSINESS AND LEGAL FORMS FOR PHOTOG-RAPHERS, 3RD EDITION BY TAD CRAWFORD

PUB@allworth.com

www.allworth.com

> Negotiation book with twenty-eight forms for photographers.

THE BUSINESS OF COMMERCIAL PHOTOGRA-PHY BY IRA WEXLER

info@watsonguptill.com

http://amphotobooks.com

> Comprehensive career guide including interviews with thirty leading commercial photographers.

THE BUSINESS OF PHOTOGRAPHY: PRIN-CIPLES AND PRACTICES BY MARY VIRGINIA SWANSON

www.mvswanson.com

THE BUSINESS OF STUDIO PHOTOGRAPHY, REVISED EDITION BY EDWARD R. LILLEY

PUB@allworth.com

www.allworth.com

> A complete guide to starting and running a successful photography studio.

CHILDREN'S WRITERS & ILLUSTRATOR'S MARKET

www.writersdigest.com

Annual directory including photo needs of book publishers, magazines and multimedia producers in the children's publishing industry.

COLOR CONFIDENCE: THE DIGITAL PHOTOG-RAPHER'S GUIDE TO COLOR MANAGEMENT BY TIM GREY

Sybex, www.sybex.com

COLOR MANAGEMENT FOR PHOTOGRA-PHERS: HANDS-ON TECHNIQUES FOR PHO-TOSHOP USERS BY ANDREW RODNEY

www.focalpress.com

CREATIVE BLACK BOOK

www.blackbook.com

> Sourcebook used by photo buyers to find photographers.

HOW TO SHOOT STOCK PHOTOS THAT SELL, 3RD EDITION BY MICHAL HERON

PUB@allworth.com

www.allworth.com

> Comprehensive guide to producing, marketing and selling sock photos.

HOW YOU CAN MAKE $25,000 A YEAR WITH YOUR CAMERA BY LARRY CRIBB

www.writersdigest.com

> Revised edition of the popular book on finding photo opportunities in your own hometown.

LA 411

www.la411.com

> Music industry guide.

LEGAL GUIDE FOR THE VISUAL ARTIST, 4TH EDITION BY TAD CRAWFORD

PUB@allworth.com

www.allworth.com

The author, an attorney, offers legal advice for artists and includes forms dealing with copyright, sales, taxes, etc.

LITERARY MARKET PLACE

custserv@infotoday.com

www.infotoday.com

www.literarymarketplace.com

Directory that lists book publishers and other book publishing industry contacts.

NEGOTIATING STOCK PHOTO PRICES BY JIM PICKERELL AND CHERYL PICKERELL DIFRANK

sellingstock@chd.com

www.pickphoto.com

Hardbound book that offers pricing guidelines for selling photos through stock photo agencies.

NEWSLETTERS IN PRINT

gale.galeord@thomson.com

www.gale.com

Annual directory listing newsletters.

O'DWYER'S DIRECTORY OF PUBLIC RELATIONS FIRMS

john@odwyerpr.com

www.odwyerpr.com

Annual directory listing public relations firms, indexed by specialties.

PHOTO PORTFOLIO SUCCESS BY JOHN KAPLAN

www.writersdigest.com

THE PHOTOGRAPHER'S GUIDE TO MARKETING & SELF-PROMOTION, 3RD EDITION BY MARIA PISCOPO

PUB@allworth.com

www.allworth.com

Marketing guide for photographers.

THE PHOTOGRAPHER'S INTERNET HANDBOOK, REVISED EDITION BY JOE FARACE

PUB@allworth.com

www.allworth.com

Covers the many ways photographers can use the Internet as a marketing and informational resource.

PRICING PHOTOGRAPHY: THE COMPLETE GUIDE TO ASSIGNMENT & STOCK PRICES, 3RD EDITION BY MICHAL HERON AND DAVID MACTAVISH

PUB@allworth.com

www.allworth.com

REAL WORLD COLOR MANAGEMENT: INDUSTRIAL-STRENGTH PRODUCTION TECHNIQUES BY BRUCE FRASER, CHRIS MURPHY AND FRED BUNTING

www.peachpit.com

SELL & RESELL YOUR PHOTOS, 5TH EDITION BY ROHN ENGH

www.writersdigest.com

Revised edition of the classic volume on marketing your own stock.

SELLPHOTOS.COM BY ROHN ENGH

www.writersdigest.com

A guide to establishing a stock photography business on the Internet.

SHOOTING & SELLING YOUR PHOTOS BY JIM ZUCKERMAN

www.writersdigest.com

SONGWRITER'S MARKET

www.writersdigest.com

Annual directory listing record labels.

STANDARD RATE AND DATA SERVICE (SRDS)

www.srds.com

Directory listing magazines and their advertising rates.

WORKBOOK

press@workbook.com

www.workbook.com

Numerous resources for the graphic arts industry.

WRITER'S MARKET

www.writersmarket.com

Annual directory listing markets for freelance writers. Many listings include photo needs and payment rates.

WEB SITES

PHOTOGRAPHY BUSINESS

THE ALTERNATIVE PICK

www.altpick.com

BLACK BOOK

www.blackbook.com

COPYRIGHT WEB SITE

www.benedict.com

EP: EDITORIAL PHOTOGRAPHERS

www.editorialphoto.com

MACTRIBE

www.mactribe.com

SHOOTSMARTER.COM

www.shootsmarter.com

SMALL BUSINESS ADMINISTRATION

www.sba.gov

MAGAZINE AND BOOK PUBLISHING

AMERICAN JOURNALISM REVIEW'S NEWS LINKS

http://newslink.org

BOOKWIRE

www.bookwire.com

STOCK PHOTOGRAPHY

GLOBAL PHOTOGRAPHERS SEARCH

www.photographers.com

PHOTOSOURCE INTERNATIONAL

www.photosource.com

STOCK PHOTO PRICE CALCULATOR

www.photographersindex.com/stockprice.htm

SELLING STOCK

www.pickphoto.com

STOCK ARTISTS ALLIANCE

www.stockartistsalliance.org

THE STOCKPHOTO NETWORK

www.stockphoto.net

ADVERTISING PHOTOGRAPHY

ADVERTISING AGE

www.adage.com

ADWEEK, MEDIAWEEK AND BRANDWEEK

www.adweek.com

COMMUNICATION ARTS MAGAZINE

www.commarts.com

FINE ART PHOTOGRAPHY

THE ART LIST

www.theartlist.com

ART SUPPORT

www.art-support.com

ART DEADLINES LIST
www.artdeadlineslist.com

**PHOTOGRAPHY IN
NEW YORK INTERNATIONAL**
www.photography-guide.com

MARY VIRGINIA SWANSON
www.mvswanson.com

PHOTOJOURNALISM

THE DIGITAL JOURNALIST
www.digitaljournalist.org

FOTO8
www.foto8.com

**NATIONAL PRESS
PHOTOGRAPHERS ASSOCIATION**
www.nppa.org

MAGAZINES

AFTERIMAGE
www.vsw.org

APERTURE
www.aperture.org

ART CALENDAR
www.artcalendar.com

ART ON PAPER
www.artonpaper.com

BLACK AND WHITE PHOTOGRAPHY
www.bandwmag.com

BLIND SPOT
www.blindspot.com

BRITISH JOURNAL OF PHOTOGRAPHY

www.bjphoto.co.uk

CAMERA ARTS
www.cameraarts.com

LENS WORK
www.lenswork.com

PHOTO DISTRICT NEWS
www.pdnonline.com

PHOTOGRAPH MAGAZINE
www.photography-guide.com

PHOTO INSIDER
www.photoinsider.com

**THE PHOTO REVIEW, THE PHOTOGRAPHY
COLLECTOR, AND THE PHOTOGRAPHIC
ART MARKET MAGAZINES**
www.photoreview.org

SHOTS MAGAZINE
www.shotsmag.com

VIEW CAMERA
www.viewcamera.com

E-ZINES
The following publications exist online only. Some
offer opportunities for photographers to post their
personal work.

APOGEE PHOTO
www.apogeephoto.com

AMERICAN PHOTO MAGAZINE
www.americanphotomag.com

AMERICAN PHOTOGRAPHY MUSEUM
www.photographymuseum.com

ART IN CONTEXT
wwww.artincontext.org

ART BUSINESS NEWS

www.artbusinessnews.com

ART SUPPORT

www.art-support.com

ARTIST REGISTER

http://artistsregister.com

DIGITAL JOURNALIST

www.digitaljournalist.org

EN FOCO

www.enfoco.org

FOTOPHILE

www.fotophile.com

HANDHELD MAGAZINE

www.handheldmagazine.com/index.html

MUSARIUM

www.musarium.com

FABFOTOS

www.fabfotos.com

FOTO8

www.foto8.com

ONE WORLD JOURNEYS

www.oneworldjourneys.com

PHOTOARTS

www.photoarts.com

PIXEL PRESS

www.pixelpress.org

PHOTO IMAGING INFORMATION COUNCIL

www.takegreatpictures.com

PHOTO LINKS

www.photolinks.com

ONLINE PHOTO WORKSHOPS

www.photoworkshop.com

PICTURE PROJECTS

www.pictureprojects.com

SIGHT PHOTO

www.sightphoto.com

ZONE ZERO

www.zonezero.com

TECHNICAL

ABOUT.COM

www.photography.about.com

FOCALFIX.COM

www.focalfix.com

PHOTO.NET

www.photo.net

THE PIXEL FOUNDRY

www.thepixelfoundry.com

SHOOT SMARTER

www.shootsmarter.com

WILHELM IMAGING RESEARCH

www.wilhelm-research.com

HOW TO

ADOBE TUTORIALS

www.adobe.com designcenter/tutorials

DIGITAL PHOTOGRAPHERS

www.digitalphotographers.net

DIGITAL PHOTOGRAPHY REVIEW

www.dpreview.com

FRED MIRANDA

www.fredmiranda.com/forum/index.php

IMAGING RESOURCE

www.imaging-resource.com

LONE STAR DIGITAL

www.lonestardigital.com

THE NATIONAL ASSOCIATION OF PHOTOSHOP PROFESSIONALS

www.photoshopuser.com

PC PHOTO REVIEW

www.pcphotoreview.com

STEVE'S DIGICAMS

www.steves-digicams.com

GRANTS: STATE, PROVINCIAL, & REGIONAL

Arts councils in the United States and Canada provide assistance to artists (including photographers) in the form of fellowships or grants. These grants can be substantial and confer prestige upon recipients; however, only state or province residents are eligible. Because deadlines and available support vary annually, query first (with a SASE) or check websites for guidelines.

UNITED STATES ARTS AGENCIES

ALABAMA STATE COUNCIL ON THE ARTS

staff@arts.alabama.gov

www.arts.state.al.us

ALASKA STATE COUNCIL ON THE ARTS

aksca_info@eed.state.ak.us

www.eed.state.ak.us/aksca

ARIZONA COMMISSION ON THE ARTS

info@azarts.gov

www.azarts.gov

ARKANSAS ARTS COUNCIL

info@arkansasarts.com

www.arkansasarts.com

CALIFORNIA ARTS COUNCIL

info@caartscouncil.com

www.cac.ca.gov

COLORADO COUNCIL ON THE ARTS

www.coloarts.state.co.us

CONNECTICUT COMMISSION ON CULTURE & TOURISM

www.cultureandtourism.org

DELAWARE DIVISION OF THE ARTS

delarts@state.de.us.

www.artsdel.org

DISTRICT OF COLUMBIA COMMISSION ON THE ARTS & HUMANITIES

cah@dc.gov

http://dcarts.dc.gov

FLORIDA ARTS COUNCIL

info@florida-arts.org

www.florida-arts.org

GEORGIA COUNCIL FOR THE ARTS

gaarts@gaarts.org

www.gaarts.org

GUAM COUNCIL ON THE ARTS & HUMANITIES AGENCY

www.guam.net

HAWAII STATE FOUNDATION ON CULTURE & THE ARTS

ken.hamilton@hawaii.gov

www.state.hi.us/sfca

IDAHO COMMISSION ON THE ARTS

info@arts.idaho.gov

www.arts.idaho.gov

ILLINOIS ARTS COUNCIL

iac.info@illinois.gov

www.state.il.us/agency/iac

INDIANA ARTS COMMISSION

IndianaArtsCommission@iac.in.gov

www.in.gov/arts

IOWA ARTS COUNCIL

www.iowaartscouncil.org

KANSAS ARTS COMMISSION

KAC@arts.state.ks.us

http://arts.state.ks.us

KENTUCKY ARTS COUNCIL

kyarts@ky.gov

http://artscouncil.ky.gov

LOUISIANA DIVISION OF THE ARTS

www.crt.state.la.us/arts

MAINE ARTS COMMISSION

MaineArts.info@maine.gov

www.mainearts.com

MARYLAND STATE ARTS COUNCIL

msac@msac.org

www.msac.org

MASSACHUSETTS CULTURAL COUNCIL

mcc@art.state.ma.us

www.massculturalcouncil.org

**MICHIGAN COUNCIL FOR ARTS
& CULTURAL AFFAIRS**

http://www.michigan.gov/hal/0,1607,7-
160-17445_19272---,00.html

MINNESOTA STATE ARTS BOARD

msab@arts.state.mn.us

www.arts.state.mn.us

MISSISSIPPI ARTS COMMISSION

www.arts.state.ms.us

MISSOURI ARTS COUNCIL

moarts@ded.mo.gov

www.missouriartscouncil.org

MONTANA ARTS COUNCIL

mac@mt.gov

www.art.state.mt.us

**NATIONAL ASSEMBLY OF STATE
ARTS AGENCIES**

nasaa@nasaa-arts.org

www.nasaa-arts.org

NEBRASKA ARTS COUNCIL

www.nebraskaartscouncil.org

NEVADA ARTS COUNCIL

http://dmla.clan.lib.nv.us/docs/arts

**NEW HAMPSHIRE STATE COUNCIL
ON THE ARTS**

www.nh.gov/nharts

NEW JERSEY STATE COUNCIL ON THE ARTS

www.njartscouncil.org

NEW MEXICO ARTS

www.nmarts.org

NEW YORK STATE COUNCIL ON THE ARTS

www.nysca.org

NORTH CAROLINA ARTS COUNCIL

carts@ncmail.net

www.ncarts.org

NORTH DAKOTA COUNCIL ON THE ARTS

comserv@state.nd.us

www.state.nd.us/arts

COMMONWEALTH COUNCIL FOR ARTS AND CULTURE (NORTHERN MARIANA ISLANDS)
 galaidi@vzpacifica.net
 www.geocities.com/ccacarts/ccac
 website.html

OHIO ARTS COUNCIL
 www.oac.state.oh.us

OKLAHOMA ARTS COUNCIL
 okarts@arts.ok.gov
 www.arts.state.ok.us

OREGON ARTS COMMISSION
 oregon.artscomm@state.or.us
 www.oregonartscommission.org

PENNSYLVANIA COUNCIL ON THE ARTS
 www.pacouncilonthearts.org

INSTITUTE OF PUERTO RICAN CULTURE
 www.icp.gobierno.pr

RHODE ISLAND STATE COUNCIL ON THE ARTS
 info@arts.ri.gov
 www.arts.ri.gov

AMERICAN SAMOA COUNCIL ON CULTURE, ARTS AND HUMANITIES
 www.prel.org/programs/pcahe/PTG/terr-asamoa1.html

SOUTH CAROLINA ARTS COMMISSION
 info@arts.state.sc.us
 www.southcarolinaarts.com

SOUTH DAKOTA ARTS COUNCIL
 sdac@state.sd.us
 www.artscouncil.sd.gov

TENNESSEE ARTS COMMISSION
 www.arts.state.tn.us

TEXAS COMMISSION ON THE ARTS
 front.desk@arts.state.tx.us
 www.arts.state.tx.us

UTAH ARTS COUNCIL
 http://arts.utah.gov

VERMONT ARTS COUNCIL
 www.vermontartscouncil.org

VIRGIN ISLANDS COUNCIL ON THE ARTS
 http://vicouncilonarts.org

VIRGINIA COMMISSION FOR THE ARTS
 arts@arts.virginia.gov
 www.arts.state.va.us

WASHINGTON STATE ARTS COMMISSION
 info@arts.wa.gov
 www.arts.wa.gov

WEST VIRGINIA COMMISSION ON THE ARTS
 www.wvculture.org/arts

WISCONSIN ARTS BOARD
 artsboard@arts.state.wi.us
 www.arts.state.wi.us

WYOMING ARTS COUNCIL
 ebratt@state.wy.us
 http://wyoarts.state.wy.us

CANADIAN PROVINCES ARTS AGENCIES

ALBERTA FOUNDATION FOR THE ARTS
 www.cd.gov.ab.ca/all_about_us/commissions/arts

BRITISH COLUMBIA ARTS COUNCIL
 BCArtsCouncil@gov.bc.ca
 www.bcartscouncil.ca

THE CANADA COUNCIL FOR THE ARTS
 www.canadacouncil.ca

MANITOBA ARTS COUNCIL

info@artscouncil.mb.ca

www.artscouncil.mb.ca

NEW BRUNSWICK ARTS BOARD (NBAB)

www.artsnb.ca

NEWFOUNDLAND & LABRADOR ARTS COUNCIL

nlacmail@nfld.net

www.nlac.nf.ca

NOVA SCOTIA DEPARTMENT OF TOURISM, CULTURE, AND HERITAGE

cultaffs@gov.ns.ca

www.gov.ns.ca/dtc/culture

ONTARIO ARTS COUNCIL

info@arts.on.ca

www.arts.on.ca

PRINCE EDWARD ISLAND COUNCIL OF THE ARTS

info@peiartscouncil.com

www.peiartscouncil.com

QUÉBEC COUNCIL FOR ARTS & LITERATURE

info@calq.gouv.qc.ca

www.calq.gouv.qc.ca

THE SASKATCHEWAN ARTS BOARD

sab@artsboard.sk.ca

www.artsboard.sk.ca

YUKON ARTS SECTION

arts@gov.yk.ca

www.btc.gov.yk.ca/cultural/arts

STATE AND REGIONAL GRANTS AND AWARDS

The following opportunities are arranged by state since most of them grant money to artists in a particular geographic region. Because deadlines vary annually, check websites or call for the most up-to-date information. Note: Not all states are listed; see the list of state, provincial and regional arts agencies on page 327–330 for state-sponsored arts councils.

California

FLINTRIDGE FOUNDATION AWARDS FOR VISUAL ARTISTS

www.flintridgefoundation.org

For artists in California, Oregon and Washington only.

JAMES D. PHELAN AWARD IN PHOTOGRAPHY

www.kala.org

For artists born in California only.

Connecticut

MARTHA BOSCHEN PORTER FUND, INC.

145 White Hallow Rd., Sharon CT 06064. For artists in northwestern Connecticut, western Massachusetts and adjacent areas of New York (except New York City).

Idaho

BETTY BOWEN MEMORIAL AWARD

www.seattleartmuseum.org/bettybowen/

For artists in Washington, Oregon and Idaho only.

Illinois

ILLINOIS ARTS COUNCIL

www.state.il.us/agency/iac/Guidelines/guidelines.htm

For Illinois artists only.

Kentucky

KENTUCKY FOUNDATION FOR WOMEN GRANTS PROGRAM

www.kfw.org/grants.html.
> For female artists living in Kentucky only.

Massachusetts
> See Martha Boschen Porter Fund, Inc., under Connecticut.

Minnesota

MCKNIGHT PHOTOGRAPHY FELLOWSHIPS PROGRAM

www.mcknightphoto.umn.edu.
> For Minnesota artists only.

New York

A.I.R. GALLERY FELLOWSHIP PROGRAM

info@airnyc.org www.airnyc.or.
> For female artists from New York City metro area only.

ARTS & CULTURAL COUNCIL FOR GREATER ROCHESTER

www.artsrochester.org

CONSTANCE SALTONSTALL FOUNDATION FOR THE ARTS GRANTS AND FELLOWSHIPS

info@saltonstall.org

www.saltonstall.org
> For artists in the central and western counties of New York.

NEW YORK FOUNDATION FOR THE ARTS: ARTISTS' FELLOWSHIPS

nyfaafp@nyfa.org www.nyfa.org
> For New York artists only.

Oregon
> See Flintridge Foundation Awards for Visual Artists, under California.

Pennsylvania

LEEWAY FOUNDATION; PHILADELPHIA, PENNSYLVANIA REGION

info@leeway.org www.leeway.org
> For female artists in Philadelphia only.

Texas

INDIVIDUAL ARTIST GRANT PROGRAM; HOUSTON, TEXAS

info@cachh.org www.cachh.org
> For Houston artists only.

Washington
> See Flintridge Foundation Awards for Visual Artists, under California.

ABSOLUTE-RELEASED IMAGES. Any images for which signed model or property releases are on file and immediately available. For working with stock photo agencies that deal with advertising agencies, corporations and other commercial clients, such images are absolutely necessary to sell usage of images. Also see Model Release, Property Release.

ACCEPTANCE (PAYMENT ON). The buyer pays for certain rights to publish a picture at the time it is accepted, prior to its publication.

AGENCY PROMOTION RIGHTS. Stock agencies request these rights in order to reproduce a photographer's images in promotional materials such as catalogs, brochures and advertising.

AGENT. A person who calls on potential buyers to present and sell existing work or obtain assignments for a client. A commission is usually charged. Such a person may also be called a photographer's rep.

ALL RIGHTS. A form of rights often confused with work for hire. Identical to a buyout, this typically applies when the client buys all rights or claim to ownership of copyright, usually for a lump sum payment. This entitles the client to unlimited, exclusive usage and usually with no further compensation to the creator. Unlike work for hire, the transfer of copyright is not permanent. A time limit can be negotiated, or the copyright ownership can run to the maximum of 35 years.

ALTERNATIVE PROCESSES. Printing processes that do not depend on the sensitivity of silver to form an image. These processes include cyanotype and platinum printing.

ARCHIVAL. The storage and display of photographic negatives and prints in materials that are harmless to them and prevent fading and deterioration.

ARTIST'S STATEMENT. A short essay, no more than a paragraph or two, describing a photographer's mission and creative process. Most galleries require photographers to provide an artist's statement.

ASSIGN (DESIGNATED RECIPIENT). A third-party person or business to which a client assigns or designates ownership of copyrights that the client purchased originally from a creator such as a photographer. This term commonly appears on model and property releases.

ASSIGNMENT. A definite OK to take photos for a specific client with mutual understanding as to the provisions and terms involved.

ASSIGNMENT OF COPYRIGHT, RIGHTS. The photographer transfers claim to ownership of

copyright over to another party in a written contract signed by both parties.

AUDIOVISUAL (AV). Materials such as filmstrips, motion pictures and overhead transparencies which use audio backup for visual material.

AUTOMATIC RENEWAL CLAUSE. In contracts with stock photo agencies, this clause works on the concept that every time the photographer delivers an image, the contract is automatically renewed for a specified number of years. The drawback is that a photographer can be bound by the contract terms beyond the contract's termination, and be blocked from marketing the same images to other clients for an extended period of time.

AVANT GARDE. Photography that is innovative in form, style or subject matter.

BIANNUAL. Occurring twice a year. Also see Semiannual.

BIENNIAL. Occurring once every two years.

BIMONTHLY. Occurring once every two months.

BIO. A sentence or brief paragraph about a photographer's life and work, sometimes published along with photos.

BIWEEKLY. Occurring once every two weeks.

BLURB. Written material appearing on a magazine's cover describing its contents.

BUYOUT. A form of work for hire where the client buys all rights or claim to ownership of copyright, usually for a lump sum payment. Also see All Rights, Work for Hire.

CAPTION. The words printed with a photo (usually directly beneath it), describing the scene or action.

CCD. Charged Coupled Device. A type of light detection device, made up of pixels, that generates an electrical signal in direct relation to how much light strikes the sensor.

CD-ROM. Compact disc read-only memory; non-erasable electronic medium used for digitized image and document storage and retrieval on computers.

CHROME. A color transparency, usually called a slide.

CIBACHROME. A photo printing process that produces fade-resistant color prints directly from color slides.

CLIPS. See Tearsheet.

CMYK. Cyan, magenta, yellow and black—refers to four-color process printing.

COLOR CORRECTION. Adjusting an image to compensate for digital input and output characteristics.

COMMISSION. The fee (usually a percentage of the total price received for a picture) charged by a photo agency, agent or gallery for finding a buyer and attending to the details of billing, collecting, etc.

COMPOSITION. The visual arrangement of all elements in a photograph.

COMPRESSION. The process of reducing the size of a digital file, usually through software. This speeds processing, transmission times and reduces storage requirements.

CONSUMER PUBLICATIONS. Magazines sold on newsstands and by subscription that cover information of general interest to the public, as opposed to trade magazines, which cover information specific to a particular trade or profession. See Trade Magazine.

CONTACT SHEET. A sheet of negative-size images made by placing negatives in direct contact with the printing paper during exposure. They are used to view an entire roll of film on one piece of paper.

CONTRIBUTOR'S COPIES. Copies of the issue of a magazine sent to photographers in which their work appears.

COPYRIGHT. The exclusive legal right to reproduce, publish and sell the matter and form of an artistic work.

COVER LETTER. A brief business letter introducing a photographer to a potential buyer. A cover letter may be used to sell stock images or solicit a portfolio review. Do not confuse cover letter with query letter.

C-PRINT. An enlargement that is printed from a negative.

CREDIT LINE. The byline of a photographer or organization that appears below or beside a published photo.

CUTLINE. See Caption.

DAY RATE. A minimum fee that many photographers charge for a day's work, whether a full day is spent on a shoot or not. Some photographers offer a half-day rate for projects involving up to a half-day of work.

DEMO(S). A sample reel of film or sample videocassette that includes excerpts of a filmmaker's or videographer's production work for clients.

DENSITY. The blackness of an image area on a negative or print. On a negative, the denser the black, the less light that can pass through.

DIGITAL CAMERA. A filmless camera system that converts an image into a digital signal or file.

DPI. Dots per inch. The unit of measure used to describe the resolution of image files, scanners and output devices. How many pixels a device can produce in one inch.

ELECTRONIC SUBMISSION. A submission made by modem or on computer disk, CD-ROM or other removable media.

EMULSION. The light-sensitive layer of film or photographic paper.

ENLARGEMENT. An image that is larger than its negative, made by projecting the image of the negative onto sensitized paper.

EXCLUSIVE PROPERTY RIGHTS. A type of exclusive rights in which the client owns the physical image, such as a print, slide, film reel or videotape. A good example is when a portrait is shot for a person to keep, while the photographer retains the copyright.

EXCLUSIVE RIGHTS. A type of rights in which the client purchases exclusive usage of the image for a negotiated time period, such as one, three or five years. May also be permanent. Also see All Rights, Work for Hire.

FEE-PLUS BASIS. An arrangement whereby a photographer is given a certain fee for an as-

signment—plus reimbursement for travel costs, model fees, props and other related expenses incurred in completing the assignment.

FILE FORMAT. The particular way digital information is recorded. Common formats are TIFF and JPEG.

FIRST RIGHTS. The photographer gives the purchaser the right to reproduce the work for the first time. The photographer agrees not to publish the work for a specified amount of time.

FORMAT. The size or shape of a negative or print.

FOUR-COLOR PRINTING, FOUR-COLOR PROCESS. A printing process in which four primary printing inks are run in four separate passes on the press to create the visual effect of a full-color photo, as in magazines, posters and various other print media. Four separate negatives of the color photo—shot through filters—are placed indentically (stripped) and exposed onto printing plates, and the images are printed from the plates in four ink colors.

GIF. Graphics Interchange Format. A graphics file format common to the Internet.

GLOSSY. Printing paper with a great deal of surface sheen. The opposite of matte.

HARD COPY. Any kind of printed output, as opposed to display on a monitor.

HONORARIUM. Token payment—small amount of money and/or a credit line and copies of the publication.

IMAGE RESOLUTION. An indication of the amount of detail an image holds. Usually expressed as the dimension of the image in pix-

els and the color depth each pixel has. Example: a 640×480, 24-bit image has higher resolution than a 640×480, 16-bit image.

IRC. International Reply Coupon. IRCs are used with self-addressed envelopes instead of stamps when submitting material to buyers located outside a photographer's home country.

JPEG. Joint Photographic Experts Group. One of the more common digital compression methods that reduces file size without a great loss of detail.

LICENSING/LEASING. A term used in reference to the repeated selling of one-time rights to a photo.

MANUSCRIPT. A typewritten document to be published in a magazine or book.

MATTE. Printing paper with a dull, nonreflective surface. The opposite of glossy.

MODEL RELEASE. Written permission to use a person's photo in publications or for commercial use.

MULTI-IMAGE. A type of slide show that uses more than one projector to create greater visual impact with the subject. In more sophisticated multi-image shows, the projectors can be programmed to run by computer for split-second timing and animated effects.

MULTIMEDIA. A generic term used by advertising, public relations and audiovisual firms to describe productions using more than one medium together—such as slides and full-motion, color video—to create a variety of visual effects.

NEWS RELEASE. See Press Release.

NO RIGHT OF REVERSION. A term in business contracts that specifies once a photographer sells

the copyright to an image, a claim of owner-ship is surrendered. This may be unenforceable, though, in light of the 1989 Supreme Court decision on copyright law. Also see All Rights, Work for Hire.

ON SPEC. Abbreviation for "on speculation." Also see Speculation.

ONE-TIME RIGHTS. The photographer sells the right to use a photo one time only in any me-dium. The rights transfer back to the photogra-pher on request after the photo's use.

PAGE RATE. An arrangement in which a pho-tographer is paid at a standard rate per page in a publication.

PHOTO CD. A trademarked, Eastman Kodak-designed digital storage system for photographic images on a CD.

PICT. The saving format for bit-mapped and object-oriented images.

PICTURE LIBRARY. See Stock Photo Agency.

PIXELS. The individual light-sensitive ele-ments that make up a CCD array. Pixels re-spond in a linear fashion. Doubling the light intensity doubles the electrical output of the pixel. See also CCD.

POINT-OF-PURCHASE, POINT-OF-SALE (P-O-P, P-O-S). A term used in the advertising indus-try to describe in-store marketing displays that promote a product. Typically, these highly-illustrated displays are placed near checkout lanes or counters, and offer tear-off discount coupons or trial samples of the product.

PORTFOLIO. A group of photographs assem-bled to demonstrate a photographer's talent and abilities, often presented to buyers.

PPI. Pixels per inch. Often used interchangeably with DPI, PPI refers to the number of pixels per inch in an image. See also DPI.

PRESS RELEASE. A form of publicity announce-ment that public relations agencies and corpo-rate communications staff people send out to newspapers and TV stations to generate news coverage. Usually this is sent with accompany-ing photos or videotape materials.

PROPERTY RELEASE. Written permission to use a photo of private property or public or government facilities in publications or for commercial use.

PUBLIC DOMAIN. A photograph whose copy-right term has expired is considered to be "in the public domain" and can be used for any purpose without payment.

PUBLICATION (PAYMENT ON). The buyer does not pay for rights to publish a photo until it is actually published, as opposed to payment on acceptance.

QUERY. A letter of inquiry to a potential buyer soliciting interest in a possible photo assignment.

REP. Trade jargon for sales representative. Also see Agent.

RESOLUTION. The particular pixel density of an image, or the number of dots per inch a de-vice is capable of recognizing or reproducing.

RÉSUMÉ. A short written account of one's ca-reer, qualifications and accomplishments.

ROYALTY. A percentage payment made to a photographer/filmmaker for each copy of work sold.

R-PRINT. Any enlargement made from a transparency.

SAE. Self-addressed envelope.

SASE. Self-addressed, stamped envelope. (Most buyers require a SASE if a photographer wishes unused photos returned to him, especially unsolicited materials.)

SELF-ASSIGNMENT. Any project photographers shoot to show their abilities to prospective clients. This is a good tool for beginning photographers who want to build a portfolio or photographers wanting to make a transition into a new market.

SELF-PROMOTION PIECE. A printed piece photographers use for advertising and promoting their business. These pieces generally use one or more examples of the photographer's best work and are professionally designed and printed to make the best impression.

SEMIANNUAL. Occurring twice a year. Also see Biannual.

SEMIGLOSS. A paper surface with a texture between glossy and matte, but closer to glossy.

SEMIMONTHLY. Occurring twice a month.

SERIAL RIGHTS. The photographer sells the right to use a photo in a periodical. Rights usually transfer back to the photographer on request after the photo's use.

SIMULTANEOUS SUBMISSIONS. Submission of the same photo or group of photos to more than one potential buyer at the same time.

SPECULATION. The photographer takes photos with no assurance that the buyer will either purchase them or reimburse expenses in any way, as opposed to taking photos on assignment.

STOCK PHOTO AGENCY. A business that maintains a large collection of photos it makes available to a variety of clients such as advertising agencies, calendar firms and periodicals. Agencies usually retain 40 to 60 percent of the sales price they collect, and remit the balance to the photographers whose photo rights they've sold.

STOCK PHOTOGRAPHY. Primarily the selling of reprint rights to existing photographs rather than shooting on assignment for a client. Some stock photos are sold outright, but most are rented for a limited time period. Individuals can market and sell stock images to individual clients from their personal inventory, or stock photo agencies can market photographers' work for them. Many stock agencies hire photographers to shoot new work on assignment, which then becomes the inventory of the stock agency.

SUBSIDIARY AGENT. In stock photography, this is a stock photo agency that handles marketing of stock images for a primary stock agency in certain United States or foreign markets. These are usually affiliated with the primary agency by a contractual agreement rather than by direct ownership, as in the case of an agency that has its own branch offices.

SVHS. Abbreviation for Super VHS. Videotape that is a step above regular VHS tape. The number of lines of resolution in a SVHS picture is greater, thereby producing a sharper picture.

TABLOID. A newspaper about half the page size of an ordinary newspaper that contains many photos and news in condensed form.

TEARSHEET. An actual sample of a published work from a publication.

TIFF. Tagged Image File Format. A common bitmap image format developed by Aldus.

TRADE MAGAZINE. A publication devoted strictly to the interests of readers involved in a specific trade or profession, such as beekeepers, pilots or manicurists, and generally available only by subscription.

TRANSPARENCY. Color film with a positive image, also referred to as a slide.

UNLIMITED USE. A type of rights in which the client has total control over both how and how many times an image will be used. Also see All Rights, Exclusive Rights, Work for Hire.

UNSOLICITED SUBMISSION. A photograph or photographs sent through the mail that a buyer did not specifically ask to see.

WORK FOR HIRE. Any work that is assigned by an employer who becomes the owner of the copyright. Stock images cannot be purchased under work-for-hire terms.

WORLD RIGHTS. A type of rights in which the client buys usage of an image in the international marketplace. Also see All Rights.

WORLDWIDE EXCLUSIVE RIGHTS. A form of world rights in which the client buys exclusive usage of an image in the international marketplace. Also see All Rights.

COPYRIGHT INDEX

ABOUT THE AUTHOR

Vik Orenstein is a photographer, writer, and teacher. She founded KidCapers Portraits in 1988, followed by Tiny Acorn Studio in 1994. In addition to her work creating portraits of children, she has photographed children for such commercial clients as Nikon, Pentax, Microsoft, and 3M. Vik teaches several photography courses at BetterPhoto.com.